BOLLINGEN SERIES XCII

Samothracian

Aspects of the Revival of the Antique

BY PHYLLIS WILLIAMS LEHMANN

AND KARL LEHMANN

BOLLINGEN SERIES XCII

PRINCETON UNIVERSITY PRESS

Reflections

THIS IS THE NINETY-SECOND IN A SERIES OF WORKS
SPONSORED BY BOLLINGEN FOUNDATION

This book is set in Linotype Times Roman

Printed in the United States of America by
Princeton University Press

*Titlepage illustration: View of the southern
coast of Samothrace (Photo: Nicholas D. Ohly)*

TO THE MEMORY OF

Ruth Wedgwood Kennedy

PREFACE

THE THREE essays contained in this little volume are by-products of discoveries made in Samothrace in the summers of 1949 and 1950. Excavation in the Sanctuary of the Great Gods on behalf of the Archaeological Research Fund of New York University in those years yielded new blocks of a frieze of dancing maidens that had been sketched by Cyriacus of Ancona when he visited the island in 1444, and established the fact that the prow of the naval vessel on which the *Victory of Samothrace* alighted once belonged to a monumental fountain. In the wake of these discoveries, Karl Lehmann and I were drawn into the varied problems considered in these essays, into an absorbing series of intellectual adventures that we pursued in our spare time in the following years, especially profitably during a prolonged stay in Rome in the autumn and winter of 1952–1953. In January 1954, my husband presented his thoughts on *The Ship-Fountain from the Victory of Samothrace to Baroque Rome* in Philadelphia, at the joint meeting of the College Art Association of America and the Society of Architectural Historians, a lecture subsequently repeated at the American Numismatic Society and at Smith College. I, myself, have presented the gist of my conclusions about *The Sources and Meaning of Mantegna's Parnassus* in the mid-sixties at Wheaton, Sweet Briar, and Smith Colleges.

In returning to Cyriacus of Ancona's visit to Samothrace, I have reconsidered a topic earlier discussed by Karl Lehmann in an article published in *Hesperia* in 1943. Investigation of the *Parnassus* and continuing preoccupation with the antiquities of Samothrace have involved me increasingly in the career of that extraordinary Quattrocento figure, and I include the tale of his visit to the island as a prelude to the other essays because the revival of interest in the antique, the influence of ancient thought and works of art—even of Samothracian antiquities—reflected in these studies converge in Cyriacus' person and activity.

In our pursuit of these problems, we have been helped on our adventurous way by a host of individuals and institutions. My husband singled out those to whom he felt especially indebted in the opening note to his essay. I shall

not repeat his statement here but supplement it with grateful reference to the many friends and colleagues whose advice and assistance have been invaluable to me. Foremost among them are Edward W. Bodnar, S.J., to whom I am indebted for all the translations of Cyriacus' Renaissance Latin published in these pages, as well as for putting at my disposal, time and again, his special knowledge of Cyriacus and giving me the advantage of his suggestions and criticism; Richard Krautheimer, who has checked and supplemented my editorial additions to my husband's posthumously published manuscript; Millard Meiss, who has given me the benefit of an expert's eye in reading the manuscript of the *Parnassus*; and Waltraut C. Seitter, who provided me with essential astronomical help in solving an astrological puzzle.

In addition, it is a pleasure to acknowledge my indebtedness and gratitude for advice, information, references, or photographs to the following friends and colleagues: Bernard Ashmole, Leonard Baskin, Germain Bazin, Harry Bober, Augusto Campana, I. Cherniakov, Louise M. Crosby, Ellen Davis, Pierre Demargne, Pierre Devambez, Richard Du Cane, Elsbeth B. Dusenbery, Sheila Edmunds, Alison Frantz, Jiří Frel, Martha Leeb Hadzi, Robert M. Harris, Nelly S. Hoyt, R. W. Hunt, Basileios G. Kallipolites, Dorothy King, Clemens Krause, Ann Kromann, Georges Le Rider, Eleanor T. Lincoln, James R. McCredie, B. D. Meritt, Viscount Mersey, George C. Miles, Mary Moore, Elizabeth Murphy, Ernest Nash, O. E. Neugebauer, Elliot M. Offner, Nicholas D. Ohly, Angelo Paredi, Hellmut Sichtermann, Gertrude P. Smith, Denys Spittle, Charles Sterling, Hanns Swarzenski, Margaret Thompson, John Travlos, Bluma L. Trell, Amy L. Vandersall, Cornelius C. Vermeule, and Nancy M. Waggoner. As always, I owe a special debt to the staff of the William Allen Neilson Library of Smith College for their indispensable service and to Erna G. Huber, in particular, for her faithful help in the preparation of my husband's manuscript for publication.

Finally, I should like to thank Mrs. E. T. Chase for a generous contribution to our work, to record my gratitude to Bollingen Foundation for a fellowship awarded in 1960 to further my studies, and to acknowledge my appreciation of John D. Barrett's continuing interest in the publication of this long-delayed volume.

I cannot conclude this brief record of help solicited and generously proffered without acknowledgement of my permanent debt to Karl Lehmann and

Erwin Panofsky for first having led me into the enchanted realm in which antiquity survives, revives, and is transformed.

In 1957, when my husband and I began to plan this volume, we agreed that it must be dedicated to Ruth Wedgwood Kennedy, dear friend and colleague, with whom I had long collaborated at Smith College in giving a seminar on the Antique and the Italian Renaissance. Indeed it was the necessity of considering the art of Mantegna in that course, soon after the discovery of our Samothracian frieze, that started me on what turned into a quest for the sources of the *Parnassus* and stimulated my interest in Cyriacus. Whatever knowledge I have acquired of Renaissance Italy ultimately stems from that long and happy association. No one shared our adventures in pursuit of the revival of the antique as eagerly as Ruth Kennedy, whose own lifelong concern with the Renaissance was increasingly directed toward its antique sources. I dedicate this volume to her memory in sorrow at her loss, in gratitude for the many years of her friendship.

Phyllis Williams Lehmann

Samothrace
August 1970

CONTENTS

ABBREVIATIONS

AA	*Archäologischer Anzeiger.*
AB	*The Art Bulletin.*
ABSA	*Annual of the British School at Athens.*
AJA	*American Journal of Archaeology.*
AM	*Mitteilungen des deutschen archäologischen Instituts, Athenische Abteilung.*
AZ	*Archäologische Zeitung.*
BCH	*Bulletin de correspondance hellénique.*
Berl. Ber.	Preussischen Akademie der Wissenschaften, Berlin. *Monatsberichte.*
BZ	*Byzantinische Zeitschrift.*
CIL	*Corpus Inscriptionum Latinarum.*
GBA	*Gazette des Beaux-Arts.*
Guide³	Karl Lehmann. *Samothrace, A Guide to the Excavations and the Museum*, 3d edn., revised, Locust Valley, 1966.
The Hieron	Phyllis Williams Lehmann. *Samothrace 3, The Hieron* (Bollingen Series LX), Princeton, 1969.
IG	*Inscriptiones Graecae.*
JDAI	*Jahrbuch des deutschen archäologischen Instituts.*
JIAN	*Journal international d'archéologie numismatique.*
JÖAI	*Jahreshefte des österreichischen archäologischen Institutes in Wien.*
JPKS	*Jahrbuch der (königlich) preussischen Kunstsammlungen.*
JRS	*Journal of Roman Studies.*
JWarb	*Journal of the Warburg and Courtauld Institutes.*
Lehmann-Hartleben, "Cyriacus"	Karl Lehmann-Hartleben, "Cyriacus of Ancona, Aristotle, and Teiresias in Samothrace," *Hesperia*, 12 (1943), pp. 115–134.
Neue Jahrbücher	*Neue Jahrbücher für das klassische Altertum Geschichte und deutsche Literatur.*
NS	*Notizie degli scavi di antichità.*
ProcBritAc	*Proceedings of the British Academy.*
RA	*Revue archéologique.*
RE	G. Wissowa et al. *Paulys Real-Encyclopädie der classischen Altertumswissenschaft.* Stuttgart, 1894–
REG	*Revue des études grecques.*
RhM	*Rheinisches Museum für Philologie.*

RM	*Mitteilungen des deutschen archäologischen Instituts, Römische Abteilung.*
Samothrake, I	A. Conze, A. Hauser, and G. Niemann. *Archäologische Untersuchungen auf Samothrake.* Vienna, 1875.
Samothrake, II	A. Conze, A. Hauser, and O. Benndorf. *Neue archäologische Untersuchungen auf Samothrake.* Vienna, 1880.
SBHeidelb	*Sitzungsberichte der Akademie der Wissenschaften*, Phil.-hist. Kl., Heidelberg.

LIST OF ILLUSTRATIONS

Note: The coins illustrated in Chapters I and III are not reproduced to scale but, for the most part, have been enlarged.

I

CYRIACUS OF ANCONA'S
VISIT TO SAMOTHRACE

1. Map of Samothrace, after Cristoforo Buondelmonti, *Liber insularum archipelagi.*
Ms. Lat. X, 123, fol. 19r. Venice. Biblioteca Nazionale Marciana

ON OCTOBER 2, 1444, Cyriacus of Ancona set sail for Samothrace from nearby Imbros. The brief account of his short stay on the island, the earliest extant report on the destroyed ancient sanctuary and city, is preserved in an eloquent, if fragmentary, extract from his lost journal in the Vatican Library.[1] The most influential and remarkable of all visitors to the island in modern times, he approached it in characteristic fashion—responsive, above all, to its antiquities and self-taught to interpret what he saw and recorded through hard-won knowledge of ancient history and literature.[2]

On the sixth day before the Nones of October, in a light boat manned by four rowers which had been provided by Asanius, the governor [of Imbros], we came from Imbros to Thracian Samos, that stately and steeply mountainous island in the Aegean which our Maro mentions in his *Aeneid* thus: "Thracian Samos, which is now called Samothrace." Our pilot was the skillful seaman, Manuel of Imbros. The passage was fortunate, thanks to good, favoring winds. When on that day we were gliding in to the southern part of the island, we saw nearby some rather

[1] Ms. Lat. 5250, fols. 13v–14v.

[2] In reconsidering Cyriacus' visit to Samothrace, a topic previously discussed in particular by Erich Ziebarth, "Cyriacus von Ancona in Samothrake," *AM*, 31 (1906), pp. 405–414, and Karl Lehmann-Hartleben, "Cyriacus of Ancona, Aristotle, and Teiresias in Samothrace," *Hesperia*, 12 (1943), pp. 115–134, I shall confine my references to the extensive and ever-growing scholarly literature on that extraordinary figure to discussions relevant to this visit and to the monuments that Cyriacus mentioned or drew in the course of it. For brief general reviews of his career, the reader is referred to Paul Mac-Kendrick, "A Renaissance Odyssey, The Life of Cyriac of Ancona," *Classica et Mediaevalia*, 13 (1952), pp. 131–145, and Georg Voigt, *Die Wiederbelebung des classischen Alterthums*, 4th edn., unchanged, Berlin, 1960, I, pp. 269–286, which, like all other discussions of Cyriacus' life, derive in considerable part from the incomplete biography by his friend Francesco Scalamonti preserved in a manuscript in Treviso written by Felice Feliciano (Ms. I, 138, in the Biblioteca Capitolare) and reprinted by Giuseppe Colucci, *Delle antichità picene*, XV, Fermo, 1792, pp. XLV–CLV. A more detailed yet still concise account of Cyriacus' life is given by Edward W. Bodnar, S.J., *Cyriacus of Ancona and Athens* (Collection Latomus, XLIII), Brussels-Berchem, 1960, pp. 17–72.

high and stormy peaks of the mountain from whose lofty top Neptune watched the Greek fleet of long ago, windy Ilium, and the forces of Hector: so we have read that Homer sang in his divine song. Today they call the higher peak ἁγία σοφία, i.e., holy wisdom.

On the next day we came on foot, over about 100 stades of steep, mountainous terrain, to the new inland town of the island. Our guide was the seaman Manuel. There I first found John Laskaris, governor on behalf of Palamede Gattilusio. He received me with great courtesy and on the next day, which was auspicious—the Lord's day—he did me the honor of accompanying me to the ancient city, which is situated on the coast in the northern part of the island. They call it Palaeopolis. There, with the governor himself as our guide, we first saw ancient walls built of large stones. They stretched from a high, steep hill a long distance down the slopes that incline toward the sea, and their towers and gates, with their marvelous, varied architectural style, are partly still extant. Moreover, to add to this island's glory, Plutarch tells that it was here that Philip, while still a youth, came to know Olympias, the mother of that noble king, Alexander.

We also saw the huge remains of the marble temple of Neptune, fragments of huge columns, architraves and bases, door posts beautifully decorated with garlanded heads of oxen and with other sculptured figures.

From there, after we came to the new citadel built by Prince Palamede, we found in the tower itself very many extraordinary monuments of this great city and some excellent old inscriptions with Greek lettering and also with our own.[3] (Figs. 2, 3.)

[3] For the greater part of the Latin text, see Ziebarth, *op. cit.*, p. 407, who printed it after a transcription made by August Mau for Alexander Conze and published in *Samothrake*, I, p. 1, n. 1. In reprinting this text, Ziebarth evidently overlooked Conze's statement that he had deleted two passages in Mau's transcription—Cyriacus' characteristic allusions to Virgil and Plutarch. In any case, he, too, omitted them and, as far as I am aware, they do not appear in print. Both are visible in figs. 2 and 3, and are quoted below in nn. 5, 21.

The last paragraph of the Vatican text recurs, in slightly amplified form, on fol. 192v of the previously mentioned manuscript in Treviso. For the text of the latter, see below, chap. II, pp. 112f.

I owe the translation of Cyriacus' report printed above, as well as all other translations of Cyriacus' statements published in this volume, to the kindness of Edward W. Bodnar, S.J., whose generous help is again gratefully acknowledged (see the Preface, p. VIII.

When Cyriacus went to Samothrace, he was a widely-traveled, middle-aged man possessed of a unique first-hand knowledge of the ancient world. Merchant, scholar, diplomat, collector of manuscripts and antiquities, welcome visitor to the courts of pope and sultan, emperors of the East and West, rulers of Italian states in Italy and the Aegean, friend and revered colleague of the scholars, patrons, and artists who were shaping the burgeoning Renaissance, he had long been familiar with the antiquities of Italy, mainland Greece, the islands, Egypt, and Turkey. Yet it was his first visit to Samothrace. As he approached its sheer southern coast, he was stirred, as is every modern visitor, by the awesome grandeur of its mountainous landscape, by the sight of that bald ridge of rock rising from the sea to dominate the landscape of the northeastern Aegean (titlepage). Coming from the region of Troy, whence its towering outline hovers in the distance, he recalled the passage in the *Iliad* where Poseidon, "aloft on top of the highest summit of timbered Samos, the Thracian place,"[4] watched the battle of Greek against Trojan and, word-for-word, Virgil's post-Homeric phrase for it.[5] Decades earlier, he had begun to learn Latin and study the *Aeneid* in order to better understand Dante,[6] as he was to study Greek to comprehend Homer, to transcribe the *Iliad,* and to follow a course of lectures on Homer during a long stay in Adrianople.[7] Now, as he approached the island, his mind was flooded with thoughts of the heroic past.

The next day, as he walked the narrow, rocky path from "the new inland town," Chora, as it is called today, to the site of the ancient city—a path still accessible only to man or beast—he saw from the distance the irregular line of the great wall that enclosed the ancient city. That it attracted his attention and comment is not surprising: it remains among the most impressive

[4] 13.12, quoted from the translation of Richmond Lattimore, Chicago, 1951, p. 271.

[5] *quam nobilem et montibus arduam in egeo insulam Maro noster suo in aenea commemorat his dictis: "Threiciamque samon, quae nunc Samothracia fertur."* Cf. *Aeneid* 7.208: *Threiciamque Samum, quae nunc Samothracia fertur.* In a note to his copy of Strabo, Cyriacus later added the same quotation to 10.2.17: Montague Rhodes James, *A Descriptive Catalogue of the Manuscripts in the Library of Eton College*, Cambridge, 1895, p. 71. For this manuscript, see the references cited below in chap. II, n. 87.

[6] See Colucci, *op. cit.*, pp. LXX, LXXVII, LXXX, LXXXII, XCIVf. (in reference to Cyriacus' visit to Mantua in 1433 in pursuit of Virgiliana), and CXXXV.

[7] *Ibid.*, pp. LXXVII, LXXX, LXXXII.

minus xxx. stadiorū circuitu ciuitatem ambisse uidetur. sed quod mag̃.
adnotari placuit eximiæ uetustatis indicium hoc ad uestibulū arcis
comperi uetustissimis characteribus epigramma.

ΕΠΙ ΘΕΟΡΩ
ΑΝΤΙΦΩΝΤΟΣ. ΤΟ ΚΡΙΤΟΒΟΛΟ ΑΘΗ
ΝΙΠΠΩ. ΤΟ. ΚΛΕΟΛΟΧΟ ΚΛΕΟΧΟ. ΤΟ.
ΑΛΚΙΠΠΩ ΤΩΝ. ΔΕΙΡΑ. ΤΑ ΧΡΗΜΑΤΑ
ΤΟ ΑΠΟΛΛΩΝΟΣ ΚΑΤΑ ΤΟΝ ΛΑΟΝ
ΤΩΝ ΤΡΙΗ ΚΟΣΙΩΝ ΑΠΙΜΑΝΤΩ. ΤΟ
ΦΙΛΩΝΟΣ ΗΡΑΣΙΡΑΙΟ ΦΙΛΩΝΟΣ. ΤΟ
ΘΕΟΓΕΙΤΟΝΟΣ ΛΥΣΙΟΣ ΤΟ. ΤΙΩΝΟΣ
ΔΙΕΣΚΟΡΙΑΔΕΩ ΝΕΟΠΟΛΙΤΕΩ
ΑΠΟ ΜΑΝ. ΤΟ. ΝΕΟΠΟΛΙΤΕΩ.

Vidimus et extra arcis moenia aliud insigne uetustissimæ antiquitatis ue
stigium. quod ad summum.

Ad vi. non. octob. ex Imbro ab Arano præside scapha quattuor munita
remigibus largita et manuele Imbrioto perdoto ducento nauta Sa
mon threiciam uenimus secundo cursu bonis fauentibus æolys.
quam nobilem et montibus arduam in ægio insulam Maro nostro
suo in ænea commemorat his dictis; Threiciamque samon quæ
nunc Samothracia fertur. Equidem cum ea die ad australem insulæ

2. Excerpt from Cyriacus' report on Samothrace. Ms. Lat. 5250, fol. 13v.
Rome, Biblioteca Apostolica Vaticana

pactem allabimur. vidimus prope altiora illa atque nimbosa montis
cacumina, quorum ab alto vertice neptuna graecam olim classem insutosque
Ilion, atque Hectoreas acies conspexisse Homeri cecinisse vatem divino
nempe carmine lectitavimus: quod altius hodie culmen ἁγίαν σοφίαν. i.
sanctam sapientiam vocant. ad postream vero diem ad mediterraneum
novum insula oppidum ad c. fere stadia peditis montana arduaque
per loca venimus, Manuele ipso ducente nauta. ubi primum Iohannem
Lascarim pro palamede Catalusio Oppidum comperi. qui me postquam
pedum ane susceperat ad sequentem faustum cyriacum quedam ad
antiquam maritimam civitatem ipsam, quam ad septemtrionalem insulae
partem palaeopolin vocant, me honorifice comitatus est. Ubi primum eo
et ipso ducitante vidimus antiqua et magnis condita lapidibus moenia
qua ab alto et arduo colle longo tractu porrecta per declivia ad mare
vergentia in hodiernum aliqua ex parte turribus portisque munita ducta
et diversa quidem architectorum compositione mirifica. praeterea quod
ad eiusdem insulae cumuli claritatis accedit. in ea philippus adolescens
adhuc olympiadem Alexandri illius nobilissimi regis matrem cogno-
vit auctore plutarcho.

 Vetusta Samothraciae moenia.

Vidimus et ingentia neptuni marmorei templi vestigia, immanium columnas
fragmenta, epistyliaque et bases, atque portarum postes ornatos e coronatis
boum capitibus aliisque figuris insculptas arte perpulchra, et inde postqu.
ad novam a palamede principe conditam arcem venimus ad turrim

3. Excerpt from Cyriacus' report on Samothrace. Ms. Lat. 5250, fol. 14r.
Rome, Biblioteca Apostolica Vaticana

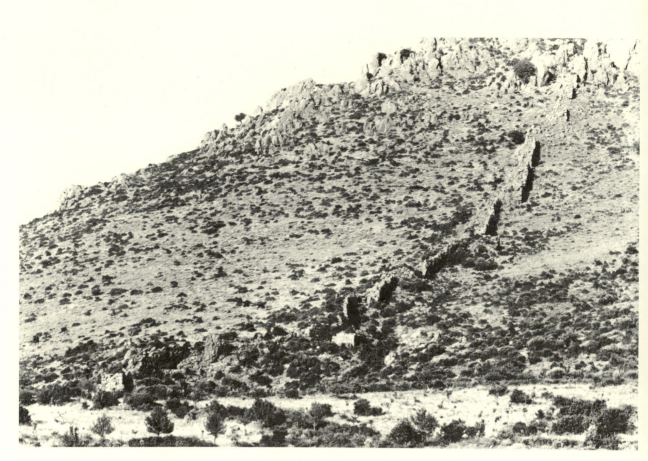

4. Palaiopolis. View of the city wall from the southwest

of ancient city walls, dropping down the steep slopes from the acropolis to the sea, as Cyriacus reports, a sight that has proved memorable to all later explorers of the island (fig. 4).[8] He had long been fascinated by walls, by the great circuits of Constantinople and Thessaloniki, by the walls of Athens, Oeniadae, and Philippi, of neighboring Thasos and Italian Fiesole,[9] and here,

[8] For a characteristic example, see Alexander Conze, *Reise auf den Inseln des thrakischen Meeres*, Hannover, 1860, pp. 61f., and the frontispiece, which shows a section of this wall, as well as Conze's later comments and illustrations in *Samothrake*, I, pp. 1f., 3, 28ff., pls. 4–8; II, pp. 45f., 106f., pls. 68–72.

[9] Colucci, *op. cit.*, pp. LXIVf., LXXXIII, XCII, CXL. See also Edward W. Bodnar, S.J., "The Isthmian Fortifications in Oracular Prophecy," *AJA*, 64 (1960), pp. 165ff.; *idem*, "Athens in April 1436," *Archaeology*, 23 (1970), pp. 103f.; and Bernard Ashmole, "Cyriac of Ancona," *ProcBritAc*, 45 (1957), pp. 34f.

as elsewhere, he seems to have made a sketch of some portion of the city wall
—such is the implication of the phrase *Vetusta Samothracum moenia* cen-
tered beneath the paragraph in which he mentions the wall (cf. fig. 3).[10]
If so, it is lost, since the copyist of the Vatican manuscript did not record it.
What is remarkable is not Cyriacus' interest in this long line of fortified wall
but the precision with which he characterized its "towers and gates, with
their marvelous, varied architectural style." For the varied masonry of this
wall (cf. figs. 5, 6), now polygonal, now ashlar, has caused its date to be
disputed, nineteenth-century visitors viewing it as a "cyclopean" wall dating
from the island's legendary past, in contrast with the view of a later student
that it is Hellenistic.[11] Whatever its date proves to be,[12] "the varied archi-
tectural style" of this wall will continue to be one of its characteristic fea-
tures, and it is evidence of Cyriacus' power of observation and sharpness of
eye that he noted it.

Although the city wall was visible to Cyriacus and his companions from
the distance as they approached Palaiopolis, the ancient sanctuary that made
Samothrace famous throughout antiquity lay hidden beneath the vegetation
of centuries. Nothing in Cyriacus' brief description suggests that he was aware
that in traversing the overgrown slopes and valleys to the west of the ancient
city he was moving in that hallowed region. Yet clearly he was, and, like a
pedestrian today, he crossed the southernmost part of the Sanctuary before
reaching "the new citadel built by Prince Palamede."

In the fifteenth century, as in the nineteenth, the scattered marbles of the
Doric Hieron, the Rotunda built by Queen Arsinoe II, and the great Propylon

[10] The drawings which Cyriacus made
of the fortification at Oeniadae (Ashmole,
ibid., pl. IX b) and of the castle of Kat-
singri (Paul Wolters, "Cyriacus in My-
kene und am Tainaron," *AM*, 40 [1915],
pp. 93–100) suggest the probable char-
acter of such a drawing.

[11] Henri Seyrig, "Sur l'antiquité des rem-
parts de Samothrace," *BCH*, 51 (1927),
pp. 353–368. See p. 353, n. 1, for earlier
bibliography on this topic.

[12] Karl Lehmann, *Samothrace, A Guide
to the Excavations and the Museum*, 3d
edn., rev., Locust Valley, 1966, pp. 12,
40, tentatively suggested that the city
wall is partly archaic, partly Hellenistic
in date. Actually, this splendid wall has
been examined only superficially in the
past. It awaits careful modern excavation
—the only means of establishing its actual
date.

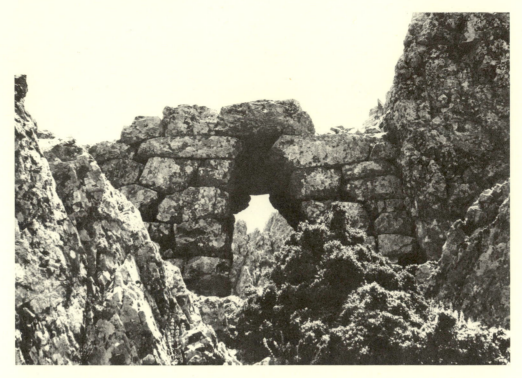

5. Palaiopolis. Detail of the upper gate of the city wall

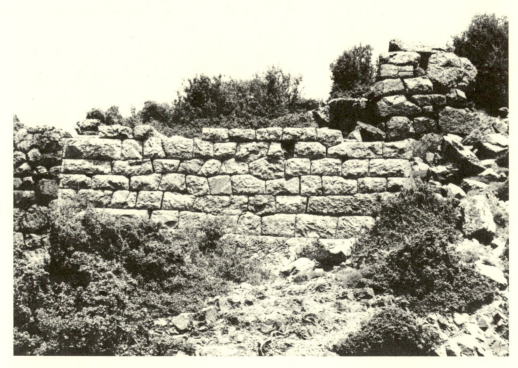

6. Palaiopolis. Detail of the city wall

erected by Ptolemy Philadelphus were evidently the most noticeable antiquities in the deserted landscape.[13] Still filled with Homeric thoughts, Cyriacus interpreted the ruins of the Hieron, the only temple-like building in the Sanctuary, as "the huge remains of the marble temple of Neptune."[14] That this building known until recent times as the "Doric Marble Temple" or the "New Temple" was not, strictly speaking, a temple, he could not possibly have known. But here, as elsewhere,[15] his reference to specific categories of building blocks attests his interest in architecture and his belief that such "stones" were an eloquent record of the past.[16] His subsequent allusion to "doorposts beautifully decorated with garlanded heads of oxen and with other sculptured figures" has been accepted as a reference to the sculptured parapet of the Arsinoeion,[17] probably because of the proximity of the Rotunda to the "Temple of Neptune." Yet it is equally possible that this phrase refers to the bucranes on the frieze of the Propylon of Ptolemy II (fig. 7).[18] Nothing in Cyriacus' report implies that he was taken to the northern part of the Sanctuary, but he was obliged to pass the site of the Propylon in walking toward the ancient city, and the fact that that building proves to have been decorated by figural

[13] The conclusion drawn by Conze, *Samothrake*, I, p. 2.

[14] For this building, the hall for initiation into the higher degree of the Samothracian mysteries, see now Phyllis Williams Lehmann, *Samothrace* 3, *The Hieron* (Bollingen Series LX), Princeton, 1969.

[15] See, in particular, Bernard Ashmole, "Cyriac of Ancona and the Temple of Hadrian at Cyzicus," *JWarb*, 19 (1956), pp. 179–191.

[16] Colucci, *op. cit.*, p. LXXII.

[17] Conze, *Samothrake*, I, p. 2.

[18] Conze, *ibid.*, assumed that Cyriacus' reference to doorposts was based on a misinterpretation of the great pilaster blocks in the gallery of the Arsinoeion between which, on both the exterior and interior of the Rotunda, an ornamental parapet was decorated with bucranes and pateras (cf. pls. 60–62). Granting the unorthodox coupling of these elements on this building, I find it difficult to understand how anyone seeing either one of the blocks which combine sections of the parapet with the lowest portion of the pilasters or fragments of parapet blocks adjacent to pilasters could have interpreted them in this manner, since the ornamental units would have impeded access to a door. Whether Cyriacus saw blocks of the Arsinoeion or the Ptolemaion, he misinterpreted their function. But the similarly decorated frieze blocks of the latter building (*ibid.*, II, pls. 38–40) could, I suppose, be misinterpreted as the crowning element of a door frame. The fact that the Ptolemaion, unlike the Rotunda, had other figural decoration (as mentioned above) makes it tally better with Cyriacus' imprecise characterization. In any case, his reference surely applies to one of these buildings.

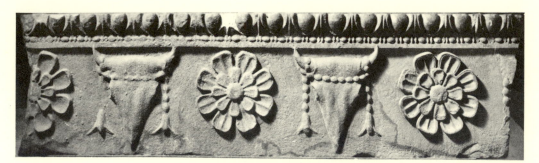

7. Fragment of the frieze of the Propylon of Ptolemy II.
Vienna, Kunsthistorisches Museum

capitals, one of which was reported by nineteenth-century visitors as found in the vicinity of the Propylon,[19] suggests the greater probability that the "garlanded heads of oxen and . . . other sculptured figures" belonged to it. In any case, this single sentence reflects Cyriacus' customary interest in architecture.

Passing through a gateway or breach in the city wall, Laskaris and his guest proceeded to the new citadel built by Palamede, that romantic keep perched above the ancient harbor which commanded the western part of the northern coast (figs. 8 and 9). Its towers, then as now, were encrusted with marble blocks, spoils from the ancient city and Sanctuary—a miscellany of building blocks, sculptures, and inscriptions that Cyriacus did not fail to note. In fact, he paused here long enough to sketch as well as to record, and since all but one of the drawings that he is known to have made during his brief visit to the island were certainly or probably of objects seen in this quarter of the ancient city, it may be well to consider that exception before returning to his hours in Palamede's stronghold.

[19] E.g., Blau and Schlottmann, "Alterthümer von Samothrake und Imbros," *Berl. Ber.*, 1855, p. 624, and Conze himself, *Reise auf den Inseln des thrakischen Meeres*, p. 66. This capital, illustrated in *Samothrake*, II, pl. 49, after it had been transported to the Louvre, was returned to Samothrace in 1955 (see *Guide³*, p. 95). Both its known provenance and the discovery in the debris of the Ptolemaion of joining fragments of its broken lateral reliefs conclusively established, in 1968, that it was one of the anta capitals on the inner, more richly adorned porch of the Propylon of Ptolemy II.

8. View of Palaiopolis, with the Gattilusi citadel in the foreground

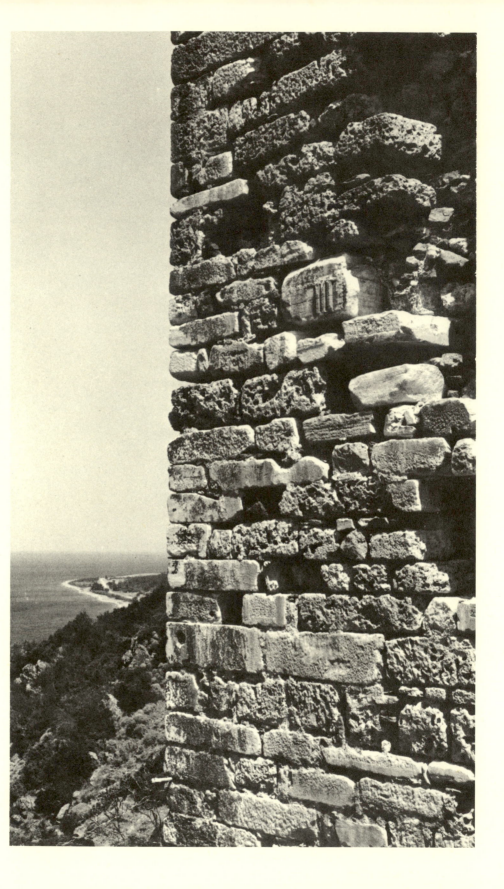

None of Cyriacus' Samothracian drawings was to be so influential as the sketch he made of a bust of a bearded man (figs. 10, 11). Where he made it —whether in the Sanctuary or in Palaiopolis—is not certain, although it seems likely, given the modern history of the piece, that he saw it in the Sanctuary. Somewhere in the silence of the deserted site he encountered a marble bust of a bearded old man (figs. 12, 13).[20] Clad in a barely visible garment and seemingly wearing a skull cap, his somber features attracted Cyriacus in spite of their severe weathering. Here on this island where Philip had met Olympias, he saw in this venerable image a portrait of their son Alexander's celebrated tutor Aristotle. Plutarch's *Life of Alexander* had been uppermost in his mind as he approached the ruined site and thought of its ancient glory:[21] of Philip and Alexander, examples of whose gold coinage he had acquired years earlier at Phocaea;[22] and of Aristotle, whose works he owned and had himself copied and translated[23]—Aristotle, whose edition of the *Iliad* Alexan-

[20] 39.531, exhibited in Hall B of the Samothrace Museum, reportedly discovered near a limekiln in the Sanctuary (hence out of precise context) in the late nineteenth century. For this Thasian marble bust, see *The Hieron*, II, pp. 62ff. It was first identified as the model of Cyriacus' drawing by Lehmann-Hartleben, "Cyriacus," pp. 123ff.

[21] *praeterea, quod ad eiusdem insulae cumulum claritatis accedit, in ea philippus adolescens adhuc olympiadem Alexandri illius nobilissimi regis matrem cognovit auctore plutarcho.* See above, p. 4 and fig. 3. This reference to Plutarch's *Alexander* (2.1) is one of the two passages in Cyriacus' report on Samothrace that has been omitted from previous quotations of it. Obviously he was acquainted with the whole life, including Plutarch's description of Philip's decision to entrust Alexan-

der's education to "the most famous and learned of philosophers" (7.1f.).

[22] Colucci, *op. cit.*, p. LXXXVII, whence Erich Ziebarth, "Cyriacus von Ancona als Begründer der Inschriftenforschung," *Neue Jahrbücher*, 9 (1902), p. 224.

[23] See Domenico Fava, "La scrittura libraria di Ciriaco d'Ancona," *Scritti di paleografia e diplomatica in onore di Vincenzio Federici*, Florence, 1944, pp. 295ff., regarding Vat. lat. 13497, a codex containing a *Libellus Aristotelis de virtutibus* translated into Latin by Cyriacus; and Hans Graeven, "Cyriacus von Ancona auf dem Athos," *Centralblatt für Bibliothekswesen*, 16 (1899), p. 211, for reference to the ancient authors, including Aristotle, whose writings Cyriacus examined (and occasionally purchased) in the rich monastic libraries of Mount Athos in the late autumn following his visit to Samothrace.

9. Detail of Palamede Gattilusio's citadel, showing re-used ancient blocks

der kept under his pillow along with his dagger, as Plutarch reported.[24] What could be more natural, it must have seemed to Cyriacus, than to find a bust of the great philosopher here in this place where Philip had met Olympias? Nor is it surprising that this learned man of the Quattrocento, accustomed to medieval representations of the philosophers as bearded men clad in caps and flowing garments,[25] his thoughts revolving about these very historical personalities, should have interpreted the unidentified statue before him as a portrait

[24] 8.2. It is interesting to recall that, before many years had passed, Cyriacus himself was destined to play the part of mentor to a youthful conqueror, Mehmed, and that among the classical authors read by the Sultan was Aristotle. See Emil Jacobs, "Mehemmed II, der Eroberer, seine Beziehungen zur Renaissance und seine Büchersammlung," *Oriens*, 2 (1949), pp. 6–30; *idem*, "Cyriacus von Ancona und Mehemmed II," *BZ*, 30 (1929–1930), pp. 197ff.; and Franz Babinger, *Maometto il Conquistatore e il suo tempo*, Turin, 1957, pp. 60–64, 83f., 127, 137, 176, 184, 550, 624f., 684f., 729ff.

[25] For a random example, see the figures of Socrates and Plato in a thirteenth-century manuscript in the Bodleian Library (Ms. Ashmole 304, fol. 31v) illuminated by Matthew Paris, illustrated by Peter Brieger, *English Art*, Oxford, 1957, fig. 43 a. I owe this reference to Robert M. Harris.

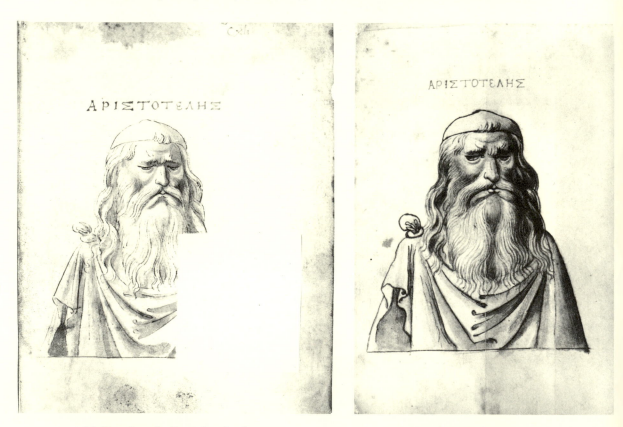

10. Drawing of a Samothracian bust,
after Cyriacus. Ms. Lat. Misc. d. 85, fol. 141r.
Oxford, Bodleian Library

11. Drawing of a Samothracian bust,
after Cyriacus. Ms. Ashb. 1174, fol. 121v. Florence,
Biblioteca Medicea-Laurenziana

of Aristotle. Not only was it his practice to interpret the ancient monuments he encountered by drawing on his knowledge of ancient literature,[26] but, in his time, no authentic inscribed portrait of Aristotle was known.[27] What more reasonable place to find one than Samothrace—given its history and, we may add, Cyriacus' preoccupations and turn of mind?

The true identity of the bust that Cyriacus drew—the fact that it is an early classical pedimental figure that quite possibly represents the seer Teiresias[28]—need not concern us here. It is Cyriacus' mentality, his characteristic intellectual procedure, that is of interest in this chance encounter with an unknown monument—his procedure and its effect.

The lost drawing in which Cyriacus recorded this bust is known in two copies, one in Oxford (fig. 10),[29] one in Florence (fig. 11).[30] They show a bearded man about whose torso a vaguely classical garment falls in diagonal folds. Over his skull, he wears a slightly peaked cap from which his hair escapes to fall on his shoulders in long, undulating locks. His eyes are curiously downcast, his nose aquiline, his lips tightly pursed, and his wide, flowing mustache merges with the mass of his long beard.

[26] See below, pp. 100ff., for his procedure in recording and interpreting another uninscribed monument during this visit to Samothrace.

[27] See below, p. 24, nn. 48f.

[28] An interpretation first proposed by Lehmann-Hartleben, "Cyriacus," pp. 127ff., and elaborated in *The Hieron*, II, pp. 65ff.

[29] Bodleian Ms. Lat. Misc. d. 85, fol. 141r. Pen drawing on vellum in black ink and pale tan wash, apart from the pale red title. Marred by a cut-out, the left half of the drawing on 141v, visible as a blank square in fig. 10. Previously discussed and illustrated by Fritz Saxl, "The Classical Inscription in Renaissance Art and Politics," *JWarb*, 4 (1940–1941), pp. 33f., pl. 6 d; Lehmann-Hartleben, "Cyriacus," pp. 123ff., pl. VI, who recognized that the drawing was based on the Samothracian bust discussed here (which had been rediscovered in Samothrace only in

1939, hence was not known to Saxl); and me, *The Hieron*, II, pp. 63ff., fig. 377. For this manuscript, which contains extracts from the journals of Cyriacus made by the Florentine scholar Bartholomaeus Fontius, see Saxl, *op. cit.*, pp. 20ff., and for further reference to Fontius himself, below, p. 19 and n. 36.

[30] Biblioteca Medicea-Laurenziana: Laurentianus Ashburnensis 1174, fol. 121v. Pen drawing in sepia ink and wash, except for the title, which is written in red ink. As far as I am aware, this page has not previously been illustrated or discussed. Like the page in Oxford, it is preceded (on fol. 121r) by the drawing of a bronze head of Medusa explicitly located in Samothrace (below, figs. 31, 32) and followed (on fol. 122r) by a non-Samothracian monument. According to Saxl, *op. cit.*, p. 37, this manuscript belonged to Francesco Pandolfini, one of Fontius' pupils.

Half a millennium of further exposure to the elements and crude modern recutting, especially of the eyes and mustache, have altered the ancient bust that Cyriacus drew, yet its essential form is still discernible: the cap-like hair over the skull, bound by an encircling fillet that separates it from the curls framing the brow and the locks that fall in undulating strands down the spare, angular torso; the thick mustache falling onto the heavy mass of the beard; the diagonal folds of the mantle clinging to the right half of the chest. Before the closed lids of the blind seer were harshly gouged open in the nineteenth century, his worn eyeballs must have suggested the curious form Cyriacus gave them by retaining the strong horizontal that once separated the closed lids and opening the lower lids.[31] Perhaps he recalled the ancient report that Aristotle was μικρόμματος,[32] in addition to being bearded and bald.[33] But probably it was as much his own reflections, coupled with the conventional forms to which he was accustomed in contemporary representations of the ancient philosophers, that led him to interpret this bust as a portrait of Aristotle as, on that same day, he interpreted a frieze of dancing maidens which he saw in the ancient city as a representation of Muses and Samothracian Nymphs through a similar application of classical literature to contemporary

[31] See *The Hieron, loc. cit.*, for further details about this recut bust and for illustrations (figs. 375, 376) of contemporary, imaginary portraits of Homer, whose legendary blindness was represented by the same device of closed eyes having lids separated by a horizontal line.

[32] Diogenes Laertius 5.1.1—an author translated into Latin at Cosimo de' Medici's request by Ambrogio Traversari (1386–1439). See J. E. Sandys, *A History of Classical Scholarship*, reprinted New York, 1958, II, p. 44.

[33] See Lehmann-Hartleben, "Cyriacus," pp. 126f., and, for the *testimonia* regarding Aristotle's appearance, the references cited below, nn. 48, 49. It is amusing to note that two learned nineteenth-century visitors to Samothrace, Blau and Schlottmann (n. 19, above), also interpreted the simplified cap-like hair of Cyriacus' model as "mit eigenthümlicher Kopfbedeckung" (*loc. cit.*).

Professor Lehmann's statement (*op. cit.*, p. 125) that both the Oxford drawing and its model show a horizontal line parallel to the lower edge of the bust, but slightly above it—that is, an indication of the degree to which the latter was inserted into the floor of its pediment—is not, I believe, correct. At least I did not discern such a line in the drawing in checking it in 1967, and recent examination of the bust itself does not verify the existence of what does, indeed, look like such a line in the photographs which he used, remote from the object itself, in this wartime article. The folds of the mantle do appear to stop above the bottom of the base, but the broken and worn condition of this surface precludes any conclusive statement on this point.

visual experience.[34] In each case, he labeled his drawing, adding to his sketch his identification of the person or persons drawn and writing his label in capital letters reminiscent of a classical inscription. Little wonder that they were accepted as such by contemporaries in search of authentic documents of the classical past who had learned to regard Cyriacus as a unique connoisseur and source of information about ancient monuments.

Before considering the iconographic tradition set off by Cyriacus' presumed Aristotle, it is well to recall that the Oxford manuscript was written by Bartolomeo della Fonte,[35] an eminent scholar who had studied with the celebrated Greek expert on Aristotle, John Argyropoulos, during the latter's years in Florence,[36] and that the Laurentian manuscript belonged to Fontius' own

[34] See chap. II, pp. 105ff.
[35] Above, n. 29.
[36] For Fontius (1445–1513), see C. Marchesi, *Bartolomeo della Fonte*, Catania, 1900, and for his association with Argyropoulos (i.e., until 1467), pp. 11ff. For Argyropoulos, see Deno John Geanokoplos, *Greek Scholars in Venice*, Cambridge, 1962.

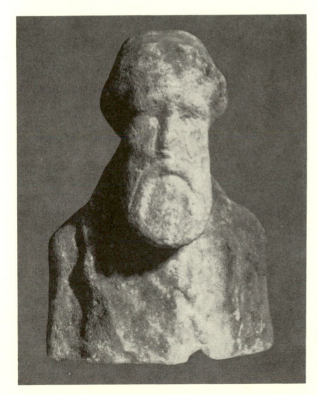

12. Marble bust from the Sanctuary. Samothrace Museum

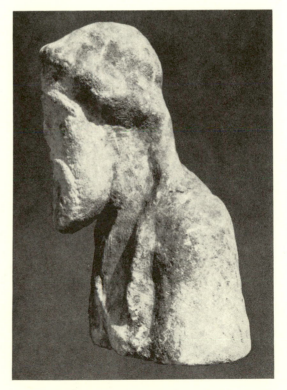

13. Marble bust from the Sanctuary, seen from the left side. Samothrace Museum

pupil, Francesco Pandolfini.[37] That the only known copies of Cyriacus' lost "Aristotle" occur in manuscripts written by or in the possession of devotees of the great philosopher is surely not an accident. And it is fascinating to consider, too, that Argyropoulos himself may have known that other Aris-

[37] Above, n. 30, and Marchesi, *op. cit.*, p. 72.

14

totelian amateur, Cyriacus,[38] and to speculate on whether Cyriacus shared with the learned professor his own recent discovery.

Shortly after Cyriacus sketched his "Aristotle" in the autumn of 1444, his drawing became known in Italy, known and accepted as an authentic document of the philosopher's appearance. The first echo of it occurs on one of the panels of Agostino di Duccio's *Arca degli Antenati e dei Discendenti*, a funerary monument in the Capella della Madonna dell' Acqua of S. Francesco at Rimini (figs. 14, 15),[39] a monument completed in the following decade.

[38] Argyropoulos was in Italy for several years preceding his temporary return to Constantinople in 1448 when Cyriacus, too, was briefly in Italy: see Bodnar, *Cyriacus of Ancona and Athens*, p. 65. There was also subsequent opportunity in the East for these two proponents of the union of the Greek and Roman churches to meet. See Geanokoplos, *op. cit.*, pp. 77ff., and for Cyriacus' last years, Emil Jacobs, "Cyriacus von Ancona und Me-

hemmed II," *op. cit.* (n. 24, above), pp. 197ff.

[39] For this monument, see Corrado Ricci, *Il Tempio Malatestiano*, Milan and Rome, n.d., pp. 498ff. For comment on some of the iconographic features and sources of the sculptural program in this mausoleum-church, see Jean Seznec, *The Survival of the Pagan Gods* (Bollingen Series XXXVIII), New York, 1953, pp. 132ff., 253ff.

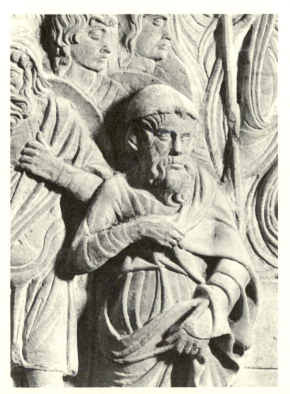

14. Rimini, Tempio Malatestiano. Detail of the *Arca degli Antenati e dei Discendenti* by Agostino di Duccio: the Temple of Minerva

15. Rimini, Tempio Malatestiano. Detail of the *Arca degli Antenati e dei Discendenti* by Agostino di Duccio: Aristotle

15

The most prominent figure in this scene set in the Temple of Minerva is that of the goddess' exemplar, Aristotle, who stands in the immediate foreground. As has already been pointed out,[40] Agostino's Aristotle is certainly derived from Cyriacus' (cf. figs. 10, 11, 15): witness his skull cap beneath which the same locks over the center of the forehead escape, the shape of his features, the character of his mustache and beard—even the turn of his head. Like Cyriacus, Agostino has altered his model stylistically, but the model is nonetheless evident.

It has been assumed that Agostino gained his knowledge of this drawing from Matteo de' Pasti, Alberti's superintendent at S. Francesco, who is known to have possessed a copy of a fragment of Cyriacus' *Commentaria*.[41] But it is not impossible that Agostino knew of it directly from Cyriacus, who visited Rimini in June 1449, when Agostino was at work on the interior decoration of Sigismondo's *Tempio*.[42]

Later in the century Cyriacus' drawing, whether directly or via Fontius' copy, served as the basis for a series of closely interrelated portraits of Aristotle on bronze medals and plaques and, subsequently, in engravings. In characteristic Renaissance imitation of ancient practice, they present the philosopher in profile, but their dependence on Cyriacus' slightly oblique view is obvious.[43] The fine medal in the National Gallery in Washington (fig. 16)[44] will suffice to illustrate this group of bronzes. The peaked cap from

[40] This excellent observation was first made, as far as I can determine, by Saxl, *op. cit.*, p. 37 and pls. 6 d, f.

[41] By Saxl, *ibid.*, p. 35. Ricci, too, *op. cit.*, p. 44, has assumed the influence of Cyriacus' drawings on Agostino's work via Matteo's knowledge of the *Commentaria*.

[42] For Cyriacus' presence in Rimini in June 1449, see Bodnar, *Cyriacus of Ancona and Athens*, p. 65, and, for Agostino's chronology, U. Thieme and F. Becker, *Allgemeines Lexikon der bildenden Künstler*, I, Leipzig, 1907, p. 127.

[43] As Saxl, once again, correctly observed in his discussion of the former Codex Ashmolensis, *op. cit.*, pp. 34, 44. With his discovery of the actual iconographic source of this group of Renaissance monu-

ments, the often repeated older theory that they reflected the appearance of one of the eminent Greek scholars who had migrated to Italy (for example, Argyropoulos) was disproven. This group of medals and plaques seems to be very imprecisely dated and placed stylistically. If they are, indeed, ca. 1500 or later in date, it is reasonable to suppose that Bartolomeo della Fonte's copy rather than Cyriacus' original provided their model, since this eminent Aristotelian lived the greater part of his life in Florence and did not die until 1513.

[44] A 1036, attributed to the Florentine School and dated late fifteenth century, ca. 1500, by G. F. Hill and Graham Pollard, *Renaissance Medals from the Samuel H. Kress Collection at the National Gallery of*

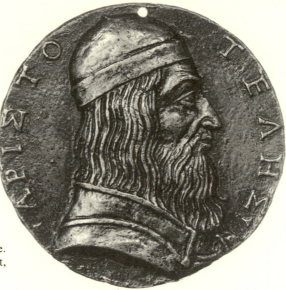

16. Late Quattrocento medal of Aristotle. Washington, National Gallery of Art, Samuel H. Kress Collection

which the slender locks stream, the furrowed brow, the aquiline nose, the tight lips, and full beard are all present, although the unreal, vaguely classical mantle of the prototype has been replaced by a more credible garment. On this example, the head is framed in good antique fashion by precisely Cyriacus' label; on the plaquettes,[45] it is sometimes elaborated to APICTOTE-

Art, London, 1967, p. 56, no. 298. See the references cited in n. 45 for further examples of this type.

[45] For the plaques as well as the medals, see, in particular, the recent comments and bibliography of John Pope-Hennessy, *Renaissance Bronzes from the Samuel H. Kress Collection*, London, 1965, p. 103, no. 373 and fig. 325 (curiously enough, the author does not mention Saxl's elliptically-phrased discovery, although he assumes that medals, plaques, and engravings all go back to a prototype "regarded in the late fifteenth or early sixteenth century as an authentic portrait"); Mrs. Arthur Strong, "A Bronze Plaque in the Rosenheim Collection," *Papers of the British School at Rome*, 9 (1920), pp. 214ff.; L. Planiscig, "Leonardos Porträte und Aristoteles," *Festschrift für Julius Schlosser zum 60. Geburtstage*, Zurich-Leipzig-Wien, 1927, pp. 137ff.

To this group of medals, medallions, and engravings, Planiscig added a life-size bronze bust of the same type, bearing the singular inscription ΑΡΙΣΤΟΤΕΛΟΙΣ on the lapel-like flap over the right shoulder, which he accepted as a lost bust of Aristotle, reported to have been similarly inscribed, that was seen in Petrarch's house at Arquà in the mid-seventeenth century. In a private collection in New York at the time of his writing, it was subsequently acquired by the Museum of Fine Arts, Boston, evidently on the same assumption (Acc. No. 47.1380, illustrated, without discussion, in the Museum's *Bulletin*, 55 [1957], p. 98, fig. 60; later reported as one of two "Cinquecento bronze busts of the pseudo-Aristotle . . . said to have been produced in northern Italy" by Cornelius Vermeule in a review of Mandowsky-Mitchell [see n. 46, below] in *Gnomon*, 36 [1964], p. 198).

ΛΗΣ Ο ΑΡΙCΤΟΣ ΤΩΝ ΦΙΛΟCΟΦΩΝ. But the relation to Cyriacus' seemingly authentic portrait is undeniable. And when headless antique herms that had once borne portraits of Aristotle were discovered in Tivoli in the sixteenth century, it was the Cyriacan type that the learned antiquarians of a later generation still associated with these genuine monuments (fig. 17).[46] Soon the descendants of Cyriacus' drawing, reconverted into a sculpture-in-the-round presented in three-quarter view, were combined with the authentic inscribed shafts in a singular mongrel type (fig. 18)[47] that evidently seemed convincing to so experienced a student of antiquity as Pirro Ligorio. Toward the end of the century, a genuine inscribed bust of Aristotle was discovered in Rome, only to disappear again in later times. That centuries passed before the drawings of this lost monument[48] were combined with uninscribed ancient busts of Aristotle to establish his actual appearance[49] is but a final irony in the chain of artistic events set off by Cyriacus' romantic experience on that October day in Samothrace.

[46] E.g., Fulvius Ursinus, *Imagines et elogia virorum illustrium et eruditorum ex antiquis lapidus et numismatibus expressa, cum annotationibus ex bibliotheca Fulvi Ursini*, Rome, 1570, p. 57. See Erna Mandowsky and Charles Mitchell, *Pirro Ligorio's Roman Antiquities* (*Studies of the Warburg Institute*, 28), London, 1963, pp. 90f., no. 75, for this plate on which two ancient herms are combined with a marble relief of the "Aristotelian" type discussed above which was accepted by contemporary collectors as authentic.

[47] *Ibid.*, p. 91 and pl. 45, in explanation of Ligorio's drawing in Naples, Bibl. Naz. cod. XIII, B. 7, p. 414, reproduced above in fig. 18.

[48] For extensive discussion of this bust, said to have been discovered at the foot of the Quirinal, and of the drawings recording it, one of the bust itself by the Fleming Dirk Galle (Theodorus Gallaeus), the other, presumably after Galle's drawing, by Rubens, see J. H. Jongkees, *Fulvio Orsini's Imagines and the Portrait of Aristotle* (*Archaeologica Traiectina*, IV), Groningen, 1960, especially pp. 26ff. Jongkees regards this lost bust as a Renaissance fake (pp. 35ff.), a position rejected by Miss Richter in her recent compendium (cf. n. 49). I am indebted to Jiří Frel for knowledge of Jongkees' article.

[49] This combination of Franz Studniczka, *Das Bildnis des Aristoteles*, Leipzig, 1908, is still generally accepted. See, for example, Gisela M. A. Richter, *The Portraits of the Greeks*, London, 1965, II, pp. 170ff. and p. 175, where the author summarizes her objections to Jongkees' theory which, it should be said, is largely concerned with rejecting Studniczka's group of monuments as portraits of Aristotle. More recently, "Greek Portraits on Engraved Gems of the Roman Period," Collection Latomus, CIII (1969), pp. 499f., Miss Richter has adduced new evidence in support of Studniczka's identification.

ΑΡΙΣΤΟΤΕΛΗΣ
ΝΙΚΟΜΑΧΟΥ
ΣΤΑΓΕΙΡΙΤΗΣ

ΑΡΙΣΤΟΤΕΛΗΣ
Ο ΑΡΙΣΤΟΣ ΤΩΝ
ΦΙΛΟΣΟΦΩΝ
ΣΤΑΓΕΙΡΙΤΗΣ

ΑΡΙΣΤΟΤΕΛΟΥ

17. Fragmentary herms of Aristotle, after Fulvius Ursinus,
Imagines et elogia virorum illustrium . . .
ex bibliotheca Fulvi Ursini, Rome, 1570, p. 57

et l'altra, che fu col nome d'Homero
simo Masco delle quali ho posto il dis

ΑΡΙΣ ΤΟΤΕΛΗΣ
ΝΙΚΟΜΑΧΟΥ
ΣΤΑΓΕΙΡΙΤΗΣ

18. Herm of Aristotle, after Pirro Ligorio.
Cod. XIII B. 7, 414 (detail)
Naples, Biblioteca Nazionale

UNLIKE his sketches of "Aristotle" and of the "Muses" and "the Samothracian Nymphs,"[50] the other extant drawings made by Cyriacus in Samothrace had no influence on the later history of art. But they offer further proof of his associative turn of mind, of the degree to which one intellectual experience conditioned another as he traveled from site to site.

[50] For the latter, see chap. II, pp. 99ff.

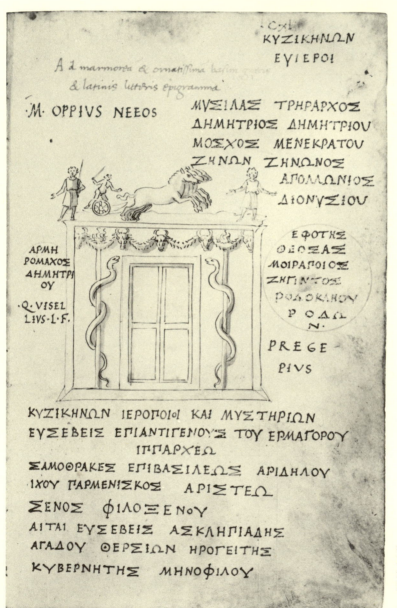

19. Drawing of an inscribed stele, after Cyriacus. Ms. Lat. Misc. d. 85, fol. 140r. Oxford, Bodleian Library

Very possibly the enigmatic inscribed relief that he drew in Palaiopolis (figs. 19–21) was one of the "excellent old inscriptions with Greek lettering and also with our own" that he reported having seen in or near Palamede's new citadel, although the precise location of this stone, at the time, cannot be ascertained. Known today in three copies, one in Oxford (fig. 19),[51] one in Milan (fig. 20),[52] and one in Florence (fig. 21),[53] this lost drawing showed a monument pierced by a closed door flanked by snake-entwined torches. Adorned by a crowning frieze of bulls' skulls linked by garlands, this structure is surmounted by a scene depicting a central figure moving to the right in a quadriga flanked by antithetical, frontally-shown male figures. These beardless youths are clad in short tunics. One extends his seemingly empty hands into space; the other holds an upright attribute, conceivably a sword, in the hand of his bent left arm. In the drawings in Oxford and Florence, the scene is provided with an irregular terrain. In the Codex Ambrosianus, there is no suggestion of setting, and this copy differs from the other two in another still more important respect: the figure visible in the chariot is without question female, and she holds what appear to be torches in her raised hands (fig. 20). The crude figure shown astride the chariot in the Florentine drawing is evidently male, like his counterpart in Oxford, and both brandish a single attribute (a sword?) in their right hands.[54] Evidently the central figure in Cyriacus' original drawing was hard to decipher. Solely on the evidence of these copies, it is difficult to determine which interpretation of the original is the correct one.

[51] Bodleian Ms. Lat. Misc. d. 85, fol. 140r. Pen drawing in black ink and pale tan wash; text in same ink, apart from the pale red heading. For this manuscript, see above, n. 29, and, for the earlier discussions of this page and the related pages in the manuscripts in Milan and Florence, see Lehmann-Hartleben, "Cyriacus," pp. 117ff., pls. III, IV, and below, nn. 61, 69, 77.

[52] Ambrosianus A55 inf., fol. 69v. Pen drawing in sepia ink and wash; text in the same ink.

[53] Biblioteca Medicea-Laurenziana: Laurentianus Ashburnensis 1174, fol. 120r. Pen drawing in sepia ink and wash except for the heading in red ink.

[54] Lehmann-Hartleben, op. cit., p. 122, in an effort to interpret this scene in the light of Samothracian mythology, tentatively suggested that the attribute held by the central figure in this pair of drawings might be a thunderbolt—i.e., that this figure might be Zeus and the youths Aëtion and Dardanos. He assumed that the drawings in Oxford and Florence are closer to the lost original in reproducing this scene than the page in Milan. I believe, on the contrary, that this is probably not the case. For discussion of the meaning of this scene, see below, p. 38. A decade after the above-cited article was published, when Professor Lehmann and I examined the Codex Ambrosianus in Milan, we agreed that the figure in the chariot is without doubt female.

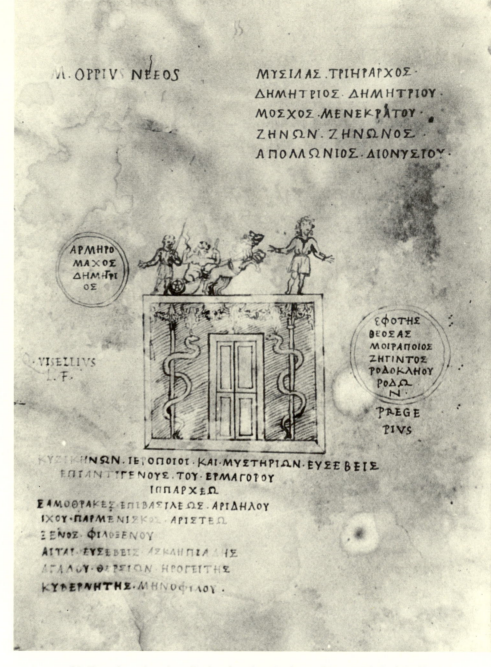

20. Drawing of an inscribed stele, after Cyriacus. Ms. A55 inf., fol. 69v.
Milan, Biblioteca Ambrosiana

21. Drawing of an inscribed
stele, after Cyriacus.
Ms. Ashb. 1174, fol. 120r.
Florence, Biblioteca
Medicea-Laurenziana

All three drawings bear the heading *Ad marmoream et ornatissimam basim graecis et latinis litteris epigrammata*[55] and, on two of the three (figs. 19, 20), the monument is, indeed, surrounded by Greek and Latin texts. The shorter two, largely enclosed in circles, appear to the left and right of it; the longest, beneath it. They indicate that the "base" drawn by Cyriacus belonged to a characteristic type of Samothracian inscription, the inscribed stelai recording the names of individuals initiated into the mysteries of the Great Gods that groups of initiates erected in the Sanctuary throughout late Hellenistic and

[55] Although at first sight this heading appears to be lacking in the Codex Ambrosianus, careful scrutiny of even a photograph of fol. 69v reveals its ghostly presence at the top of the page.

early Imperial times.[56] Recognized as such, the several parts of Cyriacus' text were published in *Inscriptiones Graecae* in 1909, but as disconnected inscriptions severed from their original, seemingly fanciful context.[57] Only the subsequent recovery, in 1939, of two fragments of the unique stone drawn by Cyriacus (fig. 22 A, B)[58] established the authenticity and essential accuracy of his drawing.[59]

The more important of the two fragments (fig. 22 A) revealed that the

[56] For this category of inscription, see *IG*, XII (8), nos. 160ff.; P. M. Fraser, *Samothrace* 2, I, *The Inscriptions on Stone* (Bollingen Series LX), New York, 1960, pp. 74ff.; and Karl Lehmann in *The Hieron*, II, pp. 10ff.

[57] See *IG*, XII (8), nos. 191, 211, 212, and Lehmann-Hartleben, "Cyriacus," p. 118.

Severed from this context, too, and unsatisfactorily explained are the two texts, one Latin, one Greek, that appear beneath the heading in both the Oxford and Milan codices (figs. 20, 21). For the former, see *CIL*, III, no. 721; for the latter, *IG*, XII (8), no. 259, and Ziebarth, *op. cit.* (above, n. 2), p. 413, 7. It has been suggested that they are out of place and belong among the inscriptions recorded in Rome in the Codex Ambrosianus (the Oxford manuscript was unknown when the previous brief comments were made). But the fact that they are similarly placed on both pages, i.e., reflect at least one prototype, and the additional fact that only two small fragments of the stele drawn by Cyriacus are extant today raise the question whether these texts were not part of the inscription recorded by him. Can they have been inscribed on the sides or back of the stone, as in the case of the two inscriptions discussed below, pp. 32ff.? The words in the upper right corner of the Bodleian page,

ΚΥΖΙΚΗΝΩΝ ΕΥΙΕΡΟΙ, seem to provide an appropriate heading for the Greek names listed beneath them. Surely this little problem deserves consideration by an epigrapher.

[58] 39.16 and 39.23. See Fraser, *op. cit.*, 29, for the former, and Lehmann-Hartleben, "Cyriacus," pp. 118ff., pls. III–V, for the original identification of these fragments as parts of the lost inscription drawn by Cyriacus. Like the related inscriptions now to be discussed, this inscription had a modern history of re-use, disappearance, and reappearance characteristic of many a Samothracian object. Plundered from Palaiopolis, it was built into the church of Hagios Demetrios in Chora. Fragment 39.23 had already been removed from the church and had passed into the collection of the local antiquarian, Dr. Phardys, when Otto Kern visited Samothrace and recorded it among the inscriptions that he published in "Aus Samothrake," *AM*, 18 (1893), p. 363, no. 7. It reappeared in 1939, together with the previously unknown fragment 39.16, when the latter was removed from the same church in the course of its restoration. One wonders whether additional fragments of this precious stone may yet appear.

[59] See Lehmann-Hartleben, *op. cit.*, pp. 120f., 123, for analysis of Cyriacus' few misreadings or alterations of the text.

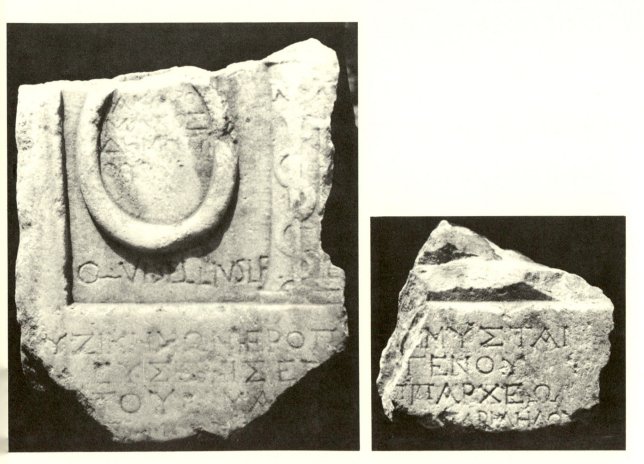

22. Fragments of a stele drawn by Cyriacus. A. 39.16. B. 39.23. Samothrace Museum

monument represented on the stele sketched by Cyriacus was a round structure, presumably a building.[60] It confirmed the fact that Cyriacus' model belonged to a group of closely related, if not identical, inscriptions. Two of the three analogous stones (figs. 23, 24), although visible in Samothrace in the nineteenth century,[61] had, in the meantime, disappeared. The third and most complete, if least legible (fig. 25), long thought to be lost, had recently been rediscovered at Bignor Park in England.[62] In 1968, the best preserved of the vanished reliefs reappeared (fig. 24).[63] It provides the most detailed repre-

[60] For further discussion of this point, see below, pp. 36ff.

[61] *CIL*, III, p. 2083, 12322. See Otto Rubensohn, *Die Mysterienheiligtümer in Eleusis und Samothrake*, Berlin, 1892, pp. 227ff., and, especially, Kern, *op. cit.*, pp. 356ff., for the lost fragment once in the collection of Dr. Phardys in Chora which is illustrated above in fig. 23, after the drawing published by Kern and made from his sketches and squeezes. According to Rubensohn, Dr. Phardys found this fragmentary inscription built into a Byzantine wall in the ancient city near the Gattilusi towers (i.e., Palamede's citadel). For further comment on this stele, see below, nn. 64, 68. For the second stone (fig. 24), see below, n. 63.

[62] See Fraser, *op. cit.*, pp. 112ff., pl. XXIII, for the history of and bibliography on this much-traveled inscription found in Samothrace and subsequently acquired for his collection in Athens by the eminent French consul and antiquarian Fauvel. It later passed to John Hawkins, to whose property, Bignor Park, Pulborough, Sussex, it was transferred early in the nineteenth century. Fraser's text and commentary reflect his examination of the stone in June 1956.

I am greatly indebted to his lordship, Viscount Mersey, for allowing the inscription to be newly photographed without its protective glass cover, and to Denys Spittle for having very kindly served as my intermediary in obtaining the resulting print reproduced above as fig. 25.

For further comment on this document, see below, pp. 34ff.

[63] 68.55, again, formerly in the collection of Dr. Phardys in Chora. Previously re-used in the church of Hagios Stephanos. Given to the Museum in Samothrace in 1968 by one of his descendants, Nikolaos Rigopoulos. Repeatedly discussed and illustrated, generally but not always in drawings made after squeezes. Among the earlier reports see, in particular, Rubensohn, *op. cit.*, pp. 160ff.; Kern, *op. cit.*, pp. 359ff.; and Fredrich in *IG*, XII (8), no. 190.

Pending republication by James R. McCredie, whose photograph I reproduce as fig. 24 with gratitude both for it and for permission to publish the present provisional remarks, it may be useful to report the current condition of the stone. Preserved height 0.51 m.; preserved width of stele at bottom of frieze 0.44 m.; at bottom of course beneath threshold 0.445 m.; thickness 0.115 m. Broken at top and bottom; chipped along projecting lateral frame; gashed in places on surface. Discolored from exposure and burning, especially at lower left. For the texts inscribed on the sides of the stele, see the references cited above and, for further comment, below, pp. 40ff.

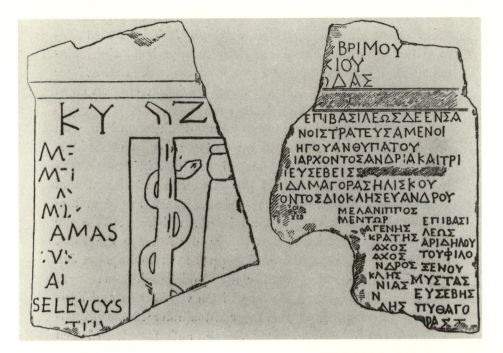

23. Fragmentary lost stele from
Samothrace

24. Fragmentary inscribed stele 68.55.
Samothrace Museum

sentation of the monument shown on all four stelai and in Cyriacus' drawing, for despite minor differences, they surely allude to the same structure.[64]

A round building constructed in isodomic courses of drafted-margin masonry, it was decorated by a continuous frieze of bucranes and garlands above a molded architrave. Its standard two-leaved door set in an orthodox eared frame stands on a threshold resting on a molded base or euthynteria.[65] A pair of monumental torches encircled by snakes and moored in pedestal-like bases flanked the door.

Ironically, only the severely weathered inscription at Bignor Park is complete at the top (fig. 25).[66] The rectangular field above the monument and beneath the pedimental crown of the stele cries out for some such scene as Cyriacus recorded in precisely this location. Indeed it is reported to have contained at least one figure in the early nineteenth century—a figure interpreted at the time as Kybele.[67] But all intelligible trace has disappeared from this area today, and short of the reappearance of the relevant portions of the fragmentary inscriptions there would be little hope of establishing the nature or meaning of the figures Cyriacus drew were it not for evidence provided by yet another group of interrelated monuments: a group of bronze coins from Kyzikos.

[64] Although the so-called Demokles stele (fig. 24) yields the most detailed evidence regarding the appearance of this structure, the images on the other stelai being either simplified or weathered (and one, fig. 23, so fragmentary in preservation and so schematically reproduced as to be unreliable in this connection), both the smaller fragment in Samothrace and the stele in Bignor Park supplement it. The bucranes are clearest on the stone recorded by Cyriacus, for example, but the worn stele in Bignor Park offers the best indication of the bases in which the monumental torches flanking the door were mounted—a feature evidently overlooked by or invisible to Cyriacus. It is needless, I think, to point out lesser discrepancies between these images, e.g., the level of the lintel and threshold of the door in fig. 25 in comparison with the doubtless more precise representa-

tion of these details in figs. 22 and 24, since they are plainly visible in the illustration.

The snake-entwined torches were misinterpreted as posts or masts surrounded by fillets in the brief discussion of this relief by Walter Altmann, *Die römischen Grabaltäre der Kaiserzeit*, Berlin, 1905, p. 15, where it appears as fig. 2.

[65] For examples of this type of door and frame, see *The Hieron*, I, pp. 189ff. The traces of an object in the lower panel of the right leaf which earlier investigators have commented on (see Kern, *op. cit.*, pp. 360f.) are, I suspect, remnants of a conventional round handle.

[66] Presumably the other stelai were similar in shape.

[67] By the learned antiquarian to whose collection the stele had passed, Fauvel, according to Conze, *Samothrake*, II, p. 113.

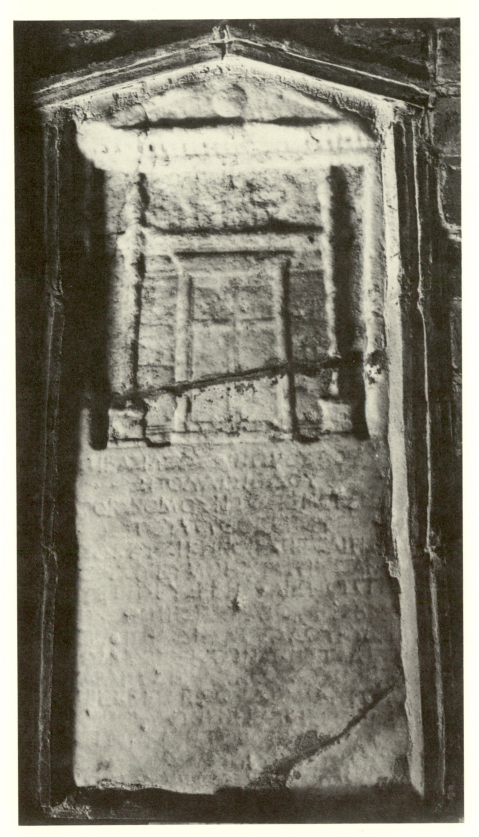

25. Inscribed stele from Samothrace. Bignor Park Sussex

Before considering this evidence, the relevance of Cyzicene documents to this group of Samothracian inscriptions must be noted: three of the four stelai, indeed probably all four, are dedications of initiates from Kyzikos.[68] What is more, they constitute a unique group among the large number of lists of initiates in the Samothracian mysteries. Only residents of Kyzikos placed the image of a building on their stelai, a fact which suggests that that structure was a Cyzicene rather than a Samothracian monument.[69] The additional fact that this very image recurs on the Imperial coinage of Kyzikos, obviously as a characteristic emblem of the city, confirms this suggestion.[70] Whatever the function of this structure, it was clearly of sufficient importance to serve as a badge of that city.

On these bronze coins (fig. 26 A, B),[71] the structure carved on the stelai and drawn by Cyriacus recurs in identical form, only the snake-entwined torches having been moved to flank it rather than its door, in accord with a common numismatic device for clarification. By detaching these monumental torches from what seemingly was their actual position before the building,[72] the die-cutter has been able to render intelligible the figures that on the coins,

[68] The three certain Cyzicene dedications are the stele drawn by Cyriacus (figs. 22; 19–21); the lost fragment recorded in Samothrace (fig. 23); and the inscription in Bignor Park (fig. 25). For their texts, see the references cited in nn. 58, 61, and 62, respectively. The fourth stone, the so-called Demokles stele recently discovered in Samothrace (fig. 24 and n. 63), retains only secondary inscriptions on its narrow sides. Broken near the bottom of the round structure, it surely bore an inscription on its lower front face, and, in view of the unique status of this group of stelai, it is reasonable to assume (as did Rubensohn, op. cit., p. 230) that it, too, recorded the names of initiates from Kyzikos.

[69] As has been observed by others, e.g., Louis Robert in his review of Samothrace, 2, I, in Gnomon, 35 (1963), p. 67, n. 2, in contrast with the older assumption of Théodore Reinach, "Inscriptions de Samo-

thrace," REG, 5 (1892), pp. 199ff., that the building represented on the stelai was a Samothracian "temple." Had this been the case, initiates from other cities would surely have adopted this device in recording their initiations.

[70] As again, other writers have long recognized: e.g., Rubensohn, op. cit., pp. 174ff.; Kern, op. cit., p. 358.

[71] For the example of this reverse type illustrated in fig. 26 A (a type issued in the second and third centuries A.D.), see Warwick Wroth, Catalogue of the Greek Coins of Mysia, London, 1892, p. 42, no. 184, pl. XI, 7; F. Imhoof-Blumer, "Zur griechischen und römischen Münzkunde," Revue suisse de numismatique, 13 (1905), pp. 201ff. I owe this reference to Bluma L. Trell.

[72] As noted by Rubensohn, op. cit., p. 169.

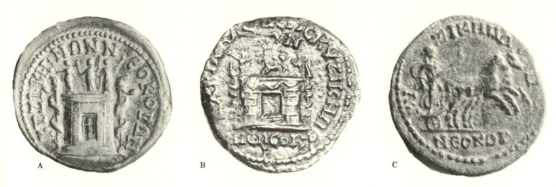

26. Reverses of Imperial bronze coins of Kyzikos. A. London, British Museum.
B. New York, American Numismatic Society. C. London, British Museum

as in Cyriacus' drawing, appear above the building. Generally these figures differ from those drawn by Cyriacus and consist of three females, a central figure holding a torch aloft in each extended hand flanked by two similarly draped figures, each provided with a torch in her outer hand.[73] But on one, apparently unique, example in the collection of the American Numismatic Society in New York, the standing central figure has been replaced by a chariot bearing a female (fig. 26 B).[74] Although moving to the left rather than to the right, it recalls the similar group in the Ambrosian drawing (fig. 20) and

[73] The example in the British Museum illustrated above, fig. 26 A, appears to belong to this variety in spite of Wroth's statement, *loc. cit.*, that all three figures hold two torches apiece. They were correctly described by Imhoof-Blumer, *loc. cit.* The examples illustrated by the author, pl. XIX, 8–12, prove that the outer figures each hold but a single torch.

[74] This example, weighing 8.19 gm., struck under Gallienus, whose bust faces left on the obverse accompanied by the abbreviated legend ΑΥΤΚΠΛΙΚ ΓΑΛΛΙ- ΗΝΟC, belonged to the late Edward T. Newell before passing to the collection of the Society. The reverse type bears the legend ΚΥΖΙΚΗΝ ΔΙC ΝΕΟΚ and, on the left rim upward, the remains of the magistrate's name, ΑΚΙΛ. ΒΑCΙΛΕΩC.

I am greatly indebted to Nancy M. Waggoner, Assistant Curator of Greek Coins at the Society, for this information and for permission to publish this coin, as well as for her assistance in checking on its seemingly unique nature among published examples of the type. Mrs. Waggoner, too, interprets the chariot-borne figure as female.

For the honorific title νεωκόρος, Temple-Warden, awarded to Kyzikos and a limited number of cities in Asia, see David Magie, *Roman Rule in Asia Minor to the End of the Third Century after Christ*, Princeton, 1950, p. 637, and Bluma L. Trell, "A Link between the Medieval West and the Pre-Greek East," *Atti del Congresso Internazionale di Numismatica, Roma 11–16 Settembre 1961*, II, Rome, 1965, pp. 543f., 548.

suggests that the copyist of the Milanese codex has recaptured Cyriacus' lost original more accurately than did his fellow copyists in depicting a male figure in the chariot (figs. 19, 21). The appearance of this torch-bearing goddess in a chariot drawn to the right by a pair of galloping horses on yet another coin of Kyzikos (fig. 26 c),[75] now as an isolated image, provides strong support for this assumption. In all likelihood, this torch-bearing goddess, whether afoot or mounted, alone or accompanied by flanking figures, is the great goddess honored in both Kyzikos and Samothrace, whether under the name of Meter, Kybele, or Axieros, who was attended by a pair of male acolytes in both Samothrace and Kyzikos.[76] On the Cyzicene monument recorded by Cyriacus, it is probably Kybele and the Kouretes to whom allusion is made.[77]

Not only are these coins invaluable in establishing the fact that it was a Cyzicene rather than a Samothracian structure that initiates from Kyzikos quoted on their stelai, but they also reveal at least the generic nature and loca-

[75] Wroth, op. cit., p. 53, no. 249, the reverse of a bronze coin bearing on the obverse a bust of Julia Domna to right. It is conceivable that here, as elsewhere on the coinage of Kyzikos, the goddess holds two torches, although in this instance her inner left hand and arm are invisible. For types showing her striding forward with a torch in each hand or, with the same attributes, mounted in a chariot drawn by snakes, see Wroth, ibid., pls. XIII, 8, and XII, 12, respectively.

[76] For the cults of Kyzikos, in whose heroic past the Argonauts figure as they do in Samothracian legend, see F. W. Hasluck, Cyzicus, Cambridge, 1910, pp. 171, 214f.; and for religious connections between Kyzikos and Samothrace, see Rubensohn, op. cit., pp. 173ff., and Bengt Hemberg, Die Kabiren, Uppsala, 1950, pp. 249ff.

For reference to the Great Mother and the Kabeiroi-Dioskouroi in Samothrace, see Karl Lehmann in The Hieron, II, especially p. 47, and idem, Guide³, pp. 22f.; for Kybele and the Kouretes in Kyzikos, see Hasluck, op. cit., pp. 214f., based especially on Apollonius Rhodius, Argonautica 1.1126ff.

[77] It is significant that in all three copies of Cyriacus' drawing the lateral figures are beardless youths clad in short chitons and that the Dioskouroi—the Greek equivalents of the Kabeiroi-Kouretes—appear in precisely this form on the Imperial coinage of Pisidia (see Fernand Chapouthier, Les Dioscures au service d'une déesse [Bibliothèque des Ecoles françaises d'Athènes et de Rome, 137], Paris, 1935, pp. 58ff. Elsewhere (p. 176), without reference to this evidence, the author concludes that Cyriacus drew a monument on which the Kabeiroi flanked Demeter in a chariot. In the context of this essay, it is needless to refute Chapouthier's inaccurate comment on the "fanciful" nature of Cyriacus' drawings). This parallel evidence offers welcome confirmation of the probable correctness of the Milan copyist's interpretation of the chariot-borne figure in Cyriacus' drawing as female rather than male, given the frequency with which the Twins are shown flanking the Goddess on a wide variety of monuments, for which see Chapouthier, ibid., passim. It is interesting to recall that Fauvel is quoted as having seen a figure of Kybele in the field above the building on the stele now in Bignor Park. See above, p. 34 and n. 67.

tion of the triad of figures shown above the edifice on both the coins and the stelai. They are neither akroteria[78] nor any other variety of external architectural sculpture; on the contrary, in accord with familiar Imperial practice, these figures which appear to stand above the building doubtless stood within it.[79] Indeed, in this instance, the roof of the building seems to have been removed in order to exhibit cult figures inside it.[80] Whether these figures constituted a statuary cult group or appeared in a relief or painting cannot be ascertained.[81]

Nor can the precise character or date of this cult building in Kyzikos be established with certainty. Its general analogy to the Rotunda dedicated to the Great Gods by Arsinoe has long been noted,[82] as has the religious affinity of

[78] As proposed by Fernand Robert, *Thymélè* (Bibliothèque des Ecoles françaises d'Athènes et de Rome, 147), Paris, 1939, pp. 87f.

[79] For an illustration of the use of this standard convention on a conspicuous monument generally contemporary with the series of coins under discussion, see such characteristic scenes on the Column of Marcus Aurelius in Rome as those illustrated by C. Caprino, A. M. Colini, G. Gatti, M. Pallottino, and P. Romanelli, *La Colonna di Marco Aurelio*, Rome, 1955, pl. LX, where the Emperor, flanked by aides, is shown above the encampment within which he actually stood at the moment represented.

For a recent discussion of the use of this convention (here described as *above = behind*) by die-cutters, see Bluma L. Trell, "Architectura Numismatica Orientalis," *The Numismatic Chronicle*, 7th ser., 10 (1970), pp. 31ff. I am indebted to Mrs. Trell for having allowed me to see the text of this article in page proof.

[80] For discussion of this point, see below, n. 82.

[81] The varying figural types shown above the constant architectural type on these coins raise the insoluble problem of whether one or the other is a paraphrase of a cult group or both are elements of a more extended composition, presumably a painting or relief. The latter alternative seems reinforced by the irregular terrain present in the Bodleian and Laurentian drawings, which, it has been argued, must reflect the same archetype as the coins. On the other hand, there remains such an obvious and relevant example of the use of irregular terrain in a three-dimensional group as the *Farnese Bull* (for a convenient reference, see Margarete Bieber, *The Sculpture of the Hellenistic Age*, rev. edn., New York, 1961, p. 134 and fig. 529).

[82] Since the remarks of Niemann in *Samothrake*, I, p. 84, n. 1, who assumed that the building shown on the coins was flat-roofed—an unlikely architectural solution in this stormy region. Apart from the fact that the structure shown on the reliefs and coins appears to lack the galleried upper story of the Arsinoeion (see below, for further reference to this point), it also exhibits features not found on that rotunda, in particular, a continuous frieze of garland-linked bucranes and the use of drafted-margin masonry for its exterior—a popular type of Hellenistic masonry employed on the interior but not the exterior of the Samothracian rotunda. (Pending the republication of this building scheduled for Bollingen Series LX, Vol. 7, see *Samothrake*, I, pl. LIV, for a very general im-

Samothrace and Kyzikos.[83] Conceivably, the building shown by citizens and ambassadors[84] of Kyzikos on the stelai recording their initiation into the Samothracian rites was a branch Samothrakion.[85] Equally plausibly, it may simply have been a famous cult building in their native city—possibly a cult building having a particular relevance or relationship to the Samothracian rites, hence especially appropriate in this context. Only full-scale excavation of that celebrated site could resolve this problem. But both the fragmentary inscription drawn by Cyriacus and the stele in Bignor Park yield further evidence regarding the date of the round building in Kyzikos and the interrelationship of Kyzikos and Samothrace.

Among the initiates from Kyzikos listed on these stelai was one Asklepi-

pression of its appearance and, for a number of revisions, *Guide*³, pp. 49ff.)

The absence of a roof and the presence at Kyzikos of an Altar of Persephone have led some writers to assume that the structure represented on this group of coins and stelai was an altar (see the discussion of Rubensohn, *op. cit.*, pp. 174ff., who left the question open; Hasluck, *op. cit.*, pp. 181ff.; and the caption to pl. 5 d, a partial illustration of the Oxford page, in the long later article by Saxl, *loc. cit.* [above, n. 29]). I do not know of the existence of any round, unroofed, monumental altar comparable in size, for example, to the numerous great unroofed rectangular altars known from a number of sanctuaries or such large-scale rectangular altar enclosures as the Altar Court in Samothrace or the Great Altar at Pergamon. It may be worth observing that the door of the monument shown on the Imperial bronzes of Kyzikos (and on both the stele drawn by Cyriacus and the so-called Demokles stele) by no means occupies the full height of the wall, as do the comparable doors on numismatic images of monumental altars. See, for example, the celebrated sestertius of Nero showing the *Ara Pacis* (well illustrated by Jocelyn M. C. Toynbee, *The Ara Pacis Reconsidered and Historical Art in Roman Italy* [*ProcBritAc*, 39], London, 1953, pl. xxviii), where the door occupies the entire height of the wall proper, as might be expected in such a one-storied structure. If this detail is meaningful and the Cyzicene coins under discussion reflect a building rather than an altar, the die-cutter obliged to show a group of figures within the building could do so only by eliminating either its front wall or part of its elevation, in particular, its roof. Franz Studniczka, "Altäre mit Grubenkammern," *JÖAI*, 6 (1903), pp. 125f., Imhoof-Blumer, *op. cit.*, pp. 201ff., 205, and Fernand Robert, *op. cit.*, pp. 359ff., have also concluded that the monument shown on these coins was a building rather than an altar.

[83] Above, n. 76.

[84] For interpretation of the term ἱεροποιοί found on the stele copied by Cyriacus, along with the normal categories of initiates, μύσται and ἐπόπται, as equivalent to θεωροί, or ambassadors, see Louis Robert, *op. cit.*, p. 67. See also Fraser's comment, *Samothrace*, 2, 1 (above, n. 56), p. 116, n. 20.

[85] For worship of the Samothracian Gods outside Samothrace, see Hemberg, *op. cit.*, pp. 212ff., the brief reference in Lehmann, *Guide*³, p. 28, to such extra-Samothracian congregations of initiates, and, for an example of such a branch, Fernand Chapouthier, *Le Sanctuaire des dieux de Samothrace* (*Exploration archéologique de Délos*, XVI), Paris, 1935.

ades, son of Attalos, a man described on the inscription in Bignor Park as an ἀρχιτέκτων, that is, either a master builder or one of the magistrates of Kyzikos called ἀρχιτέκτονες.[86] It is also reported that Asklepiades, here listed as both a *mystes* and an *epoptes*, had been sent to Samothrace by his native city at the request of the δῆμος of Samothrace in order to perform some now uncertain task. On this occasion, he evidently became an *epoptes*, for on the inscription recorded by Cyriacus, he was only a *mystes*, an initiate in the lower degree of the Samothracian mysteries.[87] The worn and incomplete state of the stele in Bignor Park precludes a satisfactory answer to the tantalizing question of what Asklepiades actually did in Samothrace. Even if the term "architect" here means master builder rather than member of a board of magistrates in Kyzikos, the image of a round building on the inscription recording his activity does not imply that he was the architect of the Rotunda dedicated by Arsinoe in view of the fact that the inscription dates, at the very earliest, from the late second century B.C.[88] Nor is there, as yet, any evidence of a major repair to that building at that time over which he, as a master builder, could have presided. On the contrary, he seems to have had to do with certain εἰκόνες, whether sculptures or paintings.[89] Tempting though it is to specu-

[86] See Fraser, *op. cit.*, p. 115 and n. 16, and for recent discussion of this term, Alison Burford, *The Greek Temple Builders at Epidauros*, Toronto, 1969, pp. 138ff.

[87] For the meaning of these terms in Samothrace, see Lehmann in *The Hieron*, II, pp. 10ff., and for reference to the inscriptions on which Asklepiades' name occurs, p. 13, n. 53. Both Lehmann-Hartleben, "Cyriacus," p. 119, n. 25, and Fraser, *op. cit.*, p. 116, assumed that the Asklepiades mentioned on the two stones must be one and the same person.

[88] See Fraser, *ibid.*, for "a Hellenistic date (ii/i B.C.) rather than an Imperial one" for this inscription which Lehmann-Hartleben, *loc. cit.*, had dated in the first century B.C., slightly later than the stele drawn by Cyriacus, for which Fraser, *op. cit.*, pp. 82, 116, prefers a somewhat earlier date, in the late second century B.C. In any case, the two inscriptions are more than a century and a half to two centuries

later in date than the Arsinoeion, hence the older view that Asklepiades was called to Samothrace to build the Arsinoeion (see Rubensohn, *op. cit.*, p. 159, for reference to this position) must be excluded, if on no other grounds. The theoretical possibility that Asklepiades was the architect of another, as yet unknown round building in Samothrace (see Otto Benndorf in *Samothrake*, II, p. 114, or Lehmann-Hartleben's similar alternative, "Cyriacus," p. 121, that the structure represented on this group of inscriptions might represent an as yet unknown building in the Sanctuary), must also be discarded, if only because of the restriction of the image of this round structure to monuments connected exclusively with Kyzikos.

[89] Fraser's suggestion, *op. cit.*, p. 116. As Burford points out, *op. cit.*, pp. 145f., more than one eminent Greek architect was also a sculptor and skilled in more than one craft.

late on the nature of his mission and on whether any relationship existed between these *eikones* and the images represented on the Cyzicene coins and inscriptions discussed here, it is futile to do so, given the incomplete nature of the evidence at hand. One credible conclusion does emerge from this evidence: Asklepiades seems to have belonged to a prominent Cyzicene family,[90] and that family evidently included at least one other ἀρχιτέκτων—Attalos, very likely his own father, a man associated with yet another image of a round building!

This Attalos, son of Asklepiodoros, appears on a well-known funerary relief from Kyzikos in the Louvre (fig. 27), his identity assured by the location of the inscription naming him directly beneath his recumbent figure.[91] Amid the orthodox elements in this richly symbolic scene, one is unconventional: the maiden at the left, who approaches the deceased bearing a model or replica of a round building.[92] Clearly, the building has a special meaning, a special connection with Attalos. Was he its donor, its architect, or a magis-

[90] See H. G. Lolling, "Mittheilungen aus Kleinasien," *AM*, 7 (1882), pp. 151–159, for a Cyzicene family in which this name occurred and which included members honored for their benefactions to local cults of the Meter. It seems reasonable to follow Benndorf, *op. cit.* (below, n. 91), p. 195, in assuming that Asklepiades belonged to this family.

[91] No. 2854. Height 1.08 m.; width 1.275 m. See Jean Charbonneaux, *La sculpture grecque et romaine au Musée du Louvre*, Paris, 1963, pp. 126f., and Rhea N. Thönges-Stringaris, "Das griechische Totenmahl," *AM*, 80 (1965), p. 76, no. 54, Beilage 28, 1, for recent reference to this relief. (I am indebted to Elsbeth B. Dusenbery for these references.) For more extensive discussion of it and a more precise description, see Otto Benndorf, "Antike Baumodelle," *JÖAI*, 5 (1902), pp. 191ff., figs. 57, 58. A photograph of a squeeze of the inscription appears on p. 193. The inscription itself, on the lower margin of the frame, may be seen in fig. 27. It is not indicated in the drawing published by Salomon Reinach, *Répertoire de reliefs grecs et romains*, Paris, 1912, II, p. 292, no. 2.

[92] So Benndorf originally interpreted this object (in *Samothrake*, II, p. 114). Later, "Antike Baumodelle," p. 195, troubled by the absence of a door on this "Kästchen" and by the fact that it is borne by a female rather than a male figure, he was less sure of its nature. In view of his own comparative material and the other analogous examples from the later history of art that might be adduced (e.g., the well-known mosaic above the door leading into the inner narthex of Hagia Sophia, for which see Heinz Kähler and Cyril Mango, *Hagia Sophia*, New York, 1967, pp. 54f., pl. 91), it seems to me hardly possible that this object can be anything but a small-scale replica of a building. Fernand Robert, *op. cit.* (above, n. 78), pp. 397f., implied that it is both a model and an ex-voto. Frau Thönges-Stringaris, *loc. cit.*, simply describes the object as "eine Ciste." Charbonneaux, *loc. cit.*, took a neutral stand, it would seem, in his reference to "une ciste en forme de *tholos* périptère—ce qui a fait supposer que le défunt était architecte."

27. Funerary stele from Kyzikos.
Paris, Musée du Louvre.

28. Detail of stele from Kyzikos.
Paris, Musée du Louvre

trate connected with its construction? Probably, its ἀρχιτέκτων, whether master builder or magistrate, especially in view of the application of that term to Asklepiades, his presumed son.[93] Was Asklepiades responsible for the choice of the motif carved on the inscriptions that bear his name, at least two among the four such inscriptions extant? And was this choice a natural reflection of family pride, of his own role as ἀρχιτέκτων, and of the appropriateness of the image for documents recording the initiation of residents of Kyzikos? It seems a plausible thought.[94]

To judge by its style, Attalos' gravestone cannot antedate the middle of the second century B.C.,[95] a period appropriate for the career of the father of Asklepiades. The basic analogy between the round building reflected in the replica on this relief (fig. 28) and the unorthodox Rotunda dedicated by Arsinoe is striking: in both instances, an unadorned drum of solid masonry was surmounted by a windowless gallery of engaged columns or pilasters, whether Doric or Ionic, beneath a slightly sagging pagoda-shaped roof.[96] It seems likely that this second-century building was a direct descendant of the early Hellenistic Arsinoeion, and linked with it in some ritual fashion. It seems unlikely that there was more than one such round building in Kyzikos in the second century. If not, the round structure quoted on the late Hellenistic stelai from Samothrace—all four of which are to be dated in the late second or first century B.C.[97]—like the Cyzicene coins of the second and third centuries A.D. alludes to the same monument, a building of sufficient local im-

[93] It is inconceivable that a normal, practicing architect, like the rare famous painters or sculptors of antiquity who are recorded as having occasionally donated their works, would have had the necessary means to pay for the construction of a major building.

[94] If these queries and suggestions are valid, one cannot but wonder whether Asklepiades' name appeared on the two other, today so fragmentary, reliefs. (For the overlapping dates of all four, see nn. 88, 97.) If so, the presence of this image on a small group of stones unique among Samothracian lists of initiates would be particularly understandable.

[95] See also Thönges-Stringaris, loc. cit.: "Gegen 160 v. Chr." With regard to the

inscription, I am grateful to B. D. Meritt for stating that, in his judgment, "the letters do not date earlier than 150 B.C."

[96] Benndorf, "Antike Baumodelle," p. 192, n. 42, quoted Etienne Michon as unable to determine the order; nor can we be absolutely certain from the photographs whether it consisted of half-columns or pilasters. For the Arsinoeion, see above, n. 82, in particular, Lehmann, Guide³, pp. 49ff.

[97] For the dates of the stele drawn by Cyriacus and the inscription in Bignor Park, see above, n. 88; and, for the other two, Fredrich, IG, XII (8), no. 189 (between 88 B.C. and A.D. 65?) and no. 190 (first century B.C.).

portance to serve as the badge of the city on its Imperial coinage.[98] If this supposition is correct, the upper story of this building has, indeed, been removed from it on the coins and stelai in order to exhibit a significant cult group within it.[99]

However hypothetical this explanation of the interrelationships between these Samothracian and Cyzicene monuments, on one point there can be no doubt: the stele drawn by Cyriacus remains one of the most important and evocative documents of the Samothracian mysteries,[100] and his lost drawing the most complete record of this now fragmentary stone. That he was attracted to it is not surprising. For years he had patiently recorded the texts of inscriptions as he traveled throughout classical lands, even simple lists of names like the other fragmentary inscriptions he copied in Samothrace,[101] such was his zeal for preserving and reconstructing every document of classical antiquity, large or small, complete or incomplete. But there was still another reason for his interest in this particular inscription—the fact that it had to do with Kyzikos.

A scant two months before his brief visit to Samothrace, Cyriacus had gone to Kyzikos.[102] It was his second visit to that deserted city. In 1431, struck

[98] For a conspicuous example of the well-known Roman practice of representing famous local monuments of an earlier period on coins struck centuries later, see Bluma L. Trell, *The Temple of Artemis at Ephesos* (Numismatic Notes and Monographs, 107), New York, 1945.

[99] The image of the total building on Attalos' stele would then prove to be somewhat more schematic than the partial quotations of it on the coins and lists of initiates which indicate its frieze and the character of its masonry. One would assume that the lost building was characterized by the sum total of all the features of all the replicas. See Trell, *The Temple of Artemis at Ephesos*, pp. 3–6, for the related problem of the conclusions to be drawn from numismatic variants of a given architectural type.

[100] Even among the four related inscriptions discussed here, it is unique in one respect: the loop-shaped objects within which the names of the *epoptai* were listed. For

interpretation of this feature as the *porphyris*, the purple scarf worn by Samothracian initiates, see Lehmann-Hartleben, "Cyriacus," pp. 122f., and *The Hieron*, II, pp. 26ff.

[101] See Ziebarth, "Cyriacus . . . als Begründer," *loc. cit.* (above, n. 22), and the discussion and references in chap. II, pp. 108ff., for Cyriacus' role as an epigrapher; for the inscriptions that he copied in Samothrace, see both Ziebarth, "Cyriacus von Ancona in Samothrake," *AM*, 31 (1906), pp. 411ff., and Fredrich in *IG*, XII (8), s.v. *Samothrace*, passim.

[102] On July 31, 1444. See Théodore Reinach, "Lettre à M. le Commandeur J. B. de Rossi au sujet du Temple d'Hadrien à Cyzique," *BCH*, 14 (1890), pp. 517ff., for the reports of this visit in Vat. lat. 5250, fols. 7–10, and Neapolitanus V. E. 64, pp. x–xii; and, for the earlier visit of 1431, Scalamonti's account in Colucci, *op. cit.* (above, n. 2), pp. LXXXVf.

by its use as a quarry for new buildings in nearby Bursa, he had gone there with a Turkish guide. His excitement over its immense ruins, still partially upright and intact, and his effort to persuade the governor of the province to put an end to the wanton and systematic destruction of its fabled sanctuary were characteristic, if futile. When he returned to the site in July 1444 and

29. Detail of the Temple of Hadrian at Kyzikos, after Cyriacus. Ms. Lat. Misc. d. 85, fol. 134r. Oxford, Bodleian Library

found it still further despoiled, he undertook one of his most ambitious archaeological ventures: he measured, described, and sketched the ruins of the colossal temple built by Hadrian, the Eighth Wonder of the World.[103] The copies of his sketches preserved in the Bodleian manuscript[104] are among the most extraordinary documents of the Italian Renaissance, the most eloquent of all testimony to the accuracy, the proto-modernity, of Cyriacus, the amateur-archaeologist. Little wonder that, after this memorable experience, he was drawn to any monument connected with Kyzikos.[105]

AMONG Cyriacus' sketches of Hadrian's temple, there is one showing a section of its wall adorned by a colossal head of Medusa (fig. 29).[106] His interest in this image is apparent both in the special care with which it has been drawn and in the fact that he devoted another entire sheet to a large-scale detail of

[103] For the most comprehensive discussion and interpretation of Cyriacus' statements and drawings on this occasion, see Bernard Ashmole, "Cyriac of Ancona and the Temple of Hadrian at Cyzicus," *JWarb*, 19 (1956), pp. 179ff., and, for subsequent discussion of the frieze of the temple and Cyriacus' drawings of it, Hans Peter Laubscher, "Zum Fries des Hadrianstempels in Kyzikos," *Istanbuler Mitteilungen*, 17 (1967), pp. 211ff.

[104] Ms. Lat. Misc. d. 85, fols. 132v–136v, all reproduced by Ashmole, *ibid.*, pls. 38ff.

[105] It is entirely possible that another related factor contributed to Cyriacus' interest in this inscription recording the initiation of Cyzicenes in Samothrace: the image of a round building carved upon it, that image which, as we have seen, occurred in identical form on the bronze coinage of Kyzikos in Imperial times. He is known to have collected coins during his travels in Turkey, indeed, during the very year of his first visit to that city (see above, n. 22), and, as any excavator can testify, nothing is more frequently encountered on a great site than bronze coins. If Cyriacus

saw or acquired such a coin during his investigations at Kyzikos, it would certainly have intensified his interest in this Cyzicene inscription.

[106] Fol. 134r. Illustrated by Ashmole, *ibid.*, pl. 37b. Professor Ashmole questions whether Cyriacus saw this gorgoneion precisely where he shows it in the drawing, although he does not doubt that Cyriacus saw it in Kyzikos, if "perhaps not . . . set in the wall at that particular point" (p. 188). In the context of the present discussion and in view of Cyriacus' care and detail in these Cyzicene drawings, it is reasonable to assume that this gorgoneion—whatever its material—was attached to the temple wall to provide its customary apotropaic protection, precisely as it did in the famous instance cited by the author and repeated here (see n. 114, below).

For the use of large-scale gorgoneia in Imperial architecture, see the examples cited by Ashmole, "Cyriac . . . and the Temple of Hadrian," n. 2, especially those discussed by J. B. Ward-Perkins, "Severan Art and Architecture at Lepcis Magna," *JRS*, 38 (1948), pp. 69, fig. 12; 74, pl. IX, 3, 4.

30. Corinthian capital from the Temple of Hadrian at Kyzikos, after Cyriacus.
A. Ms. Lat. Misc. d. 85, fol. 136v. Oxford, Bodleian Library.
B. Ms. Ashb. 1174, fol. 122v. Florence, Biblioteca Medicea-Laurenziana

30A

a Corinthian capital embellished with a similar head (fig. 30 A, B).[107] Between his first and second visits to Kyzikos, in the spring of 1436, he had spent a fortnight in Athens. There, too, as he measured, drew, and recorded on the south slope of the Akropolis, he noted a "statue of a Gorgon" high up on the citadel above the shrine of Our Lady of the Grotto (the ancient *Monument of Thrasyllos*).[108] The meaning of this phrase is uncertain. Conceivably, it refers to the colossal gorgoneion on the south wall of the Akropolis that once overlooked the Theater of Dionysos, that "gilded head of Medusa the Gorgon"

[107] Fig. 30 A = fol. 136v. As far as I can tell, fig. 30 B, an exact counterpart to the Bodleian drawing on fol. 122v of the Laurentian manuscript, Ashburnensis 1174, was not known to either Saxl or Ashmole. See, for example, the latter's statement, "Cyriac of Ancona," *ProcBritAc*, 45 (1957), p. 35. Ashmole comments on this drawing at some length ("Cyriac . . . and the Temple of Hadrian," pp. 190f.), in particular on the appropriateness of a Gorgon's head on a capital in a temple dedicated to Jupiter.

[108] See Bodnar, "Athens in April 1436," *Archaeology*, 23 (1970), pp. 196f.

Dyftone miuicem colune
p. x. iy

30в

given to the city by Antiochus IV Epiphanes.[109] No longer extant when Cyriacus visited Athens, the memory of that glittering talisman had lingered on, part of the legendary lore reported to visitors.[110] But whatever the monument

[109] Pausanias 1.21.3; 5.12.4.

[110] It is obviously the *ydolus* mentioned by Cyriacus' only recorded Western predecessor on the Akropolis, Niccolo da Martini, in 1395. For Niccolo and his report *De quodam ydolo*, see Walther Judeich, "Athen im Jahre 1395," *AM*, 22 (1897), pp. 423ff., especially 429f., and James Morton Paton, *Chapters on Medieval and Renaissance Visitors to Greek Lands*, Princeton, 1951, pp. 34, n. 24, and 173f.

Judeich, Paton, and originally Bodnar, *Cyriacus of Ancona and Athens* (above, n. 2), pp. 37f., assumed that the protective idol was a medieval replacement of the Hellenistic gorgoneion. It is hard to imagine that, once destroyed, that pagan image would have been replaced in Byzantine Athens. It is more likely that the original gorgoneion remained in place into the Middle Ages and that after it disappeared (plundered?), the memory of that conspicuous apotropaic image lingered on in the popular mind, with the result that Niccolo and, doubtless, Cyriacus, too, were told of its previous existence. That the devoutly Christian Niccolo would have termed such a pagan image an *ydolus* is to be expected; that the experienced Cyriacus,

to which Cyriacus alluded, this phrase confirms his interest in that mythological creature.[111] How natural, then, that when he encountered yet another gorgoneion a few weeks after he had drawn the Cyzicene gorgoneia, this time on a wall of Palamede's new citadel in Palaiopolis, he sketched it, too.

Once again, Cyriacus' lost original is known from replicas in the Bodleian, Laurentian, and Ambrosian manuscripts (figs. 31–33).[112] The first two, accompanied by the identical explanatory caption, *Medusae caput aheneum apud samothraciam ad novam arcem positum*, are similar despite the richer detail, the greater verve, of the Florentine drawing. They show (figs. 31, 32) an oval-faced Medusa seen from a three-quarter view, her dishevelled, fluttering locks animated by the sinuous bodies of snakes, her chest covered with what appears to be a scaly collar—her skin, the aegis. In the Codex Ambrosianus (fig. 33), these features are exaggerated, the creature's gaze has been shifted, and she has been provided with a conspicuous pair of wings—

who invariably referred to the Parthenon, in his day a church of the Panaghia, as the Temple of Minerva, would have recognized the identity of the lost monument is entirely possible. It is not unlikely, therefore, that his phrase *ad statuā gorgonis* served to locate the monuments shown in the drawing in which it occurs. There remains the difficulty that the word *statue* would not normally be used in connection with a gorgoneion. Hence Bodnar has suggested ("Athens in April 1436," pp. 196f.) that Cyriacus misinterpreted the mutilated statue of Dionysos from the *Monument of Thrasyllos* shown in this drawing in the Codex Barberinianus as a Gorgon. M. Collignon, "Documents du XVIIe siècle relatifs aux antiquités d'Athènes," *Académie des Inscriptions et Belles-Lettres, Comptes Rendus*, 25 (1897), p. 65, n. 1, drew the same conclusion, suggesting that Cyriacus garbled the tradition of a Gorgon with the panther's head on the statue of Dionysos. I am indebted to John Travlos for this reference.

[111] See Adolf Furtwängler in W. H. Roscher, *Ausführliches Lexikon der griechischen und römischen Mythologie*, Leipzig, 1884–1890, I², s.v. *Gorgones*, cols. 1701–1727, especially cols. 1721ff., still the fundamental discussion of the topic, and Gustave Glotz in Charles Daremberg and Edmond Saglio, *Dictionnaire des antiquités grecques et romaines*, II, Paris, 1892, s.v. *Gorgones*.

[112] Fig. 31: Bodleian Ms. Lat. Misc. d. 85, fol. 140v. Pen and wash drawing in black ink, apart from the explanatory text in red. Published by Saxl, *op. cit.* (above, n. 29), p. 34, pl. 8 d.

Fig. 32: Codex Laurentianus Ashburnensis 1174, fol. 121r. Pen and wash drawing in sepia ink, again, apart from the explanatory text in red ink. Mentioned and illustrated by Ziebarth, "Cyriacus von Ancona in Samothrake," *AM*, 31 (1906), pp. 409 and 411, fig. 3; see also Chapouthier, *Les Dioscures*, p. 169.

Fig. 33: Codex Ambrosianus A55 inf., fol. 71r. Pen drawing in sepia ink and wash; text in the same ink. Mistakenly cited by Ziebarth, *op. cit.*, as fol. 76.

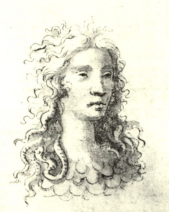

MEDVSAE CAPVT AHE
NEVM APVD SAMOTHRACIA
AD NOVAM ARCEM POSITVM

Medusæ Caput aheneum
apud Samothraciam ad novam
arcem positum

ΕΠΙΒΑΣΙΛΕΩΣ ΘΑΣΙΩΝ ΙΣΙΟΥ
ΘΑΛΑΣΙΩΝΟΣ

Sex. pompeio et Sex. Appuleio Cos.
idibus Septembr. Myftes pius.

P. Sextius lippinus Tarquitianus Q. Macedonius Sym
myfide pij popijs.

Apud

31. Bronze head of Medusa, after Cyriacus. Ms. Lat. Misc. d. 85, fol. 140v. Oxford, Bodleian Library

32. Bronze head of Medusa, after Cyriacus. Ms. Ashb. 1174, fol. 121r. Florence, Biblioteca Medicea-Laurenziana

33. Bronze head of Medusa, after Cyriacus. Ms. A55 inf., fol. 71r. Milan, Biblioteca Ambrosiana

a standard but by no means obligatory attribute for the Gorgon, which suggests that the head drawn by Cyriacus belonged to the relatively rare type of the wingless Medusa and that the conventional wings on the Ambrosian head are an addition of the copyist.[113]

Bronze, if not gilded, "set in the new citadel in Samothrace," the model for Cyriacus' hypnotic sketch is unknown. Yet both his choice of words and the previously mentioned examples imply that his caption should be accepted literally and that somewhere on the walls of Palamede's stronghold, amid the profusion of marbles pilfered from the ancient city and Sanctuary to adorn it, this brazen image continued to exert her magical influence.[114]

Still more unusual than the three-quarter view from which the head is presented or its lack of wings[115] is the depiction of the aegis on this Samothracian Medusa. This feature, absent on the Cyzicene gorgoneia drawn by Cyriacus but present on the Athenian Gorgon,[116] occurs in analogous form on a carnelian in the Hermitage and an amethyst cameo formerly in the Colonna Collection in Rome (figs. 34, 35).[117] On these classicistic or late Hellenistic

[113] Beneath this small sketch in the Codex Ambrosianus there appears, in pale ink, a narrow leafy calyx flanked by a pair of discs or pateras, a combination that causes the head to seem to emerge from the calyx. However, the differences both in ink and in scale between these elements and the head indicate that the latter do not belong with the former nor does a comparable combination of a Gorgon and a calyx occur among the varied monuments assembled by Hans Jucker, *Das Bildnis im Blätterkelch*, Lausanne and Freiburg i. Br., 1961.

The faintly preserved caption above this drawing is a variation on the identifying legend in the other drawings: *Apud Samothraciam aeneum medusae caput ad novam arcem positum.*

[114] In his brief reference to this drawing, Lehmann-Hartleben, "Cyriacus," p. 116, n. 12, came close to proposing this explanation for the Samothracian Medusa when he felt "reminded" of the gilded bronze gorgoneion on the south wall of the Akro-polis at Athens, as Ashmole, too, recalled that prototype ("Cyriac . . . and the Temple of Hadrian," p. 188) in connection with the gorgoneion at Kyzikos. However, in assuming that the words *ad novam arcem* in Cyriacus' caption referred to the Gattilusi's citadel "in the village," i.e., in Chora, rather than to their new citadel in the ancient city, Lehmann-Hartleben was mistaken, as the lengthier, more explicit statements elsewhere in Cyriacus' description make clear (cf. above, pp. 4ff.; below, pp. 112ff.

[115] See Furtwängler, *loc. cit.*, for other gorgoneia having these features, including the gems discussed below.

[116] It is specifically mentioned by Pausanias, 1.21.3: ἐπὶ τούτου [the wall] Μεδούσης τῆς Γοργόνος ἐπίχρυσος ἀνάκειται κεφαλή, καὶ περὶ αὐτὴν αἰγὶς πεποίηται; and 5.12.4: ἡ αἰγὶς ἡ χρυσῆ καὶ ἐπ' αὐτῆς ἡ Γοργώ ἐστιν. . . .

[117] Adolf Furtwängler, *Die antiken Gemmen*, Leipzig and Berlin, 1900, II, p. 196, pl. XLI, 20; p. 266, pl. LIX, 1.

34. Carnelian gem. Leningrad,
The Hermitage

35. Amethyst cameo formerly in
the Colonna Collection

gems, the face has also been shown from a three-quarter angle, and, again, the Medusa's scaly skin appears in a shallow arc on or below the neck. It has been suggested that this rare feature reflects the tradition reported in a passage in Euripides' *Ion*,[118] where Athena, having slain the Gorgon, is said to have seized her skin, the snake-edged aegis, for a breastplate.[119] Euripides was one of Cyriacus' favorite ancient authors. He had long been familiar with his tragedies—indeed, had made a Latin translation of the playwright's life,

[118] Lines 989ff. For the same tradition, according to which Athena rather than Perseus slew the Gorgon, see Diodorus 3.70.3ff., and, for the aegis in general, E. Saglio in Daremberg-Saglio, *op. cit.*, I, s.v. *Aegis*.

[119] This suggestion is Furtwängler's, *Die antiken Gemmen*, p. 181, apropos a gem formerly in the Evans Collection, pl. XXXVIII, 2, and the related gems cited above. Saxl, *op. cit.* (above, n. 29), il- lustrating this gem alongside the Bodleian drawing, pl. 8 c, d, implies (p. 34) that it—or, in any case, a gem—was the source of Cyriacus' drawing. But Cyriacus' caption precludes this explanation, making clear that his model must have been a large-scale object made of bronze. For further comment on this gem, see Lehmann-Hartleben, "Cyriacus," p. 117, n. 12.

so keenly was he interested in him.[120] It is tempting to think that, once again, he responded in characteristic fashion when he encountered the bronze Medusa in Palamede's castle, that he summoned those lines from his retentive memory as he examined her features, coupling his literary knowledge and his visual experience as he contemplated this object, as he so constantly did when confronted with new monuments.

Closest of all to the Samothracian Medusa in generic type and style is the Gorgon on another gem, the celebrated Strozzi chalcedony in the British Museum (fig. 36).[121] Although it is shown in profile view and lacks the aegis, this superb head is again wingless and its writhing locks are again interwoven with twisting snakes that turn their heads to form a frame about the face. The shape and proportions of this face and its features, together with the character, the hair, and the human form of the Medusa, constitute the nearest parallel to the monument evoked by Cyriacus' drawing and imply that it, too, was a classicistic work of the late Hellenistic or early Imperial age.[122]

The analogy between these gems and Cyriacus' drawing and his well-known enthusiasm for ancient gems[123] would lead one to suspect that his model was a gem, were it not for the existence of bronze medallions bearing similar heads[124] and the unequivocal statement of his caption. Whatever its original

[120] Scalamonti in Colucci, *op. cit.* (above, n. 2), p. LXXX; Giorgio Castellani, "Un traité inédit en grec de Cyriaque d'Ancône," *REG*, 9 (1896), pp. 225ff.; Ziebarth, "Cyriacus . . . als Begründer" (above, n. 22), p. 225.

[121] H. B. Walters, *Catalogue of the Engraved Gems and Cameos Greek Etruscan and Roman in the British Museum*, rev. edn., London, 1926, pp. LIII, LV, 195, no. 1829, pl. XXIII; Furtwängler, *Die antiken Gemmen*, pp. 191f., no. 18, pl. XL, 18, as well as his earlier characterization of the extraordinary character and quality of this gem: "Studien über die Gemmen mit Künstlerinschriften," *JDAI*, 3 (1888), pp. 309ff., pl. 11, no. 9.

For other examples of wingless gorgoneia, see the articles cited in n. 111, above.

[122] See Furtwängler, "Studien," for the classification of all these gems, and Walters, *op. cit.*, pp. LIII, LV.

[123] See Scalamonti in Colucci, *op. cit.*, p. XCII, and, in particular, Bernard Ashmole's account, "Cyriac of Ancona," *ProcBritAc*, 45 (1957), pp. 38ff.

[124] For example, the beautiful mirror cover in the Metropolitan Museum adorned with a female head seen from a similar three-quarter angle: Gisela M. A. Richter, *Greek, Etruscan and Roman Bronzes*, New York, 1915, pp. 258f., no. 758. It is worth noting, incidentally, that the gorgoneion drawn by Cyriacus in Kyzikos (fig. 29, above) is presented from a slightly oblique angle, too.

36. Chalcedony gem. London, British Museum

location, whether it came from the ancient city or the Sanctuary, from the exterior of a building or the city wall, the Medusa that Cyriacus drew was clearly a great bronze medallion mounted on a wall of Palamede's stronghold.[125]

THE fragmentary record of Cyriacus' brief visit to Thracian Samos reflects his customary interest in historical documents, in the eloquent "stones" of the past, in architecture, and in sculpture. It reveals his continuous effort to interpret the scattered physical remains of antiquity in the light of ancient literature, his reintegration of the legendary, the historical, and the monumental into an ever-expanding picture of the ancient world. Each experience of this indefatigable traveler and scholar conditioned the next. By a happy turn of Agathe Tyche, Cyriacus' experience on that distant day in 1444 when

[125] For this reason, it is needless to cite the innumerable small bronze gorgoneia that served as attachments to a variety of objects (lamps, utensils, harnesses, beams) or were applied to armor or mirrors or used as door-knockers, more especially since none of the extant examples, nor any of the other gorgoneia in such materials as stone or terracotta (e.g., sarcophagi and architectural sculpture), is as close to the lost Samothracian Medusa in type or style as the gems cited above.

he explored the ruins of Palaiopolis included the sight of yet another sculpture "set as an ornament in the wall" of Palamede's stronghold—a frieze of dancing maidens that he interpreted in characteristic fashion with the help of ancient literature and contemporary works of art, the means that had enabled him to see in the features of a similarly uninscribed sculpture a bust of Aristotle. Like his drawing of Aristotle, Cyriacus' sketch of these dancing figures whom he took to represent the Muses and the Samothracian Nymphs was to lead to a later chapter in the history of art, one in which he contributed to the equally patiently acquired knowledge of antiquity of another student of the past—the most archaeologically-oriented of all the painters of the Quattrocento, Andrea Mantegna, in whose *Parnassus* Cyriacus' Muses dance.

II

THE SOURCES AND MEANING
OF MANTEGNA'S *PARNASSUS*

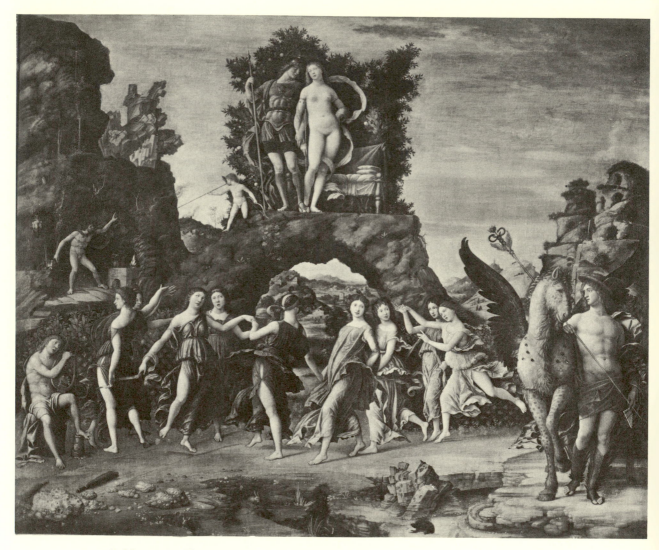

1. Mantegna, *The Parnassus*. Paris, Musée du Louvre

IN 1497, MANTEGNA finished his *Parnassus*, first of the paintings commissioned by Isabella d'Este for her studio in the ducal palace at Mantua (fig. 1).[1] Unique in theme, it is the supreme expression of the artist's lifelong preoccupation with antiquity.

Modern critics have reacted diversely to the *Parnassus*, praising it as Mantegna's ultimate paean to the beauty of a past whose image he had sought to recapture throughout a long life[2] or denouncing it as a highly unsuccessful attempt on the part of the old artist to paint in a lyrical mood.[3] Equally conflicting are the interpretations advanced for its complex imagery. Some have seen in it an allegory, a reference to Isabella's role at the Court of Mantua[4] or to the Duchess and her husband as the embodiments of strength and beauty under whose protection and inspiration the Muses rule.[5] Others have accepted it as a representation of the Homeric gods, of the adulterous lovers Mars and Venus, and of Amor, who either warns Vulcan too late[6] or stirs him to jealous action,[7] but they are not agreed on whether the scene is primarily a Triumph

[1] See Charles Yriarte, "Isabella d'Este et les artistes de son temps," *GBA*, ser. 3, 13 (1895), pp. 189ff., 382ff., 394f., and, for later discussion and bibliography on the location of Isabella's *Grotta*, the apartment in which the studio was included, the references cited by Edgar Wind, *Bellini's Feast of the Gods*, Cambridge, 1948, p. 4, n. 2.

[2] For the most eloquent expression of this point of view, see Paul Kristeller, *Andrea Mantegna* (tr. by S. Arthur Strong), New York, 1901, p. 355.

[3] W. G. Constable, *Mantegna and Humanism in Fifteenth Century Italy* (Wm. Carlton Lecture), Newcastle upon Tyne, 1937, pp. 27f.

[4] Tentatively suggested by Henry Thode, *Mantegna*, Bielefeld and Leipzig, 1897, pp. 103f. According to Thode, the painting represents the Kingdom of Love and Art, where love triumphs over discord and Apollo, inspired and protected by Venus, leads the Muses in the peace of Parnassus wrought by that goddess. He queries whether the painting was a promise of the joys of peace which Isabella prepared for her ever-warring husband in her Court of the Muses.

[5] Ilse Blum, *Andrea Mantegna und die Antike* (*Sammlung Heitz, Academische Abhandlungen zur Kulturgeschichte*, 3d ser., VIII), Strassburg, 1936, pp. 86ff.

[6] Kristeller, *op. cit.*, pp. 349ff.

[7] Richard Foerster, "Studien zu Mantegna und den Bildern im Studienzimmer der Isabella Gonzaga," II, *JPKS*, 22 (1901), pp. 158f., and the writers cited in nn. 11,

of Love[8] or a glorification of Apollo and the Muses, of Mercury, inventor of the syrinx, and the Muses' winged horse.[9] Nor, if a Triumph of Love, is the nature of the triumph undisputed. To one it is a joyous celebration of the triumph of Venus over Mars;[10] to another, an audacious parade of the triumph of free love;[11] to still another,[12] a facetious mockery in which Mars is a young gallant and Venus humorous, where an insolent Cupid pipes to a cuckold Vulcan and the dancing Muses make indecent gestures as they, the benevolent gods of poetry, and a grinning Pegasus celebrate the union of the god of battles and the goddess of love.

None of these interpretations is wholly satisfactory; none attempts to explain the singular cast of characters assembled in the *Parnassus*—the unique linking and juxtaposing of Mars and Venus, Amor and Vulcan, with Apollo and the Muses, or of either group with Mercury and Pegasus—as none considers the relative scale of these groups and the emphasis, in size and position, on Mercury and his winged companion. Many details or objects in the scene go unmentioned; others are misinterpreted. Hence any new attempt to understand this painting, whether to clarify its meaning or to consider its sources, must be based on a precise description of its rich detail.[13]

12, below. More recently, E. H. Gombrich, "The Interpretation of Mantegna's 'Parnassus,'" *JWarb*, 26 (1963), pp. 196–198, has suggested that Isabella's contemporaries interpreted the Homeric tale in the allegorical sense of the Roman rhetorician Heraclitus as a representation of the union of Ares (strife) and Aphrodite (love) from which Harmony is born, to the joy and gratitude of the gods. I am indebted to Robert M. Harris for calling my attention to this article.

[8] Kristeller, *loc. cit.*

[9] Foerster, *loc. cit.*

[10] Kristeller, *loc. cit.*

[11] Charles Picard, "Andrea Mantegna et l'antique," *RA*, ser. 6, 39 (1952), pp. 126f.

[12] Wind, *op. cit.*, pp. 7ff.

[13] Varnished tempera on canvas. Height 1.59 m.; width 1.92 m. See Charles Terrasse, *Musée du Louvre. Les primitifs italiens*, II, Paris, n.d., p. 29, pls. 29, 30; and Louis Hautecoeur, *Musée national du Louvre, Catalogue des peintures exposées dans les galeries*, Paris, 1926, II, p. 83, no. 1375, pl. XXI.

Comparison of figs. 1 and 62 reveals a significant difference in the dimensions, especially the height, of the painting in the two photographs. Fig. 62, taken in 1966, shows the picture in its present condition after restoration and reframing by M. Goulinat in July 1961. At that time, the strip of sky and foliage 12 cm. high at the top of the painting and, to a lesser extent, the outermost edges of its other three sides (as visible in an older photograph like fig. 1, above) were not cleaned, inasmuch as they apparently are additions to the original painting. They were therefore cov-

We are immediately attracted to the dancing maidens who occupy the center of the stage (figs. 1, 21). Nine in number, they are surely the Muses who move to the music of Apollo's lyre.[14] Three sing—the third, fourth, and ninth from the left. Barefoot and clad in billowing, classicizing garments of varied hue, they either clasp each other's hands or are linked by strands of material. For the two figures at the left and the last three at the right are

ered in the recent reframing of the picture, in order to leave only the original surface exposed.

M. Germain Bazin, Conservateur en Chef of the Service de la Restoration des Peintures of the Louvre, to whom I am greatly indebted for providing me with detailed information on this topic, reports that at some unknown period the *Parnassus* was reduced in size by being folded but not cut back. When it was subsequently enlarged, the damaged lateral edges could be restored and retained, but the original upper margin evidently had to be replaced. M. Bazin speculates, for technical reasons, that this action took place toward the end of the eighteenth century. In his opinion, the upper edge of the backdrop of foliage against which Mars and Venus stood before 1961 is required by the composition and must originally have been present, even though slightly less sky may have appeared above that backdrop than was restored. I wholly agree with this judgment and, faced with a comparison of figs. 1 and 62, can only deplore the recent decision to once again crop the picture visually in a fashion far more damaging to its aesthetic quality than the previous, conceivably slightly incorrect, restoration.

[14] In an inventory of the *studiolo* drawn up in 1542, some years after Isabella's death, the painting is described as ". . . un altro quadro di pittura . . . di mano del già M. Andrea Mantegna, nel qual è dipinto un Marte e una Venere che stano in piacere, con un Volcano et un Orpheo che sona, con nove Ninphe che balano" (see Foerster, *op. cit.*, p. 155, n. 4). This statement, the only near-contemporary characterization of the painting, has been accepted by certain modern critics as a correct identification of its cast of characters (e.g., Terrasse, *loc. cit.*; E. Tietze-Conrat, *Mantegna*, London, 1955, p. 195; Giovanni Paccagnini, *Andrea Mantegna*, Venice, 1961, pp. 64f.; *Louvre, Paris* [*Newsweek, Great Museums of the World*], New York, 1967, p. 128). Yet it is both incomplete and incorrect. The largest figures in the picture, Mercury and Pegasus, like little Amor, go unmentioned; nor is there antique or contemporary evidence that Orpheus was ever depicted with a group of dancing female figures—let alone precisely the number traditional for the Muses. But in contemporary painting, the musician Orpheus was at times represented in other correct contexts as a seated figure in itself almost indistinguishable from a comparable figure of Apollo (see, for example, the figure of Orpheus playing to appropriate wild creatures in the scene in the Farnesina mentioned below, n. 59). I suspect that this conventional similarity in type and appearance between the two legendary musicians was responsible for a blunder on the part of a careless cataloguer. In any case, however debatable the meaning of Mantegna's painting may be, the mythological identity of its *dramatis personae* is virtually certain. For reference to the complex iconography of the setting provided for these figures, see below, pp. 139ff.

united by thin streamers, one golden, fringed and fluttering, the other orange and tautly grasped.[15] Most of them appear lost in a trance of song and movement as they dance on the yellow-green sward, but two turn their heads to regard Mercury and Pegasus, and one looks forward, beyond the visible limits of the scene.

To the left of these lilting figures Apollo sits on a tree trunk, his left leg drawn up to support his gilded bronze lyre, foot poised on a rough-hewn stump (figs. 1, 17). Surrounded by fresh chips, it appears to have been chopped and pared to serve as the god's footrest, as the ground beneath the Muses' feet has been recently swept for their dance by the two brooms made of withes cut and bundled together by tight cords that lie before him (fig. 2).[16] Golden-haired and stalwart of figure, Apollo bends, singing, to his lyre, plucking it with both hands. His lean athletic figure is draped with a rosy mantle held tightly over his back by the golden band to which his lyre is attached. Like the Muses, he is lost in song, a musician absorbed in his art.

Behind Apollo and the first of the Muses laurel and quinces grow densely against the openwork of a plaited wicker fence (figs. 17, 21). Its latticed form reappears behind the last of the dancing figures, where tiny white flowers again animate the glossy green of laurel. Directly behind these laterally disposed plants a curious grotto dominates the center of the composition, at once backdrop for the Muses and pedestal for Mars and Venus, for it has been

[15] The singing Muse who appears fourth from the left is actually the leader of the group who, like the leader of a Greek folk dance, has one hand (her left) free. Her invisible right hand must grasp the left hand of the barely visible figure following her on whose raised right hand the right hand and arm of the third Muse rests. This figure, who looks toward our left, is linked with the solitary figure seen frontally by the above-mentioned fringed streamer. The latter and her neighbor to the right, as well as the next figure, who prances forward yet looks aside, hold hands. Unlike all her other companions, this prancing Muse wears a sleeved undergarment beneath the flame-colored robe that billows about her, concealing her left hand which holds the lowered left hand of her neighbor to the right. That figure, in turn, must grasp in her right hand one end of the orange fillet held by the final pair of leaping Muses.

[16] As the earth "floors" on which dancers circle today in rural Greece are swept by precisely such *skoupas*. They are mistakenly described by Wind (*op. cit.*, p. 13, followed and elaborated by E. Tietze-Conrat, "Mantegna's Parnassus. A Discussion of a Recent Interpretation," *AB*, 31 [1949], p. 129) as scourges, but correctly identified by Picard, *op. cit.*, p. 127—a correction ignored by Wind as recently as *Pagan Mysteries in the Renaissance*, 2d edn., rev. and enlarged, London, 1968, p. 146, n. 18.

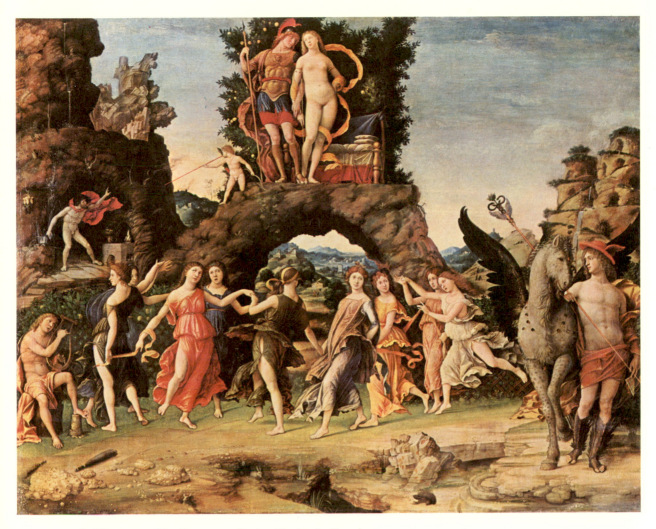

I. Mantegna, *The Parnassus*. Paris, Musée du Louvre

2. Mantegna, *The Parnassus*: detail of the foreground

artificially leveled to support these crowning figures, their couch, and foliate backdrop (fig. 21). Plants, including the shoot of a fig tree, spring from its crevices and from the vault that rises behind the Muses. Through its arched opening, distant mountains recede against a twilight sky on the far side of a lake edged by groves and buildings and animated by boats. In the middle ground of this turquoise-green monochrome landscape, tiny figures move before what appear to be houses beneath a precipitous hill surmounted by towers and ruins.

On the level surface of the grotto stand the linked figures of Mars and Venus, the culminating, the presiding figures in this scene (Pls. I, II; fig. 3). Together they form a closed unit in the pyramidal composition, their anti-thetical silhouettes in harmonious balance, inclined heads, interlaced arms, overlapping feet uniting them. Their unity is emphasized by their fluttering mantles, whose calligraphic line enframes them, and by the backdrop of dark foliage behind their luminous forms. Oranges hang in the profusion of leaves

above Mars, quinces, at his side. Still another quince tree appears to the right of Venus before the wall of myrtle that rises behind her. Occupied with each other rather than with the animated figures around them, the godly pair preside over their activity with regal detachment.

Nude save for the orange-gold bandelette wrapped about her arms and billowing about her, the brown-haired goddess wears a gold bracelet and golden armbands, one decked with two beads—one yellow, the other blue. In her right hand she holds, baton-like, a golden staff. Tipped like an arrow but knobbed at the top, it is at once arrow and scepter—fit attribute for Venus and symbol of the nature of her power.

In sharp contrast to Venus, the god at whom she gazes is fully clad. Over a scarlet tunic shot with gold he wears a deep gold cuirass from which emerge short sleeves and flaps of gold-flecked peacock-blue. His molded cuirass is equipped with loops to hold a scarlet girdle. Golden, too, are his curious scaled greaves or boots. But the helmet resting on his auburn locks is steel blue, like the tip of his scarlet spear. Scarlet plumes edged with gold crest this helmet, and the rosy-purple mantle flung over one shoulder and billowing like Venus' in ornamental rhythms at his side is again shot with gold.

Behind Mars and Venus stands a richly draped golden couch. Its pillows and covers are white fringed with gold. Beneath them falls a scarlet under-cover. Behind the couch a turquoise-blue cloth is knotted to the quince tree at Venus' right.

Adjacent to Mars and Venus, one with them, yet detached from them, an agile, auburn-haired Amor perches on the rocky slope (fig. 4). A golden baldric passes between his blue, eyed butterfly wings to support a scarlet quiver filled with arrows. In his left hand, he clasps his customary bow, but in his extended right hand he balances a singular object into which he blows with puffed-out cheeks: not a trumpet, as has been said,[17] but a hollow

[17] In particular, by Wind, *Bellini's Feast of the Gods*, pp. 10, 12, who describes Amor as piping at Vulcan "through a long, thin trumpet." But this "typical trumpet of fame" lacks the flaring terminal form requisite for the instrument, being, on the contrary, identical in shape with the traditional blowpipe, a tool that has remained unchanged in essential form for centuries. For further reference to this point, see below, pp. 155ff. Terrasse, *loc. cit.*, without defining the nature of Amor's instrument, describes him as bombarding Vulcan with pellets ("le bombarde de boulettes"). As far as I am aware, the only writer who has identified this object correctly is Gombrich, *op. cit.*, p. 197.

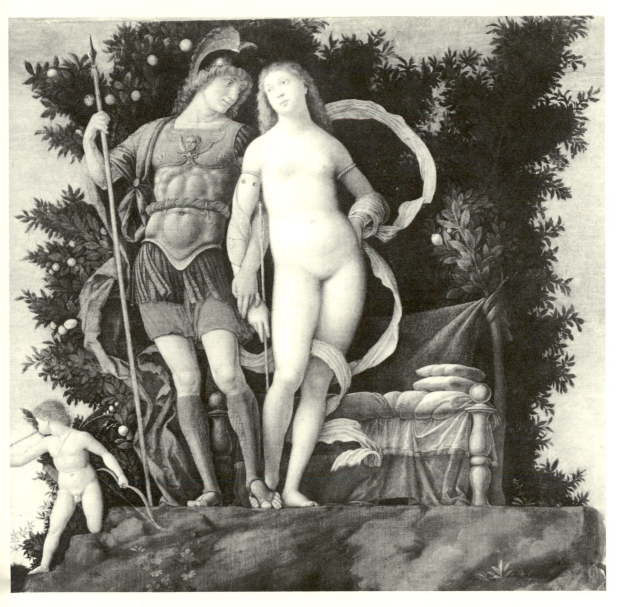

3. Mantegna, *The Parnassus*: detail of Mars, Venus, and Amor

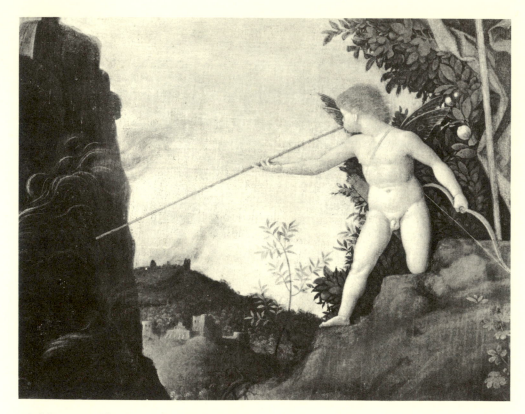

4. Mantegna, *The Parnassus*: detail of Amor

cylindrical tube—a scarlet blowpipe! From it a delicate line, originally of
gold, runs toward Vulcan.[18]

Standing at the mouth of a shadow-filled cave, the tutelary divinity of artists
and craftsmen appears in unorthodox form (fig. 5).[19] Yet the familiar at-
tributes of his trade, the metalworker's tongs, hammer, and anvil at his left,
identify him as surely as the attributes of the other gods or the number of the
Muses bespeak their identity. Seemingly, he has been making the silver jug
that stands on the forge before him. Now, attracted by Amor, he steps swiftly
to one side, raising his left hand as he looks and listens with parted lips. His

[18] Gombrich, *ibid.*, n. 9, has also noted
this normally unmentioned fact, comment-
ing that "either the artist himself or some-
body at a later date has scratched a line
which continues the direction of Cupid's
blowpipe and ends at the tip of Vulcan's
sex organ." Since this line was originally

golden and, as will be proposed below,
meaningful, it is surely part of the original
composition, not the addition of a later
hand. See below, pp. 155f.

[19] For further discussion of Vulcan's un-
usual appearance, see below, pp. 142ff.

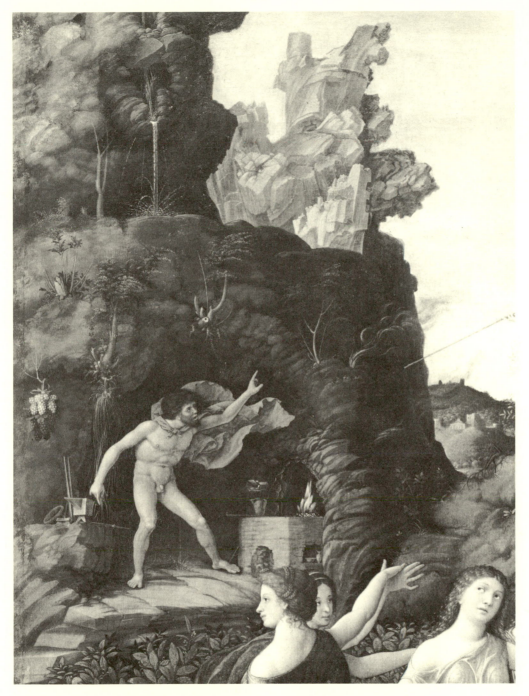

5. Mantegna, *The Parnassus*: detail of Vulcan in his cave

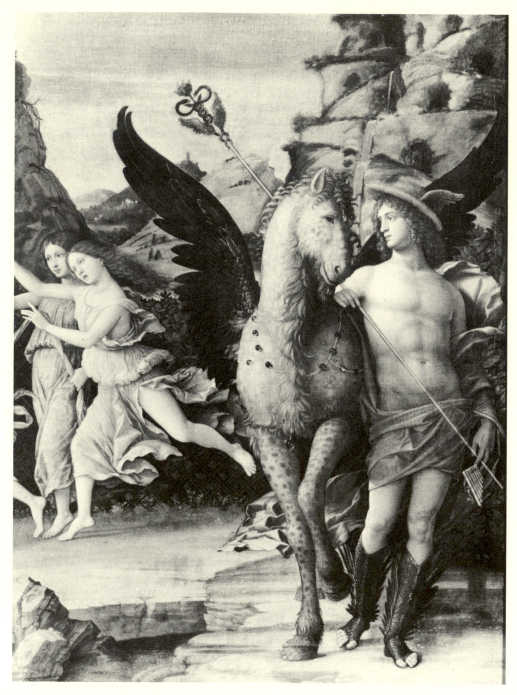

6. Mantegna, *The Parnassus*: detail of Mercury and Pegasus

powerful body is nude apart from the scarlet mantle knotted about his neck and fluttering behind him. Like his cloak, his shaggy hair is windblown. His gnarled, weatherbeaten, bearded face is gnome-like, setting him apart from the open-featured gods. Stirred by Amor, he grasps in his right hand a few of the strands of silvery, blue-gray wire which hang loosely behind him, suspended in a loop from the root of a tree growing at the mouth of the cave. At his side, a coil of similar wire lies on a rocky ledge together with his anvil, tongs, hammer, and what appear to be calipers. Other tools, one again presumably a pair of tongs, lie on or against the forge. On its top and set into a niche at its side stand samples of his handiwork: a silver jug adorned with figures in relief on the shoulder of its otherwise fluted body and two other metal vessels of antique form, a bowl and a lekythos.[20] A bronze lamp rests in a crevice above the oven, its little flame lighting the rock about it as the big golden, red, and blue flames of the fire flicker on the rocky recess at the mouth of the cave. Sooty smoke rises from this fire and issues from chinks in the rock, blown, like Vulcan's hair and mantle, in Amor's direction.

To the left of the shadow-filled cave bunches of grapes hang from a loop suspended on a root, their golden and purple clusters heavy with ripe fruit.[21] Trees and plants spring from the craggy rock at the mouth of the cave. High above, a waterfall drops from an outcropping of rock and splashes on the top of the cave, whence drops trickle through to splash again on its floor behind Vulcan's animated figure. Above and behind the cave, a strange crystalline rock formation of lavender hue adds a fantastic note to the landscape, sharpening the contrast between nature wild and tamed, for in the distance, below its jagged forms, the towers and walls of buildings crest gentler, cultivated slopes.

Diagonally across from Vulcan, the most distant and, in scale, the smallest of the figures, stands the largest figure in the painting and the one nearest the spectator—Mercury (fig. 6). Lightly poised, he rests one arm on Pegasus,

[20] It is difficult to determine the character of the metals used in these vessels. That they are metallic is, I believe, reasonably certain. The lavender hue of the jug suggests that it is silver, the ruddier tone of the bowl and lekythos that they are bronze.

[21] Not, as Wind would have it, ignoring their diversity of color, "a cluster, suitably colored, of sour grapes" (*Bellini's Feast of the Gods*, p. 10; reiterated on p. 229 of the reply to a review cited below, n. 84). Very likely this variety of vine reflects the simple fact stated by Pliny, *Naturalis historia* 14.3.15, that "grapes that are merely white and black are the common sorts."

turning to regard the beast as the Winged Horse turns his head toward him. Together they form a compact group, as mutually absorbed, as detached from the active figures behind them, as are Mars and Venus. The turn of their heads, their antithetical outer contours and ponderation, and the dance-like positions occupied by their balanced feet and legs cause them to adhere to each other in a closed compositional unit—to form a group whose unity is emphasized and expressed by Pegasus' calligraphic wings, those deep blue-green wings edged with gold that have been opened up to form a kind of backdrop to the pair and further isolate them from the rest of the scene.

Over his thick brown curls Mercury wears an orange-red winged petasos made of gold-flecked feathers. The mantle wrapped about his body that billows over his shoulder and floats under Pegasus is also orange, highlighted with gold. But his boots are blue-green. High yet open-toed, these singular boots are clasped with coils of gold, covered with gold-shot scales, and equipped with a pair of blue-green wings composed of gold-edged feathers. In his right hand and passing through his left, the god holds a strange variety of his customary caduceus. From its abnormally elongated, winged, orange staff a sprig of leaves grows,[22] entwined by the bodies of two hissing brown snakes. Dangling from the lower end of the shaft is his syrinx, held there by the scarlet band that ties together its reeds.[23]

No member of the *Parnassus'* cast of characters is more remarkable than the Winged Horse. Basically, he is the protome of a horse rather than a horse, since apart from a suggestion of his right rear hoof, his hindquarters remain invisible. Dappled and gray, his mane and forelocks and the shaggy beard that outlines his small head and grows down his neck and chest, like the scales on his hooves, are touched with gold. Over his body he wears a kind of harness composed of clear beads—red, blue, green, and yellow in color—connected by golden links. A solitary red bead hangs, pendant-like, from the central corkscrew curl over his brow, drawing attention to his shy glance directed not at Mercury but outward, toward the spectator.

[22] The surface of the upper parts of the four upper leaves of this unnatural looking sprig (laurel? lotus?) is ill preserved; hence they appear to be lighter in tone than the remainder of the deep green stalk.

[23] Thus, the pipes do not hang limply from the hand, as their juxtaposition to it might at first glance suggest. Only the long staff of the caduceus is lightly stayed by its fingers.

Immediately behind Mercury, the gray-green foliage of laurel is again present. Above him rises a terraced, double-turreted hillside bordered with trees and shrubs whence yet another waterfall drops in sparkling cascades. Beyond it, lower conical hills, one covered with dense forests from which castles seem to emerge, recede into the distance to form part of the broad, lake-indented landscape visible through the grotto.

In the foreground, near Pegasus' hooves, the blue waters of a spring flow beneath a rocky ledge (figs. 1, 2, 6, 7). Curious crystalline rocks, sandy or gray with intrusions of amber, jut up, pebbles and shelly porous rocks lie strewn on the ground, and plants and grasses spring up along the animated contours edging the clear water. They grow in and around hollows in the irregular terrain, affording nourishment to the hares whose tense presences enliven the immediate foreground. One squats, beady-eyed and watchful, at the opening of a little lair, his mouth full of tender plants; the gray hindquarters of a second are visible behind him in the cool shadow of the den; a third emerges from another hollow, wide-eyed and startled, his mouth open expectantly. To their right, a fourth creature pauses, eying the spectator warily

7. Mantegna, *The Parnassus*: detail of the foreground

8. Mantegna, *The Parnassus*: detail of the foreground

(fig. 8)—not a porcupine, as it has been called,[24] but a taupe-colored squirrel crouching beneath a huge, bushy tail, the very embodiment of his ancient

[24] For example, by Wind, *Bellini's Feast of the Gods*, p. 13, who makes much of the presumed juxtaposition of *the* rabbit and porcupine, symbols of fertility and military attack, as demonstrations of the "union of contraries—that great commonplace of Renaissance thought"! In his review of Wind's book in the *Magazine of Art* (4), 1949, p. 150, Creighton Gilbert has also pointed out that Wind's "porcupine" is actually a squirrel—a correction that the author noted but refused to accept in his rebuttal of another review in *AB*, 31 (1949), p. 230. Professor Wind passes over the almost exaggerated degree to which Mantegna's squirrel is an illustration of the animal's ancient name. For refu-

tation of his statement about the appearance of Italian as opposed to North American squirrels, see the article "Squirrel" in *The Encyclopaedia Brittanica*, 11th edn., New York, 1911, XXV, p. 748, where the light-red squirrels of northern and western Europe are contrasted with their darker gray relatives in southern Europe, with the further comment that specimens in certain regions not only change in color seasonally but also differ so much in color that they might be "distinct races."

I assume that Picard's puzzling allusion to a rabbit and a toad in the foreground of the picture is another misinterpretation of the creatures actually depicted (*op. cit.*, p. 127).

name, σκίουρος, shadow-tail.[25] Part of an idyllic vignette of nature, these animals go unobserved by any of the figures around them, at once united with the setting visually and curiously independent of their context.

EASY TO identify as single figures, if difficult to interpret collectively, the members of this cast of characters afford graphic illustration of Mantegna's use of what he believed to be genuine antique models in depicting an antique scene. His effort to base his visual reconstructions of a vanished world known to him only through random fragments on authentic prototypes—to provide an archaeologically correct setting for correctly costumed figures in painting an antique subject—is already apparent in his early frescoes in the Chapel of the Eremitani in Padua.[26] In this late work, a painting as lyrical in mood as the Paduan frescoes are somber, his vision of the past reflects half a century's fascination with ancient works of art, particularly of sculpture, and the constant association with learned students of antiquity that made him a scholar and connoisseur among artists.[27] Renewed investigation of the individual figures in the *Parnassus*, further search for the specific models that lie behind them,[28] will reveal the degree to which Mantegna revised the traditional iconographic types customarily used for such figures in his day and clarify the meaning of the scene.

Among the suggestions that have been made regarding the specific monumental sources on which Mantegna drew in shaping his figures in the *Parnassus*, one is wholly convincing: the proposal that his Venus was derived from a representation of that goddess on a Roman sarcophagus showing the Judgment of Paris.[29] Sadly weathered and defaced by faulty restoration, its front is today walled into the façade of the Casino of the Villa Pamfili in Rome

[25] For further reference to this point, see below, p. 168.

[26] See, in particular, Paul D. Knabenshue, "Ancient and Mediaeval Elements in Mantegna's Trial of St. James," *AB*, 41 (1959), pp. 59–73.

[27] For specific reference to these associations and for Mantegna's activity as a collector and connoisseur of antiquities, see below, pp. 110f, 177f.

[28] The most extensive previous attempt to identify the antique models used for these figures is that of Ilse Blum, cited in n. 5, above. Her specific proposals, as well as those of such later writers as Wind and Picard, will be found at relevant points in the following pages.

[29] Proposed by Ilse Blum, *op. cit.*, pp. 103f.

(fig. 9).[30] But in the late fifteenth century it was located in the Church of Sta. Maria in Monterone, not far from the Palazzo Valle-Capranica, where it was seen and drawn by the anonymous artist who recorded it in the Codex Escurialensis (fig. 10).[31] There, too, as in the *Parnassus,* Venus appears as a nude figure, holding a now undecipherable baton-like object in one hand, about whom drapery billows in ornamental fashion (cf. figs. 9, 11). Rising from her right arm to form an arc behind her head and shoulders and seemingly wrapped around her left forearm, as on Mantegna's figure, her mantle falls at her left side. This motif, rare in ancient representations of the goddess, reappears on Mantegna's Venus, if in modified form. Less a functional garment than a decorative streamer, its calligraphic potentialities have been enormously exploited. Yet the linear quality of its pattern, coupled with the contours of Mars' cloak and the backdrop of foliage behind the group, creates an effect suggestive of relief rather than of three-dimensional form. As is so often the case when a Renaissance artist has worked from an ancient model, Mantegna has reversed the stance of the figure, as he has turned her head inward and transferred her attribute from one hand to the other—for obvious compositional purposes, given the necessity of uniting Venus with Mars. He has, nonetheless, preserved the proportions and emphases of his model, in particular, the sharp contrast between the relaxed and the weight-bearing leg and the latter's prominent curving thigh—characteristics that recur, incidentally, in two of the three nymphs at the left of the sarcophagus, one of whom rests a hand on her thigh, as does Mantegna's figure.[32]

[30] See Carl Robert, *Die antiken Sarkophag-Reliefs*, II, Berlin, 1890, pp. 11ff., no. 10, and the references cited in n. 31, below, for description and discussion of this once-famous sarcophagus and earlier bibliography on it. The awkward urn to the right of Venus is an incorrect replacement for the *amorino* originally present at this point.

[31] On fol. 8v. See Hermann Egger, *Codex Escurialensis* (Sonderschriften des oesterreichischen archaeologischen Institutes in Wien, IV), Vienna, 1906, pp. 63f., and Christian Hülsen, *Das Skizzenbuch des Giovannantonio Dosio im staatlichen Kupferstichkabinett zu Berlin*, Berlin, 1933, p. 6, for discussion of this drawing (unknown to

Robert), made ca. 1490, and other later artists' drawings of this sarcophagus.

For Sta. Maria in Monterone, see M. Armellini, *Le Chiese di Roma del secolo IV al XIX*, rev. edn., Rome, 1942, I, p. 553; II, p. 1365.

[32] According to Robert, *loc. cit.*, the relevant right arm of this figure is a later restoration. But judging by the drawing in the Codex Escurialensis, the earliest representation of the sarcophagus, which antedates its restoration, the position of this arm has been correctly restored. Conceivably, traces on the hip indicate the proper position. The inaccessibility of the sarcophagus at the present time precludes investigation of it. For the sides of this dis-

In drawing on this sarcophagus for his Venus, Mantegna anticipated its popularity in the sixteenth century, especially in the circle of Raphael.[33] Nor is this the only instance in the *Parnassus* in which the two painters drew on the same, evidently much admired sources, as will become clear.

The specific source of Mantegna's Mars is less readily found; indeed it is doubtful that any single monumental source lies behind it. Groups of Mars and Venus in which a nude Venus appears to the right of Mars do occur on ancient monuments. One such appears on a ceiling in the Golden House of Nero, where the goddess, her drapery billowing over her like a sail, floats beside a Mars nude save for his helmet, shield, spear, and cloak.[34] Another, an Imperial coin type, shows a descendant of the Knidian Aphrodite beside an armed Mars who rests his right hand on a spear, his left on a shield.[35] Neither of these images is sufficiently close to Mantegna's group to be associated with it, although some such iconographic type may have been known to him and suggested its basic scheme.[36]

membered sarcophagus, see Bernard Ashmole, *A Catalogue of the Ancient Marbles at Ince Blundell Hall*, Oxford, 1929, p. 97, nos. 262, 263, where it is dated in the third century A.D.

[33] For other quotations from this sarcophagus in works by Marcantonio and Agostino Veneziano, cf. Carl von Pulszky, *Beiträge zu Raphael's Studium der Antike*, Leipzig, 1877, pp. 24f.; Henry Thode, *Die antiken in den stichen Marcanton's, Agostino Veneziano's und Marco Dente's*, Leipzig, 1881, pp. 24f., 34; Emanuele Löwy, "Di alcune composizioni di Raffaello ispirate a monumenti antichi," *Archivio storico dell' arte*, 2d ser., 2 (1896), pp. 241ff.; Robert, *loc. cit.*; and Hülsen, *loc. cit.* It also evidently provided the model for Jacopo Francia's *Venus and Cupid* and a figure of Prudence by Master IB with Bird: cf. A. M. Hind, *Early Italian Engraving* (London, 1938, Pt. I, Vols. I–IV; 1948, Pt. II, Vols. V–VII), VII, pls. 822, 843, fig. 13.

[34] On the vault of Room 17. Cf. N. Ponce, *Descriptions des bains de Titus*, Paris, 1786, pl. XXXII; Salomon Reinach, *Répertoire de peintures grecques et ro-*

maines, Paris, 1922, p. 66, no. 8. A similar group appears on the vault of Room 16: Ponce, *op. cit.*, pl. XXIV.

[35] A bronze coin of Amaseia Ponti struck under Lucius Verus. Cf. Max Bernhart, *Aphrodite auf griechischen Münzen*, Munich, 1936, pl. 7, no. 269.

Mars also appears as an independent figure wearing cuirass, crested helmet, and chlamys and with similar weapons on the reverse of a sestercius of Marcus Aurelius: *idem*, *Handbuch der Münzkunde der römischen Kaiserzeit*, Halle, 1926, II, pl. 38, no. 7; and Harold Mattingly, *Coins of the Roman Empire in the British Museum*, IV, London, 1940, nos. 1088ff. and pls. 76, 5; 83, 5.

[36] The use of coins in the circle of Mantegna's teacher, Jacopo Bellini, is too well known to require elaboration. For good examples, see Victor Golubew, *Die Skizzenbücher Jacopo Bellinis*, pt. II, Brussels, 1908, pls. XXII (Paris sketchbook, fol. 23r), XXVII (fol. 28r), XL (fol. 41r), XLIIII (fol. 44r), and C. For comment on Mantegna's own use of coin types, see Knabenshue, *op. cit.*, pp. 67ff.

9. Relief from a Roman sarcophagus: the Judgment of Paris.
Rome, Casino of the Villa Pamfili

10. Codex Escurialensis, fol. 8v, after Hermann Egger

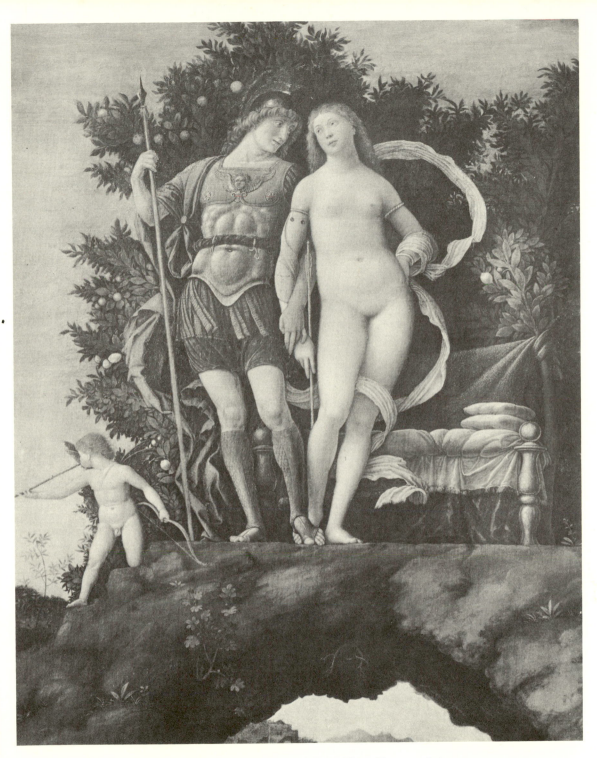

11. Mantegna, *The Parnassus*: detail of Mars, Venus, and Amor

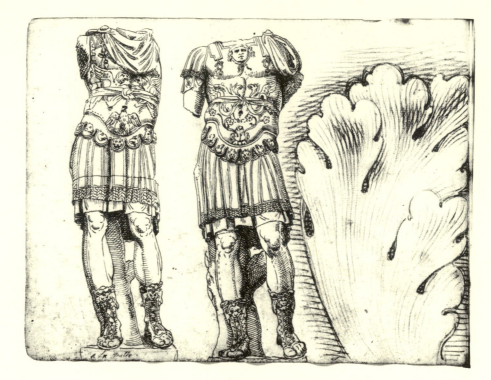

12. Roman cuirass statues, drawn by Pierre Jacques.
Bibliothèque Nationale, Paris

Far closer to the painter's Mars is a figure of the god that once adorned one of the frescoed vaults of Hadrian's Villa at Tivoli.[37] Clad in a square-necked cuirass and short chiton and wearing a plumed helmet and high, open-toed boots, he holds a spear in his right hand, which also appears to grasp a mantle falling at his side in undulating folds. Were it not that this painting was seemingly discovered long after Mantegna's lifetime, it would be tempting to assume that it provided the primary source for his Mars.[38] It is entirely

[37] See Salvatore Aurigemma, *Villa Adriana*, Rome, 1961, pp. 182, 185, and Reinach, *op. cit.*, p. 58, no. 5, after Pierre Gusman, *La villa impériale de Tibur*, Paris, 1904, p. 217, in turn based on Agostino Penna, *Viaggio pittorico della Villa Adriana*, IV, Rome, 1836, pl. CXXXIX.

[38] According to Aurigemma, *op. cit.*, p. 185, the painting was discovered in the last years of the eighteenth century. Yet knowledge of the Villa itself is documented at least as early as Cyriacus of Ancona's visit to it in 1432, reported by Scalamonti in Giuseppe Colucci, *Delle antichità pi-*

possible that another similar figure, like it lost today, served as the painter's model. In either case, he has drawn on still another antique source in shaping his Mars, as examination of his cuirass reveals. For in spite of their generic similarity, the two cuirasses differ in significant details, in particular, in the absence on the Roman armor of the *putto*-like gorgoneion, the delicate scroll-work, the flaring V-shaped termination directly above the long, narrow flaps of Mantegna's cuirass, and the scarlet girdle clasped to it. The former elements are more closely related to representations of armor in Florentine engraving of ca. 1460–1470[39] than to any ancient cuirass, Greek or Roman, but the latter is evidently a form of *cingulum* or military sash, a feature of innumerable Roman cuirassed figures such, for example, as the pair drawn by Pierre Jacques (fig. 12).[40]

These very features recur on a second cuirass painted by Mantegna a few years before he delivered the *Parnassus* to Isabella. Among the rich booty exhibited in Panel VI of the *Triumph of Caesar*,[41] completed for Gian Francesco in 1494, is a cuirass borne as a kind of *tropaion* beneath a helmet so similar to Mars' cuirass as to suggest that both derive from a common prototype (cf. figs. 11, 13)—some object known to the painter, whether directly or indirectly, which afforded a reliable representation of a Roman cuirass. Although the captured cuirass is more correct in detail (lacking the Quattrocento ornament on Mars' cuirass, for example, and showing the shoulder clasps normally present on such a cuirass), its basic form is identical and it,

cene, XV, Fermo, 1792, p. LXXXIX. See also Pius II's well-known description of it in 1461: for an easily accessible reference, see *Memoirs of a Renaissance Pope, The Commentaries of Pius II*, tr. and ed. by Florence A. Gragg and Leona C. Gabel, New York, 1959, p. 193. One may wonder to what extent portions of the Villa later reported as discovered were actually known or accessible at a much earlier date.

[39] For example, on figures in Hind, *op. cit.*, II, pls. 4, 25, 101. Knabenshue, *op. cit.*, p. 69, has pointed to a similar connection with contemporary engraving in

discussing the ornamental features of the cuirasses worn by the guards in the *Trial of St. James*.

[40] Salomon Reinach, *L'album de Pierre Jacques*, Paris, 1902, p. 116 and pl. 12 bis. For other examples of this type of armor, see Cornelius C. Vermeule, "Hellenistic and Roman Cuirassed Statues," *Berytus*, 13 (1959), pp. 1–82, pls. I–XXVI, passim.

[41] C. H. Collins Baker, *Catalogue of the Pictures at Hampton Court*, Glasgow, 1929, pp. 101ff., Inv. 873–881. No. 797 = Panel VI, the so-called Corselet Bearers.

13. Mantegna, *The Triumph of Caesar*: Panel VI. Hampton Court Palace

14. Roman capital. Rome, Tabularium

too, is adorned with the same winged *putto* in place of the standard classical gorgoneion and the same unantique girdle.[42]

In all probability, the model for this pair of cuirasses, one mounted as a *tropaion*, was an antique representation of such a trophy, whether on a figural capital or on a pier or pilaster decorated with a still life of armor—a representation so weathered or damaged as to be unclear in detail. If this hypothetical model was some such capital as the one found in Rome in the sixteenth century that was later drawn by G. B. Piranesi and is now in the garden of the Antiquarium Comunale (fig. 14),[43] the peculiarities of Mars' armor, helmet, cuirass, and greaves alike would be understandable. On this Flavian example, decorated similarly on all four faces, cuirass and helmet are

[42] Both types, the gorgoneion and the winged *putto*, also occur in the Roman portraits on the ceiling of the Camera degli Sposi: e.g., the former on the medallion of Julius Caesar, the latter on that of Octavianus. Cf. Tietze-Conrat, *Mantegna*, pls. 92, 94.

Longinus wears a cuirass and boots similar to those of Mars in Mantegna's engrav-

ing of the *Risen Christ between St. Andrew and Longinus*, another late work. See Hind, *op. cit.*, V, p. 16; VI, pl. 496.

[43] See Eugen von Mercklin, "Zwei Bruchstücke eines Trophäenkapitells im Tabularium zu Rom," *RM*, 42 (1927), pp. 193ff.; and *idem, Antike Figuralkapitalle*, Berlin, 1962, no. 625, p. 263, figs. 1216–1220.

mounted on a cross-shaped pole like the one carried in Panel VI of the *Triumph* and flanked in orthodox fashion by shields and weapons. Both the gorgoneion and the knotted military sash are so worn as to be little more than a round-faced winged head and a horizontal band held, to the left and right of the simulated navel, in some kind of loop-like attachment. Confronted with such a model, Mantegna could well have deduced his *putto*-masks and clasped girdles, and if, as seems likely, the helmet on his model was equally damaged, he would have been forced to devise his own helmet, as the customary absence of greaves or boots on trophies obliged him to invent his essentially unantique boots.[44]

That the painter was familiar with such antique representations can be established beyond question, for in the scene depicting *St. James on His Way to Execution Healing a Lame Man* in the Chapel of the Eremitani one of the pilasters of the vaulted structure in the background is decorated with a *tropaion* carved in low relief, this time equipped with flanking shields (fig. 15).[45] Nor is it surprising that he retained his early interest in military costume in view of the fact that his ducal patron, Gian Francesco, is reported to have had the richest *armeria* in Italy[46] and of the iconographic requirements of the *Triumph of Caesar* commissioned by that same patron. Thus, in their differing ways, the figures of Mars and Venus reveal the care with which Mantegna strove to create correct classical images by drawing, in so far as possible, on authentic monumental sources.[47]

[44] As Raphael, drawing on another damaged Roman monument to document the appearance of the instruments held by Apollo, Sappho, and the Muses in his *Parnassus*, made precisely analogous errors of interpretation and reconstruction in attempting to understand the broken forms of his model. For this case, see the splendid article by Emanuele Winternitz, "Archeologia musicale del Rinascimento nel Parnaso di Raffaello," *Rendiconti della Pontificia Accademia Romana di Archeologia*, 27 (1952–1954), pp. 359ff.

For Mantegna's use of more authentic open-toed boots for his military figures, see below, p. 125, fig. 39. It is amusing to note that the artists who recorded the painting of Mars in Hadrian's Villa also drew un-antique boots, very likely because their model, too, was hard to decipher.

[45] Tietze-Conrat, *Mantegna*, pl. 18. A Roman coin on which Germania Capta sits beneath a similar *tropaion* occurs among the miscellaneous antiquities on fol. 44r of Jacopo Bellini's Paris sketchbook, where the inscription repeated by Mantegna in *St. James before Herod Agrippa* also occurs: Golubew, *op. cit.*, pl. XLIII.

[46] Kristeller, *op. cit.*, p. 347.

[47] Far from representing Mars, as Wind would have it, *Bellini's Feast of the Gods*, p. 10, "as a young gallant" and providing Venus with "the humorous expression of φιλομειδῆς Ἀφροδίτη, 'the laughter-loving Venus.'"

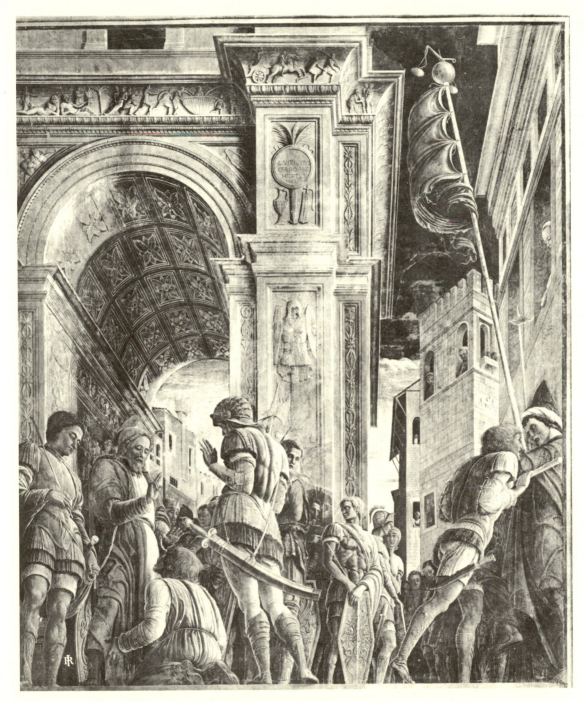

15. Mantegna, *St. James on His Way to Execution Healing a Lame Man.*
Padua, Chapel of the Eremitani

It is tempting to think that another sarcophagus, the front of which was later walled into the Casino of the Villa Pamfili, was known to Mantegna and provided the model for his Amor as it seems to have influenced his group of Mercury and Pegasus.[48] Documented as early as the mid-sixteenth century and, like the Judgment of Paris sarcophagus, recorded in later sketchbooks, it may well have been visible in the previous century.[49] Its three decorated sides showed scenes from the life of Bellerophon. It is, in fact, the only sarcophagus known from Italy on which this legend is represented. On the main side, the hero's departure from Proetus and Stheneboea appears at the right, his fight with the Chimaera at the left (fig. 16 A, B). In the former scene, two Erotes once flanked the figure of the seated queen. The partly preserved if now damaged one at the left was once similar to Mantegna's Amor in posture, type, and proportions (cf. figs. 4, 16 B). Like the painted figure, this curly-haired, plump-faced child was equipped with small wings and wore a baldric slung over one shoulder. Again, only the tip of his quiver was visible and again he held an attribute in at least one of his outstretched hands. Now missing, it must have been a bow, given the presence of the quiver. Turning his head backward to regard the unhappy queen, he strode forward, his right leg and raised right arm thrust before him, his bare left leg half concealed by her extended draped limbs. Hence, the lower part of his leg, like that of the kneeling Amor, was invisible. This singular feature of both figures makes it likely that Mantegna knew and adopted this sculptural prototype and, re-motivating the disappearance of one leg, converted it into his agile, kneeling figure.[50] If so, he has once again reversed the turn of his model's head to adjust his figure to the demands, the content, of his own composition, as he has slightly altered the position of the left arm and reversed the direction of the baldric.

[48] Discussed below, pp. 116ff.

[49] See Robert, *op. cit.*, III, pt. 1, Berlin, 1897, pp. 44ff., pls. VIII, IX, for this inaccessible, now badly damaged and crudely restored sarcophagus.

[50] Erotes who kneel on one leg and thrust the other to one side occur in the compressed fields on sarcophagus lids, for example, on the Alcestis sarcophagus at St. Aignan illustrated on pl. VI of the same volume. They are the only other antique representations of Venus' child analogous to Mantegna's Amor. But in view of the exceptional coincidence of form between the latter and the Villa Pamfili Eros, it is unlikely that any of them served as its prototype.

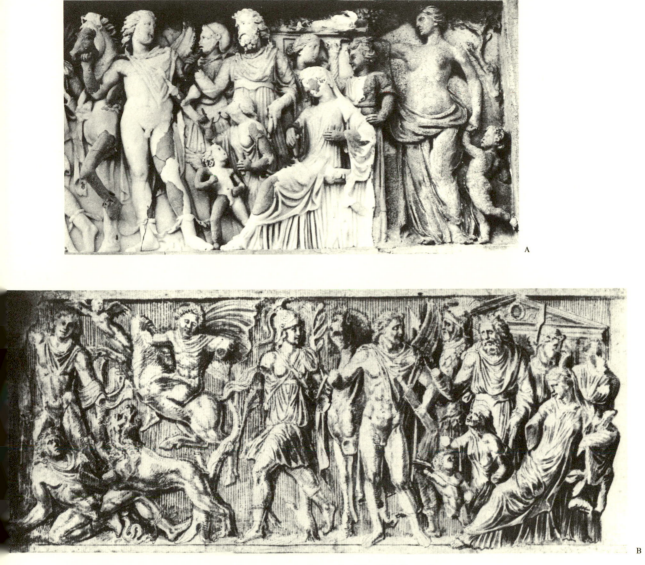

16. A. Relief from a Roman sarcophagus: scenes from the life of Bellerophon.
Rome, Casino of the Villa Pamfili. B. Fig. 16 A before restoration.
Codex Coburgensis, fol. 56, no. 229

Turning from this crowning group, let us consider the figures beneath them —first of all, that of Apollo (fig. 17). It has been suggested that it derives from the Grimani Apollo, a *standing* figure, because it sits in "so uncertain,

17. Mantegna, *The Parnassus*: detail of Apollo, Vulcan, and Muses

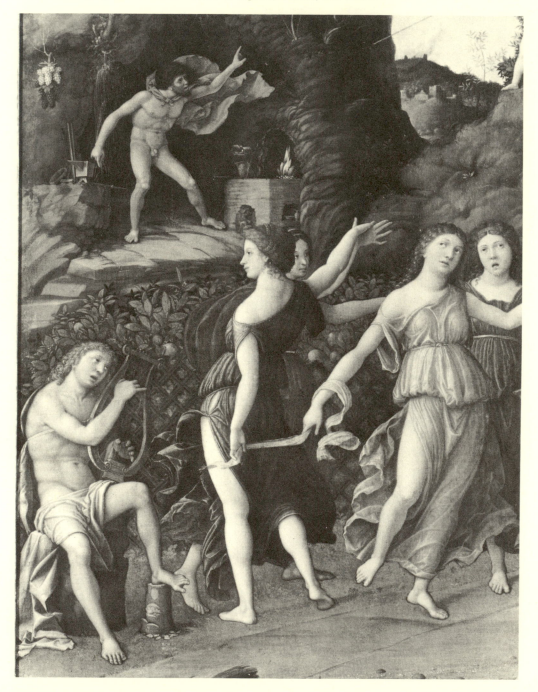

almost sliding a position" that its prototype was probably a standing figure![51] Few will accept this unlikely proposal or agree with this description of Mantegna's Apollo. Its author has, however, very properly noted the striking similarity between this seated musician and another seated Apollo—a figure on the ceiling of the Stanza della Segnatura[52] often attributed to Raphael (fig. 18).[53]

[51] Blum, *op. cit.*, p. 104, followed by Kathi Meyer-Baer, "Musical Iconography in Raphael's Parnassus," *The Journal of Aesthetics and Art Criticism*, 8 (1949), p. 94.

[52] Blum, *loc. cit.* The author assumes, therefore, that both these seated figures are dependent on the standing Apollo Grimani and that they illustrate the manner in which Renaissance artists reformulated an antique prototype, in this instance, in some mysterious fashion it seems, altering it in the very same way—an unconvincing explanation. Obviously, the two figures are so similar in type because they reflect a common prototype, another seated figure. But they differ from each other markedly in pictorial style and are the more interesting in revealing the differences in style between Mantegna and his Cinquecento successor.

[53] For example, in the past by Carl von Pulszky, *op. cit.* (above, n. 33), p. 37; more recently, by Oskar Fischel, *Raphael* (tr. by Bernard Rackham), London, 1948, I, pp. 74f.; S. J. Freedberg, *Painting of the*

18. Raphael, ceiling of the Stanza della Segnatura: detail of Apollo and Marsyas. Rome, The Vatican

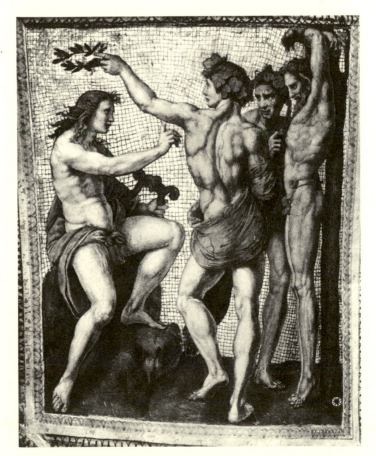

In both paintings, the god is long-haired and nude save for the mantle draped loosely about his body. In each case, this mantle is worn over the left arm and shoulder, falls across the back, is drawn over the thigh, and hangs between the legs. Each figure is shown more or less in profile, his left leg drawn up and resting on a support, his right relaxed. Each holds a lyre. Each left hand is partly visible, each right arm extended before the figure. To be sure, Mantegna's Apollo plays his lyre while Raphael's god is otherwise occupied, gesticulating with his right arm as he clasps the lyre, attribute-like, in his left, and one sits on a tree stump, the other on a rocky ledge. But clearly they depend on a common prototype, a prototype slightly altered to adjust it to differing actions in the two scenes, yet transparently visible beneath the differing pictorial forms of the two masters, one firm and minute, the other powerful and free.

It has long been recognized that Raphael's panel is dependent on a Marsyas sarcophagus,[54] one of the numerous representations of that group on which the musical contest between Apollo and Marsyas and the latter's defeat and terrible punishment are shown.[55] Both thematically and formally, his composition reflects this category of monument on which the punishment of Marsyas frequently appears at the right end of the front relief and the defeated satyr is represented at its very extremity, a bearded nude figure tied to a tree trunk by arms bent painfully over his head, in the presence of the Scythian knife-grinder who will torture him (as, for example, in figs. 19, 20). In the earlier scene of the contest, Marsyas appears as a standing figure, his divine opponent as a seated figure of appropriately heroic size, now shown frontally, now in profile. Long-haired and nude except for the mantle worn over his left shoulder and back and looped about his thighs to fall between his legs,

High Renaissance in Rome and Florence, Cambridge, 1961, pp. 112ff.; and Luitpold Dussler, *Raffael, Kritisches Verzeichnis der Gemälde, Wandbilder und Bildteppiche*, Munich, 1966, p. 80, among others.

Attributed to Peruzzi by Georg Gombosi, "Sodomas und Peruzzis Anteil an den Deckenmalereien der Stanza della Segnatura," *Jahrbuch für Kunstwissenschaft*, 1930, pp. 19ff. Gombosi's argument, in so far as it applies to this particular panel, is not persuasive. If, as he assumed, the scene was primarily derived from an ancient sarcophagus, its supposedly sculptural, relief-like effect is scarcely a reason for assigning it to one artist rather than the other.

[54] See, for example, Edgar Wind, *Pagan Mysteries in the Renaissance*, pp. 171f.

[55] Cf. the various examples discussed by Robert, *op. cit.*, III, pt. 2, Berlin, 1904, pp. 242ff., especially 249ff., pls. LXV–LXVIII.

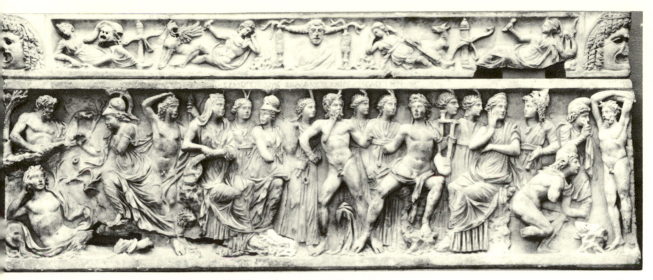

19. Roman sarcophagus from Sidon: Contest of Apollo and Marsyas.
Copenhagen, Ny Carlsberg Glyptotek

20. Lost Roman sarcophagus: Contest of Apollo and Marsyas.
Codex Coburgensis, fol. 163, no. 156

he sits on a rocky support, his bent left leg drawn back and resting on a projecting ledge, his right thrust forward. His almost invisible left arm holds his lyre, his extended right his plectrum.

Among all the figures of Apollo known or extant on such monuments, the one closest to Mantegna's and Raphael's figures in type and posture occurs on an early Severan sarcophagus in the Ny Carlsberg Glyptotek (fig. 19).[56]

[56] *Ibid.*, no. 208, pp. 260–263, pl. LXVIII. See also Frederick Poulsen, *Catalogue of Ancient Sculpture in the Ny Carlsberg Glyptotek*, Copenhagen, 1951, no. 782, pp. 549ff., and Franz Cumont, *Recherches sur le symbolisme funéraire des romains* (Bibliothèque archéologique et historique, 35), Paris, 1942, pp. 316ff.

Like Raphael's Apollo, he sits on a narrow crag, his left leg resting on a projecting ledge; his lyre, like that of Mantegna's Apollo, is fully visible. Since both painters have evidently slightly altered their common prototype in adjusting it to the contexts of their scenes, one might be willing to overlook the only significant difference between the three figures—the fact that the sculptured one is shown frontally, the painted ones in profile—and suggest that it was this very sarcophagus that served as the painters' model were it not for the insurmountable obstacle that it was discovered in the vicinity of Sidon in 1886.

The true model for these figures must have occurred on a sarcophagus which, like other examples from this group once recorded, has disappeared.[57] Presumably the figure of Apollo and possibly, too, the defeated Marsyas appeared in profile on this lost monument as they do in other instances (cf. fig. 20).[58] Such is the implication of Mantegna's Apollo and Raphael's panel. Once again, a sarcophagus later popular in the circle of Raphael[59] seems to have been quoted in the *Parnassus*. Like the models proposed for the figures of Mars, Venus, and Amor, it may well have been located in or near Rome in the late fifteenth century.

The Muses who dance and sing to the music of Apollo's lyre (fig. 21) present a more difficult problem. Clad in radiant garments ranging from azure to royal blue, from gold to orange, now green, now rose, now gleaming white, some wear golden girdles, a few gold or turquoise headbands. Given their

[57] Cf., Robert, *op. cit.*, no. 200, pp. 249f., pl. LXV; no. 208¹, p. 263.

[58] Cf. *ibid.*, nos. 200, 205, 211, pp. 249ff., 257f., 265f., pls. LXV, LXVII, LXIX. These examples, in other respects much less close to the painted figures than the Apollo of the sarcophagus from Sidon, cannot have served as the model for them.

[59] A variation on the same figure seems to recur in Peruzzi's panel of Orpheus and Eurydice in the Villa Farnesina: F. Hermanin, *La Farnesina*, Bergamo, 1927, pl. XXX.

Gombosi (*op. cit.*, p. 20) suggested that the third prominent figure in the Segnatura panel, the youth crowning Apollo, was probably also dependent on an antique statuary type. I agree with him in principle, although I do not accept his specific proposal. On the contrary, the analogy between this youth and the fragmentary figure, also seen from the back, in the left niche in the courtyard of the Casa Sassi, as recorded by Marten van Heemskerck, is so great as to make it highly probable that this statue served as the model for the painted figure. See Christian Hülsen and Hermann Egger, *Die römischen Skizzenbücher von Marten van Heemskerck* (Berlin, I, 1913, II, 1916), I, pp. 42ff. and pl. 81.

21. Mantegna, *The Parnassus*: detail of the Muses

action, they naturally lack the individual attributes or features commonly associated with them in antiquity as, for example, on the well-known relief in the British Museum which represents the *Apotheosis of Homer* (fig. 22),[60] where they appear in their customary antique fashion as essentially static figures. For although the choir of Muses sing to Apollo's lyre—and even dance—throughout ancient literature,[61] seemingly, no extant monument shows

[60] No. 2191. See A. H. Smith, *A Catalogue of Sculpture in the Department of Greek and Roman Antiquities*, British Museum, III, London, 1904, pp. 244ff.; Gisela M. A. Richter, *The Portraits of the Greeks*, London, 1965, I, p. 54; and, especially, Doris Pinkwart, "Das Relief des Archelaos von Priene," *Antike Plastik*, 4 (1965), pp. 55–65, pls. 28–35.

[61] For random examples, see the Homeric Hymns to Pythian Apollo and to Artemis (3.189ff.; 27.13ff.): *Hesiod, The Homeric Hymns, and Homerica*, ed. by Hugh G. Evelyn-White, Loeb edn., London and Cambridge, 1936, pp. 338, 452; and Pausanias 5.18.4. For classification of ancient representations of the Muses, see Oscar Bie, *Die Musen in der antiken Kunst*, Berlin, 1887.

22. Late Hellenistic relief:
The Apotheosis of Homer.
London, British Museum

them, like the ecstatic followers of Dionysos, engaged in this activity. Mantegna was certainly familiar with this static tradition, since on the so-called *tarocchi*, those North Italian prints or playing cards once popularly attributed to him, the Muses appear as single figures, each provided with an appropriate attribute (as in fig. 23).[62]

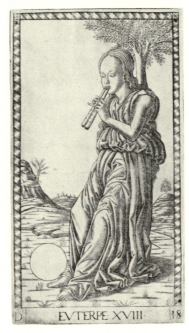

23. North Italian engraving: the Muse Euterpe. London, British Museum

In representing the Muses as a group of maidens in the presence of Apollo, Mantegna has, to start with, drawn on a post-antique tradition accessible to him, if nowhere else, via Francesco Cossa's paintings in the Palazzo Schifanoia, the Ferrarese residence of Isabella d'Este before her marriage to Gian Francesco. In the scene depicting the *Triumph of Apollo,* the Muses appear as a compact group of nine maidens dressed in contemporary attire and coiffed

[62] Cf., for example, Hind, *op. cit.*, IV, pls. 330–338, and I, pp. 221ff., for discussion of the style of this series which the author considers probably to have been Ferrarese in origin. More recently, it has been suggested that the *tarocchi* are Paduan: see Giuseppe Fiocco, *L'arte di Andrea Mantegna*, Venice, 1959, pp. 79f.

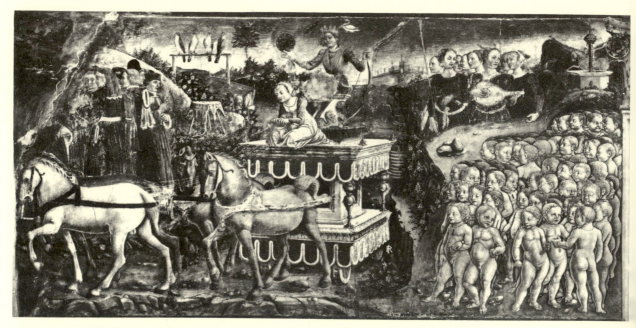

24. Francesco Cossa, *The Triumph of Apollo*. Ferrara, Palazzo Schifanoia

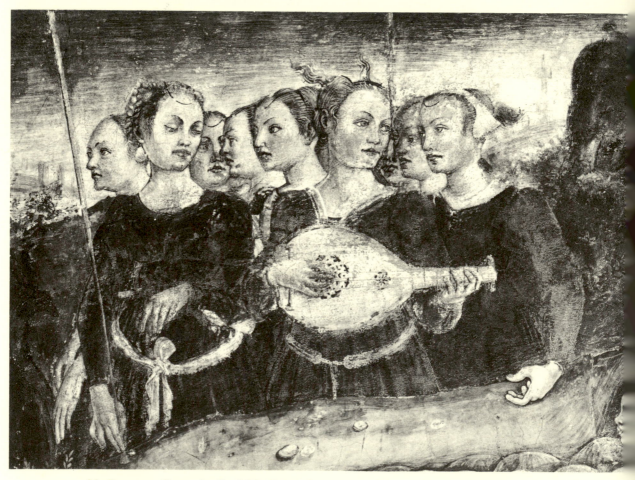

25. Francesco Cossa, detail of *The Triumph of Apollo*. Ferrara, Palazzo Schifanoia

in the prevailing fashion of ca. 1470 (figs. 24, 25).[63] They neither dance nor sing, but one plays a lute and one, possibly two, appear to hold a trumpet. In this painting, as in the *Parnassus,* Apollo's traditional laurel grows in dense profusion.

Many curious iconographic features of this cycle of paintings have been shown to derive from that influential illustrated handbook, the *Libellus de imaginibus deorum.*[64] Written in the north of Italy, probably in Padua, ca. 1420,[65] its short text is a nonmoralizing extract from the introduction written to his *Metamorphoses Ovidiana moraliter explanata* by the fourteenth-century scholar and friend of Petrarch, Petrus Berchorius. The brief paragraphs of this treatise describing the appearance of the gods are illustrated by pen drawings in sepia ink. Under the description of Apollo,[66] the youthful god

[63] For this cycle, see the basic discussion, first written in 1912, by A. Warburg, "Italienische Kunst und internationale Astrologie im Palazzo Schifanoia zu Ferrara," *Gesammelte Schriften,* II, pp. 461–481, as well as such recent brief discussions as those by Paolo d'Ancona, *The Schifanoia Months at Ferrara,* Milan, 1954; Alberto Neppi, *Francesco del Cossa,* Milan, 1958, pp. 11ff.; and Eberhard Ruhmer, *Francesco del Cossa,* Munich, 1959, pp. 29ff., 71ff.

[64] Vat. Reg. lat. 1290. For this manuscript, see Fritz Saxl, *Verzeichnis astrologischer und mythologischer illustrierter Handschriften des lateinischen Mittelalters in römischen Bibliotheken* (*SBHeidelb,* 1915, 6.7 Abh.), Heidelberg, 1915, Vol. I, pp. VIIIff., 67ff., pl. 19, fig. 38, as well as Warburg, *op. cit.,* pp. 627ff.; Hans Liebeschutz, *Fulgentius Metaforalis* (*Studien der Bibliothek Warburg,* IV), Leipzig and Berlin, 1926, pp. 41ff., 117–128, pls. XVI–XXXII; and, for a brief statement on its derivation and importance, Erwin Panofsky, *Renaissance and Renascences in Western Art* (The Gottesman Lectures, Uppsala University, VII), pp. 78ff., n. 2.

For the iconographic features that link Cossa's paintings to the *Libellus,* see Warburg, *op. cit.,* pp. 471f. In pronouncing Raphael the first to represent Apollo as leader of the Muses, Kathi Meyer-Baer (*op. cit.,* pp. 92, 96) has overlooked the medieval tradition reflected in the *Libellus* and related manuscripts and misinterpreted the implication of Apollo's location in Mantegna's *Parnassus.*

[65] The date proposed by Warburg, *op. cit.,* p. 471, n. 1, and Liebeschutz, *op. cit.,* p. 43. Saxl, *op. cit.,* p. 67, dating the manuscript ca. 1400, tentatively suggested that it was written in Verona. According to A. Campana, to whom I am indebted for providing this information in the winter of 1953, examination of the original writing decipherable on certain folios of this palimpsest manuscript reveals: "Ce sont des feuilles provenantes d'un registre d'office judiciaire; dans plusieurs articles, f. 4r, 5v, 5Ar, on lit la date 'M. iiij. Indic. viij': l'écriture du ms. est donc certainement postérieure à l'an 1400; quelques noms de lieu semblent orienter vers Padove: Flexo, f. 4r, prob. Fiesso d'Artico; Rostoga (?), f. 5v, prob. Rustega."

[66] On fol. lv. The full text of the manuscript, including its illustrations, was reproduced by Liebeschutz, *op. cit.,* pp. 117–128, pls. XVI–XXXII, where fol. lv appears on pl. XVII. See also Saxl, *op. cit.,* pp. 113f.

sits between the twin summits of Parnassus clad in flowing medieval garments and surrounded by appropriate attributes and accessory figures (fig. 26). His crowned head supports a tripod; in his right hand he grasps bow and arrows, in his left a lyre.[67] At his feet, below his quiver, there lies a triple-headed monster. To the left, the winged Python snarls from a rocky ledge beneath which the waters of Castalia flow. To the right and of greatest relevance in the context of the *Parnassus*, the nine Muses form a circle around a laurel tree over which Apollo's prophetic raven hovers. Wearing long-sleeved, high-girdled robes, like the Ferrarese Muses, they clasp each other's hands, a doleful looking little group circling slowly but, contrary to the requirements of the text, silently—again, like Cossa's group.[68] Yet in so far as they clasp

[67] Here called a cithara.

[68] Python, too, appears in contradictory fashion—not yet transfixed by an arrow, as the text requires.

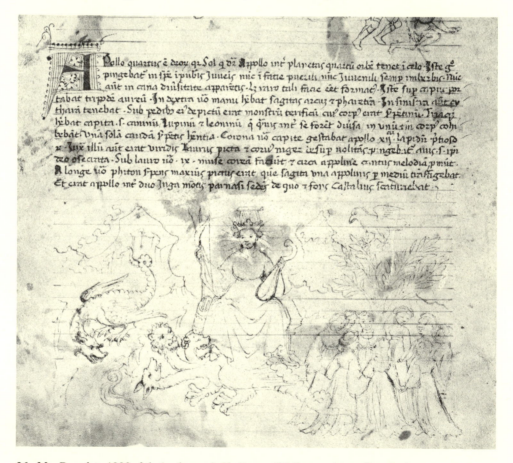

26. Ms. Reg. lat. 1290, fol. 1v, lower half. Rome, Biblioteca Apostolica Vaticana

27. Ms. Rawl. B 214, fol. 198r. Oxford, Bodleian Library

hands and dance, however slowly, these swaying figures are closer to Mantegna's than to Cossa's. Nor are they unique in this respect, for they appear in similar guise in a mid-fifteenth-century English picture-book dependent on the same late medieval tradition (cf. fig. 27).[69] There, in a primitive scene

[69] Ms. Rawlinson B 214, fol. 198r, inserted in a *Historia Troiana* in the Bodleian Library. See Fritz Saxl and Hans Meier, *Catalogue of the Astrological and Mythological Illuminated Manuscripts of the Latin Middle Ages*, ed. by Harry Bober, Vol. III, *Manuscripts in English Libraries*, Pt. 1, London, 1953, pp. 395f.; Panofsky, *op. cit.*, pp. 80f., n. 2.

Kristeller, *op. cit.*, pp. 353, 355, was evidently unaware of this alternate iconography for the Muses and puzzled, therefore, by the absence of attributes in Mantegna's group. The two types are, of course,

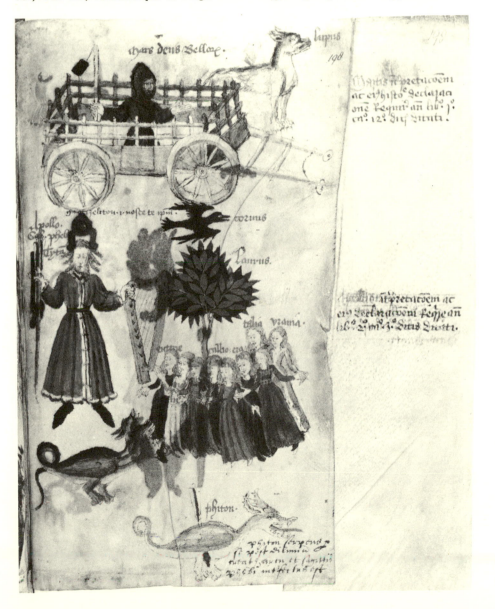

stripped of all landscape elements save the essential tree, the long-haired Muses dance before Apollo's laurel, linked in something approaching the complicated fashion of Mantegna's. No longer forming a simple circle, they hold hands in an intricate manner, occasionally gesticulating or extending an arm.

Whatever the specific means by which Mantegna had access to this medieval tradition—whether via the *Libellus* itself,[70] or through some other channel—his Muses stem from that tradition in being active dancing figures, as it, in turn, reflects knowledge gained from ancient literature about the behavior characteristic of the Muses. Yet apart from this basic similarity, his lilting figures clad in windblown classicizing garments have nothing in common with their demure predecessors draped in long-sleeved, flowing robes. Obviously, the wholly unantique aspect of these figures would have been distasteful to him: clearly he has revised this late medieval iconographic type, reinterpreting it in classicizing terms on the basis of some ancient prototype. As the unknown author of the *Libellus* had purged his learned source of its medieval moralizing contents three-quarters of a century earlier, so Mantegna stripped the medieval vestiges from this iconographic type and attempted to replace them with authentic classical forms.[71]

The very fact that no extant antique representation of the Muses shows them as a group of dancing maidens has hindered previous attempts to discover an antique model for Mantegna's Muses. It has been held that they are most closely related to the so-called Borghese Dancers in the Louvre.[72] But

logically incompatible. Nonetheless, in his characterization of these figures, Kristeller has caught an overtone that distinguishes them from the other figures in the painting, all faithfully derived, it becomes evident, from extant monumental prototypes.

[70] Given its evidently Paduan origin and its established use in the circle of Isabella's family, this alternative is by no means impossible. Mantegna's Vulcan, too, it will later be seen, is not unrelated to the representations of that god in the *Libellus* (below, pp. 142f.). A last singular—doubtless

fortuitous—coincidence in layout between the *Parnassus* and the *Libellus* should be mentioned: namely, that the facing folios lv and 2r show Mars and Venus at the upper left and right, respectively, Apollo and Mercury at the lower left and right, respectively.

[71] For further examples of this procedure, see below, pp. 122ff., 142f.

[72] This view, first proposed by Emanuel Löwy, *Neuattische Kunst*, Leipzig, 1922, p. 10, was still advocated by Ilse Blum, *op. cit.* (above, n. 5), pp. 98ff., if in modified

these sandaled dancers clad in authentic antique garments are not strictly analogous to Mantegna's figures,[73] nor are any of them linked by fluttering streamers. Five in number, they seem to move in two divergent directions, two to the right, three to the left, against an architectural backdrop. It is primarily their generic nature as a chain of dancing female figures clad in wind-blown drapery that links them with Mantegna's Muses, a relationship unlike that between the other figures in the *Parnassus* and their ancient prototypes. For elsewhere in the painting, Mantegna has based his figures on models selected with great care in so far as their identity is concerned and has deviated from them only by adding details meaningful for the content of his painting or altered them for aesthetic, primarily compositional reasons, on the whole, re-using his models with little typological alteration.[74] Indeed it is worth noting that, with one possible exception,[75] he has derived his cast of characters from literal antique equivalents: his Venus from a Venus, his Apollo from an Apollo, his Mercury from a Mercury, and so forth.

There was, in fact, one seemingly authentic reflection of the Muses' appearance in antiquity available to Mantegna's circle—if not an actual monument, a drawing of one—and it emanated from a source of information on

form. Considering that the major difference between the Neo-Attic dancers and Mantegna's was one of *"tempi,"* she concluded by suggesting that, in addition to working from the Borghese relief, the painter had drawn on several sources for his group, among them figures on a Medea sarcophagus in Mantua and a Victory on the Arch of Constantine. None of these comparisons is close or compelling. Hind, too (*op. cit.,* V, p. 27), continued to consider the possibility that Mantegna's Muses were derived from the Borghese relief. For a convenient illustration of this relief, see *Encyclopédie photographique de l'art,* III, Paris, 1938, p. 256, fig. A; and, for a recent discussion of it and late Hadrianic date for it, Werner Fuchs, *Die Vorbilder der neuattischen Reliefs* (*JDAI,* Suppl. Vol. 20), Berlin, 1959, p. 92, and the references cited in n. 23, p. 181.

[73] As Picard, *op. cit.* (above, n. 11), p. 127, n. 1, has pointed out.

[74] Picard's own vague suggestion, *ibid.,* p. 127, that Mantegna could have known a variety of similar dancing Bacchic or other figures on reliefs and sarcophagi or used such prototypes as the Therapenides, "un sujet antique à la mode," along with the Muses, is equally unsatisfactory. As the author admits, the painter could never have seen the Syrian mosaic in which these obscure figures appear—nor are they strictly analogous to Mantegna's Muses in any formal sense, whether in numbers, costume, or position.

[75] See below, pp. 142ff.

ancient monuments held in the highest esteem by his humanist friends and contemporaries: Cyriacus of Ancona. This was a drawing of a marble relief which Cyriacus had seen and copied in the ancient city of Palaiopolis when he visited the island of Samothrace in October 1444.[76] Cyriacus' original drawing, like almost all of his precious journals and sketches, is lost.[77] But like many of his other copies of ancient monuments and inscriptions, it was itself copied at least twice in the fifteenth century. For two copies of the lost original are extant, one in Oxford (fig. 28 A–C),[78] one in Florence (fig. 29 A–C).[79]

They show a band of nine dancing female figures followed by a tenth figure, a musician bearing a tympanon. In both copies, the first six figures are identified as Muses, each having above her head the name of a Muse written in large

[76] For Cyriacus' life and, in particular, his visit to Samothrace, see above, pp. 3ff.

[77] See *ibid.*, for documentation of all the general statements made about Cyriacus in this essay.

[78] Bodleian Ms. Lat. Misc. d. 85, fols. 137v–138v. They are among the extracts from the journals of Cyriacus made by the Florentine scholar Bartholomaeus Fontius, connoisseur of inscriptions, translator and editor of classical manuscripts, professor in Florence, Rome, and Ragusa (see above, pp. 19f., for further reference to him). Portions of this manuscript, formerly in the possession of Professor Bernard Ashmole, including these very drawings, were first published by Fritz Saxl, "The Classical Inscription in Renaissance Art and Politics," *JWarb*, 4 (1940–41), pp. 21ff., especially 33ff., 44, pl. 7 b. (In this illustration, the sequence of the Muses is incorrect, fol. 138r appearing before instead of after 137v, the triad beginning with Erato. The mistake was repeated by Karl Lehmann-Hartleben, "Cyriacus," pl. II A, before he had personally examined the manuscript.) Pen and wash drawings on vellum. Text and original Greek names written in pale red ink; Italian names and defacements added in black ink. See below, n. 80.

[79] In the Biblioteca Medicea-Laurenziana: Laurentianus Ashburnensis 1174, fols. 123v, 124r, 125r. Previously illustrated and discussed by Erich Ziebarth, "Cyriacus von Ancona in Samothrake," *AM*, 31 (1906), pp. 408ff. (Ziebarth had evidently not seen the manuscript himself, hence his misconception that all six Muses occur on fol. 123v.)

Pen drawings in sepia ink and wash, except for the names, which are written in red ink. The verso of 124 is blank—an indication that the copyist was aware that three figures were missing in his archetype, whereas the former Codex Ashmolensis lacks this feature, the extant figures occurring on three successive pages. (For further reference to these missing figures, see below, n. 89.) The explanatory text on fols. 123v and 137v, respectively, of the two manuscripts is also differently spaced.

According to Saxl, "The Classical Inscription," p. 37, this manuscript belonged to one of Fontius' pupils, Francesco Pandolfini, and is "one of the manuscript copies of Fontius' work." If so, whoever made this copy must have had access to another, more complete version of Cyriacus' drawing—or the drawing itself. For although the different spacing of the texts in the two copies mentioned above may be accepted as the variation in an individual copyist's work, the blank verso of 124 in the Ashburnensis implies a prototype other than the Ashmolensis.

Greek capital letters. The remaining four figures bear a common title also written in Greek capitals: ΑΙ ΤΩΝ ΣΑΜΟΘΡΑΚΩΝ ΝΥΜΦΑΙ, the Samothracian Nymphs.[80] Thus, Cyriacus must actually have drawn another three Muses, i.e., a relief on which thirteen figures appeared. (That this did, indeed, happen will be evident shortly.) Whether the sheet on which he recorded these now missing figures was lost before the extant copies of his other sheets were made or the latter were derived from another, defective copy cannot be determined. In any case, at least three copies of a drawing made from an ancient relief that purported to represent the Muses were available in Italy at the end of the Quattrocento, drawings from an impeccable source showing what appeared to be an inscribed monument. Given Cyriacus' legitimate fame as a recorder of inscriptions and the fact that his own brief accompanying remarks were written in Latin, who would have doubted that his drawing showed an inscribed relief, the most reliable document conceivable of how the Muses were represented in antiquity? Certainly not Mantegna. For comparison of his Muses with Cyriacus' figures makes it clear that Cyriacus' drawing, whether the original or a copy,[81] served as the model for them.

Like Mantegna's Muses, Cyriacus' dancing figures form a troupe, a chain of moving forms. Some look forward, heads in profile, while others turn their heads to gaze behind them. Some are shown obliquely, others frontally. Barefoot and long-haired, they wear similar classicizing garments, garments not authentically antique but a hybrid cross between a girdled peplos and a sleeved chiton. High-girdled, with a fluttering overfold, these full-skirted garments blow between their legs and flow behind them. Varied in neckline,

[80] The ill-written Italian transcriptions above the Greek names in the Bodleian manuscript are a later addition, presumably the work of the person who further defaced the drawing by adding a beard and mustache to Ourania's features, brows to the first and fourth Nymphs, and eyes to the third and fourth, and reinforced the contours of this group of figures. The ground lines inserted between these figures are a similar addition. As reported above, n. 78, these additions were made in a different (black) ink. Ignoring the Greek text labeling the last four figures as Samothracian Nymphs, or unable to read it, the de-

facer struggled to supply these figures with the names of the missing Muses. His difficulties are reflected in the mistranslated or altered identifications over the figures of Cyriacus' Muses and the repetition and canceling of the Muses' names applied to his Nymphs. Apart from these later blemishes, the quality of the Bodleian drawing is superior to that of the Laurentian. R. W. Hunt, Keeper of Western Manuscripts in the Bodleian Library, kindly informs me that the Italian additions to fols. 137v–138r are "perhaps 17th or 18th century" in date.

[81] For further reference to this point, see below, p. 114.

A

Ad artem antique samothrace urbem
quam hodie ΠΑΛΑΙΟΠΟΛΙΝ uocitant
ad antiquissimam listam marmoream
insigni arte psculptam ad turris pane
tem ornamento positam

Chito. Le Musd. Talia
 Zathcope ΘΑΛΕΙΑ
ΕΡΑΤΩ ΤΕΡΨΙΚΟΡΗ

Polimnia Vrania Calliopie
ΠΟΛΥΜΝΙΑ ΟΥΡΑΝΙΑ ΚΑΛΙΟΠΙ

ϚΧΧΧVΙΙΙ

Ad artem antiqz samothracie urbem qua hedie παλαιοπολι
uocitant an antiquissimam listam marmoream insigni
arte psculptam ad turrisqz parietem ornameto positam

ΕΡΑΤΩ ΤΕΡΨΙΚΟΡΗ ΘΑΛΕΙΑ

A

ΠΟΛΥΜΝΙΑ ΟΥΡΑΝΙΑ ΚΑΛΙΟΠΙ

B

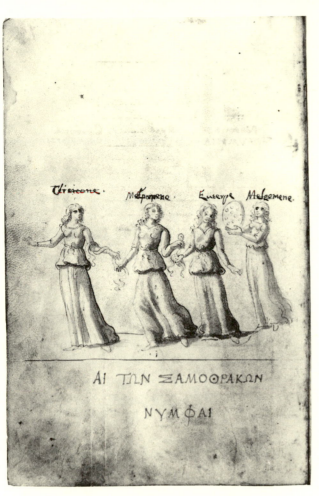

c

28. Ms. Lat. Misc. d. 85.
A. Fol. 137v. B. Fol. 138r.
C. Fol. 138v.
Oxford, Bodleian Library

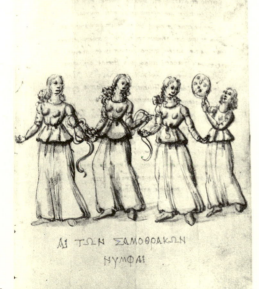

c

29. Ms. Ashb. 1174. A. Fol. 123v.
B. Fol. 124r. C. Fol. 125r.
Florence, Biblioteca
Medicea-Laurenziana

the Muses' dresses are short-sleeved, the Nymphs' long-sleeved, as one of Mantegna's backward-looking Muses wears long, slashed sleeves. Most remarkable of all the features that link the two groups is the fashion in which the figures are connected with each other, for although the majority of them clasp each other's wrists, once again, the first and the last three grasp fluttering strands of material. The recurrence of this singular formal motif would in itself almost suffice to establish the dependence of Mantegna's figures on Cyriacus'. Coupled with the other analogies between them in dress and type, it affords convincing evidence that Cyriacus' amateur sketch provided the means whereby the painter could transform the late medieval iconographic type still current in his day into a more authentic antique image.[82]

Retaining the concept of the Muses as a group of dancing maidens common to both his medieval and antique prototypes, he has eliminated from his Muses the untraditional crowns of laurel and ivy worn by Cyriacus' Muses but not his Nymphs and, following medieval scholarship and the ancient literary tradition on which it rested, has caused three of his Muses to open their mouths in song.[83] Above all, he has replaced the modest robes of the recent past by the fanciful "antique" garments of his ancient model, with his superior artistic skill intensifying their classical potentialities, manipulating them into wind-blown draperies which here and there part to reveal the nude limbs associated with classical figures.[84]

[82] For Cyriacus' accuracy as an amateur sketcher, see above, chap. I, pp. 45, 47. Judging by the best of his sketches, he was more accomplished than his gauche copyists.

[83] If one of the extant manuscripts served as Mantegna's model, it is conceivable that, confronted with six silent Muses but lacking the remaining three and knowing that traditionally the Muses sang, he assumed that one or more of the missing figures sang, hence adopted this scheme for his group.

[84] It is not possible to identify the individual Muses in the *Parnassus* as Wind, *Bellini's Feast of the Gods*, pp. 10f., has attempted to do. As is so often the case in his fanciful, highly personal essay, the "evidence" quoted in support of his statements is, again, irrelevant: e.g., the passage cited in the *Nomina Musarum* provides no basis for his identification of specific figures. I fail to detect "the spirit of mockery" in this group or the "frivolous" nature of the single figures, as I find the supposed use of obscene gestures in it wholly incompatible with the content of the painting, discussed below, pp. 160ff.

Both these objections to Wind's interpretation were raised by E. Tietze-Conrat in her previously cited review (above, n. 16). Unfortunately, that review contained a number of erroneous statements which the author subsequently exploited in a blistering attack on the reviewer: "Mantegna's *Parnassus*. A Reply to Some Recent Reflections," *AB*, 31 (1949), pp. 224ff.

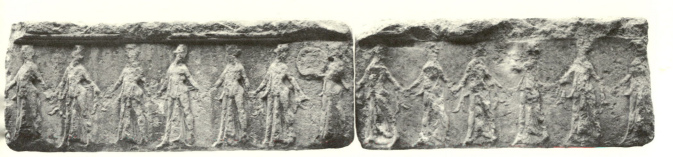

30. Frieze of dancing maidens. Samothrace Museum

Ironically enough, the seemingly so authentic document of the Muses' appearance in antiquity on which Mantegna can with reasonable certainty be said to have modeled his figures was not reliable. A faithful, if amateur, sketch of a genuine classical relief, it recorded two fragments of a long, uninscribed frieze that once adorned a fourth-century Ionic propylon in the Sanctuary of the Great Gods (fig. 30).[85] Plundered from the destroyed and deserted Sanctuary, they had been re-used in one of the towers of the citadel built by Cyriacus' friends, the Gattilusi, on the rocky slopes above the abandoned ancient city.

On the autumn day when the self-taught merchant-scholar crossed the island to visit its ancient sites, his imagination stirred by thoughts of the Homeric past, his mind stocked with hard-won knowledge of ancient literature, he recorded a number of Samothracian antiquities, inscriptions and sculptures

[85] For these blocks, sent to the Louvre by the French consul Charles Champoiseau after his visit to Samothrace in 1863 but returned to the Samothrace Museum in 1955 as a permanent loan, see A. Héron de Villefosse, *Catalogue sommaire des marbres antiques* (Musée du Louvre, Departement des antiquités grecques et romaines), Paris, n.d., p. 39, nos. 698, 699; Eduard Schmidt, *Archaistische Kunst in Griechenland und Rom*, Munich, 1922, pp. 39ff.; and Lehmann-Hartleben, "Cyriacus," pp. 115ff. For the better preserved blocks of the frieze discovered in 1949 and the building to which it belonged, see, for the time being, Karl Lehmann, "Samothrace: Fourth Preliminary Report," *Hesperia*, 20 (1951), pp. 16ff.; *idem, Guide*[3], pp. 57ff., 87ff.; and Evelyn B. Harrison, *Archaic and Archaistic Sculpture* (*The Athenian Agora*, XI), Princeton, 1965, pp. 55, 61, 64, 81. Vol. 5 of *Samothrace*, Excavations Conducted by the Institute of Fine Arts, New York University (Bollingen Series LX), now in preparation, will be devoted to this building and its context.

The relationship between the Louvre blocks and the *Parnassus* proposed here was first published as "An Antique Ornament Set in a Renaissance Tower: Cyriacus of Ancona's Samothracian Nymphs and Muses," *RA*, new ser., 2 (1968), pp. 197–214.

alike, among them, the two plundered blocks on which a procession of thir-
teen maidens appeared. Moving on tip-toe and clasping wrists, now looking for-
ward, now backward, twelve dancing figures clad in flowing classical garments
preceded a thirteenth figure bearing a tympanon. Confronted with this chorus
of dancing maidens and recalling descriptions of the Muses as figures dancing
to Apollo's lyre,[86] he interpreted the first nine as Muses and, in his learned
fashion, assumed that the remaining four figures must be local nymphs—a
conclusion he probably drew from a passage in one of his favorite authors,
Strabo.[87] Hence he added the names of the Muses to his drawing in bold let-
ters having the character of an inscription as, a second time during his brief
stay in Samothrace, he drew an uninscribed marble bust which he interpreted
as Aristotle and inscribed in similar majuscule letters, in that instance, too,
providing the basis for later incorrect Renaissance representations of the great
philosopher.[88]

When Cyriacus drew these blocks, they must already have been severely
weathered. He cannot be blamed for having misunderstood the indecipherable
traces of some object on the heads of his "Muses" which he interpreted as

[86] The marginal notes to 5.8ff. on fol. 58r of his copy of the *Fasti* (Vat. lat. 10672, the oldest known codex in Cyriacus' hand, finished in May 1427, for which see Fava, *op. cit.*, above, p. 15, n. 23) indicate his interest in the Muses, Pegasus, and the Castalian spring as does the letter to his friend Pietro Donato (see below, pp. 109f.) in which he reports having seen in Thessaloniki the inscribed base of a tripod dedicated to the Muses. His interest in this inscription, which he linked with a passage in Aulus Gellius (3.11.3f.), illustrates the fashion in which he constantly sought to relate the monuments he encountered to the information he had gained through reading ancient literature. For this letter on fol. 81v of Ham. Ms. 254 in the Deutsche Staatsbibliothek in Berlin, see Theodor Mommsen, "Über die Berliner-Excerpten-handschrift des Petrus Donatus," *JPKS*, 4 (1883), especially pp. 77ff. and pl. A (the old manuscript number, 458, is no longer correct); Lehmann-Hartleben, "Cyriacus," p. 117, n. 13; Edward W. Bodnar, S.J., *Cyriacus of Ancona and Athens* (Collection Latomus, XLIII), pp. 159f.; and Helmet Boese, *Die lateinischen Handschriften der Sammlung Hamilton zu Berlin*, Wiesbaden, 1966, pp. 125ff.

[87] 10.3.21, where the author refers to nymphs called Cabirides in the context of a discussion on the Cabiri in Samothrace and elsewhere. For Cyriacus' annotated Strabo, see Richard Foerster, "Zur Handschriftenkunde und Geschichte der Philologie, IV," *RhM*, new ser., 51 (1896), pp. 481ff., and Bodnar, *op. cit.*, pp. 118f. Although he did not acquire this particular codex until 1447, there is every reason to assume that he had long been familiar with the author who, for example, was even translated by Guarino of Verona (J. E. Sandys, *A History of Classical Scholarship*, reprinted New York, 1958, II, p. 50).

[88] See above, pp. 15ff.

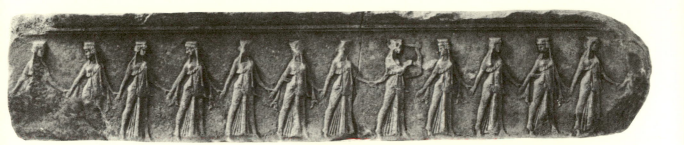

31. Frieze of dancing maidens.
Samothrace Museum

32. Detail of frieze of dancing maidens.
Samothrace Museum

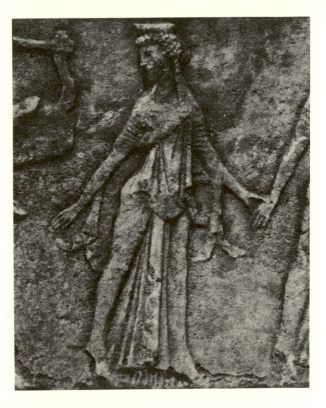

crowns of laurel and ivy rather than the low *poloi* that the well-preserved recently discovered blocks show them to have worn (cf. figs. 31, 32). Nor could he detect the characteristic zigzag swallow-tail folds of these archaistic figures. But he did catch their narrow-shouldered, flaring contours, the turn of their heads, the conspicuous line of drapery at their hips, the prominent vertical folds between their legs, and the presence of strands of material fluttering between each pair of figures. He did not realize that these were elegant mantles worn by alternate figures, seeing them, instead, as fillet-like objects that he interpreted, reasonably enough, as occasional connectives between

the figures. Looking at the three figures which precede the tympanist,[89] one can only say that his transcription and interpretation of the worn surfaces between the figures was a plausible one if, as is now clear, incorrect.

All in all, Cyriacus' transcription of this damaged relief was a creditable performance for an amateur. That the frieze he recorded was archaistic rather than classicistic as he unwittingly made it, that it represented neither Muses nor Samothracian Nymphs but members of a long progression of ritual dancers, he could not know.

Cyriacus had long been dead when Mantegna painted his *Parnassus*, yet it is by no means impossible that the two had known each other half a century earlier, when Mantegna was at work on the Eremitani Chapel and Cyriacus had returned from the long voyage in the course of which he had visited Samothrace in October 1444.[90] In 1443, before he set out on that journey, Cyriacus had visited Padua and stayed with his good friend Pietro Donato, Bishop of Padua, another avid student of antiquity and collector of inscriptions with whom he corresponded and to whom he sent copies of inscriptions and sketches of monuments during his travels in classical lands.[91] Although there is no record of his having visited Padua in the early years of Mantegna's adult activity there from 1448–1459,[92] he is known to have been in Rimini and

[89] The two fragments drawn by Cyriacus probably come from a single block in which the tympanist appeared at the center. If so, they were mounted in the Gattilusi tower in the wrong order, as Cyriacus' drawing indicates. The third figure from the right in the order followed in the later installation in the Louvre (shown here in fig. 30) and in the present installation in Samothrace is a flute-player, shown in profile, followed by a figure linked with her by holding the tip of her mantle, and preceded by a figure who turns to regard her. This figure, difficult to interpret even at close hand, does not appear among the six Muses in the extant copies of Cyriacus' sketch. Yet it is evident that it is the six figures on this block that the six Muses in the extant drawings represent and that the missing Muses were drawn from the three figures which precede the final four, termi-
nating in a tympanist, that Cyriacus interpreted as Samothracian Nymphs. See above, n. 79, for the blank page reserved for this triad of figures in Ashburnensis 1174, fol. 124v. (For illustration of the blocks in the order in which Cyriacus saw them and as they were originally exhibited in the Louvre, see Lehmann-Hartleben, "Cyriacus," pl. II B.)

[90] For Cyriacus' biography, see the references cited above, chap. I, nn. 2, 9, 22, 24, 38, 102, and for the specific facts and dates mentioned here those cited below, nn. 91, 93–95, 106.

[91] For Cyriacus' visits to Padua and connection with Pietro Donato, see Mommsen, *op. cit.*, pp. 76ff. Boese, *op. cit.*, p. 125, dates the Berlin manuscript containing texts and drawings that the Bishop had received from Cyriacus ca. 1440–1445.

[92] Kristeller, *op. cit.*, pp. 62f.

Ferrara (at the court of Isabella's uncle, Lionello) in 1449.[93] The following year, before his subsequent return to the East, he seems still to have been in Italy and to have witnessed the coronation of Frederick III in Rome.[94] It is tempting to speculate on the possibility that these two kindred spirits met in the course of those years and to imagine the antiquarian painter poring over the learned traveler's sketches of hitherto unknown ancient monuments and hearing about, if not actually seeing, some of the precious manuscripts and antiquities—the sculptures, coins, and gems—that he had collected in Greece and the islands.[95] But beguiling as the vision is, credible though the suggestion, it must remain a hypothetical possibility.

Yet even if Mantegna did not know Cyriacus personally or at any time have direct access to his original drawing of the Samothracian blocks, he can have known it from a copy—precisely such copies as are extant today. For throughout his life, from his youth in Padua to his old age in Mantua, a number of significant associations linked him indirectly with Cyriacus and his drawings.

Pietro Donato died the year before the youthful painter began his first major work in the Chapel of the Eremitani in Padua. But even if, as Squarcione's apprentice, he had never known the bishop himself, surely Donato's collection of inscriptions, the letters and sketches he had received from Cyriacus and sometimes annotated, as well as the copies he himself had made of his friend's drawings and transcriptions[96] had passed into the hands of some other learned student of antiquity and collector of inscriptions in that city in which Marcanova then taught—Marcanova who, in later years, was to be co-consul with Mantegna of a group of humanists in pursuit of antiquities.[97] Conceivably,

[93] Emil Jacobs, "Cyriacus von Ancona und Mehemmed II," *BZ*, 30 (1929–1930), p. 198.

[94] Cf. my discussion in "Theodosius or Justinian? A Renaissance Drawing of a Byzantine Rider," *AB*, 41 (1959), pp. 49ff.

[95] Erich Ziebarth, "Cyriacus von Ancona als Begründer der Inschriftenforschung," *Neue Jahrbücher*, 9 (1902), pp. 224f. Another link between Cyriacus and artists at work in Padua is of interest: the fact that he composed the inscription for the statue of Gattamelata later executed by Dona-
tello. See Giorgio Castellani, "Un traité inédit en grec de Cyriaque d'Ancône," *REG*, 9 (1896), p. 228; H. W. Janson, *The Sculpture of Donatello*, Princeton, 1957, pp. 153ff., 160.

[96] See above, n. 91.

[97] Cf. Kristeller, *op. cit.*, pp. 176ff. Knabenshue, *op. cit.* (above, n. 26), pp. 72f., has suggested that it was Marcanova who served as archaeological adviser to the youthful painter when he worked on the Chapel of the Eremitani.

Donato, earlier the recipient of Cyriacus' letter reporting an inscribed base in Thessaloniki honoring the Muses, had been sent or given a later installment on the Muses, Cyriacus' drawing of the frieze of dancing maidens. Nor was he the only Paduan in correspondence with Cyriacus. Ludovico Mezzarota, physician to Cyriacus' old friend Eugenius IV, later leader of the papal troops in the war against the Turks and himself a Cardinal, was another of Cyriacus' correspondents and an opulent collector of antiquities whose portrait Mantegna painted shortly before he went to Mantua in 1459 to take up his duties as court painter to Lodovico Gonzaga.[98]

Lodovico's well-known interest in antiquity was not confined to the acquisition of codices of Latin poets or the production of Latin dramas.[99] He, too, shared the current enthusiasm for inscriptions, hence interest in Cyriacus' diaries and letters, and in 1461 commissioned his Milanese agent, Vincenzo Scalone, to borrow from Francesco Sforza his copy of a collection of inscriptions recorded by Cyriacus so that it might be brought to Mantua and copied for him.[100]

If it was fashionable for such men to concern themselves with Cyriacus' collections, how much greater their interest to those who, like the Paduan Marcanova and the Veronese Feliciano, carried on and extended his work, incorporating it in their own.[101] And it was this very circle of humanists with whom Mantegna remained closely affiliated—witness Feliciano's report of an excursion to the Lake of Garda on September 23, 1464, in which he, the "consuls" Marcanova and Mantegna, and the "Emperor" Samuele da Tradate took part in order to investigate ancient monuments and copy inscriptions.[102] This report, with its vivid picture of the richly adorned boats in which

[98] Kristeller, *op. cit.*, pp. 170ff.

[99] *Ibid.*, p. 190.

[100] Cf. Ziebarth, "Cyriacus . . . als Begründer," p. 223, and R. Sabbadini, "Ciriaco d'Ancona e la sua descrizione autografa del Peloponneso tramessa da Leonardo Botta," *Miscellanea Ceriani*, Milan, 1910, pp. 240ff. For the text of Lodovico's letter, see *Giornale storico della letteratura italiana*, 16 (1890), p. 159. Cyriacus had visited Mantua in search of antiquities in 1433, as Scalamonti reported (see Colucci, *op. cit.* [above, n. 38], xcivf.).

[101] Ziebarth, "Cyriacus . . . als Begründer," *loc. cit.*, and, in particular, Charles Mitchell, "Felice Feliciano *Antiquarius*," *ProcBritAc*, 47 (1961), pp. 209ff. I am indebted to Edward W. Bodnar for knowledge of this lecture.

[102] For convenience, cf. Kristeller, *op. cit.*, pp. 176, 472f., document no. 15, the first partial publication of this report, and, for comment on it, Millard Meiss, *Andrea Mantegna as Illuminator*, New York, 1957, p. 91, n. 3.

the company sailed, of Samuele da Tradate playing a cithara, of thanksgivings sent up to "the supreme thunderer and his glorious mother" in the temple of the Madonna, is preserved in a codex in Treviso[103] which is of the greatest interest in the present context. For it contains a copy of Francesco Scalamonti's *Vita Ciriaci Anconitani* made by Feliciano in 1463 for Samuele da Tradate (through whom, it has been suggested, Mantegna may have been introduced to Lodovico),[104] as well as copies of inscriptions and monuments originally drawn by Cyriacus, and is dedicated to none other than Andrea Mantegna![105]

Among the miscellaneous extracts from Cyriacus' journals preserved in this codex is an excerpt of the description of his visit to Samothrace otherwise known from a manuscript in the Vatican containing a copy of a letter written by Cyriacus to an unknown friend in 1444.[106] In this unillustrated account of his visit to the island, Cyriacus told of his trip to the ancient city,

[103] In the Biblioteca Capitolare, formerly no. 221, now I, 138, fol. 201v, 205r. The full text of this report was published by Erich Ziebarth, "Die Nachfolger des Cyriacus von Ancona," *Neue Jahrbücher*, 11 (1903), pp. 491ff.

[104] Kristeller, *op. cit.*, pp. 181f.

[105] As correctly reported by Kristeller, *ibid.*, p. 17, and Ziebarth, "Cyriacus . . . als Begründer," *loc. cit.* In a subsequent article, Ziebarth published and discussed the Samothracian texts preserved in this codex: "Cyriacus von Ancona in Samothrake" (above, n. 79), pp. 405–414. The Codex Tarvisinus contains, in addition, copies and drawings of monuments recorded by Cyriacus in scattered other places (e.g., Thasos, Ainos, Rome). For further reference to the Samothracian inscriptions copied or drawn by Cyriacus, see above, pp. 27ff.

For discussion of another portion of this manuscript containing a report on Cyriacus' subsequent journey from Thasos to Mount Athos in November 1444, in pursuit of manuscripts, see Hans Graeven, "Cyriacus von Ancona auf dem Athos," *Centralblatt für Bibliothekswesen*, 16 (1899), pp. 209ff.

For recent comment on Mantegna's association with Feliciano, see Meiss, *op. cit.*, pp. 68ff.; Mitchell, "Felice Feliciano *Antiquarius*," pp. 199, 213; Dario A. Covi, "Lettering in Fifteenth Century Florentine Painting," *AB*, 45 (1963), pp. 8ff.; Emanuele Casamassima, *Trattati di scrittura del cinquecento italiano*, Milan [1966], pp. 20ff. (I am indebted to Millard Meiss for this reference); and n. 263, below.

[106] Cod. Vat. lat. 5250, fols. 13v–14v. The greater part of this description was reprinted by Alexander Conze et al., *Samothrake*, I, p. 1, n. 1, whence it was quoted by Ziebarth, "Cyriacus von Ancona in Samothrake," p. 407. Ziebarth had not seen the manuscript himself and he evidently miscopied the text in Conze's note, omitting several lines, including Cyriacus' reference to the dancing nymphs, which he assumed occurred only in the Codex Tarvisinus. Cf. his comment, *ibid.*, p. 408. On this manuscript, see also E. Jacobs, "Die Thasiaca des Cyriacus von Ancona im Codex Vaticanus 5250," *AM*, 22 (1897), pp. 113ff. For further reference to this letter, see above, p. 3.

toward the end singling out certain marble blocks and sculptures in the deserted sanctuary that evidently were of particular interest to him and continuing:

> From there [i.e., the sanctuary], after we came to the new citadel built by Prince Palamede, there were seen in a tower many old marbles constructed with painstaking skill, on which we noticed several sculptured dancing nymphs; and we found here and there very many extraordinary monuments of the antiquity of this great city and some excellent old inscriptions with Greek lettering and also with our own.

This latter portion of the letter in Codex Vaticanus 5250 recurs in the Codex Tarvisinus.[107]

That in his brief allusion to the ancient city Cyriacus specifically mentioned the carving of dancing nymphs and the Greek and Latin inscriptions that he had seen again indicates that they were of special interest to him, as is reflected, too, by the fact that he drew the frieze and recorded a number of inscriptions. Although his drawing of the dancing maidens does not appear in either Vaticanus 5250 or the Codex Tarvisinus, directly beneath the reference to *nympharum choreas consculptas* and *nobilia atque veterima graecis ac etiam nostratum litteris epigrammata* in Feliciano's manuscript the label found beneath the last four figures in the Laurentian and Bodleian manuscripts, ΑΙ ΤΩΝ ΣΑΜΟΘΡΑΚΩΝ ΝΥΜΦΑΙ, does occur—in the form of an inscription! Written in Greek capitals, it has been inserted in an ornamental frame (fig. 33).[108]

Whether Feliciano's copy lacked the drawing accompanying this seeming inscription in both the Bodleian and Laurentian manuscripts or, given his well-known preoccupation with inscriptions, he simply neglected copying it cannot be determined. In both these manuscripts, the caption identifying the

[107] On fol. 192v: *Et inde postq(uam) ad novam a palamade principe condita(m) arcem venimus ad turrim ipsam pleraq(ue) vetusta arte elaborata marmora vident(ur) composita ubi plerasq(ue) nymphar(um) choreas consculptas inspeximus et alia q(uam) plurima hinc inde veternitatis tantae urbis eximia monume(n)ta co(m)p(er)imus et nobilia atq(ue) veterima graecis ac et(iam) nostra(tu)m litt(eris) epigrammata.*

[108] Written in sepia ink. The upper and lower borders and the lateral semicircles are yellow. See Erna Mandowsky and Charles Mitchell, *Pirro Ligorio's Roman Antiquities* (*Studies of the Warburg Institute*, 28), London, 1963, p. 9, for comment on Feliciano's practice of providing a "coloured frame *à l'antique* of his own invention" in presenting an inscription.

Imbrom insulam Samotrachiam

Vidimus & ingentia Neptuni marmorei
templi uestigia immanium columnarum frag
menta epistiliaq et basses atq portarum postes
ornatas e coronatis bouum capitib aliysq fi
guris insculptas arte p̄ pulchra . Et inde
postq ad nouam ap Athnade principe conditi
arcem uenimus ad turrim ipsam plerisq ue
tusta arte elaborata marmora uident̄ compo
sita ubi plerisq nympharu choreas consulptas
inspeximus et alia q plurima hinc inde uet
nitatis tante urbis eximia monumenta co
pimus & nobilia atq ueterrima grecis ac
et nostrarum litt̄ Epigrammata .

Ι ΤΩΝ ΣΑΜΟΘΡΑΚΩΝ
ΝΥΜΦΑΙ

33. Ms. I, 138, fol. 192v. Treviso, Biblioteca Capitolare

Samothracian Nymphs appears beneath the figures, whereas the names of the Muses occur above their heads. And although the explanatory text accompanying the drawing in each manuscript is briefer than that in the Codex Tarvisinus, it provides much of the same information (cf. figs. 28A, 29A):

> On the citadel of ancient Samothrace, the city which today they call Palaiopolis, on a very old marble frieze sculptured with exceptional skill set as an ornament in the wall of a tower.[109]

If the Codex Tarvisinus contained a copy of the drawing preserved in both the Bodleian and Laurentian manuscripts, one could assume that it provided Mantegna with the actual model for his Muses. Conceivably, as has been mentioned, the manuscript from which Feliciano worked contained his actual model. In any case, Mantegna must have had access to another copy of Cyriacus' report on Samothrace in which the drawing of the chorus of maidens was preserved, whether it was one of the extant manuscripts or another, now lost, where they were identified with explanatory labels. Given the text and illustration in the copy dedicated to him, he could hardly have questioned the authenticity of the seemingly inscribed text ΑΙ ΤΩΝ ΣΑΜΟΘΡΑΚΩΝ ΝΥΜΦΑΙ in this hypothetical model or, by analogy, the authenticity of the identifications placed over the heads of the remaining figures. Clearly, Cyriacus had seen an inscribed relief; clearly, he could accept these figures as genuine antique Muses. The very fact that this chorus of dancing figures was related to the late medieval tradition with which he was familiar must have made it as natural for Mantegna to accept them as Muses as it had been for Cyriacus to interpret the Samothracian relief in this fashion.

In view of the previously defined formal and iconographic relationships between Mantegna's Muses and Cyriacus' and of the near certainty that he had access to copies of that almost legendary man's drawings, it is reasonable to

[109] On fols. 137v and 123v of the Bodleian and Laurentian codices, respectively: *Ad arcem antiquae samothraciae urbem quam hodie* παλαιόπολιν *vocitant ad antiquissimam listam marmoream insigni arte persculptam ad turrisque parientem ornamento positam.*

This brief indication, which appears above the first triad of figures, describes the location of the sculptured relief so specifically that one familiar with the text of either the Vatican or Treviso manuscripts could not fail to identify the drawings in the former two as illustrations of the monument described in the latter two.

assume that Cyriacus' chain of Samothracian Nymphs and Muses served as the model for Mantegna's lilting figures—a model that would have seemed to the painter reliable in content, if amateur in execution.[110]

To the right of the Muses, in the foreground of the painting, stands the group of Mercury and Pegasus (figs. 1, 34). Unconcerned with the dancing figures behind them or with their leader, remote in spirit from either the activity or the presences behind them, they stand apart, mutually absorbed. Equal in height, their antithetical figures adhere to each other in a compact compositional unit whose isolation from the remainder of the scene is intensified by Pegasus' calligraphic wings, which provide a backdrop for them.

As has long been recognized, the combination Mercury-Pegasus is a singular one, for the Winged Horse is not normally attached to Mercury.[111] But he is

[110] For a variation on four of the Muses in the *Parnassus* in which the fifth, sixth, and seventh of Mantegna's Muses are reversed and his first quoted in still freer form, see the engraving attributed to Zoan Andrea by Hind, *op. cit.* (above, n. 33), V, p. 27, no. 21; VI, pl. 519 (no. 21a is a reversal of no. 21). For two much-debated drawings in Munich and Berlin associated with the sixth and ninth Muses, respectively, see Paccagnini, *op. cit.* (above, n. 14), pp. 65, 165f., nos. 122, 123, figs. 140, 141.

The panel representing the *Dance of the Muses with Apollo* in the Palazzo Pitti in Florence (formerly attributed to Giulio Romano) presents still another variation on the Mantegnesque-Ciriacesque tradition in which the Muses (but not Apollo!) are identified by their Greek names placed in an undulating scroll beneath their feet and written in a painful cursive hand. This painting, recently attributed to Peruzzi (see Freedberg, *op. cit.* [above, n. 53], p. 405, fig. 488, pl. 355), is illustrative, once again, of the use of common iconographic sources by Mantegna, Raphael, and his circle.

Charles Mitchell, "Archaeology and Romance in Renaissance Italy," *Italian Renaissance Studies*, ed. by B. F. Jacobs, New York, 1960, p. 474, has suggested that the nymphs on a puteal in one of the illustrations of the *Hypnerotomachia Polifili* were derived from Cyriacus' drawing of the Samothracian "Muses," citing and illustrating (fig. 34) the triad of figures on fol. 137v of the Bodleian manuscript. Conceivably this was the case. But it is more likely that the figures in this illustration were inspired by a comparable monument—i.e., a neoclassical puteal—especially in view of their lack of such characteristic features of Cyriacus' Muses as their crowns and costume.

[111] As Foerster observed, "Studien zu Mantegna" (above, n. 7), p. 158, n. 5. The purportedly Hadrianic coins on which a standing Mercury restrains a rearing Pegasus cited by Wind, *Bellini's Feast of the Gods*, p. 12, as providing "a classical precedent for representing Mercury as a tamer of Pegasus" have long been recognized as forgeries. See G. Blum, "Numismatique d'Antinoos," *JIAN*, 16 (1914), p. 36. Wind, evidently preferring to follow earlier writers in accepting this type as authentic (it bears no formal analogy to Mantegna's group, whether genuine or not), then continues with a confused discussion in which

associated with Bellerophon. It is hardly surprising, therefore, that confronted with the iconographic necessity of combining Mercury with Pegasus,[112] Mantegna seems to have once again been influenced by the Bellerophon sarcophagus from which he appears to have derived his Amor (cf. fig. 16).[113] There, too, Pegasus and his companion are equal in height, Pegasus at the left, Bellerophon at the right. There, too, the horse's forelegs were once similar in position to Pegasus', as the long-haired hero's hip-shot pose, sloping shoulders, and curving thigh are similar to the god's. There, too, Pegasus' left wing curves up behind Bellerophon's left shoulder, and there, too, he is only a protome whose hind legs are invisible. Mantegna has exactly reversed Bellerophon's stance and the turn of the departing hero's head to adjust the action of his model to the special and static requirements of his group—precisely as he did in adjusting the Venus of the Judgment of Paris sarcophagus to the formal demands of his equally isolated and antithetical group of Mars and Venus, in both cases creating a tightly closed composition in which the heads are turned toward each other, the outer legs bear the figures' weight, and the firm, fluent contours of the group are animated by calligraphic elements in the background.[114] The very invisibility of Pegasus' right wing on the sarcophagus would have freed the painter from his model, stimulating him to devise the

he refers to genuine Hadrianic coins which show on the reverse a mounted horseman holding a caduceus, whom Blum, pp. 53, nos. 1ff., regards as Antinous with that attribute. In the caption to his illustration of this type in fig. 41, Wind identifies it as "Mercury as Horseman. Coin of Antinous." But his note to this type cautiously describes the rider only as a "horseman." In any case, whether Antinous or Mercury, this mounted horseman rides a normal, unwinged horse—hence, the type is as irrelevant to any consideration of Mantegna's group as the author's discussion is misleading. That Mercury and Pegasus were associated in the *Renaissance* is, of course, quite another matter: cf. pp. 139, 170ff., below.

[112] This point will become clear below, pp. 172ff.

[113] See above, p. 84ff. A very similar group of Bellerophon and Pegasus occurs in a painted lunette of the Tomb of the Nasonii on the Via Flaminia, but that richly decorated monument was not excavated until the late seventeenth century. See Bernard Andreae, *Studien zur römischen Grabkunst* (*RM*, 9th suppl. vol.), Heidelberg, 1963, pp. 120ff., pl. 48, fig. 2.

The only other specific model previously proposed for Mantegna's group, a fully dressed, armed horseman and his mount on the Column of Trajan, is unconvincing both from the standpoint of strict formal analogy and of content. Cf. Ilse Blum, *op. cit.* (above, n. 5), pp. 102f., and, for the comparison proposed, Karl Lehmann-Hartleben, *Die Trajanssäule*, Berlin and Leipzig, 1926, pl. 34, sec. LXXIV.

[114] Cf. p. 74, above, and figs. 3, 9, 10.

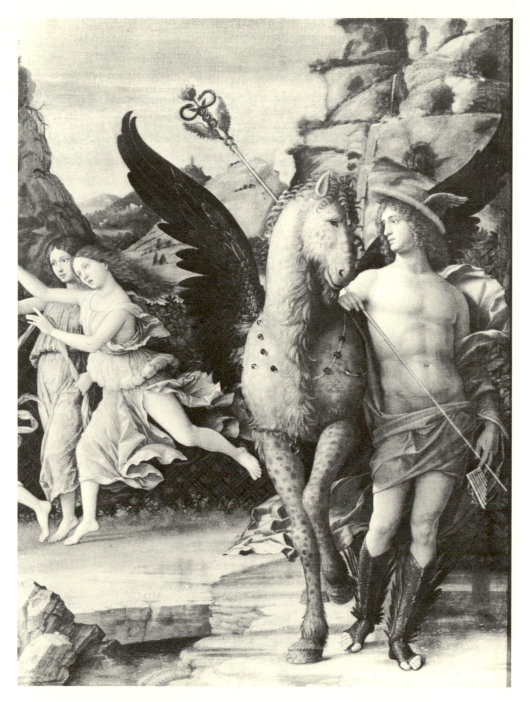

34. Mantegna, *The Parnassus*: detail of Mercury and Pegasus

heraldic wings that play so important a role in detaching this group from its neighbors.

Plausible as it is to regard this sarcophagus as the source of Mantegna's group as such, as having afforded him a genuine antique model for a group combining Pegasus with a male figure, it could not provide him with the details of an authentic Mercury—with the kind of specific iconographic prototype that we have found him using for the other figures in the painting. In this most intricate and significant pair of figures in so far as the content of the *Parnassus* is concerned, he has drawn on additional sources of the highest iconographic and formal relevance in shaping both his Mercury and his Pegasus. And once again, in this connection, he appears to have been attracted by a monument later admired by Raphael and his circle.

Toward the left end of the great panel depicting *Psyche Received into Olympus,* designed and executed by Raphael and his pupils in the Villa Farnesina in Rome,[115] there stands a youthful Mercury so similar to Mantegna's figure in type, stance, bodily form, and contour as to imply that the two figures reflect a common prototype equipped, like them, with mantle and winged petasos (cf. figs. 34, 35). It has long been recognized that Raphael's Mercury must be dependent on an ancient statue, some such figure, it has been suggested, as the *Hermes Belvedere,* but that that statue found on the Esquiline around 1545 cannot itself have been his model.[116] Actually, there did exist in Rome in the master's lifetime a statue so like his Mercury as surely to have served as its prototype: a figure of the youthful god placed in one of the upper niches in the garden façade of the Palazzo Valle-Capranica built for Cardinal

[115] For this painting, see Hermanin, *op. cit.* (above, n. 59), pp. 69f., pl. XXIV; Richard Foerster, *Farnesina-Studien,* Rostock, 1880, pp. 72ff. I shall not discuss the evident use of other antique models for the figures in this scene (e.g., the *Belvedere Torso*) or its antique literary sources or the debated attribution of these figures to the master or his pupils—intricate problems that lie apart from the specific issue of interest here. The figure of Mercury has been attributed to Penni by Frederick Hartt, "Raphael and Giulio Romano with Notes on the Raphael School," *AB,* 26 (1944), p. 76. However greatly the original surface has suffered from restoration, the type, as such, is surely unchanged.

[116] See, for example, F. A. Gruyer, *Raphael et l'antiquité,* Paris, 1864, p. 299; Foerster, *op. cit.,* p. 82; Hermanin, *op. cit.,* p. 69. For the *Hermes Belvedere,* see Walther Amelung, *Die Skulpturen des Vaticanischen Museums,* II, Berlin, 1908, no. 53, pp. 132ff., pl. 12.

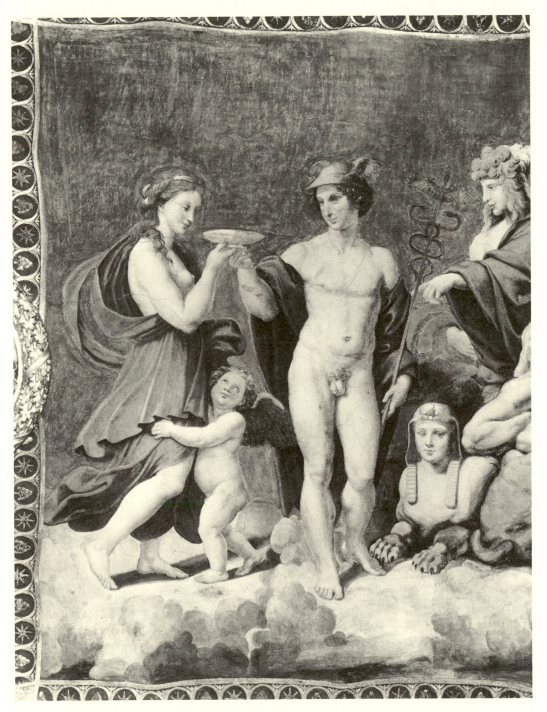

35. Raphael, detail of *Psyche Received into Olympus*. Rome, Villa Farnesina

Andrea della Valle under the direction of Raphael's student and assistant, Lorenzo Lotti (fig. 36).[117] Begun between 1520 and 1523, this palazzo contained the rich collection of antiques assembled by Cardinal Andrea himself, as well as others previously scattered throughout the houses built by his family in the latter years of the previous century.[118] The drawing by Francesco d'Ollanda which records the appearance of this sumptuous *cortile* was not made until a few years after the Cardinal's death in 1534, when the palazzo had passed to his nephew, Camillo Capranica.[119] Numerous attempts have been made to identify the sculptures standing in these niches, including the figure of Mercury.[120] None is wholly convincing. But whatever the fate of this statue after ca. 1540, it was surely accessible to artists working in Rome in the previous decades.

Like Raphael's figure, this nude Mercury stands with his weight on his right leg, his left being bent and drawn lightly to the rear, and extends his bent right arm forward (cf. figs. 35, 37). The latter is broken at the wrist, as is the

[117] As recorded by Francesco d'Ollanda. See the facsimile edition of his sketchbook in Madrid from which figs. 36 and 37 are reproduced: Eliás Tormo y Monzo, *Os desenhos das antigualhas que vio Francisco d'Ollanda, pintor portugués*, Madrid, 1940, fol. 54r.

For the Palazzo Valle-Capranica in this context, see Hülsen-Egger, *op. cit.* (above, n. 59), II, pp. 56ff.; P. G. Hübner, *Le statue de Roma (Römische Forschungen herausgegeben von der Bibliotheca Hertziana*, II), Leipzig, 1912, pp. 117ff. and pl. v, where the collections of the Valle family are characterized as having been of special importance and interest.

[118] A. Michaelis, "Römische Skizzenbücher nordischer Künstler des XVI. Jahrhunderts, II," *JDAI*, 6 (1891), pp. 218ff.

[119] Hülsen-Egger, *op. cit.*, II, p. 56.

[120] Hülsen-Egger, *ibid.*, I, p. 15, correctly refuted the earlier attempt of P. G. Hübner, "Detailstudien zur Geschichte der antiken Roms in der Renaissance," *RM*, 26 (1911), p. 309, to equate Francesco d'Ollanda's Mercury with a statue now in the Uffizi (no. 159; Dütschke, no. 98). The latter differs from the former in a

number of respects: e.g., in the turn of the head, the position of the right arm, the use and position of the mantle. It is unquestionably a different statue. For this statue, see now Guido A. Mansuelli, *Galleria degli Uffizi, Le sculture*, I, Rome, 1958, no. 159, pp. 176f. Francesco d'Ollanda's figure is, however, the one mentioned by Aldrovandi in referring to the house of Camillo Capranica in the "rue de la Valle," where he saw "cinq belles statues en pied; au milieu, Mercure nu, avec une draperie enroulée sur son bras gauche." See, for convenience, the French translation of the edition of 1572 by Salomon Reinach, *L'album de Pierre Jacques* (above, n. 40), pp. 57f. (*Le antichità della città di Roma . . . raccolte per Lucio Mauro. . . . Appresso, tutte le statue antiche che in Roma in diversi luoghi e case particolari si veggono, raccolte e descritte per M. Ulisse Aldroandi*, Venice, 1572, pp. 218f.)

In referring to efforts to identify the statues shown in this drawing, I confine my remarks to those pertaining to Mercury.

36. Francesco d'Ollanda, garden façade of the Palazzo Valle-Capranica, Rome. Madrid, Biblioteca Nacional

37. Francesco d'Ollanda, detail of the garden façade of the Palazzo Valle-Capranica, Rome. Madrid, Biblioteca Nacional

slightly lowered left arm wrapped in a mantle that passes behind the figure and over his upper right arm. Like the painted figure, he wears a winged petasos and doubtless his now-missing hands held attributes, the left probably the caduceus with which Raphael has supplied his Mercury. In the painting, the god turns his head toward his right and holds a dish in his right hand, a minor modification and addition required by his function—to proffer ambrosia to Psyche. His mantle, too, is disposed in looser, freer folds, but its primary relationship to the figure is the same. Given the exceptional similarity of these figures and the accessibility of the statue to the painter, we may surely assume that Raphael's Mercury was derived from this statue in the Palazzo Valle-Capranica.

In view of the relationship between Raphael's and Mantegna's figures of Mercury, it is reasonable to assume that Mantegna's figure was derived from the same model as Raphael's.[121] In drawing on this statue to complete his Mercury, Mantegna, too, has turned his figure's head to its right and supplied the missing attributes for analogous compositional reasons. He has also, as we have seen, reversed the stance of his two models to adjust their ponderation to the demands of his group—aesthetic demands different from those confronting Raphael in his long, frieze-like composition. This reversal in ponderation, affecting the line of the shoulders as well as the stance, is the basic difference between the painted figures, both of which are provided with the winged petasos and mantle of their antique prototype and reflect its missing left hand. The hand of Mantegna's Mercury, in particular, through whose fingers the abnormally long caduceus passes, gives the impression of having been artificially attached to its forearm, an impression that reinforces the connection between this figure and the damaged statue. And even though he has manipulated the mantle that is virtually an attribute of such antique figures of Mercury into a characteristically calligraphic garment that flutters over his Mercury's shoulder and swirls beneath Pegasus' body, he has retained the effect of a less standard feature of his model's cloak—that it is wrapped around the forearm.

In addition to elaborating the cloak of his sculptured prototype into a windblown, billowing mantle and restoring to his Mercury the caduceus doubt-

[121] In denying that Mantegna's Mercury reflects any specific statuary prototype, however sculptural his appearance, Picard, *op. cit.* (above, n. 11), p. 126, has overlooked this lost prototype.

less once held by that statue,[122] Mantegna has provided his figure with two attributes that the statue surely lacked, a syrinx and winged boots. His motivation in depicting Mercury as a god of music, inventor of both Apollo's lyre and the shepherd's pipes, is best postponed to a later point in this analysis. But that Mercury was inventor of the syrinx, that it therefore constituted one of his attributes, was a commonplace known both from ancient literature[123] and from the text and accompanying illustration describing the appearance of Mercury in the *Libellus de imaginibus deorum,* that influential mythological handbook with whose contents and imagery Mantegna has been shown to have been familiar, whether directly or indirectly.[124] Obviously, the grotesque appearance of Mercury in the *Libellus* (fig. 38)[125] can have held no attraction for an antiquarian-minded artist to whom genuine antique monuments were available, and, equally obviously, it cannot have been difficult for him to replace the shepherd's pipe of this late medieval iconographic tradition with an authentic syrinx—the object specified in the text of the *Libellus*[126] but not represented in the accompanying drawing.[127]

The boots with which Mantegna has shod his Mercury afford another graphic illustration of the fashion in which he transformed the late medieval imagery of the *Libellus,* replacing it with more authentic—or seemingly authentic—antique forms. Following the prescription of wings at both the head and heels of the god,[128] he has altered their form, replacing the directly attached

[122] I shall return to the atypical form of this standard attribute below.

[123] E.g., the Homeric Hymn to Hermes, for which see below, n. 136.

[124] Above, pp. 98f.

[125] Ms. Reg. lat. 1290, fol. 2r, reproduced by Liebeschutz, *op. cit.,* pl. XVIII.

[126] *. . . fistulansque de calamo factam Syringe ad os suum ponebat, dextra sonans.* It is futile to speculate on the means whereby Mantegna became acquainted with the appearance of a genuine syrinx, given the occurrence of this instrument on countless varieties of ancient monuments. But cf. Emanuel Winternitz, "The Inspired Musician, A Sixteenth-Century Musical Pastiche," *The Burlington Magazine,* 100 (1958), pp. 3f., especially n.

14, for reference to the correct depicting of the seven-pipe syrinx and the fact that, on the advice of Poliziano, Filippino Lippi modeled a correctly represented syrinx after an antique sculpture.

[127] It is tempting to think that in placing the syrinx close to Mercury's lowered left hand, Mantegna may have been consciously or unconsciously affected by the position of the fateful tablet (letter) that Bellerophon seems to have held in his lowered left hand on the sarcophagus which provided him with the model for his group of Mercury and Pegasus. Cf. fig. 16, above, and Robert, *op. cit.* (above, n. 30), III, pt. 1, p. 41, and n. 49, above.

[128] *Erat ipsius signum homo unus, qui in capite et in talis alas habebat.*

Enus quam tenet int planetas locu qp qd qnto loco figurabat. Pingebat go venus
puela pulceriu nuda et i mani natis et i manu sua dextra conchas marinas
contines atqz gestas. Que uero rosis candidis et rubeis sertu gerebat in capi-
te ornatu et columbis circa se uolantibz comitabat. Vulcano deo ignis rustico turpissimo
in uulgari erat assignata q stabat ad ei dextru et cora ipa tres astabat Iuuenculle et
nude q tres gratie dicebantur. Ex qbz duas facies uersus nos aduerse erat tercia uo dor-
sum in gtrarius uertebat, hinc et cupido fili suus alatus rece assistebat q sagita et artu
quos tenebat applinie sagitauerit qp qd deos d se turbatos timens ad matris gremium
fugiebat eu et illa sinistra pingebat.

Ercurius sextus i ordie planetaru sic raliz ab antiqs getilibz sextus deus se di-
cebat cuis v magies in huic moru pingere uoluerit. Erat eius ipi s zuu ho vn
q in capite et in talis alas hebat. In manu eius sua leua uirgaz tenebat que
uirtute hebat soporifera et q erat serpetibz circusepta et gladius curuu que homo pe uira-
bat fistulas qz de calamo fac syringe ad os suu apponebat eus dextra qi sonas Sileni-
us qz sen capellu capite deportabat. Cora ipo aut erat gallus sibi spalis osecratus. Ab
altera uo parte eius erat argus cuis caput et facies plena oculis erat, q cora eo iacebat de-
colatus. Iste qo dius e deus mercator et deus furtor. Et io ab alus eius latere erat depicta mercator...
eius mercibz aligbz et latro q ipi mercatori bursas abscidebat. Eloquietia aut in fistula de-
signata qd de uiro in femina et de femina in masculis se mutabat eu uolebat. Et io pinge-
batur eius uiro q sexu. De albis uo nigra et de nigris alba faciebat, qd ondit eis pyleus
semialbus et seminigrus. Aliquo eus cui capite canino pingebar. Ideo qz etz lancea p viri-
li et colum p mulieribz sexu tribuerut.

38. Ms. Reg. lat. 1290, fol. 2r. Rome, Biblioteca Apostolica Vaticana

members of earlier tradition by winged gear. The antique statue that served as the model for his figure could provide him with an authentic winged petasos, but it lacked the obligatory winged feet. In devising the unique feathered boots worn by his Mercury, Mantegna seems to have drawn on the open-toed laced boots long familiar to him from Roman cuirass statues—witness their appearance on the armed figures in his early painting, *The Trial of St. James before Herod Agrippa,* in the Chapel of the Eremitani in Padua (cf. figs. 12, 39). But no ancient monument known to the painter directly can have provided a model for the most essential and singular feature of Mercury's boots—the pair of wings at the back of each high boot that at once carry on the tradition and alter the form of a pair of wings at the god's heels.

This unantique feature of Mantegna's otherwise so authentic figure of Mercury must reflect the influence of still another drawing by Cyriacus of Ancona, a drawing widely circulated and of exceptional influence in the Quattrocento both in Italy and elsewhere. It is known today from two copies, one in the Bodleian Library in Oxford (fig. 40), the other in the Staatsbibliothek in Munich (fig. 41). The former is included in a manuscript written near Urbino in 1474 which contains geographical treatises copied by Cyriacus, as well as excerpts from his letters and a number of his drawings;[129] the latter, drawn by

[129] Ms. Can. Misc. 280. This tinted pen drawing occurs on fol. 68r. Flesh and hair, pale tan; cap, pale olive-green; mantle, softer olive-green; boots, light rusty-brown; kerykeion, pink; snakes, white—i.e., outlined and dotted. The colors have been sloppily added to this hesitant pen sketch, frequently overlapping it or, at times, being unintentionally omitted (e.g., the portion of cloak over the left thigh is colorless). Like the Muse on fol. 138r of the Codex Ashmolensis and numerous other drawings in this same manuscript, the figure of Hermes has been defaced by later additions in black ink, in this case, by a mustache and genitalia and presumably, too, the curious object toward which Mercury appears to point (can this be a variation on the symbol associated with the planet Mercury and frequently seen in Quattrocento woodcuts as, for example, in fig. 63, below? If so, the defacer was well informed about such signs, which, it is interesting to note, occur in Cyriacus' hand on fol. 89v of the Berlin manuscript mentioned above, n. 86, where a full set of the seven planetary signs appears). For this manuscript, see Saxl-Meier-Bober, *op. cit.* (above, n. 69), pp. 340f., pl. XV, fig. 39; Otto Pächt, *Italian Illuminated Manuscripts from 1400 to 1550,* Catalogue of an Exhibition Held in the Bodleian Library, Oxford, 1948, no. 44, p. 16; and, most recently, Charles Mitchell, "Ex libris Kiriaci Anconitani," *Italia medioevale e umanistica,* 5 (1962), pp. 283–299, where it is convincingly argued that the entire Bodleian manuscript is only one step removed from a manuscript in Cyriacus' hand. Completed ca. 1447–1448, that autograph included the 1422 version of Cristoforo Buondelmonti's *Liber insularum,* a treatise with which the Bodleian manuscript opens (fols. 2r–67v). It is followed immediately thereafter (fol. 68r) by the drawing of Hermes-Mercurius. I am indebted to Edward W. Bodnar for having called my attention to this important article.

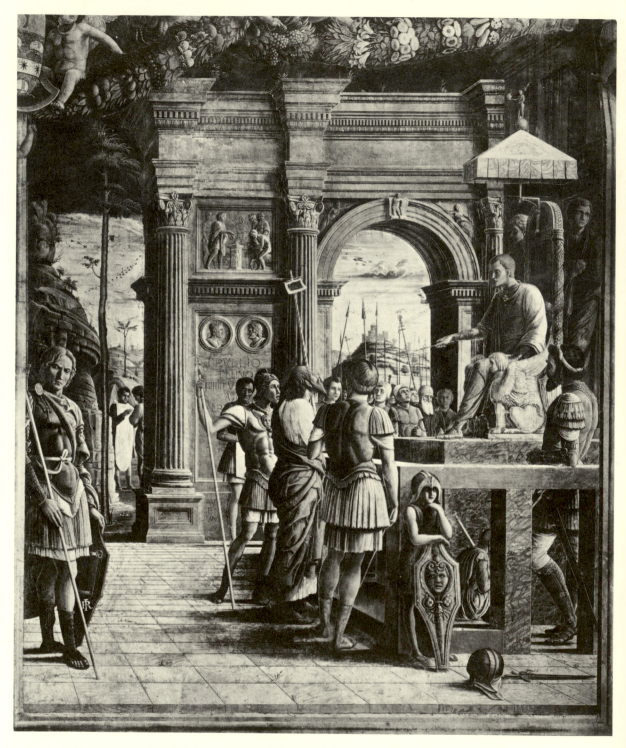

39. Mantegna, *The Trial of St. James before Herod Agrippa*. Padua, Chapel of the Eremitani

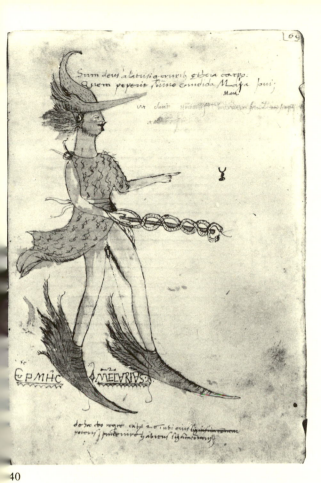

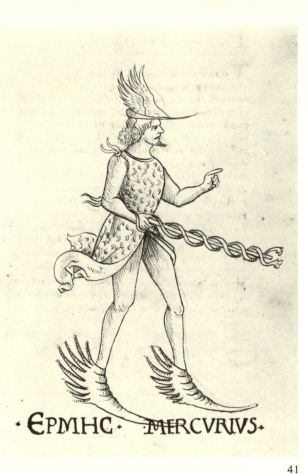

40

41

40. Ms. Can. Misc. 280, fol. 68r. Oxford, Bodleian Library

41. Ms. Lat. 716, fol. 38r. Munich, Staatsbibliothek

42. Detail of archaistic relief from Panticapeum. Odessa Archaeological Museum

42

Hartmann Schedel, also appears among drawings and excerpts from Cyriacus' diaries.[130] Labeled in both Greek and Latin in characteristic capitals, they show a bearded Mercury clad in fluttering short chiton and winged hat and boots, bearing a caduceus in his right hand and pointing with his left.

Again, it has long been recognized that the model for this drawing must have been an archaistic relief in which the god was represented striding forward, caduceus in hand, wearing a winged petasos and a short chiton—some such figure, it has been proposed, as the representation of Hermes on an archaistic relief in Odessa (fig. 42).[131] This relief cannot itself have been Cyriacus' model.[132] But the figure he recorded must have been similar, if less

[130] Cod. Lat. 716. This pen drawing in black ink apart from the red capital of EPMHC appears on fol. 38r. For this manuscript, see *Catalogus codicum latinorum bibliothecae regiae monacensis*, I, 1, Munich, 1892, p. 181; O. Jahn, "Intorno alcune notizie archeologiche conservataci da Ciriaco di Ancona," *Bullettino dell' Instituto di Correspondenza Archeologica*, 1861, pp. 180ff.; Emil Reisch, "Die Zeichnungen des Cyriacus im Codex Barberini des Giuliano di San Gallo," *AM*, 14 (1889), p. 226, n. 3; Otto Rubensohn, "Paros," *AM*, 25 (1900), pp. 349ff. As Reisch pointed out, *loc. cit.*, the provenance of the model of Cyriacus' drawing is uncertain. The preceding folios, 31–37, record monuments seen on Mykonos and Delos in 1445, those immediately following it, monuments on Naxos and Paros.

[131] Archaeological Museum, Inv. No. 50037. For this relief, see Salomon Reinach, "Un bas-relief de Panticapée (Kertch) au Musée d'Odessa," *Fondation Piot, Monuments et Mémoires*, 2 (1895), pp. 57ff., pl. VII. The statement that Cyriacus' drawing must reflect a relief like that published by Reinach (indeed, by implication, that that relief actually served as his model) was made by Fritz Saxl, "Rinascimento dell' antichità," *Repertorium für Kunstwissenschaft*, 43 (1922), pp. 252ff., and repeated by Erwin Panofsky and Saxl in a now classic article, "Classical Mythology in Mediaeval Art," *Metropolitan Mu-*

seum Studies, IV, 1932–1933, pp. 258, 265, fig. 45. Following Reinach's mistaken view, they described the relief in Odessa as archaic rather than archaistic—a mistake that has been repeated by subsequent writers (as recently as Mitchell, "Ex libris Kiriaci," p. 298, and Wind, *Pagan Mysteries in the Renaissance*, p. 121, n. 30), although Panofsky corrected it in his *Albrecht Dürer*, Princeton, 1943, II, p. 96, no. 936. There can be no question that the relief is archaistic rather than archaic, as Adolf Furtwängler, "Von der Reise," *Berliner philologische Wochenschrift*, 8 (1888), col. 1516, and Friedrich Hauser, *Die neu-attischen Reliefs*, Stuttgart, 1889, p. 163, n. 3, had earlier recognized. Cf. now Harrison, *op. cit.* (above, n. 85), p. 60, where it is described as "an archaistic relief, probably of Hellenistic date" and attributed to a "north Ionian artist."

Knabenshue, *op. cit.* (above, n. 26), p. 72, n. 85, following Panofsky and Saxl in the assumption that the Bodleian drawing represents an archaic Hermes, rejects their proposed model, preferring to see in the drawing a free translation, in the pictorial terms of middle Byzantine illumination, of a Greek gem. I find the comparison adduced unconvincing.

[132] Given the fact that Cyriacus' drawing and this figure differ in a number of respects (e.g., the precise position of the right arms; the form of their garments; the circumstance that one is provided with

well preserved. The winged hat that he drew is a hybrid between a genuine winged petasos and a contemporary broad-brimmed, peaked shepherd's hat,[133] and his long-toed boots spurred with feathers from top to bottom are without precedent. One can only assume that confronted, a second time, with a weathered relief, he interpreted its worn details as best he could, now responding to it in contemporary terms, now interpreting what he saw through his knowledge of ancient literature—precisely as he saw in the archaistic frieze of dancing maidens in Samothrace figures corresponding to the Muses and Samothracian Nymphs known to him from some of his favorite ancient authors.[134] It is tempting to imagine him eagerly scrutinizing this figure of his patron saint[135] and summoning from his well-stocked memory the passage in the Homeric Hymn to Hermes where the god makes for himself marvelous sandals:

> Then he wove sandals with wicker-work . . . wonderful things, unthought of, unimagined; for he mixed together tamarisk and myrtle twigs, fastening together an armful of their fresh, young wood, and tied them, leaves and all, securely under his feet as light sandals.[136]

winged boots, the other with a pair of wings at each ankle), that, unlike the Samothracian "Muses," this figure of Hermes is sufficiently well preserved to have precluded its being misinterpreted by Cyriacus, and that it is one of four figures on an incompletely preserved relief, it is exceedingly unlikely that it was the model for his drawing. In view of his documentary and mythological interests, he would surely not have excerpted one figure from such a relief rather than drawing them all—as he drew all thirteen of the Samothracian figures. Jean Seznec's statement that the relief from Panticapaeum "is an exact replica of the one seen by Cyriacus" overlooks the differences between the relief and Cyriacus' drawing, although his Hellenistic-archaistic date for it is correct. See *The Survival of the Pagan Gods* (Bollingen Series XXXVIII), New York, 1953, pp. 200f.

[133] Cf., for example, the hat worn by Tristan on the North Italian birth-plate illustrated below in fig. 59. The educated Schedel's copy is the more reliable in depicting this hybrid headgear, his broad-brimmed hat being provided with the proper pair of wings surely present on Cyriacus' petasos, whereas the less well-informed copyist of the Oxford manuscript has converted the more distant wing into a curving peak.

[134] Cf. his similar reaction in interpreting the bust of an unidentified bearded man as Aristotle, above, pp. 15ff.

[135] See Georg Voigt, *Die Wiederbelebung des classischen Alterthums*, 4th edn., unchanged, Berlin, 1960, I, p. 285, for Cyriacus' invocation to Mercury.

[136] Lines 79ff., quoted from the translation by Hugh G. Evelyn-White, *Hesiod, The Homeric Hymns, and Homerica* (above, n. 61), p. 369.

Cyriacus is known to have possessed manuscripts of Homer and Hesiod. (Cf. Ziebarth, "Cyriacus . . . als Begründer" [above, n. 95], p. 225.) Since manuscripts

Can this description have provided one ingredient of the strange boots Cyriacus drew, those befeathered flippers? In any case, whatever the basis for Cyriacus' interpretation, he cannot have seen such boots on any ancient monument, nor would he have totally fabricated them, for such was not his practice. But once his Mercury had been drawn and equipped with this unique footgear, it would certainly have been accepted as authentic, as a genuine feature of the god's appearance in antiquity.

None of Cyriacus' drawings can have been more popular or influential.[137] Sent to friends, it was itself the subject of poems, caused Cyriacus to be hymned as Our Mercury, the New Mercury, Mercury from Ancona, and provided the iconographic basis for representations of the god in miniatures and woodcuts, on the *tarocchi*, on medals and *cassoni*, in paintings in Italy[138] as well as in Germany, where it was known to Dürer via Hartmann Schedel's copy.[139] Schedel, who studied medicine in Padua in the very years when Mantegna and his friends searched for antiquities on the Lake of Garda and Feliciano wrote his copy of Scalamonti's life of Cyriacus and excerpted inscriptions from the traveler's diaries, presumably made his own copies of Cyriacus' drawings, letters, and inscriptions from originals or copies available to him in Padua. Very possibly, Mantegna and Schedel knew the same drawing of Cyriacus' Hermes. In any case, a copy of this celebrated drawing was certainly available to Mantegna, and it is plausible to assume that it provided the painter with the model for the most unorthodox feature of his blue-green

of both Homer and Hesiod occasionally include the so-called Homeric Hymns, as does the first printed edition of Homer (Florence, 1488), he was in all probability familiar with this poem. For the extant manuscripts of the Homeric Hymns (for the most part written in the fifteenth century), see Evelyn-White, *op. cit.*, pp. XLVIf., and Jean Humbert's edition, *Homère, Hymnes*, Paris, 1936, pp. 11ff.

[137] Cf. Saxl, "Rinascimento," pp. 252ff.; Jahn, *op. cit.*, pp. 183ff., 346ff.; and Voigt, *op. cit.*, pp. 284f.

[138] As far as I am aware, it has not been observed that both the figure of Mercury coupled with Mars in one of the hexagons in the Sala di Galatea and the figure of the god in Peruzzi's painting of the *Rape of Europa* in the Stanza del Fregio of the Farnesina are also dependent on this same iconographic tradition. For illustration of the former, cf. Hermanin, *op. cit.* (above, n. 59), pl. VIII; for the latter, pl. XXXI. The singular brimmed, winged hat worn in each case is especially telltale.

[139] Cf. Jahn, *op. cit.*, pp. 184, 348ff., and Panofsky, *Albrecht Dürer, loc. cit.*

boots—the feathered wings at their back.[140] In revising the late medieval iconographic type for the planet Mercury and replacing the hitherto unantique image of the god by an authentic antique figure, he has once again drawn on the authority of Cyriacus.[141]

Nonetheless, the verbal tradition of the *Libellus* continued to play a part in shaping the new imagery created by Mantegna. In equipping Mercury with a syrinx, he followed a requirement of its text.[142] That text also demanded a *virga*, the magical wand that induces sleep.[143] But it is not the source of a singular feature of the abnormally long caduceus held by Mantegna's Mercury: the sprig of leaves[144] in which it terminates, its calyx flanked by the requisite pair of wings associated with this attribute, its green stem encircled by the canonical snakes.[145] In devising this caduceus, Mantegna may have been influenced by another model—the caduceus carried by Mercury in illustrations of Hyginus' *De descriptionibus formarum coelestium*. There, too, the god's staff blossoms at its upper end in an analogous foliate form, and the calyx is flanked by wings (fig. 43).[146]

[140] Wind's comment in *Pagan Mysteries in the Renaissance* (above, n. 16), p. 121, n. 28, that the boots of Mantegna's Mercury are typical of representations of the god in the Quattrocento and his reference to similarly-clad figures on the *tarocchi* overlook the fact that this closely related set of figures is based on a common prototype, Cyriacus' Mercury.

[141] In view of the availability of the Homeric Hymns (above, n. 136), it is conceivable that this passage was known to Mantegna as well as to Cyriacus and that the green boots of his Mercury reflect Hermes' exotic sandals.

[142] Above, p. 123.

[143] Fol. 2r: *in manu autem sua laeva, virgam tenebat, quae virtutem habebat soporiferam, atquae erat serpentibus circum septa.* Cf. Liebeschutz, *op. cit.* (above, n. 64), p. 119, pl. XVIII. For reference to the sleep-giving property of the caduceus, see Virgil, *Aeneid* 4.242–244.

[144] The green stem emerging from this calyx sprouts six leaves, four at the top, two lower down, beneath the serpents' heads. Unlike this pair of deep green leaves, the upper cluster has lost some of its original color and today looks gray-greenish white.

[145] See Charles Daremberg and Edmond Saglio, *Dictionnaire des antiquités grecques et romaines*, III², Paris, 1904, p. 1808, s.v. *Mercurius*, for the form and implications of this standard attribute.

[146] See above, for example, fig. 43, from *C. Iulii Hygini . . . fabularum liber . . . Eiusdem poeticon astronomicon . . .* , Basel, 1549, p. 104, in one of the early printed editions of this text. I suspect that this woodcut is dependent upon the iconographic tradition of the manuscripts underlying the sixteenth-century editions, although I have not had an opportunity to check this suggestion.

43. Hyginus, *De descriptionibus
formarum coelestium*: Mercurius

That the painter drew on the iconographic tradition of the classical litera-
ture on astronomy so popular in his day is apparent from his representation of
Pegasus. We have seen that his Pegasus is in essence a protome.[147] But unlike
the Winged Horse led by Bellerophon (fig. 16), this Pegasus is not simply
the forepart of a normal horse provided with wings—the forepart of one of
the beasts cherished by the horse-loving Gonzagas, of some such horse as the
splendid animal Mantegna had painted long earlier in the Camera degli Sposi
(fig. 44). Nor does this strangely unreal creature with a shaggy beard and
beaded harness resemble the Winged Horse traditionally associated with Apol-
lo and the Muses in the kind of late medieval mythological treatise from which
Mantegna seems to have derived a number of details in the *Parnassus* (cf.,
for example, fig. 47, below). On the contrary, he has drawn on a still more
venerable iconographic tradition in shaping his Pegasus: illustrations of the
Winged Horse as the constellation Equus.

On the Star Mantle of Emperor Heinrich II in the Treasury of Bamberg
Cathedral (fig. 45), that extraordinary product of the early eleventh century
on which pagan and Christian images mingle in a hierarchical scheme, the

[147] Above, p. 70.

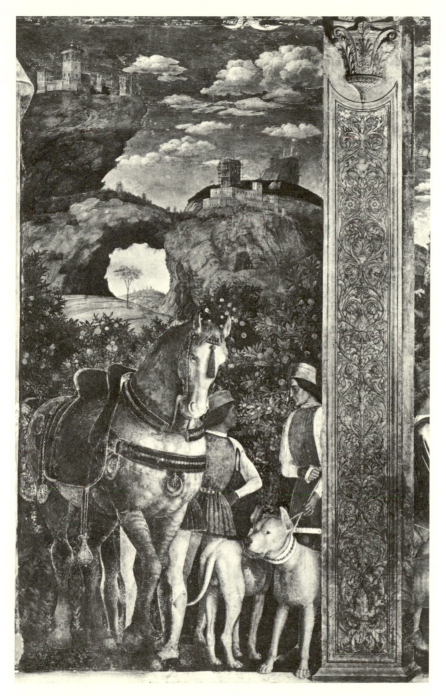

44. Mantegna, Camera degli Sposi: detail. Mantua, Palazzo Ducale

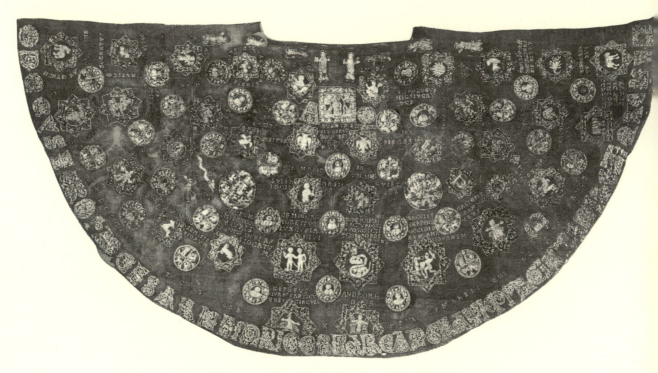

45. Star Mantle of Emperor Heinrich II. Bamberg, Cathedral Treasury

various constellations appear in canonical fashion.[148] Among them is the Winged Horse, "Pegasus, the Horse Consecrated to the Muses," as the legend embroidered about him explains.[149] He appears as a protome, shown in profile, a standard image for the constellation Equus. The astrological types on this bespangled mantle have been shown to derive from a vulgar recension

[148] For this imperial mantle given to the Emperor by the Duke of Apulia and later made into a cassock, see Robert Eisler, *Weltenmantel und Himmelszelt*, Munich, 1910, I, pp. 5ff.; Wilhelm Messerer, *Der Bamberger Domschatz*, Munich, 1952, pp. 10f., 54ff., pls. 49, 50; E. Zinner, "Die astronomischen Vorlagen des Sternmantel Kaiser Heinrichs," *XXXIII. Bericht der Naturforschenden Gesellschaft*, Bamburg, 1952, p. 41; and, for additional bibliography, *Berner Kunstmuseum, Kunst des frühen Mittelalters*, Bern, 1949, pp. 78f., no. 191, and *Sakrale Gewänder des Mittelalters*, Munich, 1955, p. 18, no. 19.

[149] Pegasus Eq(u)us Musi(s) Consecratus.

of manuscripts of the Hellenistic poet, Aratus,[150] whose versified version of Eudoxos of Knidos' *Phainomena*, the earliest Greek treatise on the constellations, was highly prized by the astrological-minded humanists of the Quattrocento.[151]

Both the text describing the constellation Equus in the *Phainomena* and the illustration accompanying it, and the parallel text and illustration in the *Aratea* of subsequent Roman authors, including Hyginus, are relevant to the *Parnassus*. After describing the position of the Horse in the heavens and remarking on the brilliant stars shining on his body, especially on his flank and shoulders, Aratus continues:

> Parted at the navel, with only half a body, wheels in heaven the sacred Horse. He it was, men say, that brought down from lofty Helicon the bright water of bounteous Hippocrene. For not yet on Helicon's summit trickled the fountain's springs, but the Horse smote it and straightway the gushing water was shed abroad at the stamp of his forefoot and herdsmen were the first to call the stream the fountain of the Horse (Hippocrene). From the rock the water wells and never shalt thou see it far from men of Thespiae; but the Horse himself circles in the heaven of Zeus and is there for thee to behold.[152]

The illustration accompanying the description of the constellation Equus in numerous manuscripts both of Aratus and his followers written in Italy in the Quattrocento shows the half-horse in profile, his body spangled with the stars so specifically mentioned, especially by Hyginus.[153] In these delicate

[150] Ernst Maass, "Inschriften und Bilder des Mantels Kaiser Heinrichs II," *Zeitschrift für christliche Kunst*, 12 (1899), pp. 321ff., 361ff. For this antique iconographic tradition and the most important extant illustrated manuscripts of Aratus' poem and the subsequent *Aratea*, see Georg Thiele, *Antike Himmelsbilder*, Berlin, 1898, especially pp. 45, 76ff., 89, 153, 168ff., and, for the specific passage and illustration cited here, p. 108, fig. 32. Useful brief statements on this topic are given by Panofsky-Saxl, "Classical Mythology," pp. 231ff., and Franz Cumont, s.v. *Zodiacus*, in Daremberg and Saglio, *Diction-*

naire des antiquités grecques et romaines, V, Paris, 1919, pp. 1046ff.

[151] See B. Soldati, *La poesia astrologica nel quattrocento*, Florence, 1906, especially pp. 13ff., 21, 75f., for the popularity and influence of this poem known at least as early as 1438.

[152] Quoted from the translation of G. R. Mair in *Callimachus, Lycophron, Aratus*, tr. by A. W. Mair and G. R. Mair, Loeb edn., New York, 1921, p. 398, lines 214ff.

[153] For example, Vatican Mss. Barb. lat. 76, fol. 32r; Barb. lat. 77, fol. 20r; Urb. lat. 1358, fols. 18v and 130r; Vat. lat. 3099, fol. 15v; Vat. lat. 3109, fols.

pen drawings, the gray-washed body of the Horse is dotted with circles of scarlet or gold indicative of the stars. It can hardly be a pure coincidence that Mantegna's singular Pegasus is also a protome (if, for obvious artistic reasons, shown from the front) and that over the chest and flanks of his gray body he wears his curious harness of colorful circular beads, some red, some yellow. Surely these basic features of Mantegna's Pegasus were shaped under the influence of some such illustration of the constellation Equus as the example shown in fig. 46, from a fifteenth-century Italian manuscript containing fragments of Aratus and his commentators.[154] Here the conventional half-horse is dotted with scarlet circles, and his big calligraphic wings as well as the little hairs at the top of his leg are remarkably analogous in type to the spreading wings and hairy body of Mercury's shaggy companion. A further detail links Mantegna's Winged Horse with the description of the constellation Equus in yet another astrological text, doubtless the most influential of them all—the *Fasti* of Ovid:

> And now when the stars shall spangle the blue sky, look up: you will see the neck of the Gorgonian steed. . . . Now he enjoys the sky to which aforetime he soared on wings, and he sparkles bright with fifteen stars.[155]

39r and 57r; Vat. lat. 3121, fol. 12v; and others, including the earlier Vat. lat. 3110, fol. 71r. See Saxl, *Verzeichnis*, I (above, n. 64), pp. 4ff., 88ff., 103ff. In the printed successors to these manuscripts, this standard type was retained to illustrate the text, now in the form of a woodcut. Cf., for random examples, Hyginus, *Poeticon astronomicon*, Venice, Erhard Ratdolt, 1485, and *Scriptores astronomici veteres*, Venice, Aldus Manutius, 1499.

For the enormous influence of the manuscripts of Hyginus in Quattrocento Italy, particularly in court circles, see Saxl-Meier-Bober, *op. cit.* (above, n. 69), pp. LIIIff., and Patrick McGurk, *Catalogue of Astrological and Mythological Illuminated Manuscripts of the Latin Middle Ages*, IV, *Astrological Manuscripts in Italian Libraries (Other than Rome)*, London, 1966, pp. XIVff.

[154] Vat. Barb. lat. 77, fol. 20r. See Saxl, *Verzeichnis*, I, p. 6, for this manuscript containing, in addition, excerpts from Pliny's *Naturalis historia* and Hyginus.

[155] 3.449f., 457f.: *iamque, ubi caeruleum variabunt sidera caelum,*
 suspice: Gorgonei colla videbis equi.
 .
 nunc fruitur caelo, quod pennis ante petebat,
 et nitidus stellis quinque decemque micat.

Quoted from the text and translation of Sir James George Frazer (Loeb edn., New York, 1931), pp. 153f.

46. Ms. Barb. lat. 77, fol. 20r: the constellation Equus. Rome, Biblioteca Apostolica Vaticana

perseo autem liberata est et ob id persea dicta be
nesunoq, minerue astris recepta est. Euripides ea
dicit inter astra collocatam ut labor persei eter
nus pateret manibo eius extensis quemadmodu
cetui apposita est que cum a perseo liberata esset
patri neq, matri uoluit commorari Sed conunuo cu
perseo argis profecta est. Habet stellas in capite
claram unam in singulis humeris singulas: in
singulis cubitis singularas claras. in dextera
manu claram unam in eodem brachio claras
duas in gena tres Sub gona quatuor in singulis
genibus claras singulas. in dextro pede duas in
sinistro unam Sunt omnes xx

Andromede uero radiat qua stella sub ipsa
Albo fulget equus tres armo sed latera equis
Distinguint spatio capiti tristissima forma
Et ceruix sine honore obscuro lumine sordet
Spumam mandet sed que ore lupato
Et capite et longe insignior exit ceruice

Once again, it can hardly be by chance that the linked harness on Pegasus' shaggy body includes precisely fifteen beads![156]

Not only was the *Fasti* at hand in the ducal library at Mantua,[157] not only were manuscripts of Aratus and Hyginus surely accessible to Mantegna,[158] but he also lived in a society in which astrology, hence such texts, played a major role.[159] It is needless to elaborate at this point on Isabella's known predilection for astrology.[160] The taste and temper of the painter's patrons will be sufficiently clear if we recall that Isabella arrived in Mantua on February 15, 1490, four days after her marriage at Ferrara, because that day was construed by astrologers to be an auspicious one, and that on this occasion the wedding guests witnessed appropriate pageants, including one devoted to that popular subject, the seven planets.[161] Brought up on classical literature in a palazzo adorned with conspicuous astrological paintings and accustomed

[156] The text of Aratus does not specify the total number of stars in the constellation Equus. In the *Aratea*, they are said to be eighteen. Given the special authority and popularity of the *Fasti*, it is not surprising that it was this text that Mantegna followed in providing Pegasus with fifteen beads.

[157] In two copies. See Alessandro Luzio and Rodolfo Renier, "La coltura e le relazioni letterarie di Isabella d'Este Gonzaga," *Giornale storico della letteratura italiana*, 42 (1903), pp. 79f., nos. 78, 98, and Giulio Bertoni, *La biblioteca estense e la coltura ferrarese ai tempi del Duca Ercole I (1471–1505)*, Turin, 1903, pp. 62 and n. 2, 110, 218, nos. 60, 66, for its presence still earlier in the library of Borso d'Este.

The fact that more than a hundred manuscripts of the *Fasti* are extant is an index to its popularity. See Frazer, *op. cit.*, pp. xxiff.

[158] Cf. Soldati, *op. cit.*, especially pp. 21, 75f. It is worth noting that Ms. 260 in the Fitzwilliam Museum, Cambridge, a fragmentary illustrated Hyginus written in northern Italy between 1470–1480, later belonged to Leonora Gonzaga, Isabella's

eldest child (cf. Saxl-Meier-Bober, *op. cit.*, pp. 439f.). Although the illustration of Equus on fol. 15r of this manuscript is less analogous in details to Mantegna's Pegasus than that of Vat. Barb. lat. 77 reproduced above and cannot, therefore, be adduced as the specific model for his winged horse, Leonora's ownership of this manuscript attests the continuing interest among the Gonzagas in this category of manuscript and its accessibility at the Court of Mantua.

It is interesting to note that the oldest and best manuscript of Aratus, Marcianus 476, written at Serres in Macedonia in the eleventh century, was owned by Cardinal Bessarion, in whose library it came to Italy. See G. R. Mair (above, n. 152), p. 364, and Soldati, *op. cit.*, p. 75.

[159] For a general characterization of the contemporary attitude toward astrology, see the well-known statement of Jacob Burckhardt, *The Civilization of the Italian Renaissance in Italy* (tr. by S. G. C. Middlemore), New York, n.d., pp. 268ff.

[160] See, for example, Jan Lauts, *Isabella d'Este, 1474–1539* (tr. by Germaine Welsch), Paris, n.d., pp. 135f., 212f.

[161] *Ibid.*, pp. 16ff.

to the presence of court astrologers,[162] Isabella would have grasped the implication of Pegasus' beaded harness. Doubtless this iconographic translation, at once learned and playful, would have delighted her. How much more immediately apparent must it have been to Isabella and her learned circle that the mutually absorbed pair of figures who dominate the foreground of the *Parnassus,* the mythologically unorthodox group of Mercury and Pegasus, is in fact an image of the planet Mercury and the constellation Equus, not simply a representation of the inventor of the lyre and syrinx, the patron saint of travelers and merchants, and the Winged Horse associated with the Muses. Hence Mantegna's use of astronomical texts and illustrations in shaping this most complex of all the groups in the painting, a group in which he has once again combined medieval iconographic tradition with authentic antique imagery.[163]

The implications of this group, the significance of this pair of figures within the context of the *Parnassus,* is best postponed until the sources of Vulcan, last and smallest of the figures in the painting, have been considered. Before leaving it, however, it may be worth commenting on one more feature of this portion of the painting. Surely, the spring flowing at Pegasus' feet (figs. 1, 34) is an allusion to the Hippocrene struck from the rock by a stamp of his forehoof. And confronted with the landscape immediately above and behind the group, it is tempting to think that the passage in Aratus quoted above is

[162] For the degree to which life at the Court of Ferrara was governed by astrology and astrologers, see Edmund G. Gardner, *Dukes and Poets in Ferrara*, New York, n.d., pp. 46f., and Warburg, *op. cit.* (above, n. 63), pp. 473ff.; for court astrologers at Mantua and Milan and the astrological treatises in the ducal library at Mantua, Luzio-Renier, *op. cit.*, 35 (1900), pp. 254f.; Soldati, *op. cit.,* pp. 108ff.; and Bertoni, *op. cit.*, pp. 192ff. See C. A. J. Armstrong, "An Italian Astrologer at the Court of Henry VII," *Italian Renaissance Studies* (ed. by E. F. Jacob), New York, 1960, p. 434, for reference to the popularity of astrological almanacs by the last decade of the fifteenth century and to the custom of having official astrologers prepare annual prognostications for the benefit of both rulers and citizens.

[163] Reference to Bellerophon in the text of the *Aratea* dealing with Equus-Pegasus as well as Ovid's fusion of Pegasus and the constellation Equus (*Fasti* 3.449ff.) must have made it seem especially appropriate to the painter to draw on a Bellerophon sarcophagus in shaping his group of Mercury-Pegasus-Equus. For the gradual fusion of Equus and Pegasus, see Boll-Gundel, s.v. "Sternbilder, Sternglaube und Sternsymbol bei Griechen und Römern," in W. H. Roscher, *Ausführliches Lexikon der griechischen und römischen Mythologie*, VI, Leipzig, 1924–1937, cols. 928ff., re: *Pferd*.

reflected here, that the pair of conical crags over whose terraced slopes a sparkling waterfall drops represents "lofty Helicon" and "the bright water of bounteous Hippocrene."[164] If so, in giving pictorial form to this poetic image, the painter has drawn on a late medieval iconographic tradition in which "the great and holy mount of Helicon" has acquired the twin-peaked form of Apollo's sacred mount, Parnassus, a contamination reflected in the illustration shown in fig. 47 from an *Ovide Moralisé* written ca. 1400,[165] where the Heliconian Muses wash their tender bodies in the Horse's Spring struck from one of a pair of craggy peaks presided over by Apollo and labeled Mons Helicon.[166] There Apollo and the twin peaks of Parnassus have been fused with the Muses' shrine on Helicon, and Hesiodic Muses bathe in the waters of Hippocrene. In this concentrated image, the Muses appear simultaneously in their own Boeotian setting and under the leadership of Delphic Apollo— and Helicon has become twin-peaked. Forced to represent the dancing Muses and their Parnassian leader in the context of the Winged Horse, Mantegna has provided his Pegasus with an appropriate setting derived from the imagery of both ancient literature and medieval illumination, creating a complex visual unit at once detached from the remainder of the scene yet linked with it. Given the complexity of the literary and visual sources underlying this portion of the painting, one wonders, finally, whether the authentic twin-peaked Parnassus of Ovid, Dante, and the influential *Libellus* is not present in the obliquely juxtaposed asymmetrical crags that frame the full scene—that is,

[164] Although he did not discuss this problem in his brief reference to Mantegna's painting, A. Venturi, *Storia dell' arte italiana*, VII, Milan, 1914, p. 239, also assumed that the distant peaks behind Mercury represent Helicon and the cascade pouring from them the waters of Hippocrene.

[165] In the Bibliothèque Nationale, Paris. Ms. fr. 871, fol. 116v. For this manuscript, a versified translation of Petrus Berchorius' *Metamorphoses Ovidiana moraliter explanata* (ultimately the source of the *Libellus*, it will be recalled), see Panofsky,

Renaissance and Renascences, p. 80, n. 2.

[166] Cf. the beautiful opening lines of the *Theogony*. In contrast with the Muses' home on "highest Helicon," Apollo's shrine at Delphi is twin-peaked—not only in such a familiar source as Ovid, *Metamorphoses* 1.216f., 2.221, but also in Dante, *Paradiso*, Canto 1, lines 13ff., and the influential *Libellus* where, it will be recalled, the Muses circle beneath an Apollo flanked by peaks correctly identified in the text as the two summits of Mount Parnassus, whence flow the waters of Castalia (above, fig. 26).

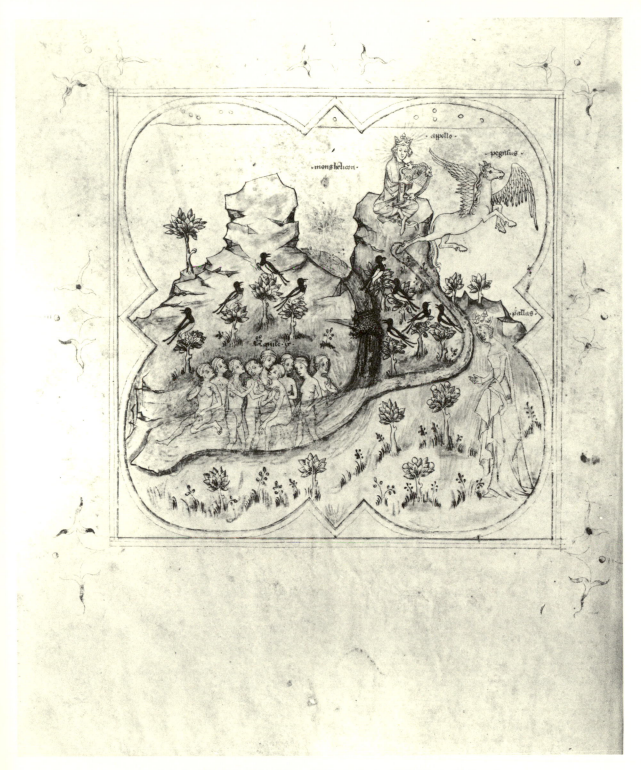

47. Ms. fr. 871, fol. 116v: Mons Helicon. Paris, Bibliothèque Nationale

whether the twin-peaked Helicon of the later Middle Ages has not itself become one of the two summits of Parnassus.[167]

NONE OF the figures in the *Parnassus* is more classical in appearance than Vulcan (fig. 48). The vigorous musculature of his active body is even more sculptural in form than that of the seated musician below him. Yet this nude god with shaggy beard and windblown hair whose cloak billows about him could not be identified as the God of Fire were it not for his habitat and the telltale objects that surround him, so greatly does he differ, for example, from the dignified figure of Vulcan clad in his traditional garb, the workman's *exomis* and *pilos,* on a late Republican altar or base in Civita Castellana (fig. 49).[168] But there, too, the god of heavenly fire retains his attributes as a divine artisan, for he holds the craftsman's hammer as well as the flaming torch that symbolizes his mastery over an element, and at his side tongs lie on an anvil.[169]

Nor does Mantegna's Vulcan resemble the craftsman of the *Libellus,* who wears an apron over his knee-length artisan's dress (fig. 50).[170] Expelled from

[167] Again, Strabo's specific statement (9.2.25) that Helicon is "not far distant from Parnassus" might well have encouraged this view. In assuming that the imagery of Mantegna's *Parnassus* and certain earlier Renaissance poems reflect a simple transposal of the Muses, Pegasus, and the Hippocrene from Helicon to Parnassus, probably as a result of the influence of Servius' commentary on *Aeneid* 10.163, Richard Foerster (*Francesco Zambeccari und die Briefe des Libanios*, Stuttgart, 1878, pp. 238f.) was evidently not aware that a visual as well as a literary tradition lies behind this feature of the painting. The literary tradition according to which Parnassus had been combined with the Pegasian fountain to become the dwelling place of the Muses was, evidently, at least as old as the late twelfth century: see Panofsky, *op. cit.*, pp. 71f.

For the suggestion that the landscape background of the *Parnassus* reflects the influence of the drama and stage sets, see Tietze-Conrat, *Mantegna*, p. 29.

[168] Now in the Cathedral. See Reinhard Herbig, "Römische Basis in Civita Castellana," *RM*, 42 (1927), pp. 129ff., Beilage 15–19; M. Rostovtzeff, *The Social and Economic History of the Hellenistic World*, Oxford, 1941, II, p. 950, pl. CIV; D. E. Strong, *Roman Imperial Sculpture*, London, 1961, no. 19, pp. 12, 89.

[169] For this powerful divinity honored with Mars and Venus by a victorious commander, see Herbig, *op. cit.*, pp. 144f.; Franz Altheim, *A History of Roman Religion* (tr. by Harold Mattingly), London, 1938, pp. 119, 150.

[170] On fol. 4v. See Liebeschutz, *op. cit.* (above, n. 64), p. 122 and pl. XXIII. A similar figure of the *deus ignis rustico turpissimo* holding a hammer in his right hand and fire in his left attends Venus on fol. 2r. The similarity between the figure of Vulcan at his forge in the *Libellus* and the barelegged craftsman clad in his *exomis* and working at his anvil, hammer in one hand, tongs in the other, on a Hellenistic grave stele in Berlin implies that the iconographic

heaven, the *deus ignium* appears as a smith, hammer in hand and, following the prescriptions of the text, works in his shop at a flaming forge while Jupiter's eagle flies toward him bearing a thunderbolt, the sacred fire from which the arts and crafts of civilized man will one day be produced.[171] Yet however different in appearance these smiths may be, each has his shop in a cave (a feature not required by the text of the *Libellus* that probably reflects Servius' commentary on Virgil),[172] and from each cave smoke or flames escape from a crevice in the rock—a singular feature which suggests that, once again, Mantegna has drawn on the *Libellus* in devising Vulcan's cave-workshop.[173] But just as he has discarded the medieval craftsman's bellows, so he has stripped him of his cumbersome costume, replacing it by classical nudity save for the swirling mantle indicative of the wind required for Vulcan's workshop by classical authority.[174]

If the influences that shaped Vulcan's cave-shop in the *Parnassus* are easily defined, the prototype for his atypical figure as the classical God of Fire is enigmatic.[175] No feature of his appearance is so unorthodox for a god as his head—that bearded, gnome-like face and shaggy mane of hair. Yet these very features are strikingly reminiscent of one of the figures of Marsyas on the sarcophagus from Sidon which has proved to be related to the lost sarcophagus that provided Mantegna with the model for his Apollo (fig. 19).[176] The bearded, shaggy-locked figure with low brow and snub nose visible behind a

tradition of the *Libellus* was dependent, whether directly or indirectly, on some genuine antique prototype. For this relief, see Salomon Reinach, *Répertoire de reliefs grecs et romains*, Paris, 1912, II, p. 37, no. 1.

[171] See below, n. 185. The illustration does not clearly reveal his deformity, lameness, as prescribed in the text.

[172] See Erwin Panofsky, "The Early History of Man in a Cycle of Paintings by Piero di Cosimo," *JWarb*, 1 (1937–1938), p. 20, for medieval and Renaissance knowledge of this passage in a widely-consulted ancient author. Two copies of Virgil and his commentators were available in Isabella's library. See Luzio-Renier, *op. cit.*, 42 (1903), p. 76, nos. 21, 25.

[173] See Panofsky, *op. cit.*, pp. 20f., for the fact that Piero di Cosimo drew on the iconographic tradition of the *Libellus*, too, in painting a scene representing *Vulcan, Assisted by Aeolos, as Teacher of Mankind*, executed in the same decade as the *Parnassus*.

[174] Again Servius, quoted by the same influential scholars, including Boccaccio. See Panofsky, *loc. cit.*

[175] The only sources previously suggested for this figure, Roman gems on which Diomedes sits or crouches, very tentatively proposed by Ilse Blum, *op. cit.* (above, n. 5), pp. 101f., present no satisfactory analogy to it in type, pose, gesture, or action, as the author herself stated.

[176] Above, pp. 89f.

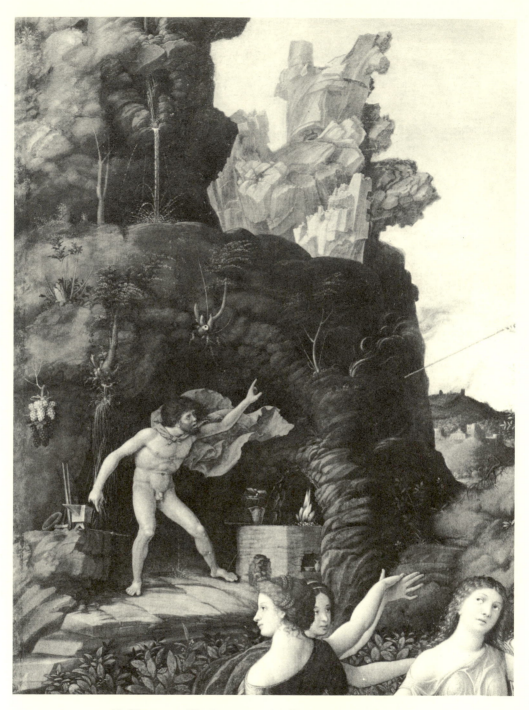

48. Mantegna, *The Parnassus*: detail of Vulcan in his cave

49. Late Republican base: detail of Vulcan, Venus and Mars. Civita Castellana, Cathedral

50. Ms. Reg. lat. 1290. Detail of fol. 4v. Rome, Biblioteca Apostolica Vaticana

Vlcanus deus ignum. pingebat in similitudine fabri deformis z claudi maleum i manu teneris z de ou impulsu de celo in terram cadeis. Iuxta eum plures dy eum irridentes pingunt. q eu de celo expellere figurat. Ipe est e expulsus fulmia in teris Iouis patris. dicebat. ique e ad celu Iouis ipi Aquila deferebat. Ideo qz uir ipz Bulcanu depzcta erat officina fabrilis. z aquila pizta us fulmina deferenda.

rocky ledge in a grotto-like hollow framed by trees in the upper left corner of the relief (fig. 51) is not only closer in type to Vulcan than any true representation of the god on an ancient monument could be, but he is also remarkably similar in other respects: in the proportions and modeling of his torso and arms, with its pronounced emphasis on the pectoral muscles and rib-cage, and in the fact that he, too, wears a cloak over his shoulder. On this sarcophagus, the satyr juxtaposed to Athena is shown half-length rather than as the full-size opponent of the goddess in Myron's famous group.[177] As has been noted in connection with Apollo, the protagonists are variously represented on the numerous examples of this sarcophagus-type, now shown full-face, now obliquely, now in profile. Can Marsyas have appeared as a full-length figure in the sylvan scene of his encounter with Athena on the lost sarcophagus from which Mantegna and Raphael derived their Apollos? It is tempting to speculate on this possibility, especially if one observes the further analogies in form between Vulcan's legs and feet and those of the active opponent at Apollo's left (cf. figs. 19, 48) and the similarity in pose and gesture between Mantegna's Vulcan and the figure of Marsyas on an unfinished Neo-Attic krater in the National Archaeological Museum in Athens on which Myron's group is quoted (fig. 52).[178] Yet however attractive this hypothesis, particularly if one recalls that Mantegna appears to have made use of more than one figure on another sarcophagus,[179] it cannot be proven. Indeed, one obstacle to its credibility immediately comes to mind.

In so far as the models for Mantegna's cast of characters were drawn from ancient monuments, they have proved to be literal equivalents—or what he evidently believed to be literal equivalents—however much they have been enhanced by details or attributes culled from supplementary sources. That is, his Venus was derived from a representation of Venus; his group of Mars

[177] See Paolo Enrico Arias, *Mirone* (*Quaderni per lo studio dell' archeologia*, 2), Florence, 1940, passim, and figs. 17–33, for a concise collection of monumental and literary sources, as well as earlier bibliography on this lost bronze group.

[178] No. 127. See Semni Karouzou, *National Archaeological Museum, Collection of Sculpture*, Athens, 1968, p. 43; Reinhard Kekulé, "Athena und Marsyas, Marmorrelief in Athen," *AZ*, 7 (1875), p. 93, pl. 8.

[179] The Bellerophon sarcophagus on which he drew for his Amor and the compositional group of Mercury and Pegasus. Cf. above, pp. 84, 116.

51. Roman sarcophagus from Sidon: detail.
Copenhagen, Ny Carlsberg Glyptotek

52. Unfinished Neo-Attic krater.
Athens, National
Archaeological Museum

and Venus from antique groups of Mars and Venus; his Apollo from an Apollo; his Muses from what he took to be Muses; his Mercury from a Mercury; his Pegasus from the combination Pegasus-Equus. To be sure, his *group* of Pegasus and Mercury seems to reflect a group of Bellerophon and Pegasus; but the alien element, Bellerophon, was replaced by a proper Mercury. Given the total consistency of the master's systematic approach to the iconographic-formal problems posed by this painting, it seems unlikely that he would consciously have modeled his Vulcan on a figure of Marsyas. Can he have misinterpreted the identity of his model? One wonders, in view of the analogy between the figures and the atypical appearance of his Vulcan. Can he have associated the musician Marsyas with Vulcan in his Roman role as maker of trumpets? One can only speculate.

But that this figure surrounded by the canonical attributes of the divine smith and placed in a cave-workshop for which there is late medieval precedent is a Quattrocento Vulcan and reflects contemporary emphasis on Vulcan as the founder of civilization, the transmitter to man of the arts and crafts, is evident. It is not the injured Homeric husband but the heaven-sent artisan of Boccaccio and his antique sources who is stirred to creativity by Amor's blowpipe.[180] And, like Apollo and the dancing, singing Muses, like Pegasus, the Horse consecrated to the Muses, and Mercury, inventor of the lyre and syrinx, he is concerned with music.

Before attempting to interpret Vulcan's action, it is well to recall that in the *Fasti*, a volume in Isabella's library that has already provided a key to one

[180] See Panofsky, "The Early History of Man," pp. 15ff., and *Studies in Iconology*, New York, 1939, pp. 34ff., for discussion of this antique-medieval tradition and its expression in a cycle of paintings by Piero di Cosimo. Not only was this emphasis evidently a contemporary one, but the literary sources on which it rested are either known to have existed in the Este-Gonzaga libraries (e.g., Boccaccio, Diodorus Siculus, and Lucretius) or were widely available. See Warburg, *op. cit.* (above, n. 63), p. 641, for the two copies of Boccaccio in Borso d'Este's library; Bertoni, *op. cit.*, pp. 26, 39f., 222, nos. 109, 113, p. 239, nos. 103, 121, 141, 149, and p. 244, no. 266, for manuscripts of Diodorus Siculus and Lucretius in Ercole I's library in 1495; and, for Vitruvius, Panofsky's comment, *op. cit.*, p. 16, n. 1.

It is also worth recalling that in such mythological sources as the *Fasti* and Apollodorus, for example, there is no allusion to the Homeric tale of Aphrodite, Ares, and Hephaestus. For further reference to these points, see below, n. 213.

of the singular details of the *Parnassus,* Vulcan is honored in the Roman Forum in a festival known as the *Tubilustria* and that "the trumpets which he makes are then cleansed and purified."[181] A still more significant link between Vulcan and music is apparent in the parallelism between Vulcan and his Old Testament counterpart Tubal-Cain.

Like Vulcan, Tubal-Cain was a forger and "instructor of every artificer in brass and iron," and teacher of men in the art of getting fire.[182] According to the *Golden Legend* of Jacobus de Voragine, a work present, it is worth noting, in the ducal library at Ferrara,[183] it was Tubal-Cain, son of Lamech, who

> found first the craft of smithery and working iron, and made things for war, and sculptures and gravings in metal to the pleasure of the eyes, which he so working, Tubal, tofore said [his half-brother, "the finder of music, that is to say of consonants of accord"], had delight in the sound of his hammers, of which he made the consonants and tunes of accord in his song.

Thus, like the god celebrated in the Homeric Hymn, "famed for his skill . . . who with Athena taught glorious crafts to men on earth"[184] and was worshiped as patron of all skilled artisans,[185] Tubal-Cain was associated in medieval thought with the arts and crafts of civilization and, like the Roman Vulcan, maker of military trumpets,[186] specifically linked with music.

[181] 5.725f.: *Proxina Volcani lux est, Tubilustria dicunt:*
 lustrantur purae, quas facit ille, tubae.
 Quoted from Frazer's text and translation, Loeb edn., p. 314.

[182] Gen. 4:22. See also J. A. Selbie in James Hastings, *A Dictionary of the Bible,* IV, New York, 1902, pp. 820f.

[183] See Bertoni, *op. cit.*, p. 214, no. 7. The translation quoted above comes from the edition of William Caxton, London, 1900, I, pp. 178f.

[184] 20.1–3.

[185] Cf. Diodorus Siculus 5.74.2–3: "Hephaestos, we are told, was the discoverer of every manner of working iron and copper and gold and silver and everything else that requires fire for working, and he also discovered all the other uses to be made of fire and turned them over both to the workers in the crafts and to all other men as well. Consequently, the workmen who are skilled in these crafts offer up prayers and sacrifices to this god before all others." Quoted from the translation of C. H. Oldfather, Loeb edn., III, Cambridge, 1939, pp. 297–299.

[186] See above, nn. 169f., and below, n. 213, for further reference to Vulcan's connection with Mars.

He appears in this capacity as the very exemplar of Music in Andrea da Firenze's painting of *Thomas Aquinas in Glory* in the Spanish Chapel of Sta. Maria Novella in Florence (fig. 53).[187] Bearded and wearing the garb of a craftsman, he sits at his anvil, a hammer in each hand, under the spell of the personification of Music seated behind him amid the Liberal Arts. Leaving aside its superior quality and expressive power, this figure is identical in iconographic type with the figures of Vulcan in the previously mentioned English picture-book executed more than a century later, where the god appears as a medieval craftsman wearing an apron over his long-sleeved tunic, boots over his trousered legs, and grasps his attribute, the hammer (fig. 54).[188] Only his bare legs and feet set the Vulcan of the *Libellus* somewhat apart from these figures, an authentic classical feature that does not alter the fact that he, too, is in essence a medieval artisan. In appearance and attributes, these bearded craftsmen are alike, whether they be Vulcan or Tubal-Cain.

An even more graphic illustration of the result of Tubal-Cain's activity is preserved in an early Renaissance sketchbook in the Galleria Nazionale in

[187] For Tubal-Cain, see Raimond Van Marle, *Iconographie de l'art profane au Moyen-Age et à la Renaissance*, The Hague, 1932, II, pp. 224ff., 260, and, for the Spanish Chapel, for which the contract was signed in 1365, *idem, The Development of the Italian Schools of Painting*, The Hague, III, 1924, pp. 425ff.; and Millard Meiss, *Painting in Florence and Siena after the Black Death*, Princeton, 1951, pp. 94ff., where the figure of Tubal-Cain is well characterized (p. 100, n. 15) as "at the same time withdrawn from his action and quite visibly stirred by musical inspiration."

As this essay goes to press, Elliot M. Offner draws my attention to the discussion of Paul E. Beichner, *The Medieval Representative of Music, Jubal or Tubalcain?* (Texts and Studies in the History of Mediaeval Education, 2), Notre Dame, 1954, pp. 5–27. It must suffice to point out that the author traces the medieval and modern telescoping of the brothers, whereby Jubal (Tubal) and Tubal-Cain and their tradi-

tional activities become contaminated and Tubal-Cain, rather than Jubal, emerges as the inventor of harmony and the exemplar of Music. The fact remains that this confusion did exist in early Renaissance iconography—witness the representations illustrated above in figs. 53, 55. The carefully labeled figure in fig. 55 unmentioned by Beichner makes it legitimate to follow the modern scholars who, like Meiss, have interpreted the medieval craftsman at his anvil in the Spanish Chapel as Tubal-Cain rather than Tubal-Jubal.

For the position of Music among the Liberal Arts, see, for example, Karl Gustav Fellerer, "Die Musica in den Artes Liberales," *Artes Liberales von der antiken Bildung zur Wissenschaft des Mittelalters*, ed. by Josef Koch, Leiden-Köln, 1959, pp. 33–49. I owe this reference to Karl Lehmann.

[188] Ms. Rawlinson B 214, fol. 198v. A similar figure of Vulcan occurs on fol. 200r. See above, n. 69, for this manuscript.

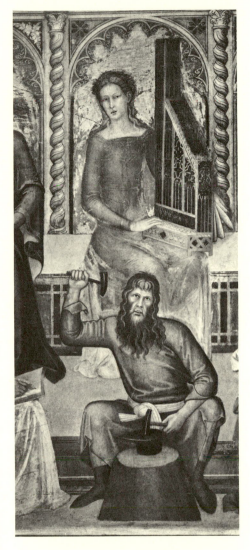

53. Andrea da Firenze,
Thomas Aquinas in Glory: detail.
Florence, Sta. Maria Novella

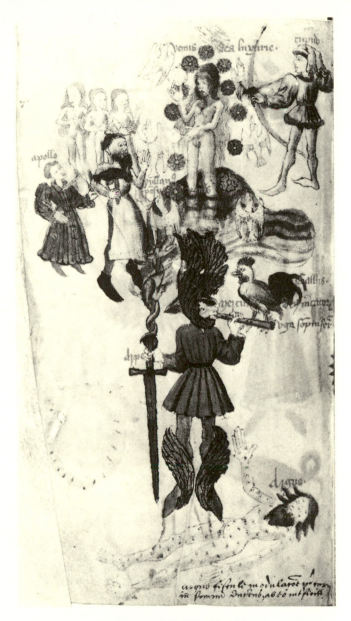

54. Ms. Rawl. B 214, fol. 198v.
Oxford, Bodleian Library

Rome (fig. 55).[189] Like the figure in the Spanish Chapel, he strikes his anvil, head cocked, rapt in inspiration, as notes dance on the base of the anvil. Behind him, Musica, surrounded by a representative selection of stringed and wind instruments, plucks a lute. Here Tubal-Cain's hammering visibly results in the production of tones. At the end of the century, in Gafori's *Theorica Musice*,[190] Jubal is associated with the discovery of measurable intervals through hearing the striking of an anvil with hammers of differing size, in anticipation of Pythagoras' later experiments in harmony through striking on glasses and bells or playing flutes of differing length, until at last the harmonic intervals of a many-stringed instrument have been established (fig. 56).[191]

Whatever the precise relationship between the original illustrations of the sketchbook in the Galleria Nazionale, including that of Tubal-Cain, and Giusto of Padua's lost cycle of the Liberal Arts and their representatives in the Chapel of Sant' Agostino in the Church of the Eremitani,[192] Mantegna was obviously familiar with the paintings themselves[193] and with the iconographic tradition reflected in both Giusto's and Andrea da Firenze's frescoes.

[189] In the Gabinetto delle Stampe. See Van Marle, *The Development of the Italian Schools of Painting*, IV, 1924, pp. 172ff., and VII, 1926, pp. 399ff., for discussion of and earlier bibliography on this sketchbook published by A. Venturi, "Il libro di Giusto per la cappella degli Eremitani in Padova," *Le Gallerie Nazionali Italiane*, IV, 1899, pp. 345ff.; V, 1902, pp. 391f. The entire sketchbook, including the full-page illustration of Musica (15r), is reproduced in this volume. For transcription of the several texts on the page, see *ibid.*, pp. 371f.

[190] Published in Milan in 1492. For Gafori, here described as "one of the greatest musical theorists of the Renaissance," see Otto Kinkeldey, "Franchino Gafori and Marsilio Ficino," *Harvard Library Bulletin*, 1 (1947), pp. 379–382; Gaetano Cesari's introduction to his facsimile edition, Franchini Gafuri, *Theorica Musicae* (Reale Accademia d'Italia, Musica), Rome, 1934,

pp. 15–28; and the references cited below, n. 194.

[191] For discussion of this page and the iconographic tradition to which it belongs, see Kathi Meyer, "Die Illustrationen in den Musikbüchern des 15.–17. Jahrhunderts (II)," *Philobiblon, Zeitschrift für Bücherliebhaber*, 8 (1935), pp. 284ff.

[192] See Sergio Bettini, *Giusto de' Menabuoi e l'arte del Trecento*, Padua, 1944, pp. 113–115, for recent discussion of this much-debated sketchbook, the earlier part of which has been ascribed to the second half of the fourteenth century, the later to the mid-fifteenth century. I am indebted to Millard Meiss for this reference.

[193] As was Hartmann Schedel, whose description of them attests their continuing interest to Quattrocento humanists: see Venturi, in *Le Gallerie*, IV, pp. 345ff., and Van Marle, *Iconographie de l'art profane*, p. 225.

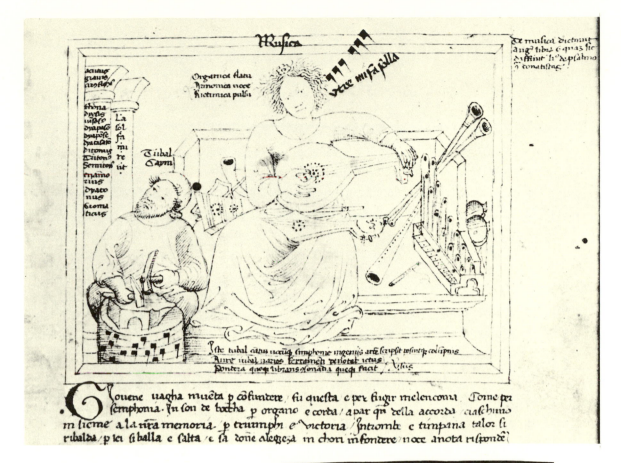

55. Renaissance sketchbook:
detail of Musica. Rome,
Galleria Nazionale Italiana

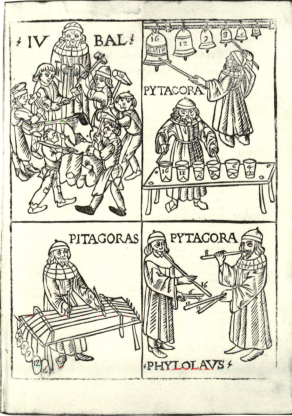

56. Gafori, *Theorica Musice*,
Milan, 1492. New York,
Pierpont Morgan Library

And equally obviously, the *Theorica Musice* published in Milan by an eminent North Italian choirmaster and musical theorist in 1492, with its mixture of antique and medieval theory, was available at the court of the music-loving Gonzagas.[194] The long-established interrelationship or equivalence between Vulcan and Tubal-Cain as legendary craftsmen and teachers of the arts, the identity of their appearance in the late Middle Ages, Vulcan's role as a maker of musical instruments, and Tubal-Cain's part in Jubal's discovery of the laws of musical harmony make it reasonable to assume that Mantegna's Vulcan, like the majority of the mythological characters in the *Parnassus,* is associated with some form of musical activity or invention. A contamination of the classical and Biblical figures in meaning and function, his nude Vulcan replaces the medieval craftsman at work in his cave-shop in the *Libellus* and, stirred to action by Amor, grasps a few of the silvery, blue-gray wires suspended in a loop from the root of a tree behind him. Surely these are steel wires, the material used for the best stringed instruments, and the god of artisans is about to make a stringed instrument—some such instrument as the clavichords and viola made for Isabella and her sister Beatrice by the finest North Italian instrument-maker, Lorenzo Gusnasco of Pavia, who imported the steel wire for his instruments from Munich, contemporary source of strings of the best quality.[195]

[194] See A. Luzio and R. Renier, "La coltura e le relazioni letterarie di Isabella d'Este Gonzaga, I," *Giornale storico della letteratura italiana,* 33 (1899), pp. 48ff.; A. Bertolotti, *Musici alla Corte dei Gonzaga in Mantova dal secolo XV al XVIII,* Milan, n.d., pp. 7–18; and Alfred Einstein, *The Italian Madrigal,* Princeton, 1949, I, pp. 34f., 38ff., 42ff., 52f., 93f., 104f., 110f., for the role of music at the Court of Mantua and Isabella as a patron of this art. On the importance of Gafori, see Einstein, *ibid.,* pp. 11f., as well as Paul Oskar Kristeller, "Music and Learning in the Early Italian Renaissance," *Journal of Renaissance and Baroque Music,* 1 (1947), pp. 261ff., 267f., and the references cited above in n. 190. Isabella's close association with the court of her sister and brother-in-law at Milan makes it virtually certain that she knew the work of the man who had been choirmaster of Milan Cathedral since 1484 and, from 1494 to 1499, professor of music at the University of Pavia.

[195] See the article on strings in Grove's *Dictionary of Music and Musicians,* 3d edn., New York, 1928, V, p. 172, for the invention of wire-drawing ca. 1350, its use for instruments like the clavichord, harpsichord, and virginal, the early use of steel, especially for the trebles of clavichords, and the continuing production in Germany of superior steel made from iron found in the Harz Mountains.

For Isabella's personal interest in the beauty and quality of the instruments made for her and her specifications to Lorenzo, see Luzio-Renier, "La coltura . . . , I," pp. 48f.; Bertolotti, *op. cit.,* pp. 15, 17; and Lauts, *op. cit.* (above, n. 160), pp. 49f.

Vulcan's desire to create, his stimulus to action, is induced by Amor, who arouses him by means of a blowpipe which transmits his animating breath to the divine craftsman. This creative charge is represented as a delicate gold line emanating from the scarlet blowpipe and terminating at Vulcan's genitalia. Amor's blowpipe, the main tool of the glassmaker, is the standard implement used for centuries and illustrated, for example, in an early fifteenth-century miniature showing glass-making (fig. 57).[196] Its use and Amor's

[196] One of a set of miniatures illustrating the travels of Sir John Mandeville: British Museum Additional Ms. 24189, fol. 16: *Catalogue of Additions to the Manuscripts in the British Museum in the Years 1854–75*, London, 1877, II, p. 18. For the technique of glass-making illustrated in this miniature, see *Le vitrail français* (Musée des Arts Décoratifs), Paris, 1958, pp. 55ff., fig. 33, and *The Flowering of the Middle Ages*, ed. by Joan Evans, London, 1966, p.

253. I am indebted to Amy Vandersall for the last two references.

For the primitive iron tool shown here and mentioned in a description of glass-making in the twelfth-century treatise of Theophilus, *The Various Arts* (tr. by C. R. Dodwell), London, 1961, pp. 40f., see D. B. Harden, "Glass and Glazes," in *A History of Technology*, II, Oxford, 1956, p. 332.

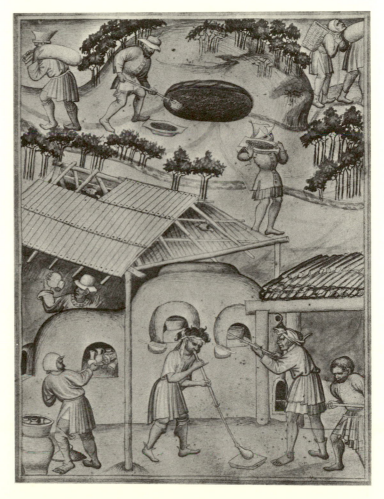

57. Ms. Add. 24189, fol. 16r:
glass-making.
London, British Museum

puffed-out cheeks make clear that the golden line represents his breath—as the lines issuing from the mouths of the winds in an early thirteenth-century illustration of the Harmony of the Spheres (fig. 58) indicate the dynamic force that sets the wheel of the universe in motion, causing it to revolve from east to west,[197] or a shaft of golden lines of conception links the Holy Spirit with the Virgin in scenes of the Annunciation.[198] So, too, on a North Italian birth-plate in the Louvre (fig. 59), a celestial Venus flanked by singular Cupids hovers in the sky above a verdant meadow in which six legendary warriors and lovers of classical, Biblical, and medieval fame kneel before her, their faces transfused by the radiance emanating from her pubic zone.[199] From this heavenly source rays transmit the goddess' generative power to man and nature.[200]

[197] A parchment sheet, Ms. 672, fol. 1v, in the Bibliothèque Municipale in Reims, where the element Air appears astride the universe and transmits to the mythical musicians Orpheus, Arion, and Pythagoras the tones emanating from the spheres, which are presided over by the Muses, as planetary goddesses. For discussion of this illustration and the Pythagorean concepts behind it, see Charles de Tolnay, "The Music of the Universe," *Journal of the Walters Art Gallery*, 6 (1943), pp. 85ff. and fig. 4, and Erika Simon, "Ixion und die Schlangen," *JÖAI*, 42 (1955), pp. 20f. De Tolnay (p. 89 and n. 17) notes the persistence of this antique-medieval tradition into the Renaissance and its recurrence in Gafori's *Practica Musice*. His description of the attributes of the mythical musicians, especially of Pythagoras, is incomplete, however, omitting reference to the hammer and closed hinged object (a portable stringed instrument?) which the philosopher holds in addition to the balance symbolic of the harmonious equilibrium of the universe—attributes which further link him with the imagery and content of the representation of Pythagoras in Gafori's earlier treatise illustrated above (fig. 56).

[198] For example, in Fra Angelico's *Annunciation* from the altarpiece for the Church of S. Domenico, Fiesole, now in the Prado. See *Fra Angelico da Fiesole*, ed. by Frida Schottmüller (*Klassiker der Kunst*, XVIII), Stuttgart and Leipzig, 1911, p. 66, for a convenient illustration.

[199] Attributed to an unknown master of the School of Verona working in the first half of the fifteenth century by Terrasse, *op. cit.* (above, n. 13), p. 47, pl. 45. For such wedding presents or maternity gifts, including the present example, see Eugene B. Cantalupe, "The Anonymous *Triumph of Venus* in the Louvre: An Early Italian Renaissance Example of Mythological Disguise," *AB*, 44 (1962), pp. 238ff. The author does not explain the clawed feet of the goddess' attendants, the left of whom surely carries a bow and several arrows rather than a quiver—a feature worth investigating. Nor do I follow his comment that the warriors are armed only with greaves: their several varieties of armor, helmets, mail, and swords are all visible.

[200] The use of linear connectives to link the signs of the zodiac with the parts of the human body over which they have power in medieval medical-astrological diagrams appears to be a related artistic convention. See the illustrations discussed by Harry Bober, "The Zodiacal Miniature of the *Très Riches Heures* of the Duke of

Who is this extraordinary Amor? Surely he must be the all-powerful Eros of Plato's *Symposium*, "a composer so accomplished that he is the cause of composing in others," who is "well-skilled . . . in all that has to do with music," that cosmic force who guides and directs the other gods to play their special roles. He is the inspirer of all arts and crafts, under whose guidance the Muses make music, Hephaestus creates metal-work and Athena weaving, who inspires in them the love of beauty. For, as Agathon explains, "since this god arose, the loving of beautiful things has brought all kinds of benefits to gods and to men."[201] He it is who reigns over the gods.[202] It is through Eros that Aphrodite has captivated Ares.[203]

Mantegna's Amor, who at once inspires Vulcan to artistry by means of his blowpipe and with the aid of his more familiar attributes, the bow and arrow, has allowed Venus to conquer Mars, is a figure both concerned with Vulcan and attached to the group of Mars and Venus. Presiding over the music-making figures beneath them, yet detached from them, they are as little the adulterous lovers of Homeric song as Vulcan is the jealous husband stirred to vengeful action.[204] On the contrary, they are best understood in the terms of Lucretius and Ovid—Ovid of whose *Fasti* Isabella possessed two copies, it will be recalled,[205] and Lucretius, whose *De rerum natura* was first printed in

Berry—Its Sources and Meaning," *JWarb*, 11 (1948), especially pp. 13ff.

The Muse who inspires a musician or literally baptizes an instrument by sending a stream of milk from her breast offers a somewhat analogous convention for the transfer of creative power. See Emanuel Winternitz, "The Inspired Musician, A Sixteenth-Century Musical Pastiche," *loc. cit.* (above, n. 126). The claw-footed siren, illustrated on p. 3 of this article, may offer a clue to the implications of this feature of the *amorini* on the Louvre plate.

[201] Extracts from 196E–197B, quoted from the translation of W. R. M. Lamb, Loeb edn., reprinted 1953, pp. 157f. It is needless to emphasize the influence of this dialogue in cultivated circles in Italy during the second half of the fifteenth century or its availability through Ficino's Latin and Italian translations. Nor is this the

place for an extended bibliography on Neoplatonism or Marsilio Ficino. But for the latter see, in particular, Paul Oskar Kristeller, *The Philosophy of Marsilio Ficino*, New York, 1943; idem, *Supplementum Ficinianum*, I, Florence, 1937 (where it is pointed out, p. CXXIV, that Ficino's Italian version of his commentary on the *Symposium* was available in manuscript form from at least 1474 on); and, for this commentary, S. R. Jayne, "Ficino's Commentary on Plato's Symposium," *University of Missouri Studies*, Vol. 19, No. 1, 1944. For brief statements on this topic, see Kristeller, *The Classics and Renaissance Thought* (Martin Classical Lectures, XV), Cambridge, 1955, pp. 57ff., and Panofsky, *Renaissance and Renaissances*, pp. 182ff.

[202] 195C. [203] 196D.

[204] See above, pp. 59f.

[205] See above, n. 157.

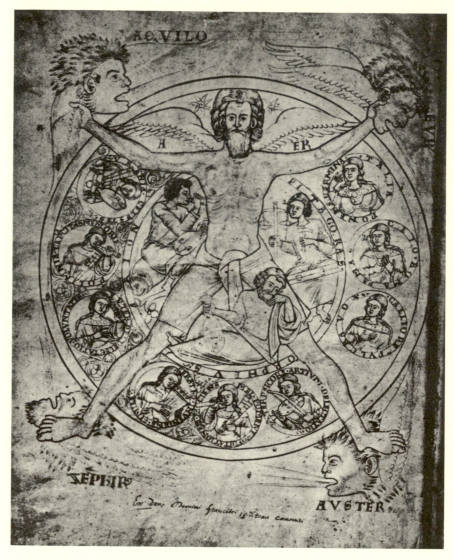

58. Ms. 672, fol. 1v: the Harmony of the Spheres.
Reims, Bibliothèque Municipale

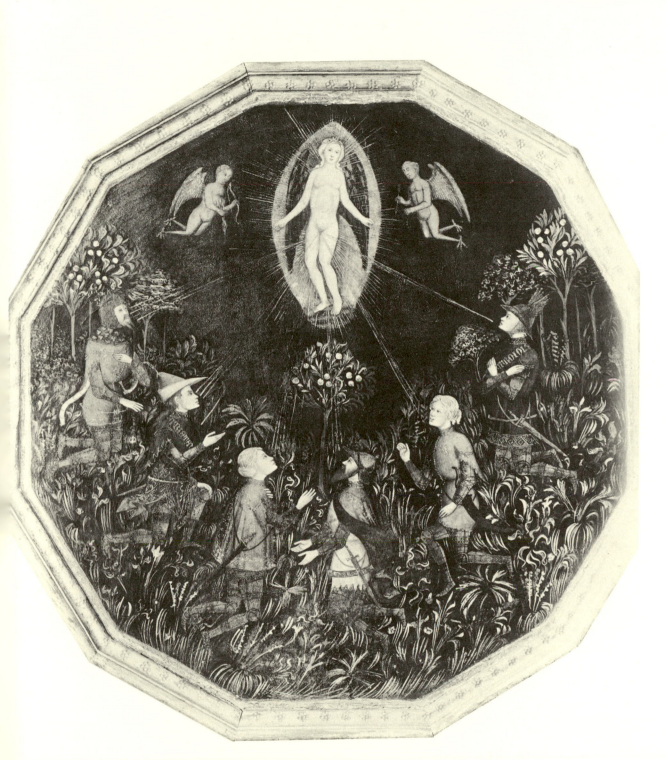

59. North Italian birth-plate: the Triumph of Venus. Paris, Musée du Louvre

Brescia in 1473, an *editio princeps* followed by two others printed in Verona and Venice in 1486 and 1495 before the Aldine edition of 1500.[206]

To Lucretius, Venus is the supreme divinity, the cosmic source of life:

Thou alone dost govern the nature of things, since without thee nothing comes forth into the shining borders of light, nothing joyous and lovely is made.

She alone can bring peace to men through her power over Mars—that peace without which the poet cannot work with untroubled mind:

Cause meanwhile the savage works of war to sleep and be still over every sea and land. For thou alone canst delight mortals with quiet peace, since Mars mighty in battle rules the savage works of war, who often casts himself upon thy lap wholly vanquished by the ever-living wound of love.[207]

In the *Parnassus,* Mars stands beside Venus "vanquished by the ever-living wound of love," under the sway of her arrow-tipped scepter.[208] Arm-in-arm, heads inclined, their all-important unity is emphasized by the calligraphic mantles fluttering about them and by the backdrop of foliage behind them, that dense wall of plants sacred to Venus—of myrtle, quince, and orange.[209]

[206] Apart from the numerous fifteenth-century manuscript copies in Italy derived from the famous archetype discovered by Poggio Bracciolini in 1418, including the example in the ducal library at Ferrara cited above, n. 180. For a concise statement on the manuscript tradition and the printed editions, see *Titi Lucreti Cari De rerum natura*, ed. by Cyril Bailey, Oxford, 1947, I, pp. 37–51, and for bibliography on Lucretius' influence in the Middle Ages and the Renaissance, Panofsky, *Renaissance and Renascences*, p. 178, n. 1.

[207] *De rerum natura* 1.21ff., quoted from the translation of W. H. D. Rouse, Loeb edn., Cambridge, 1943, p. 5. Cf. the parallel statement in *Fasti* 4.85ff., according to Bailey, *op.cit.*, II, p. 591, a conscious reflection of Lucretius. Both Lucretius 1.2ff., 8, and Ovid, *Fasti* 4.15ff., 113, invoke the goddess, as a super-Muse, to inspire their work.

[208] P. Schmidt-Degener, "Deux dessins inédit de Mantegna pour le 'Parnasse' du Musée du Louvre," *GBA*, ser. 3, 38 (1907), pp. 294f., recognized Venus' primacy in the *Parnassus* and the direct connection between her role in the painting and in Lucretius' poem. (I have not commented on the author's, to me, unconvincing suggestion that the drawings discussed in this article were studies for the painting, inasmuch as I know them only through his illustrations. The figures strike me as poor reflections of Mantegna's Mars and Venus, Mercury and Pegasus, whatever their date, and as marred by unintelligible, illogical iconographic details uncharacteristic of the painter's mentality—e.g., Mercury's footless winged puttees.)

[209] See below, pp. 168f., for the specific associations and implications of the plants in the painting.

From their union Harmonia is born,[210] the celestial concord symbolized in the title page of another treatise by Gafori, his *Practica Musice* (fig. 60), where the Muses, as planetary divinities, produce the harmony of the spheres under the direction of a Platonic Apollo.[211]

Ficino, commenting on the very portion of Agathon's speech quoted above, on the sequence whereby Eros' gifts are transmitted to man through the agency of the gods and the signs of the zodiac, concludes with a statement on the music of the spheres, that heavenly harmony which, on earth "is then imitated in various instruments and songs."[212] Whether or not there are any intentional Neoplatonic overtones in the *Parnassus,* it is evident that under the image of Mars and Venus united through the power of Amor, the Muses dance and sing to Apollo's lyre, and Vulcan is stirred to turn from the production of metal vessels to the creation of a steel-stringed instrument—that in the peace wrought by Venus the arts flourish,[213] in particular, the art of music.[214]

[210] According to both Hesiod, *Theogony* 934ff., and Apollodorus 3.4.2. For the persistence of this tradition into the late Middle Ages and the Renaissance, see Panofsky, *Studies in Iconology*, pp. 163ff.

In suggesting that the *Parnassus* represents the union of Ares (strife) with Aphrodite (love) from which Harmony is born, Gombrich, *loc. cit.* (above, n. 7), arrived at a partial explanation of the painting's rich imagery. His assumption that this view of the gods must imply an allegorical reinterpretation of the Homeric tale overlooks the variant Lucretian-Ovidian tradition presented here.

[211] See the references cited above, nn. 190, 191, 194, for this work published in Milan in 1496, and below, n. 217, for its author's admiration of Plato in whose *Cratylus* (405c–d) Apollo is described as the director of harmony among gods and men, of the harmony of the heavens and the concord of song, of that harmony which makes "all things move together."

For consideration of the Muses as the mistresses of universal harmony in ancient thought and the medieval and Renaissance development of this concept, see Cumont,

op. cit. (above, n. 56), chap. IV, passim.

[212] Jayne, *op. cit.*, p. 181.

[213] Hence Ovid, *Fasti* 4.113, can call Venus "the mother of a thousand arts" (*mille per hanc artes motae*).

It is interesting to recall that in the series of "Vulcan stories" by Piero di Cosimo depicting what Panofsky has described as man's progress toward civilization from an *aera ante Vulcanum* to an *aera sub Vulcano*, a final, now seemingly lost painting mentioned by Vasari showed Mars, Venus with her Cupids, and Vulcan—i.e., one of the three interrelated, yet in a sense independent units of which the *Parnassus* is composed. The concepts behind both Piero's series and Mantegna's painting reflect an interpretation of these gods at the opposite pole from that of the Homeric tale. Nor is it by accident, I assume, that Piero, too, has drawn on such sources as the *Libellus*, Lucretius, and the *Fasti*. For Piero's series, see the references cited in n. 180, above, and, for a brief summary, Panofsky, *Renaissance and Renascences*, pp. 179ff.

[214] The emphasis on music in the foreground of the *Parnassus* has been pointed

The role of music at the Court of Mantua is well known.[215] There Poliziano's opera, *Orfeo,* the first work of its kind, had been produced for Lodovico in 1472. Under Gian Francesco, himself an amateur musician, and his still more accomplished wife, the traditional importance of music in the life of the Court was maintained. It would suffice to explain the emphasis on the art of music in the *Parnassus.* Yet in view of the Platonic doctrine underlying its iconography, it seems likely that the painter and his patron also had in mind another Platonic concept—the supreme importance of music in the education of the soul—and that the learned circle by whom the painting was seen would have recalled Apollodorus' speech in *The Republic*:

> "And is it not for this reason, Glaucon," said I, "that education in music is most sovereign, because more than anything else rhythm and harmony find their way to the utmost soul and take strongest hold upon it, bringing with them and imparting grace, if one is rightly trained, and otherwise the contrary? And further, because omissions and the failure of beauty in things badly made or grown would be most quickly perceived by one who was properly educated in music, and so, feeling distaste rightly, he would praise beautiful things and take delight in them and receive them into his soul to foster its growth and become himself beautiful and good. The ugly he would rightly disapprove of and hate while still young and yet unable to apprehend the reason, but when reason came the man thus nurtured would be the first to give her welcome, for by this affinity, he would know her."[216]

out by earlier writers and explained as an allusion to a musical contest between Apollo and Hermes, as Picard put it, *op. cit.,* p. 127, between "musique citadine et sacerdotale, avec la lyre d'Apollo; musique rustique, avec la syrinx."

[215] See Bertolotti, *loc. cit.*; Lauts, *op. cit.,* pp. 47ff.; and the references in Einstein, *op. cit.* (above, n. 194). In proclaiming Gian Francesco Gonzaga an example of the ideal prince, Castiglione was obviously affected by his prowess as a soldier ("the principal and true profession of the Courtier") and his ability to perform as well as understand music. See, for convenience, Count Baldasar Castiglione, *The Book of the Courtier*, tr. by L. E. Opdycke, 2d edn., 1929, 1.17.47; 4.36, pp. 25, 62, 270f.

[216] III, 401D–402A, quoted from the translation of Paul Shorey, Loeb edn., Cambridge, 1946, I, p. 251. See also Strabo 10.3.10, a passage in which this concept is reinforced by an author easily accessible to Isabella (cf. Bertoni, *op. cit.,* p. 250, no. 447).

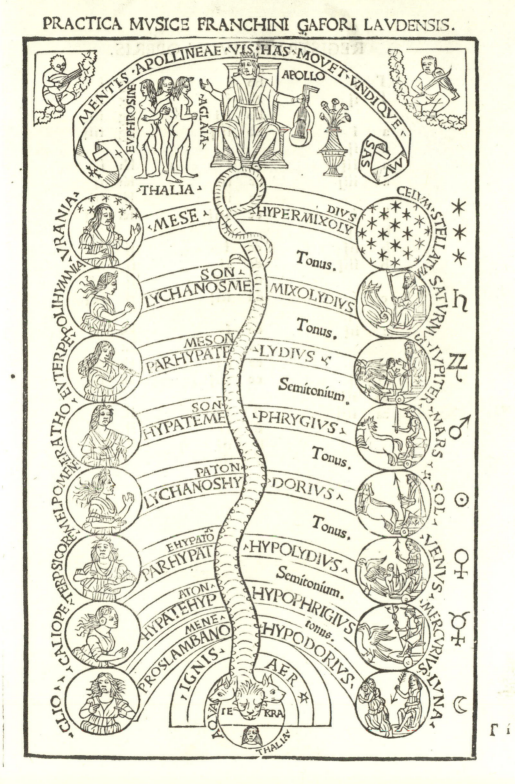

60. Gafori, *Practica Musice*, Milan, 1496, title page. New York, Pierpont Morgan Library

Surely no one familiar with the Neoplatonism of Ficino[217] would have failed to catch this allusion in the painting; surely no one would have been more responsive to Apollodorus' praise of beautiful things or his rejection of things ugly than Isabella, lifelong collector and connoisseur that she was.[218]

Given the intense musical life at the Court of Mantua and Isabella's passion for music and dancing,[219] one may query whether behind the mythological-philosophical content of the painting there is implicit a specific allusion to the Duchess and her soldier-husband. It has, in fact, been suggested that they appear here as the embodiments of strength and beauty under whose protection and inspiration the Muses rule.[220] That the figures presiding over the scene are both Mars and Venus and Gian Francesco and Isabella may be established with certainty.

The divine couple stand before a golden couch of "antique" form (fig. 3; Pl. II),[221] very likely an allusion to the *lectisternium* of Republican Rome, the

[217] See Kristeller, *The Classics and Renaissance Thought*, p. 65, and "Music and Learning" (above, n. 194), pp. 269ff., for Ficino as an amateur musician who wrote several treatises on musical theory in addition to commenting in extenso on the passages in Plato concerned with musical proportions.

For interest in Plato's views about music on the part of contemporary musical theorists, including Gafori, see Kristeller, "Music and Learning," pp. 268ff., and Kinkeldey, *loc. cit.* (above n. 190). The fact that by 1489 Gafori owned Ficino's translation of the complete works of Plato (printed in Venice, 1484–1485) is a graphic illustration of this point. See Kinkeldey, p. 380, for this now incomplete annotated copy in the Harvard Library.

[218] For this aspect of Isabella's personality see, for example, Lauts, *op. cit.*, pp. 162–180.

[219] In addition to the previously quoted references attesting Isabella's accomplishments as a musician, her concern for the quality and beauty of the instruments she played, and the role of music at her court, see Bertolotti, *op. cit.*, p. 11, Bertoni, *op. cit.*, p. 100, and Lauts, *op. cit.*, pp. 9, 46f., for her parallel enthusiasm for dancing. The Duchess' preoccupation with music is presumably reflected in her use of musical notation on her personal device, for which see Luzio-Renier, "La coltura e le relazioni letterarie di Isabella d'Este Gonzaga, I," *op. cit.*, pp. 51f., and n. 225, below.

[220] See Ilse Blum, *op. cit.* (above, n. 5), pp. 86ff. Thode, too, *Mantegna, loc. cit.* (above, n. 4), and Lauts, *op. cit.*, p. 151, have queried the possibility of a specific allusion behind the general allegory. It is unnecessary to linger over Julia Cartwright's fanciful notion (*Isabella d'Este, Marchioness of Mantua, 1474–1539; A Study of the Renaissance*, New York, 1903, I, p. 160) that the central Muse who leads the dance (sic!) is "the young Marchesa herself whom the painter has here introduced as the presiding genius of the studio."

[221] I do not know of an exact parallel to the forms and proportions of this couch.

festival at which six couches were prepared for images of the Twelve Great Gods, including one for Mars and Venus.[222] Splendidly draped, its pillows and covers are white fringed with gold. Beneath them hangs a scarlet valance; behind the couch, as it were, protecting it, a turquoise-blue cloth is knotted to the quince tree at Venus' right. This triple band of color, so insistent and striking a feature of the picture to anyone standing before it, has gone singularly unmentioned in discussions of the painting, considering its aesthetic prominence and the degree to which these horizontal stripes attract the spectator's eyes in a composition otherwise so filled with calligraphic forms. Their prominence is intentional and their significance clear: they are at once the colors of the planetary gods—red for Mars, white for Venus, blue for Mercury[223]—and the primary colors of the Gonzaga-Este coats of arms: the red and white of the Gonzagas; the blue, red, and gold of the Este.[224] Coupled, they may be seen on a majolica plate in the Museum of Fine Arts in Boston, one of a service made for Isabella (Pl. III): to the left of the impaled arms

But its generic scheme of turned legs, mattress, pillows, and valances is analogous to the forms on such Hellenistic or Roman monuments as the terracottas illustrated by Caroline L. Ransom, *Studies in Ancient Furniture. Couches and Beds of the Greeks Etruscans and Romans*, Chicago, 1905, fig. 30, and Gisela M. A. Richter, *Ancient Furniture*, Oxford, 1926, figs. 187, 188; the additional terracottas and funerary relief, idem, *The Furniture of the Greeks Etruscans and Romans*, London, 1966, figs. 302, 303, 568; and a marble relief in the Museo Nazionale in Naples, for which see Heinrich Bulle, *Der schoene Mensch im Altertum*, Munich and Leipzig, 1911, pp. 588f. and pl. 285.

[222] For the *ludi magni*, a three-day celebration in which images of the gods were laid on couches provided with cushions and meals were served before them, see Livy 22.10.9, as well as Daremberg and Saglio, *Dictionnaire des antiquités grecques et romaines*, III², Paris, 1904, pp. 1006ff.,

s.v. *lectisternium*, and Altheim, *op. cit.* (above, n. 169), pp. 284f. It may be worth noting that the *editio princeps* of Livy, reputedly one of Boccaccio's favorite ancient authors, was printed in Rome in 1469; see Sandys, *A History of Classical Scholarship*, II, pp. 13, 97.

[223] See Franz Cumont, *Catalogus codicum astrologorum graecorum*, VIII, pt. 1, Brussels, 1929, pp. 196f.

[224] Gonzaga: Argent a cross patty gules cantoned by four eagles displayed sable (Gonzaga modern, granted 1433), an escutcheon over all, quarterly, 1, 4, gules *or* or a lion rampant argent *or* or (for Bohemia); 2, 3 barry of six or and sable (Gonzaga ancient). Este: Quarterly, 1, 4 azure three fleurs-de-lys or a bordure indented gules and 2, 3 azure an eagle displayed argent. See Vittorio Spreti et al., *Enciclopedia storico-nobiliare italiana*, III, Milan, 1930, pp. 515ff., Appendix, pt. II, 1935, p. 157.

the gules cross of the Gonzagas on an argent field, to the right, the prominent azure fields of the Este.[225]

Nor is it surprising that these colors recur on the figures of Mars and Venus in allusion to their mortal representatives. The scarlet plumes of Mars' helmet, his scarlet *cingulum* and tunic, the blue sleeves and flaps of his cuirass, even his mantle, a rosy-purple variant of red, proclaim the Gonzaga scarlet and the Este azure, as Venus' golden bandelette, her golden bracelet, and golden armbands from one of which two beads dangle, one gold, one blue, evoke the blue and gold of the Este—the very colors used, once again, in the richly carved ceiling of the *studiolo*.[226]

However obscure these allusions to the modern eye, they were an obvious commonplace in a heraldically-minded, superstitious society in which a man like Isabella's uncle, Lionello, is known to have worn clothes each day of the week that corresponded in color to the successive colors of the seven planetary divinities.[227] To contemporaries, the secondary meaning of the *Parnassus* must have been transparent. Through the union of Isabella and Gian Francesco, those mortal representatives of Venus and Mars,[228] and under the influence of the planet Mercury, the arts flourish at the Court of Mantua, in particular the noblest of the arts, music.

[225] Acc. No. 41.105. Made in Urbino (presumably at Castel Durante) ca. 1519 by Nicolo Pellipario. For this painter and other plates from the same service, see Bernard Rackham, *Catalogue of Italian Majolica* (Victoria and Albert Museum, Department of Ceramics), London, 1940, pp. 181ff. and no. 547; and Giuseppe Liverani, *Five Centuries of Italian Majolica*, New York, 1960, pp. 43f., pl. 55. Below the shield on these plates a scroll of music appears—yet another manifestation of Isabella's continuing pleasure in this device, for which see above, n. 219, and the comments of Rackham.

[226] For this coffered wooden ceiling, see Guglielmo and Annalena Pacchioni, *Mantova* (*Italia artistica*, ser. 1 A, no. 103), Bergamo, 1930, pp. 52, 53, 97.

Among the ornamental tiles extant from the pavement of this sadly pillaged apartment is a type showing the Gonzaga arms.

Like the other varieties displaying the ducal pair's favorite mottoes and devices, it reflects their penchant for heraldic schemes (for these tiles, see Rackham, *op. cit.*, p. 62, no. 193; Henry Wallis, *Italian Ceramic Art. The Maiolica Pavement Tiles of the Fifteenth Century*, London, 1902, pp. xxvf., figs. 89, 90; and Yriarte, *op. cit.* [above, n. 1], pp. 390ff.). Isabella herself is known to have sought patterns of the Este arms to be used in embroidered decorations on her garments, as well as enamel and gold clasps exhibiting the Gonzaga colors (Lauts, *op. cit.*, pp. 30, 33).

[227] Gardner, *op. cit.* (above, n. 162), p. 47.

[228] See Panofsky, *Studies in Iconology*, *loc. cit.*, for other examples of the representation of a married couple as Mars and Venus.

As this essay goes to press, Millard Meiss calls my attention to a paper by

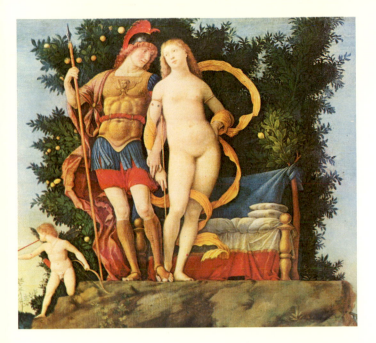

II. Mantegna, *The Parnassus*: detail of Mars, Venus, and Amor.
Paris, Musée du Louvre

III. Majolica plate by Nicolo Pellipario, from a service made for Isabella d'Este. Boston, Museum of Fine Arts

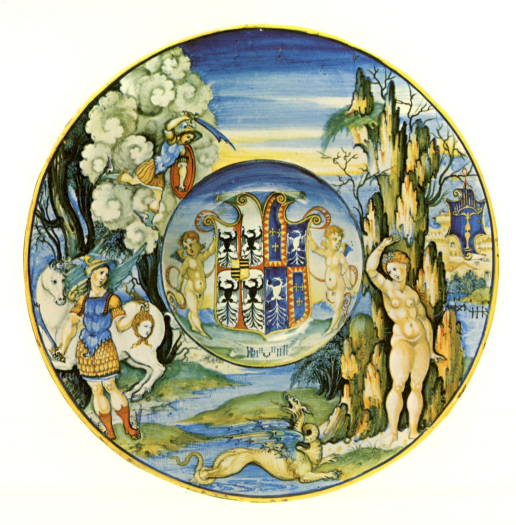

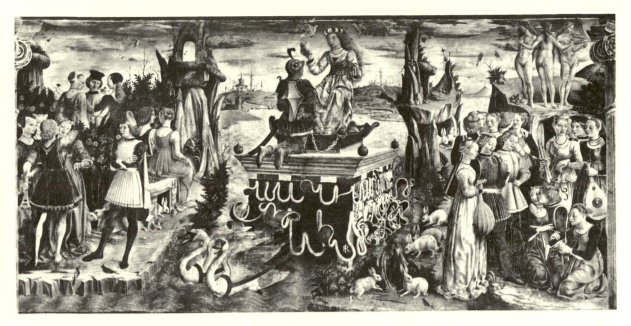

61. Francesco Cossa, *The Triumph of Venus*. Ferrara, Palazzo Schifanoia

FOR IT IS the planet Mercury and the constellation Pegasus-Equus that dominate the painting. Before returning to them and considering the astrological implications of this group, however, it is appropriate at this point to note two other meaningful features of the picture: the animals in the foreground and the plants associated with the primary figures.

Below the group of Mars and Venus in the center of the foreground, a squirrel and three hares appear (figs. 1, 3, and especially 2, 7, 8). Unobserved by the figures around them, they constitute an emblematic vignette in the context of the scene, alluding, as they do, to Mars and Venus. Hares, the traditional symbol of fertility, were a standard attribute of Venus—witness their multiple presence in Cossa's *Triumph of Venus* in the Palazzo Schifanoia (fig. 61). There, their proverbial fertility is evident, that quality emphasized

Eugenio Battisti, "Il Mantegna e la letteratura classica," *Atti del VI Convegno Internazionale di Studi sul Rinascimento*, Sansoni, Florence, n.d., in which (pp. 42ff.) the author cites a poem addressed to Isabella by the poet Fiera. Referring to Mantegna as "il nostro Apelle" and alluding to the *Parnassus*, Fiera equates the painter's Venus with Isabella, youthful wife of a warrior husband. Battisti, too, sees in the painting "un ideale trionfo" of Isabella and Gian Francesco in a scene "largamente dedicato alle arti del canto e della musica." At the same time he assumes, without elaborating his view, that Ovid's account of the adulterous lovers, *Metamorphoses* 4.171ff., and Lucretius' lines to Venus Genetrix provide the key to it.

by ancient authors, including the cherished Pliny and Philostratus.[229] In Mantegna's less overtly explicit vignette, they form part of an idyllic scene, a miniature landscape of exquisite delicacy and precision. Tense and watchful, wide-eyed, they doubtless reflect Pliny's statement that hares sleep with their eyes open.[230] If so, as symbols of vigilance as well as fertility, they are an appropriate emblem for both the goddess and her consort.

The bushy-tailed squirrel that crouches at their right, shadow-tail, as the ancients called it,[231] has a similar double symbolism. To Pliny notable for its foresight and its capacity to protect itself,[232] to Martial a lovable creature,[233] the σκίουρος became a heraldic symbol of skill and experience triumphant over force,[234] of the noble "who carefully keeping the love and affection of his Followers and Retainers, is sure they will sticke to him, protect and shaddow him in time of need."[235] What more appropriate emblem for Mars–Gian Francesco Gonzaga, Lord of Mantua and popular *condottiere*?

The wall of myrtle rising behind Venus is equally appropriate in its multiple symbolism (figs. 1, 3). The prime plant associated with the goddess, the "myrtle of Cythara" as Ovid called it,[236] it was also the "myrtle of Venus Victrix" worn by victorious generals who had triumphed without bloodshed, and the *myrtus coniugulis* specifically linked with marriage, as Pliny reports.[237] Nor is myrtle the only plant behind the pair equally suitable to Mars and

[229] *Naturalis historia* 8.81.217ff.; 10.83. 179, 182, and elsewhere; Philostratus, *Imagines* 1.6 ("For you know, I imagine, what is said of the hare, that it possesses the gift of Aphrodite to an unusual degree."); as well as Herodotus 3.108 and others, including Oppian, *Cynegetica* 3.161ff. For the manuscripts of Pliny, Philostratus, and Herodotus in the ducal libraries at Mantua and Ferrara, see Luzio-Renier, *op. cit.*, 42 (1903), p. 80, no. 107; Bertoni, *op. cit.*, pp. 57, 224, no. 135, p. 229, no. 1, p. 248, nos. 379, 403; Lauts, *op. cit.*, p. 187.

[230] 11.54.147. Wind, "Mantegna's *Parnassus*" (above, n. 84), p. 230, was quite correct in his remarks about the double symbolism of hares and Mantegna's use of it both in the *Parnassus* and elsewhere.

[231] See above, n. 24, for comment on the identity of this animal.

[232] *Naturalis historia* 8.58.138. See also Oppian, *Cynegetica* 2.586ff.

[233] *Epigrams* 5.37.13.

[234] See, for example, Arthur Henkel and Albrecht Schöne, *Emblemata*, Stuttgart, 1967, cols. 490ff.

[235] The formulation of John Guillim, *A Display of Heraldrie*, 4th edn., London, 1660, p. 203, to explain the use of squirrels on a coat-of-arms. I am indebted to Leonard Baskin for this reference.

[236] *Fasti* 4.15; see also 4.869 and Virgil, *Eclogue* 7.62.

[237] *Naturalis historia* 15.37.122, 123. See also Cato, *De agri cultura* 8.2; Plutarch, *Marcellus* 22; and *RE*, XVI, 1935, s.v. *Myrtos*, cols. 1171ff.

Venus—Gian Francesco and Isabella and their wedded state. The quinces at each side of the group (figs. 3, 4) have been termed the "wedding fruit *par excellence*" in Renaissance iconology,[238] and the golden fruit that gleams in the dark foliage above and beside Mars, the *citrus* or *malus medica* prized by the ancients[239] as an antidote against poison, was the golden apple of Venus, symbol of the bitter-sweetness of love in emblematic language.[240]

Richest of all in implication is the laurel visible behind Apollo, the Muses, and Mercury (figs. 1, 17, 33). Symbol of joy and victory, sign of military truce and of peace,[241] it was said by Pliny to flourish in the greatest beauty on Mount Parnassus, hence to be dear to Apollo,[242] and to Virgil and Ovid, too, it was the "laurel of Parnassus."[243] Stretching across the painting, it is at once indicative of the locale of the scene[244] and the gifts of the presiding divinities, in particular, the all-powerful Lucretian goddess from whom all peace and joy emanate, without whom "nothing joyous and lovely is made."[245] Vanquished by Venus, Mars is stilled, in token whereof a shoot of wild fig springs from the rock beneath his spear—the fruit by whose miraculous power the fiercest creature is tamed (figs. 1, 3, 4).[246]

[238] See Panofsky, *Studies in Iconology*, p. 163, and the references adduced there, as well as Pliny, *Naturalis historia* 15.10. 38; Plutarch, *Coniugalia praecepta* 1; *Quaestiones Romanae* 65; *Solon* 20.3. Quinces also appear in one other spot in the picture: behind Apollo and the first Muses. Can the god be playing an epithalamium, one wonders?

[239] Pliny, *Naturalis historia* 12.7.15.

[240] Cf. A. Alciati, *Emblemata*, Lyon, 1550, p. 221.

[241] See, for example, Pliny, *Naturalis historia* 15.39.127, 40.133; Plutarch, *Pompey* 41.3 (another author available in Isabella's library: cf. Luzio-Renier, *op. cit.*, p. 80, no. 109). See also Ovid, *Amores* 1.11.25, for the use of laurel around tablets bearing love messages.

[242] 15.40.134. See also Virgil, *Eclogue* 7.64.

[243] *Georgics* 2.18; *Metamorphoses* 5.165. (See Luzio-Renier, *op. cit.*, p. 76, nos. 21,

25, and p. 21, no. 117, for Isabella's copies of these poems.)

[244] It is, therefore, not without interest in connection with the previously discussed issue of the landscape setting. See above, pp. 139ff.

[245] See above, pp. 160f.

[246] Pliny, *Naturalis historia* 23.64.130: "The wild fig, if a branch be put round the neck of a bull, however fierce, by its miraculous nature so subdues the animal as to make him incapable of movement." (Quoted from the translation of W. H. S. Jones, Loeb edn., VI, Cambridge and London, 1951, p. 501.) Cf. the variation in Plutarch, *Quaestiones conviviales* 2.7 and, especially, 6.10: ". . . the fiercest of bulls, if tied to a fig tree, becomes quiet, lets people touch him, and completely abandons his rage, as if the spirit were withering in him." (Quoted from the translation of P. A. Clement and H. B. Hoffleit, Loeb edn., VIII, Cambridge, 1969, p. 513.)

The traditional implications and associations of these plants and animals are clearly as applicable to the ducal pair metaphorically as to their mythological counterparts—none more so than the repeated connection with marriage. And it is precisely the wedding of Gian Francesco and Isabella, that event so auspicious for the Court of Mantua, that is celebrated in the *Parnassus,* as will become evident if we return to the figures of Mercury and Pegasus.

Far the largest in scale of all the figures in the painting, they occupy a prominent, not to say dominant position within it (figs. 1, 62). At the same time, both their absorption in each other and the closed, self-contained character of the group in which they have been paired cause them to appear detached from the other figures in the composition. The clue to this effect lies in the fact that it is the planet Mercury and the constellation Pegasus that are represented: Mercury, the all-powerful divinity addressed by Ovid as "arbiter of peace and war to gods above and gods below, thou who dost ply thy way on winged foot; thou who dost delight in the music of the lyre" in the popular poem devoted to the "starry signs that set beneath the earth and rise again."[247] The Winged Horse has proven to be the constellation Pegasus-Equus and to reflect the text of the *Fasti* in the number of stars to which his beaded harness alludes.[248] His companion is the planetary divinity who presides over artistic, scientific, and intellectual activities in such a characteristic product of the

A last variety of plant must be mentioned: the clusters of grapes that hang so conspicuously at the side of Vulcan's cave. Surely they, too, like every other plant or fruit in the picture are meaningful, but I have not been able to find any meaning appropriate for them within the context of the *Parnassus.* Among the innumerable references to grapes and vines in the *Naturalis historia* there are many, like 23.1.2–3.6, that allude to their varied medicinal properties. Yet I fail to see an intelligible relationship between this virtue and the sphere or activities over which Vulcan—the figure to whom they should refer—presides.

One wonders whether the sheared-off grotto on which Mars and Venus stand is a punning allusion to Isabella's *Grotta* (indeed, Wind, *Bellini's Feast of the Gods*, p. 17, implies as much). Were it not for the appearance in Quattrocento Ferrarese illumination and painting of similar formations of rock that open up to reveal and frame a distant view and, at times, even serve as a pedestal for crowning figures, it would be tempting to think so (see fig. 61 for a random example). Under the circumstances, however, the point cannot be pressed.

[247] *Fasti* 5.665ff. and 4.12, quoted from Sir James George Frazer's translation (*loc. cit.*).

[248] Above, pp. 136ff.

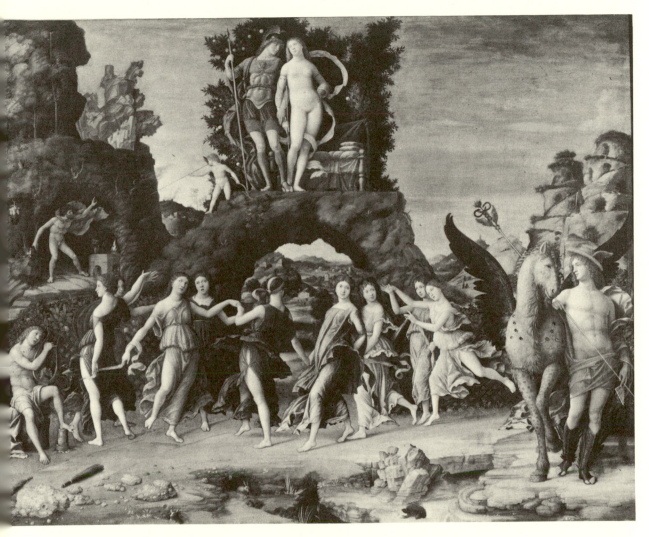

62. Mantegna, *The Parnassus*. Paris, Musée du Louvre

period as the series of Florentine engravings illustrating the influence of the planets based on a *Picture-Chronicle* attributed to Finiguerra (fig. 63).[249] There artists and artisans, scientists, musicians, and scholars engage in creative activity under the benign influence of the planet Mercury. In the *Parnassus,* too, Mercury is in the ascendant. In size and prominence, he is as conspicuous as the popular image of the seated divinity hovering in the sky, but he has been transposed from the celestial position conventional for the planetary gods in such scenes to the right foreground of the painting, where he retains his paramount importance within a rearranged, less orthodox composition.[250] Once again, Mantegna has reinterpreted an older iconographic scheme, preserving its content yet revising its form. The large-scale planetary divinity in the foreground presides over the activities represented in the painting and sheds his benign influence over those concerned with them, in particular, the divine-ducal couple who foster them, as they, in turn, stand in similar detachment and authority above the active figures whose artistic creativity they sponsor.

Not only size and position, but the heraldic language of color proclaims Mercury's supremacy. For suspended above the scarlet and white coverings appropriate for the couch of Mars and Venus[251] is a protective blue cloth— blue, color of the planet Mercury, thus symbol of his ascendant power (Pl. I). Under his beneficent auspices and the peace wrought by Venus, the arts

[249] Hind, *op. cit.* (above, n. 33), I, p. 82, no. 6a, II, pl. 124, where the first series is dated ca. 1460; Friedrich Lippmann, *Die sieben Planeten,* Internationale chalkographische Gesellschaft, 1895, pp. 1ff. and pl. A.VI; and Sidney Colvin, *A Florentine Picture-Chronicle,* London, 1898, pp. 16ff.

[250] The diversity of scale within the *Parnassus* has elicited bewildered or unenlightened comment (for example, that of Schmidt-Degener, *op. cit.* [above, n. 208], p. 293). In a work by one of the most accomplished painters of the period, it was obviously intentional. And although the comparative size of the figures was clearly determined by the content and the iconographic tradition behind certain units of the composition, it is evident that the artist has exploited the obligatory emphasis on Mercury and Pegasus in a skillful aesthetic fashion, establishing an oblique contrast between this large-scale group in the right foreground and the small figure of Vulcan at the far left, which balances and reverses the obliquely juxtaposed masses of the jagged crag that dominates the left portion of the painting and the distant peaks of Helicon at the right.

[251] See above, n. 223, for the colors of the various planets.

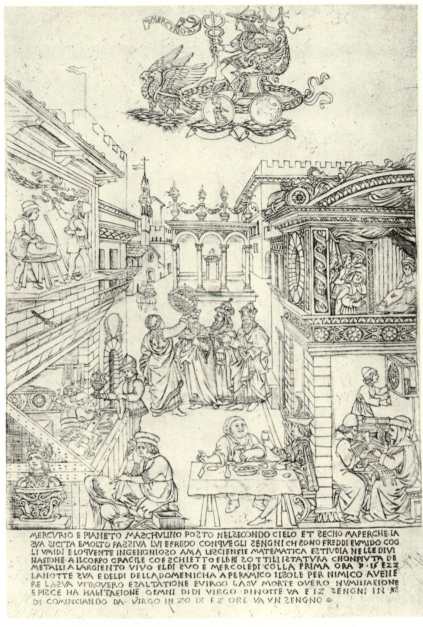

MERCVRIO E PIANETO MASCHVLINO POSTO NELSECONDO CIELO ET SECHO MAPERCHE LA
SVA SICITA EMOLTO PASSIVA LVI EFREDO CONQVEGLI SEGNI CH SONO FREDDI EVMIDO COG
LI VMIDI E LOQVENTE INGENGNIOSO AMA LESCIENSIE MATEMATICA ESTIVDIA NELLE DIVI
NASIONE A ILCORPO GRACILE COE SCHIETTO ELBI SOTTILI ISTATVRA CHONPIVTA DE
METALLI A LARGIENTO VIVO ELDI SVO E MERCOLEDI COLLA PRIMA ORA P. IS EZZ
LANOTTE SVA E DELDI DELLA DOMENICHA A PERAMICO ISSOLE PER NIMICO AVENE
RE LASVA VITA OVERO ESALTATIONE EVIRGO LASV MORTE OVERO NVMILIASIONE
E PISCE HA HABITASIONE GEMNI DI DI VIRGO DINOTTE VA E IZ SENGNI IN
DI COMINCIANDO DA VIRGO IN ZO DI E Z ORE VA VN SENGNO

63. Finiguerra, *Picture-Chronicle*: the planet Mercury.
London, British Museum

flourish, especially the art of music dear to the inventor of the lyre and the syrinx.[252] Thanks to the union of the music-loving Duke and Duchess, it flourishes at the Court of Mantua. And it is to the all-important union of Gian Francesco and Isabella that a final concrete reference is made through the ever-meaningful imagery of this densely allusive painting.

On February 11, 1490, the day when, on the advice of astrologers, the Duke of Mantua and his long-affianced Este bride were married at Ferrara,[253] the planets Mercury, Mars, and Venus stood within the sign of Aquarius and the westernmost bright star of the extra-zodiacal constellation Pegasus fell within its boundaries.[254] What is more, Mars and Venus stood in harmonious symmetry equidistant from and flanking Mercury. On this auspicious occasion, the martial Duke and his cultivated bride were united.[255] Hence the presence

[252] Above, pp. 123, 139.

[253] Above, p. 138 and n. 161.

[254] I am greatly indebted to O. E. Neugebauer for having directed me to the first two references cited in this note and to Waltraut C. Seitter for having ascertained for me the relative positions of Mars and Venus, Mercury and Pegasus on this day. I owe to her the crucial points that the three planets and ε Pegasi, the westernmost bright star in the constellation Pegasus, all stood within the sign of Aquarius on February 11, 1490, and that during that day the planets Mars and Venus were each almost exactly ten degrees distant in ecliptical longitude from the planet Mercury. See Bryant Tuckerman, *Planetary, Lunar, and Solar Positions A.D. 2 to A.D. 1649 at Five-Day and Ten-Day Intervals* (*Memoirs of the American Philosophical Society*, LIX), Philadelphia, 1964, p. 763; Tycho Brahe, *Scripta Astronomica* (ed. by I. L. E. Dreyer), Hauniae, 1916, III, pp. 367f.; and, for a map showing the positions of the planets adjusted in relation to their ecliptical co-ordinates and to the positions of the stars in 1490, see Jean Fortin, *Atlas céleste de Flamstéed*, publié en 1776 (ad-

justed to 1780), 3d edn., Paris, 1795, pl. 21.

For the extra-zodiacal constellations (i.e., the paranatellontes rising to the north and south of the zodiacal signs), in this case, Pegasus-Equus to the north of the ecliptic, see Richard Hinckley Allen, *Star-Names and Their Meanings*, New York, 1899, pp. 10ff., 321ff., and E. J. Webb, *The Names of the Stars*, London, 1952, pp. 54ff., 125, 132.

[255] To the evidence of concern for astrological protection and interest in planetary lore at the courts of Ferrara and Mantua cited above, pp. 138ff., 166, and the references thereto, it is worth adding the fact that the theater in the Castello at Mantua in which Mantegna's *Triumph* served as a stage set was roofed in such a manner as to simulate the vault of heaven studded with constellations, and that over the stage sun and moon and the signs of the zodiac moved in their accustomed orbits. For a contemporary description of this celestial decoration which was coupled with a display of appropriate banners and arms, including devices of the Gonzagas and Este, see Cartwright, *op. cit.*, I, pp. 185f.

of quinces at the sides of Mars and Venus, their mythological counterparts, hence the *myrtus coniugulis* behind them. Mercury was in the ascendant, linked with the Horse consecrated to the Muses. Under his benign influence the arts would flourish at the Court of Mantua, especially the art of music. Through their patronage of the Muses, the ducal pair would win fame and immortality; through music they and the fortunate circle around them would be transported to the pure realm of beauty and intellect; through the Muses and music, they might discern the celestial harmony of the spheres.[256] Rich in overtones yet fundamentally simple in content, this, the first painting commissioned by Isabella for her *studiolo* commemorates her marriage to Gian Francesco and, in mythological terms, their patronage of the arts, in particular, music.[257]

ESSENTIALLY simple in content if densely allusive in detail, especially to the select company to whom it was exposed, the *Parnassus* proves to have been devised with the aid of a limited number of classical monuments and texts: some half-dozen Roman sculptures visible in the city of Rome; some dozen of the most widely-read and influential ancient writings easily available in the ducal libraries at Mantua and Ferrara. Presumably Mantegna saw and recorded the Imperial reliefs and the solitary statue he used during his sojourn in Rome from June 1488 to September 1490,[258] the years immediately pre-

[256] For the varied functions of the Muses, including their role as dispensers of terrestrial glory, see Cumont, *Recherches sur le symbolisme funéraire des romains* (above, n. 56), chap. IV, passim.

[257] For a representative example of the contemporary practice of alluding in a painting to celestial positions on the occasion of a significant date in the life of an individual, such, for instance, as a birthday or wedding day, see the well-known study of Fritz Saxl, *La fede astrologica di Agostino Chigi* (Reale Accademia d'Italia, Collezione "La Farnesina," I), Rome, 1934, where it is shown that the planets and constellations depicted on the vault of the Sala di Galatea in the Farnesina are those of the Roman sky

on December 1, 1466, Chigi's birthday.

Allusion to the ducal couple's patronage of the arts at the Court of Mantua through the imagery of the *Parnassus*, in a sense, likens their court to Mons Parnassus. It is interesting to note that the court at which Isabella grew up in Ferrara had been complimented in an analogous fashion long earlier, when Cleofe de' Gabrielli dedicated to Borso d'Este a poem describing his ascent of Parnassus as a result of his own patronage, especially of poetry (*Anecdota litteraria*, ex mss. codicibus eruta, Rome, 1773, IV, pp. 461ff.).

[258] See Kristeller, *Andrea Mantegna*, pp. 297ff., and G. Fiocco in U. Thieme and F. Becker, *Allgemeines Lexikon der*

ceding his work for Gian Francesco and Isabella on his return to Mantua. Together with two of Cyriacus' drawings of ancient reliefs and an equally limited number of illustrations available in innumerable copies of the classical astrological treatises so popular in his day, they enabled him to revise certain late medieval iconographic types and schemes that were relevant to the imagery of the painting and accessible to him, in particular, via the *Libellus*, the illustrations of Gafori's books, and contemporary prints of the planets. Accurate in the choice of his models, careful to use literal ancient equivalents for his cast of characters, he enriched his figures and their setting by details and features culled with equal precision from the most revered classical writers.

This characteristically archaeological approach to a subject, this passion for authentic detail, are so much the hallmark both of Mantegna and the *Parnassus* as to revive the vexed problem of the painter's role in the creation of the picture. Obviously it fulfills Isabella's later stipulation to Bellini that his painting should represent a classical subject with a beautiful meaning.[259] And inasmuch as Mantegna's successors in the *studiolo* were provided with explicit programs by the Duchess and her advisor Paride da Ceresara, some critics have assumed that he, too, simply executed an "invention" devised by others.[260] A few earlier writers steeped in the facts of Mantegna's career and with a strong sense of his artistic personality and procedure have believed that he might himself have been largely responsible for both program and execution.[261]

bildenden Künstler, XXIV, Leipzig, 1930, pp. 38f., for this interlude arranged at the request of Innocent VIII.

The fact that three of these monuments were sarcophagi, that all were Roman (conceivably the statue of Mercury was a copy of a Greek original), and that at least three of them were subsequently quoted in works by Raphael and his circle are points worth recalling. The use of predominantly sculptural prototypes in the *Parnassus* is in accord with the well-known report of Vasari on Mantegna's conviction that "good antique statues are more perfect and beautiful than anything in Nature" (see, for convenience, the Every-man edition of *Vasari's Lives of the Painters, Etc.*, tr. by A. B. Hinds, London and New York, 1927, II, p. 104).

[259] For recent reference to this requirement and the text of Isabella's statement, see Gombrich, *op. cit.* (above, n. 7), p. 196, n. 1.

[260] For example, Yriarte, *op. cit.* (above, n. 1), p. 397, and Wind, *Bellini's Feast of the Gods*, pp. 14ff. For Paride da Ceresara, see Luzio-Renier, *op. cit.*, 34 (1899), pp. 86–90.

[261] Thode, *Mantegna*, p. 103, and, to some extent, Kristeller, *Andrea Mantegna*, p. 345.

No extant documents reveal Isabella's arrangements or consultations with the court painter in connection with this first of the paintings commissioned for her cherished apartment.[262] No certain conclusion may be reached on the degree of the artist's participation in the total project. Yet in view of his life-long preoccupation with antiquity both as a painter and as a collector, and of his long association with the most learned scholars of northern Italy,[263] and given Isabella's and the Gonzagas' great respect for his knowledge and connoisseurship,[264] it seems more likely than not that he played a major part in the conception of the painting,[265] as he surely must have been responsible for the extraordinary degree to which classical form and content were reinte-

[262] Yriarte, *op. cit.*, p. 394.

[263] See Panofsky, *Renaissance and Renascences*, p. 173, for a sound statement on the primacy of this region at the time in the pursuit of antiquarian studies and on the emergence there "of an antiquarian attitude so pervasive that the archaeologists, the painters and the humanists pure and simple worked and lived, as it were, in unison"—in token of which he cites Mantegna's well-known excursion on the Lago di Garda in the company of his humanist friends, for which see above, pp. 110f. Panofsky has made an equally correct appraisal of the unique range of Mantegna's knowledge of ancient monuments and literary sources, pp. 200f.

Millard Meiss, "Toward a More Comprehensive Renaissance Paleography," *AB*, 42 (1960), pp. 97 and, especially, 102ff., in proposing that Mantegna played a key role in the Quattrocento revival of the Roman majuscule, has analyzed another characteristic facet of his interest in antiquity not evident in the *Parnassus*. Alluding to his Paduan background and associations, Meiss concludes (p. 109): "In this environment the painter was seized with a more passionate desire than any other artist of the century to bring antiquity back to life."

[264] For characteristic examples of this attitude, note the Duchess' rejection of a purportedly antique head because the painter considered it neither authentic nor good (A. Bertolotti, *Le arti minori alla corte di Mantova*, Milan, 1889, p. 181), and Cardinal Francesco Gonzaga's earlier request that Mantegna be sent to visit him so that he might enjoy himself by showing the painter his antiques (Cartwright, *op. cit.*, I, p. 34).

[265] The fact that in writing to Isabella about Bellini's painting for the *studiolo*, Lorenzo da Pavia remarked, "Although it is true that in *point of invention* [italics mine] it cannot compare with the work of Messer Andrea, that most excellent master" (Cartwright, *op. cit.*, II, p. 351), surely implies that Mantegna did far more than execute a program devised by others in painting the *Parnassus*.

It has been suggested that Marcanova served as his archaeological advisor when, as a youth, he worked in the Chapel of the Eremitani (Knabenshue, *op. cit.* [above, n. 26], pp. 72f.) and that throughout his life he was influenced by the precepts of Alberti (Michelangelo Muraro, "Mantegna e Alberti," *Atti del VI Convegno Internazionale di Studi sul Rinascimento* [above, n. 228], pp. 103ff. I am indebted to Ruth W. Kennedy for knowledge of this paper). Obviously Mantegna sought such associations, but equally obviously the venerable painter of the *Parnassus* differed radically from the youth

grated[266] in this unique picture. Analysis of the painting figure by figure, item by item, has yielded concrete evidence of the mentality and artistic procedure behind it—of the painter's rigorous pursuit of the authentically antique. It is hard to believe that, master, connoisseur, antiquarian that he was, Mantegna's role in the creation of the picture was as limited as that of his successors in the *studiolo*.

Whatever Mantegna's contribution to the program of the *Parnassus*, whether Isabella or one of her circle provided him with the courtly compliment, the mythological metaphor, that seems to be its dominant theme, it was surely he who gave it its concrete imagery, its antique form. It is tempting to speculate on the degree to which the learned painter must have fostered his youthful patroness' growing appetite for ancient works of art[267] and touching to recall that in the last year of his life, when illness and debts forced him to part with his favorite possession, it was to Isabella, the collector, that Mantegna sold a Roman sculpture.[268] No painting of the period is more richly evocative of the attitudes and tastes of the late Quattrocento than the *Parnassus*, early fruit of their association.

who worked in Padua half a century earlier in his knowledge and experience of ancient art and literature, hence in his dependence on the advice of others.

[266] To use the apt phrase of Panofsky, "Classical Mythology in Mediaeval Art" (above, n. 131), pp. 225f.; *Studies in Iconology*, p. 27; *Renaissance and Renascences*, pp. 111ff.

It is relevant to recall that Panofsky has assumed that Piero di Cosimo was personally responsible for the complex program and sources of his cycle of paintings dealing with the early history of man:

JWarb (above, n. 172), pp. 28ff.; *Renaissance and Renascences*, p. 179.

[267] See, for example, her comment to a Ferrarese jeweller charged with engraving a figure of Orpheus on one of her gems, that he might take his time as long as his work came near to ancient art (Cartwright, *op. cit.*, I, p. 74).

[268] The cherished bust of Faustina that presumably appears in Panel II of the *Triumph of Caesar*. See Kristeller, *Andrea Mantegna*, pp. 273, 414, 417, 496ff. (documents 76, 77, 80), and Lauts, *op. cit.* (above, n. 160), pp. 172f.

III

THE SHIP-FOUNTAIN FROM
THE *VICTORY OF SAMOTHRACE*
TO THE *GALERA*

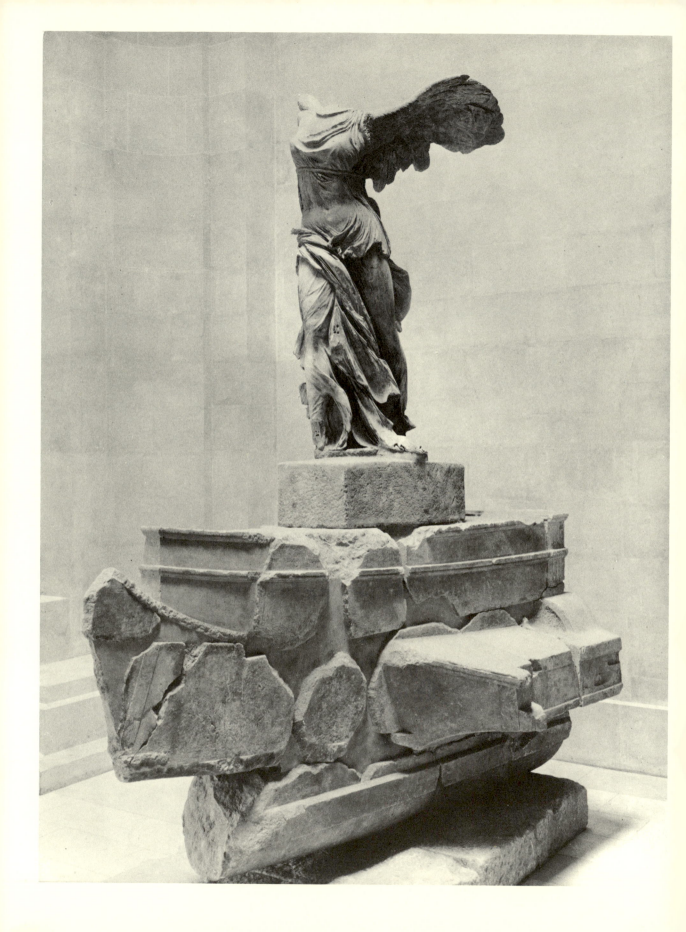

THE ISLAND of Samothrace, once renowned for its mysterious rites and potent gods, is associated by most people in our time with a masterpiece of Greek sculpture: the *Victory of Samothrace* in the Louvre (fig. 1). This work by an unknown genius—among the greatest in the history of western art—may, in antiquity, too, have been the most beautiful work of art exhibited among the various monuments in the Sanctuary of the Great Gods.

Colossal, carved in shining Parian marble, with wings wide-spread, swaying slightly in her arrested flight, the Victory is alighting on the grayish marble prow of a warship, her feet just touching its deck. Her powerful body struggles against the strong wind that for most of the year sweeps down on the Thracian sea and the island. It presses her draperies against her limbs, making them flutter and flap with almost audible vivacity.

The monument stood on a hillside in the background of the Sanctuary, overlooking it from a position high above the curved auditorium of a Greek

I AM greatly indebted to many persons who have helped me on an adventurous voyage of exploration which started on a hillside in Samothrace with the investigation of the site of the *Victory*. Apart from my numerous helpers there, including Jean Charbonneaux, who took part in the excavation, and Alec Daykin and Stuart M. Shaw, who measured and drew the plans and sections and worked on the restoration of the monument, I should acknowledge here the assistance and advice generously given by many others, among them: James S. Ackerman, Axel Boëthius, Raissa Calza, A. M. Colini, Rudolf Hess, Ernst Kantorowicz, J. D. Kondis, Richard Krautheimer, Elaine P. Loeffler, A. Hyatt Mayor, Erwin Panofsky, John Ward Perkins, and P. Pietrograndi. As always, my wife, Phyllis Williams Lehmann, has contributed immeasurably to this investigation. [This essay stands as it was written in the mid-fifties, apart from a modest number of additions to the notes which either incorporate references subsequently collected for this purpose by the author before his death in December 1960 or provide information or bibliography that has become available since that date. All such additions appear in brackets and, for the most part, are initialed. P.W.L.]

1. The *Victory of Samothrace*. Paris, Musée du Louvre

theater and facing the not far distant deep blue sea, beyond which the shores of Thrace are visible[1] (fig. 2).

For several centuries after the end of antiquity, when the pagan cult had been abandoned, the statue seems to have remained upright. A Greek writer of the Early Christian era mentions a figure of a goddess who, he thought, was rushing forward to defend her sanctuary—surely the *Nike*.[2] Together with all the buildings of the Sanctuary, it probably collapsed in a severe earthquake in the time of Justinian,[3] and its debris was soon covered by earth and vegetation. Thus Cyriacus of Ancona could not have seen any fragment of it, nor

[1] For the Sanctuary as it is now known, see my *Samothrace, A Guide to the Excavations and the Museum*, New York, 1955 [3d edn., rev., Locust Valley, 1966]; for the *Nike Fountain, ibid.*, pp. 71f. [3d edn., pp. 76f.].

[2] This is the enigmatic Nikostratos, whose manuscript quoted by Francesco Piacenza (*L'Egeo redivivo*, Modena, 1688, p. 448) I, like previous searchers, have not been able to find. See Otto Rubensohn, *AA*, 1896, p. 35.

[3] See "Samothrace: Third Preliminary Report," *Hesperia*, 19 (1950), pp. 21f.; "Samothrace: Fourth Preliminary Report," *ibid.*, 20 (1951), p. 12.

2. Samothrace. View of the Sanctuary from the *Nike Fountain*

did the learned men who visited Samothrace four hundred years after him in the first half of the nineteenth century.

In 1863, when Champoiseau, a French consul and amateur antiquarian, began to excavate in a nearby building, native workmen reported one day that they had "found a woman," and the body of the *Nike* began to emerge. A little distance behind it, the fragments of the prow were soon discovered, and slabs of the same material on which the prow had rested were found still in place.[4] These blocks and fragments were gradually transferred to the Louvre and ultimately put together.[5]

Champoiseau's discoveries and subsequent investigations and discussions gave a general idea of the appearance of the monument. They revealed that the ship's prow had been placed obliquely within some kind of rectangular architectural setting, but the exact nature of that setting was unknown. Inasmuch as the arms as well as the head were missing, the restoration of the statue remained uncertain. Suggestions for it varied between having the figure blow a trumpet or extend a crown or diadem in her right hand. Until recently, the date of the monument, too, has been debated. Antiquarian, historical, and art-historical arguments have shifted the figure around over a wide span of time from the late fourth to the first century B.C.

In the course of recent excavations, some of these problems have been solved. Observations drawn from ceramics found in the precinct enable us to say that the monument dates from the late third or early second century B.C.[6] Discovery of the major part of the figure's right hand on the site and of

[4] I owe valuable information on Champoiseau's discovery to an unpublished report of his in the Archives of the Quai d'Orsay, a copy of which was given to me by Jean Charbonneaux.

[5] See, especially, A. Conze in *Samothrake*, II, pp. 55ff. Further bibliography is cited by Chr. Blinkenberg, "Triemiolia," *Lindiaka* VII, *Det Kgl. Danske Videnskabernes Selskab* (Archaeologisk-Kunsthistoriske Meddelelser, II, 3), Copenhagen, 1938, pp. 37ff. Most important are Champoiseau's report "La Victoire de Samothrace" (*RA*, new ser., 39 [1880], pp. 11ff.), showing the statue and prow in unrestored state at the time, and the story of the discovery and restoration given by Salomon Reinach, "La Victoire de Samothrace," *GBA*, ser. 3, 5 (1891), pp. 89ff.

[6] It is a quite cheerful fact that most serious students of Hellenistic sculpture had arrived at this date through the method of stylistic criticism before it was confirmed by our recent excavations. For bibliography on this topic, see Heinz Kähler, *Der grosse Fries des Altars von Pergamon*, Berlin, 1948, pp. 173ff., n. 75. [Unfortunately, the old incorrect date ca. 300 B.C. lingers on in non–art-historical discussions like that of Paul Gille, "Les navires à rames de l'antiquité, trières grecques et liburnes romaines," *Journal des savants*, 63 (1965), p. 57. P.W.L.]

some of its fingers in a basement storage room of the Kunsthistorisches Museum in Vienna revealed that that hand had never held an object:[7] Nike alighted on the ship extending her arm forward against the enemy in a great gesture of command (fig. 3).

But the most important new observations concerned the setting of the monument.[8] Patient work gradually revealed its nature, and if some details still remain uncertain, the general restoration is well founded. It results that the monument, although undoubtedly commemorating naval power, was actually part of a fountain. An aqueduct—parts of which are still preserved (fig. 4 A)—led water into a shallow basin in which the rippled surface of the base slabs lay beneath the surface of the water. Various holes on these slabs suggest that marine creatures such as dolphins, in bronze, may have played around the ship, which was surrounded by water. In front of this basin in which the prow stood, there was a lower basin of equal width from which

[7] See Jean Charbonneaux, "La main droite de la Victoire de Samothrace," *Hesperia*, 21 (1952), pp. 44ff. When writing this note, M. Charbonneaux considered the possibility of a victor's taenia in metal having been slung around the fingers. However, given the high position of the hand and the exposure of the statue to the storms of Samothrace, such an attribute could not have existed without dowels, of which there are no traces, and, even if it had been thus fastened, the wind would immediately have ripped it apart, as Messrs. Daykin and Shaw observed. The alleged traces of an attribute are simply chisel marks that have not quite been polished off this distant part of the statue. A hand previously found in Samothrace and allegedly belonging to the statue (for which see Charles Picard, *BCH*, 36 [1912], p. 357, and Kähler, *op. cit.*, p. 175, n. 76) was left by the discoverer in Samothrace, I am told, and seems to have disappeared for the time being. I am also told that after its discovery had been announced (*loc. cit.*), it proved to be too small to belong to the figure.

[In 1967, yet another fragmentary hand related to the *Victory of Samothrace* was recovered from the dump of a French-Czech excavation on the western hill of the Sanctuary in the area to the north of the Stoa. Colossal in size and made of Parian marble, it is a left hand identical in style with the right hand discovered in the Nike Precinct in 1950. Somewhat smaller in scale than the right hand, it must either have belonged to the *Victory* (whose raised right hand may well have been intentionally enlarged) or come from another otherwise unknown statue by the same sculptor. Renewed investigation of the *Victory*, desirable for many reasons, should yield a final answer to this problem. In the meantime, see James R. McCredie, "Samothrace: Preliminary Report on the Campaigns of 1965–67," *Hesperia*, 37 (1968), pp. 211f., pl. 62 e, and, for additional illustrations, "Chronique des fouilles . . . en 1967," *BCH*, 92 (1968), p. 937, figs. 9, 10. P.W.L.]

[8] See "Samothrace: Fifth Preliminary Report," *Hesperia*, 21 (1952), p. 20; "Samothrace—Seventh Campaign of Excavations, 1952," *Archaeology*, 6 (1953), p. 33; *Guide*[3], p. 77, fig. 37.

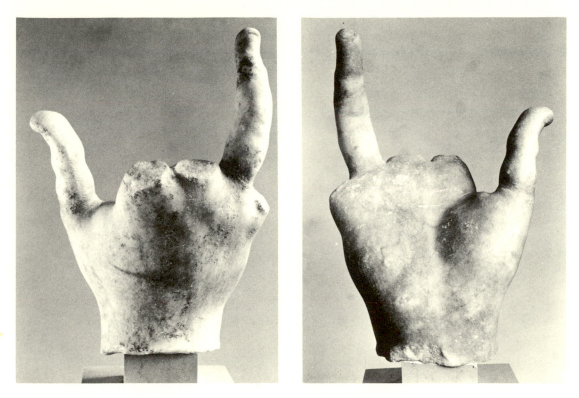

3. Right hand of the *Victory of Samothrace*. Paris, Musée du Louvre

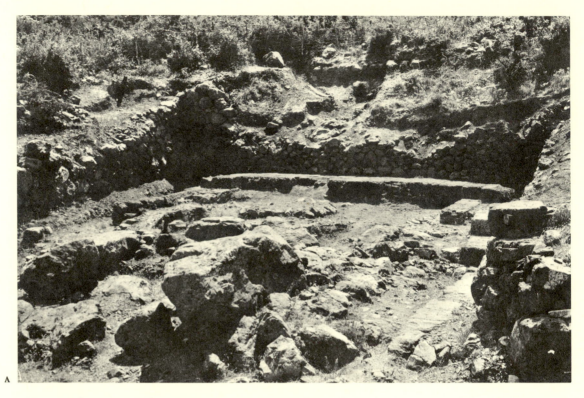

A

4. Samothrace. Views of the ruins of the *Nike Fountain*.
A. From the northwest, showing the pipeline (upper center).
B. From the east, showing the oval foundation for
the ship (center) and the lower basin (right center)

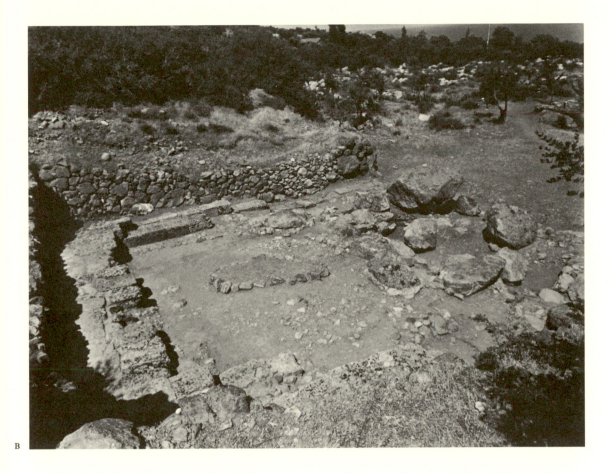

B

two huge boulders emerged—an allusion to the rocky scenery of an Aegean harbor from which the ship seemed to sail forth. Water channels at the sides of this basin led off the overflow. It was in one such channel that the right hand of the statue was discovered. It had slipped into it when the figure fell from its high position into the lower basin where Champoiseau found its remains.

The Nike on her ship sailing obliquely forward through actual water, her body outlined against the high mountains of the island and the sky, must have been seen reflected between the huge boulders in the lower basin (fig. 5). The illusion was not yet complete, but intermingled with the artificial, regular framework of the two basins in a manner similar to the easy interplay of sculpture, water, natural forms, and architectural setting in many fountains from the sixteenth to the eighteenth century.

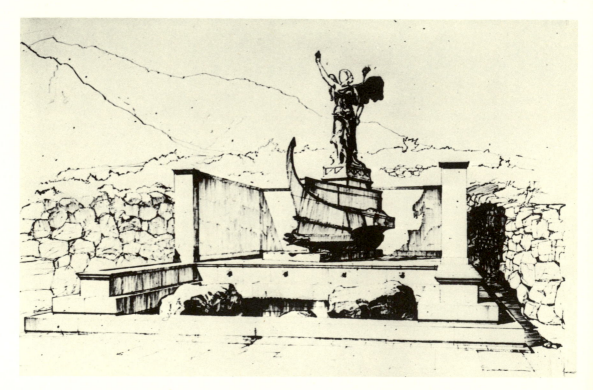

5. Provisional reconstruction of the *Nike Fountain*.
(The enframing outer walls are a later addition)

The illusionistic mingling of sculpture with natural landscape elements is known in the late, Hellenistic phase of Greek art.⁹ And the specific idea of evoking the sculptural image of a ship in a natural setting of rocks—an expression of such romantic illusionism—is also known. If one ascends to the ruins of the Sanctuary of Athena at Lindos on the island of Rhodes, one sees at the turn of the road, carved out from the rocky slope in high relief, the rear part of a warship which once supported statuary and which commemorated a naval victory of the early second century B.C. (fig. 6).¹⁰ Only the ship's stern is visible, its forepart disappearing behind the rocks as if it were seen from the beach of a harbor (ancient ships turned their sterns toward a beach).

What is novel in Samothrace is the fountain itself and the introduction of the ship in such a context into its true element, water. The idea is strikingly analogous to the play with ships in water in the Baroque fountains of Rome, the best known among them probably being the *Barcaccia* in Piazza di Spagna.¹¹ Is this analogy but one of the tedious, if instructive, examples of the production of similar ideas by various peoples at different times and in

⁹ One may simply recall such instances as those of the small Pergamene groups and the *Barberini Faun* in Munich. The existence of sculptures connected with fountains in the Hellenistic period has been wrongly denied by Erna Lange, *Die Entwicklung der antiken Brunnenplastik* (unpublished dissertation, Göttingen, 1920; *AA*, 1920, pp. 100ff.). See B. Schweitzer, *Ein Nymphaeum des frühen Hellenismus, Festgabe*, Leipzig, 1938. The bronze Eros in the Metropolitan Museum of Art (Gisela M. A. Richter, "Archaeological Notes, A Bronze Eros," *AJA*, 47 [1943], pp. 365ff.), a masterpiece of Rhodian sculpture of the third century B.C., was undoubtedly a fountain statue, as was its replica in Rome (Margarete Bieber, *The Sculpture of the Hellenistic Age*, rev. edn., New York, 1961, p. 145, with bibliography n. 78). Traces of exposure to the spray of water are clearly visible on the left foot. See also the dolphin carved in relief on a rock in Thera which appeared to jump out of the water which spouted forward be-

hind his tail: *Monument of Artemidoros* (250–240 B.C.), F. Hiller von Gaertringen, *Thera*, III, Berlin, 1904, p. 98, fig. 79.

¹⁰ See Chr. Blinkenberg, *Lindos, Fouilles de l'Acropole, 1902–1914*, II (*Inscriptions*), Berlin and Copenhagen, 1941, pt. I, cols. 431ff., no. 169; *idem*, "Triemiolia," *op. cit.*, pp. 22ff.; M. Rostovtzeff, *The Social and Economic History of the Hellenistic World*, Oxford, 1941, II, p. 682, pl. LXXVII.

[See also E. Dyggve, *Le Sanctuaire d'Athana Lindia et l'architecture lindienne* (*Lindos, Fouilles et Recherches, 1902–1914*, 1952, III), Berlin and Copenhagen, 1960, III, pp. 56f., 72, fig. III, 27; 73, fig. III, 28; 74, pl. III A; 435. On p. 56, the author mistakenly describes the relief as representing the *prow* (rather than the stern, as correctly reported by Blinkenberg, Rostovtzeff, et al.) of a warship. See now, too, J. S. Morrison and R. T. Williams, *Greek Oared Ships 900–322 B.C.*, Cambridge, 1968, pp. 180, 282, 284. P.W.L.]

¹¹ See below, pp. 246f., figs. 57, 58.

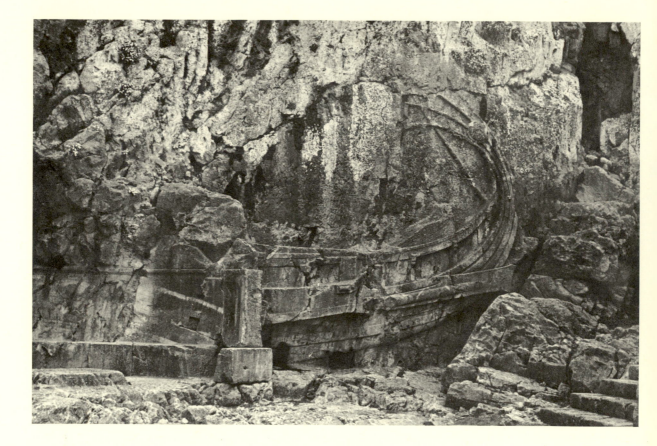

different regions, if certain conditions of society and a certain mentality recur? Or does a problem of survival and revival exist here, a historical tradition of some kind that leads from the antique to the Renaissance? To be sure, in this case, there was not and could not have been a mediator like Cyriacus of Ancona to transmit a true or alleged antique model to his age. The tradition, if it exists, is more complex and less direct. Such, I believe, it was.

LIKE ALL great monuments of ancient art, the *Nike of Samothrace* is but a creative variation on a familiar theme. Prows of warships as symbols of maritime power or in commemoration of specific naval victories had been a familiar device on the coins of Greek city-states for centuries.[12] In the last decade

[12] See, for example: Samos, K. Regling, *Die antike Münze als Kunstwerk*, Berlin, 1924, pl. VI, fig. 167 (before 480 B.C.); Phaselis, British Museum, Department of Coins and Medals, Barclay V. Head, *A Guide to the Principal Coins of the Greeks*, London, 1932, pl. 9, fig. 43 (before 400 B.C.); Kyzikos, *ibid.*, pl. 8, fig. 15 (ca. 410 B.C.); Cius, *ibid.*, pl. 28, fig. 24 (time of Alexander the Great).

6. Lindos, Rhodes. Relief showing the
stern of a naval vessel

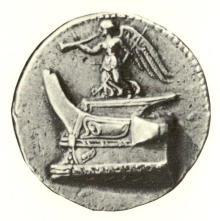

7. Obverse of tetradrachm of Demetrios Poliorketes:
Nike on prow of captured vessel.
New York, American Numismatic Society

of the fourth century B.C., Demetrios the Besieger adopted this simple symbol on his coinage, and, in a famous series of coins commemorating his Cyprian victory, Nike stands on the prow of a captured enemy ship with broken finial and blows on a trumpet a fanfare of victory (fig. 7). It is by no means certain that this coin type reflects a major work of art, sculpture-in-the-round, relief, or painting, dedicated by the victor.[13] In Samothrace itself, the ship's prow appears as a symbol on Hellenistic coins documenting the fact that the city prided herself on her small navy and suggesting the possibility that the

[13] See E. T. Newell, *The Coinages of Demetrius Poliorcetes*, London, 1927, passim; Charles Seltman, *Greek Coins*, London, 1933, pp. 221f. Although before our excavation ascertaining for the *Nike of Samothrace* a date almost one hundred years later than the battle of Cyprian Salamis stylistic reasons were sometimes advanced for refuting the old and still lingering connection of the statue with that event, Newell has the merit of having been the first to point out that such a connection is impossible because of the broken upper end of the prow on the coins of Demetrios. This reveals that the coins show not the *Nike of Samothrace* but the partly damaged prow of an actually captured warship or a representation of such a prow. It will be noted that rather in favor of the first alternative is the fact that, particularly on smaller denominations of the coinage of Demetrios, the prow often appears without a Nike (pls. 2, 9; 4, 4 and 8; 17). In one instance, a Palladium appears on the captured prow (Athena of Lindos having occupied it [pl. 18, 8]). [For this type, see now Alfred R. Bellinger and Marjorie Alkins Berlincourt, *Victory as a Coin Type* (Numismatic Notes and Monographs, 149), New York, 1962, pp. 28ff., pl. VII, 2. P.W.L.]

great monument may as well have commemorated Samothracian participation in a naval battle of the time as have been a dedication in the Sanctuary by a Hellenistic king or city, or by Rome, as has been suggested.[14]

Not only are the symbol of the ship and of Victory on it familiar as such, but sculptural monuments representing ships and prows of ships were evidently a common type in the Hellenistic age from the third, if not from the late fourth,

[14] It may be noted that beginning with the fourth century B.C. the coinage of Samothrace commonly shows a ship's prow, sometimes with a warrior on it, and thus documents the existence of a Samothracian navy (see Herodotus 8.90) throughout the Classical and Hellenistic periods. Though the warrior's figure has been misinterpreted as a Nike (by N. B. Phardys, Νομισματικὰ Σαμοθρᾴκης, *JIAN*, 1 [1898], pp. 256f.), as Miss Loeffler has ascertained, the documentation of Samothracian naval power by the coins is unequivocal. Under these circumstances, and given the fact that the Nike monument belongs to a fountain—indeed, seemingly the only fountain in the Sanctuary—it is quite possible that the monument was commissioned by the Samothracians themselves and not meant to commemorate a naval victory of a foreign power such as Rhodes. The attribution to Rhodes and all subsequent speculation were caused by the use of Rhodian (Lartian) marble for the base and ship. The fragment in such material with a signature of a Rhodian artist, now in the Louvre (H. Thiersch, "Die Nike von Samothrake ein rhodisches Werk und Anathem," *Nachrichten von der Gesellschaft der Wissenschaften zu Göttingen*, Phil.-hist. Kl., 1931, pp. 341ff.), has letters much too small to belong to this large monument (see also Thiersch, *ibid.*, p. 343, and Kähler, *loc. cit.*). Another fragment of such marble with part

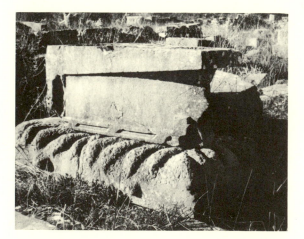

8. Epidauros, Sanctuary of Asklepios.
Ship-monument

9. Lindos, Sanctuary of Athena.
Fragmentary ship-monument

century B.C. onward. Apart from the previously mentioned rock relief in Lindos,[15] I know of remnants of at least six Hellenistic ship-monuments in-the-round. The earliest of them was found in the Sanctuary of Asklepios in Epidauros (fig. 8) and dates from the early third, if not the late fourth, century B.C.[16] A second, again found in the Sanctuary of Athena at Lindos, commemorates a naval victory of the mid-third century B.C. (fig. 9).[17] Both are

of one large letter found by us and now in the Louvre may belong to it and deserves more consideration, but it does not really help. There may have been other monuments of this material in Samothrace, where all marble had to be imported. The use of Rhodian marble in a monument commissioned by the Samothracians for their sanctuary may easily be explained by such facts as that a Samothracian sculptor, Hieronymos, worked in Rhodes and in conjunction with Rhodian sculptors in this period (ca. 220 B.C.; Lindos, II, pt. 1, pp. 316ff.). He has as much claim to be the creator of the *Nike of Samothrace* as any other sculptor of the age.

[15] Above, p. 189 and n. 10.

[16] P. Cavvadias, *Fouilles d'Epidaure*, Athens, 1893, pp. 38ff., n. 20; *IG*, IV¹, nos. 1180–1183; IV², no. 306D; Chr. Blinkenberg, *Asklepios*, Copenhagen, 1895, p. 124; idem, "Triemiolia," *op. cit.*, p. 33, fig. 9; idem, *Bonner Jahrbücher*, 120 (1911), p. 155, fig. 5. Cavvadias dated the original dedicatory inscription in the fourth century, while Fraenkel (*IG, loc. cit.*) preferred a later date. I do not see why. The monument was later usurped by Mummius, and its present location probably goes back to that time. Examination of it by Mrs. Lehmann and me in Epidauros in the summer of 1955 revealed that (a) the base on which the prow now stands is of different material and workmanship from the prow itself and therefore presumably dates from Mummius' time; and (b) originally the prow was posed on its

base obliquely, like the prow of the *Nike of Samothrace*, to give the illusion of sailing by, rather than straight forward, as it does standing on the present base. This is borne out by the fact that the carving is asymmetrical, with the side on which the original dedicatory inscription is preserved being longer than the other; consequently, in the present straight position, the back is oblique. The original location is unknown, therefore, and may conceivably have been connected with a fountain. The figural decoration on top (holes are extant from the two different periods for different statues) may or may not have been a Nike. Height 0.52 m.; length 1.15 m. [See, too, J. Marcadé, "Sur une base lindienne en forme de proue," *RA*, ser. 6, 26 (1946), p. 149, n. 3; and J. F. Crome, *Die Skulpturen des Asklepiostempels von Epidauros*, Berlin, 1951, p. 27. P.W.L.]

[17] Blinkenberg, *Lindos*, II, pt. 1, cols. 301ff., no. 88; idem, "Triemiolia," pp. 14ff., 30ff.; Marcadé, *op. cit.*, pp. 147ff. In this case again, the fragments were discovered out of the context of their original position, and it is a mere conjecture that they were placed in the huge outer stoa of the Sanctuary. The possibility is not excluded that the monument formed part of a fountain. [The date 265–260 B.C. proposed by Blinkenberg, *Lindos*, II, pt. 1, col. 308, is not questioned by Dyggve, *op. cit.*, pp. 247f., but he, too, considers any relationship between this monument and the Stoa to be unproved and improbable. P.W.L.]

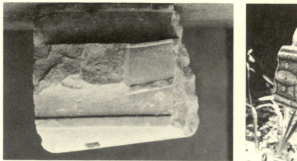

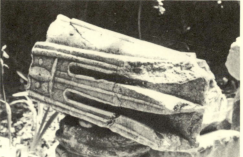

10. Fragmentary ship-monument,
Kos, Archaeological Museum

11. Fragmentary ship-monument.
Rhodes, Archaeological Museum

prows. Three others, also Hellenistic, to judge from their style and workmanship, and hitherto unpublished, are preserved in the museums of Kos,[18] Rhodes,[19] and Ephesos[20] (figs. 10–12). In the museum of Rhodes, there is, in addition, a funeral altar of the Hellenistic period which supports a ship's prow (fig. 13).[21]

[18] Kos, Museum. Prow of white marble, broken at tip and damaged on sides. Preserved length 0.40 m.; height 0.34 m.; greatest width 0.22 m. Roughly picked behind and provided below with the upper part of a slightly swallow-tailed cutting for a Π-shaped clamp which fastened the prow to its base at this point. Below, at the sides of the keel, toward the rear, two square dowel holes 0.023 m. deep also for fastening to the base. The upper face is roughly finished and lacks holes; seemingly, there was no statue on top. The piece is said to have been found in the Asklepieion, but its original context is unknown. Seen and photographed in June 1953.

[19] Rhodes, Museum. Prow of Rhodian gray marble. Preserved length 0.53 m.; height 0.28 m.; greatest width 0.21 m. Broken behind, on top, and at tip. On top, in the center, a narrow upstand. No holes. This prow must have been part of a longer section of a ship, inasmuch as what is now preserved of the keel slants upward, and the bottom shows no holes for attachment to a base. Said to be from Rhodes; specific

provenance unknown. Seen and photographed in the garden of the Museum in June 1953.

[20] Selçuk, Archaeological Museum. Fragmentary ship's prow of white Island marble. Broken at tip, top, and rear. On front, above ram, a shallow circular dowel hole; above it, on broken top surface, trace of another small dowel hole; on rear (dressed for an adjacent block), a square dowel hole. Preserved length 0.81 m.; preserved height ca. 0.68 m.; greatest width 0.28 m. No accession number but, according to Halil Bey, found at the harbor. Seen and photographed in May 1953.

[21] Marble. Upper diameter of altar 0.46 m. The prow is broken at the tip and has part of a hole, as if for a metal attachment at its lower end. On the upper surface there are two dowel holes for fastening a crowning statuette. Seen and photographed in the garden in June 1953. [According to J. D. Kondis, the altar had been placed in a rock-niche from which the ship seemed to sail forth. P.W.L.]

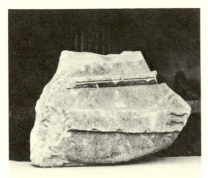

12A

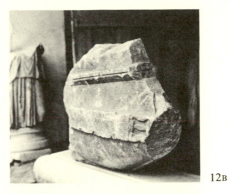

12B

12. Fragmentary ship-monument.
Selçuk, Archaeological Museum

13. Funeral altar. Rhodes,
Archaeological Museum

12C

13A

13B

Three more monuments of the kind found in the Greek world may come from the Hellenistic age, too, although they could also be descendants of the type dating from the Roman Imperial period. One was another marble ship's prow, seen by an observer about fifty years ago in the town of Samothrace itself, which seems to have vanished in the meantime.[22] Fragments of a monument representing a prow with double ram were found in Cyrene, believed to be Hellenistic, and restored by the excavators in the market place (fig. 14).[23] This may be the correct date, too, of a small complete marble ship found in Sparta (fig. 15).[24] Only one monument of this type discovered in Greece is certainly of Roman date, as its rather crude workmanship indicates: a ship's prow in the Agora of Thasos.[25] Surely it is not without direct inspiration from the *Victory* of the neighboring island of Samothrace, inasmuch as it was set in a similar frame of low walls at the back and along the sides.

Thus, including the *Nike of Samothrace*, we have in Greece remnants of

[22] Otto Kern, *RE*, X, 1919, col. 1432.

[23] *Bollettino dell' Associazione Internazionale degli Studi Mediterranei*, 1 (1931), pp. 12, 17; *AA*, 1931, cols. 707f., fig. 33; *Cyrenaican Expedition of the University of Manchester, 1952*, Manchester, 1956, pl. 3, fig. a. S. Fuchs, *Kyrene*, Rome, 1942, pp. 27ff., pl. 7, dates the monument in the early first century B.C. Marcadé, *op. cit.,* pp. 149, 151, calls it Hellenistic. I owe the photograph reproduced here to the kindness of J. B. Ward Perkins. [See now Sandro Stucchi, *Cirene 1957–1966 (Quaderni dell' Istituto Italiano di Cultura di Tripoli*, 3), Tripoli, 1967, pp. 86ff., figs. 61–71, for this monument, the original location of which has been ascertained. The author states unequivocally that a figure reminiscent of the *Victory of Samothrace*, variously interpreted as Nike, Athena, an Aura, Artemis, or Athena-Nike (!) and long disputed stylistically (whether copy or original, Hellenistic or Roman) originally stood on this prow to which it has now been restored. P.W.L.]

[24] *ABSA*, 30 (1928–1930), p. 208, fig. 19. On top there are traces of two feet of a statuette (Nike?). Found in the Theater, but the original location and function of the monument are unknown.

[25] "Chronique des fouilles en 1949," *BCH*, 74 (1950), p. 348, fig. 65. The statement above is based on my own observation on the site. [See now *Guide de Thasos*, Athens, 1967, p. 27 and fig. 6, where the monument is reported to come from the second century B.C.

I add certain details observed on the site. Two blocks of this ship of Thasian marble are preserved. It is dressed at the front to receive the now missing ram-block which would have abutted a block bearing the letters Δ, H, on its surface. Sculptured waves appear below the vessel. Both the clamp holes and dressing of the (rear) block imply that the monument was altered at a time subsequent to its erection. P.W.L.]

14. Cyrene. Fragmentary ship-monument

15. Ship-monument from Sparta.
Sparta, Archaeological Museum

altogether eleven three-dimensional ship-monuments, the majority of them dating from the Hellenistic age. If one considers how little of the artistic production of that age is preserved, this evidence conveys the impression that the type was immensely popular.

Several of the extant monuments still retain traces of statuary—seemingly in bronze—which was supported by the ships. This is true of the monuments in Epidauros and Lindos, the funeral monument in Rhodes, and the ship found in Sparta. Similar crowning statues may be assumed in all the other cases where this feature is not preserved. But it is by no means certain that any or all of them supported a figure of Nike, although this possibility exists, too.

With the exception of the prow in Cyrene—the Hellenistic date of which is not certain—and of the lost second prow in Samothrace, the size of which was not reported, all these monuments differ from the *Nike of Samothrace* in being much smaller in scale. Though the type was common, and it was itself certainly not the prototype, the famous Samothracian monument emerges as the one great work among them: a conspicuous elaboration of the highest artistic quality.

The next question which arises is whether some of the other sculptured ships in the Greek world were also connected with fountains and water. This is certainly not so in the case of the Rhodian tomb-monument nor, in their present positions (which may not be the original ones), of the earliest of the monuments in Epidauros and the latest in Thasos, both of which show sculptured representations of the sea under the ship.[26] In all the other cases, the possibility of a connection with fountains remains. Thus, it is impossible to decide whether the Samothracian monument was the only Greek fountain which included a ship and combined an established symbol of naval glory with the type of the monumental fountain, whether it was the first such work

[26] See above, nn. 16, 25. [It is apparent in Blinkenberg, *Lindos*, II, pt. 1, pp. 303f., figs. 2, 4, that the smaller Rhodian ship rested on a base irregularly grooved and reminiscent, therefore, of the irregular surface of the slabs on which the ship of the *Victory of Samothrace* stood. If, as I assume, the latter animated the appearance of the water in which the great ship was placed, the grooving of the Rhodian base may also have been intended to suggest ripples—in which case it, too, may have rested in water. P.W.L.]

of art and was followed by other Greek descendants, or whether in this respect, too, it merely elaborated on an already extant type within Hellenistic art.

In Samothrace, it seems, the Sanctuary otherwise lacked a monumental fountain such as is customarily found in Greek sanctuaries.[27] For many centuries, the water needed in the rites of the cult was probably taken from the stream running through the Sanctuary which in antiquity was perennial, although it is now dry throughout most of the year. There was also a little "grotto" spring sacred to Hekate within the precinct.[28] Yet, in the Hellenistic age, when the cult reached the climax of its fame with great organized international summer festivals, the need for a major fountain may have been felt acutely, and it may have caused the ingenious synthesis of ship-monument and fountain then and there.

Whatever the answer to this question may be, the *Nike of Samothrace* was not only a particularly magnificent elaboration of a type, a masterpiece of sculpture and, if not the only, the greatest Greek ship-fountain; it was also seen in a conspicuous place that attracted masses of Roman visitors in the second and first centuries before the Christian era, at the time when Rome built her empire and took it upon herself to carry on vigorously the Greek cultural and artistic tradition.

[27] [Excavation to the east of the Ptolemaion in 1962 (i.e., outside the Sanctuary proper) revealed the existence of carefully constructed pipelines leading water toward the south, but whether they served to drain the slopes above the building or carried water to the Sanctuary remains unclear in view of the incompleteness of the lines, whose points of departure and arrival are unknown. See James R. McCredie, "Samothrace: Preliminary Report on the Campaigns of 1962–1964," *Hesperia*, 34 (1965), p. 120, pl. 38 a, b. As of 1969, therefore, no new fountain has been uncovered in the Sanctuary. P.W.L.]

[28] [In the heart of the Sanctuary, there had been a natural spring from the Archaic period on, but it was buried beneath the ground after the latter part of the fourth century B.C.: "Samothrace: Sixth Preliminary Report," *Hesperia*, 22 (1953), pp. 23f.; *Guide*³, pp. 56f. The streams in and near the Sanctuary (*ibid.*, p. 40), which were perennial in antiquity, may have been sufficient for ritual purposes. But it is doubtful whether their water, obviously exposed to contamination and pollution, could be used for drinking as the Sanctuary grew increasingly popular. The position of the *Nike Fountain* next to the great Stoa for pilgrims (*ibid.*, pp. 74f.) and its contemporaneity with it indicates its primary function as a fountain. [The function of the *Nike Fountain* has been underlined in recent years by the discovery of a pipeline running to the south and west of the Stoa from the direction of the fountain. Obviously, it originally served the pilgrims quartered in this part of the Sanctuary. See McCredie, *op. cit.*, pp. 113f. P.W.L.]

A CURIOUS monument provides evidence for the early transfer from Hellenistic Greece to Republican Rome of the sculptured ship-monument placed illusionistically in actual water. In fact, given this idea, the type of ship, the dimensions, and even the analogy of certain details, the famous travertine ship at one tip of the Tiber Island (fig. 16)[29] seems to have been directly inspired by the *Nike of Samothrace*. The monument of a Roman admiral, it commemorates a naval victory of the first century B.C.,[30] and the ship's prow here, as in Samothrace, was certainly crowned by a statue, conceivably, a statue of Victory. The Tiber Island was sacred to Asklepios, the god from Epidauros who, according to legend, had arrived there in the form of a snake. The man who commissioned the monument had placed his flagship under the god's protection—his bust appeared in a niche on the prow (fig. 17), analogous to such recesses for images of protective gods on the prow from Samothrace. Undoubtedly, the victorious admiral had vowed before the battle to dedicate such a monument to Asklepios in his island sanctuary after victory. The idea of achieving an illusionistic effect by placing the prow in the river at the tip of the island—like so many other basic ideas in the art of Republican Rome— is a bold elaboration of a Hellenistic Greek concept, the concept of the *Nike of Samothrace*.

But the sculptured ship as decoration of a fountain had also come from Hellenistic Greece to Rome, at least by the middle of the first century A.D. The most conspicuous among preserved fountain decorations in ship form from the Roman Empire was found in the late nineteenth century on the slope of the Caelian Hill in Rome: a magnificently carved marble prow ending in a

[29] M. Besnier, *L'île Tiberine dans l'antiquité* (Bibliothèque des Ecoles françaises d'Athènes et de Rome, 87), Paris, 1902, pp. 32ff.; F. Krauss, "Die Prora an der Tiberinsel in Rom," *RM*, 59 (1944), pp. 159ff., Beilage 1–6; K. Kerényi, *Der göttliche Arzt*, Basel, 1947, pp. 1ff. [J. Le Gall, *Recherches sur le culte du Tibre* (Publication de l'Institut d'Art et Archéologie de l'Université de Paris, 2), Paris, 1953, pp. 102ff.; C. Kerényi, *Asklepios* (Bollingen Series LXV, 3), New York, 1959, pp. 1ff.; Ernest Nash, *Pictorial Dictionary of Ancient Rome*, I, 2d edn., New York and Washington, 1968, pp. 508f., figs. 625–627. A. Conze, in discussing the antecedents and analogies to the *Victory of Samothrace, op. cit.*, pp. 75ff., remarked on the similarity of this Roman ship to that of the *Victory*. P.W.L.]

[30] Krauss, *op. cit.*, p. 172.

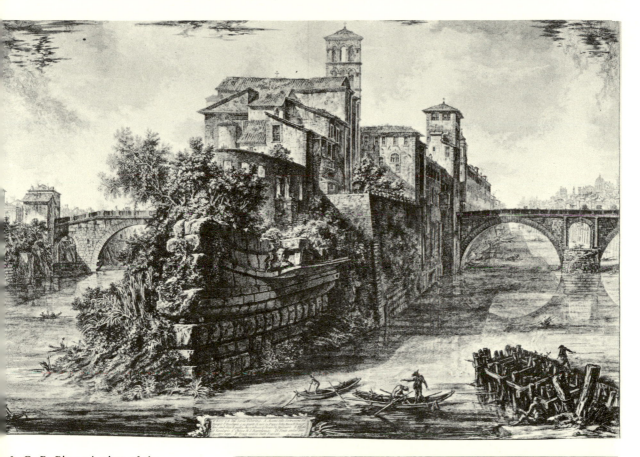

6. G. B. Piranesi, view of the Tiber Island (etching). New York, Metropolitan Museum of Art

7. Detail of the ship on the Tiber Island, Rome

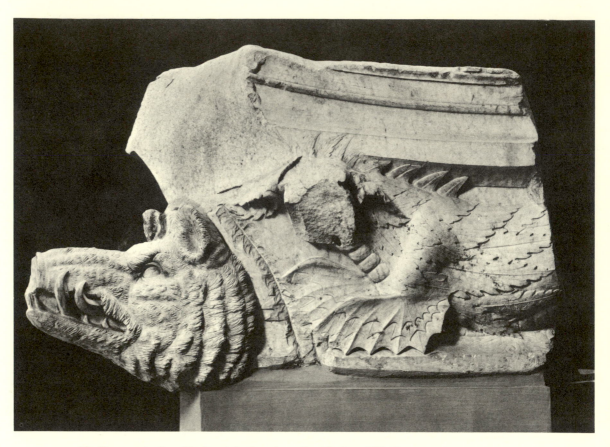

18. Fragment of a ship-fountain found on the Caelian Hill, Rome

boar's head (fig. 18). Channels for water pipes were bored obliquely through it, and the water was spouted out, on both sides, from the now destroyed heads of sea monsters that adhere to the sides of the ship. A statue seems to have crowned this fountain monument.[31]

A second such ship's prow, or a complete ship adorning the same fountain or a counterpart to it, was found in this region in the sixteenth century, and its marble was re-used in the Cappella della Madonna in the Gesù.[32] To judge

[31] *NS*, 1881, p. 105; C. L. Visconti, *Bullettino della Commissione Archeologica Comunale, Roma*, 1882, pp. 63ff., pl. 12; W. Helbig and W. Amelung, *Führer durch die öffentlichen Sammlungen klassischer Altertümer in Rom*, 4th edn., ed. by Hermione Speier, II, Tübingen, 1966, pp. 529f., no. 1754; D. Mustilli, *Il Museo Mussolini*, Rome, 1939, p. 112, no. 20, pl. 70, fig. 277. Height 1.115 m.; length 1.30 m.; A. M. Colini, "Storia e topographia del Celio nell' antichità" (*Atti della Pontificia Accademia Romana di Archeologia, Memorie*, 8), 1944, pp. 157f., fig. 119. [Nash, *op. cit.*, I, p. 248, fig. 290.]

[32] Colini, *op. cit.*, p. 140. For the re-use of the marble in the Gesù, Dr. Haas has kindly referred me to Pio Pecchiai, *Il Gesù di Roma*, Rome, 1952, p. 88.

from the style of the preserved prow, it may well have belonged to the decorations in the gardens of Nero. It certainly dates from that period, if it is not earlier.

An epigraphical document from the following century shows that by that time ships' prows had become quite common elements in the fountains of Rome and its vicinity. This inscription refers to the private donation of a bronze fountain "basin with three waterspouts in the form of ships' prows" (*labrum aeneum cum salientibus [r]ostris navalibus tri[bu]s*) in a bath building at Civita Lavinia in the Alban Hills.[33]

Another very modest waterspout in the form of a small ship's prow, dating from the second or third century A.D., was found on the main street of Ostia (fig. 19). It has a cutting for a water pipe beneath it, and, on top, a hole with a dowel for a crowning statuette, possibly a Victory. In its very cheapness of execution, it shows the popularity of this type of fountain decoration in the later Empire.[34]

[33] *NS*, 1881, p. 139; Visconti, *op. cit.*, pp. 66ff.

[34] *NS*, 1910, p. 170, fig. 3; length 0.52 m.

My attention was first drawn to this monument by Axel Boëthius. The photograph reproduced here I owe to Raissa Calza.

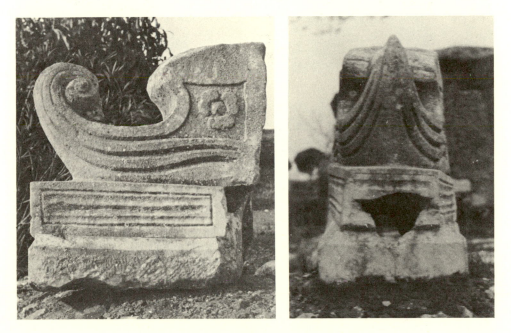

19. Fragmentary ship-fountain from Ostia

Under the circumstances, it seems probable that several other antique marble ships and prows in Rome, for which no clear indication of their function is preserved, also belonged to fountains (figs. 20, 21).[35] Most interesting

[35] Palazzo Farnese: two marble slabs with projecting ships' prows: F. Matz and F. von Duhn, *Antike Bildwerke in Rom*, Leipzig, 1882, III, no. 3541 (from the Palatine?), and no. 3542, from the Palatine. The German Archaeological Institute in Rome possesses photographs (Nos. 1280, 1281) of two other marble prows, the provenance and whereabouts of which are unknown. [They are reproduced here, figs. 20, 21, to facilitate their future identification. P.W.L.]

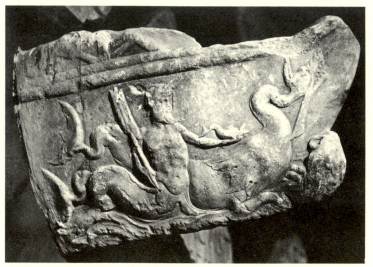

20

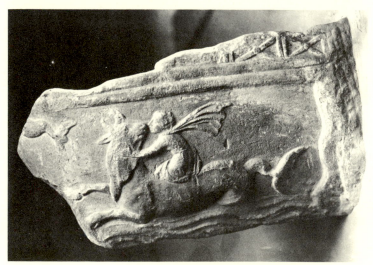

21

among them is a pair of small marble ships which supported on their decks columns probably crowned, in turn, by statuary—one in the Villa Albani, the other in the Roman National Museum (figs. 22, 23).[36] This pair of ships must have belonged to a decorative ensemble, most likely a fountain or a pair of fountains.

[36] P. Arndt and W. Amelung, *Photographische Einzelaufnahmen antiker Skulpturen*, Munich, 1893—, no. 3673. (In the text, Arndt felt reminded of the *Navicella* on the Caelian.) J. Le Gall, "Un 'modèle réduit' de navire marchand romain," *RA*, ser. 6, 33–34 (1949), pp. 607ff., pl. 10, fig. 21.

Phyllis Lehmann calls my attention to the representation of the celestial *Navis* (see, in general, F. Boll, *Sphaera*, Leipzig, 1903, pp. 169ff., 405, pl. 1; *idem, Sternglaube und Sterndeutung*, Leipzig, 1926, p. 56, pl. 9, figs. 18, 19) as a ship bearing a column instead of a mast in Hyginus, *De descriptionibus formarum coelestium*, Book III, in the edition of *C. Iulii Hygini . . . fabularum liber . . . Eiusdem poeticon astronomicon . . .*, Basel, 1549, p. 93. Is it derived from some such monument?

20. Fragmentary ship's prow of unknown provenance and location

21. Fragmentary ship's prow of unknown provenance and location

22. Fragmentary ship-monument. Rome, Villa Albani

23. Fragmentary ship-monument. Rome, Museo Nazionale Romano

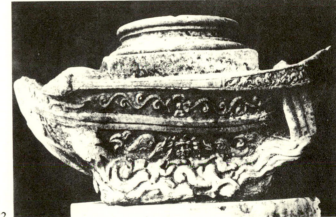

22

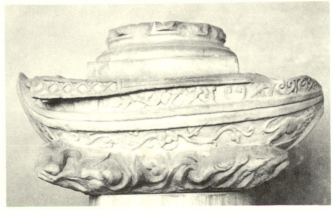

23

23

One more Roman ship-fountain, found again on the Caelian Hill and still in part preserved, we shall meet later. Indeed, it forms a tangible link between this antique type and its revival in the Renaissance.

To UNDERSTAND the widespread use of the ship-fountain in Imperial Rome and its ultimate revival in the Renaissance, we must ask the question whether the Roman adoption of the type was caused by a merely "decorative" use of a motif invented by the Greeks, or the survival of this Greek type in later antiquity was motivated by ideas that led to its continuous use. It is always easy to explain such features as merely "decorative." But modern interpretation of Roman and late antique art reveals increasingly that almost every living form in that age had a specific meaning, and that changes in form and style imply a recasting of ideas inherent in traditional types.

The Hellenistic ship-monuments, including the *Nike Fountain* of Samothrace, had been monuments commemorative of naval power. This was the case, too, of the ship's prow on the Tiber Island. The illusionistic tendency to show a ship in its natural element, water, had led to the creation of the ship-fountain. During the Republic, when Rome ascended to power, the prows of captured enemy vessels had been used to decorate honorary columns and the Rostra on the Roman Forum, which received its name from such decoration.[37] But allusion to naval victories did not make much sense in the Empire when, under the complete dominion of the Romans, naval battles became practically obsolete after the last great contest won by Augustus at Actium in 31 B.C., which established imperial power without rivalry. Augustus had commemorated that event by coins showing the traditional Hellenistic type of Victory on the prow of a warship (fig. 24).[38] But where the type occurs during the early and middle Empire, it gradually acquires a quite different meaning.

[37] See S. B. Platner and Thomas Ashby, *A Topographical Dictionary of Ancient Rome*, Oxford, 1929, s.v. *Rostra*. [Nash, *op. cit.*, II, p. 272. I find among notes later assembled by my husband, presumably for use in this essay, reference to P.-M. Duval, "Proues de navires de Paris," *Gallia*, 5 (1947), pp. 123ff. (on consoles in the Grande Salle of the baths in the Cluny Museum); pp. 139f. (the prow of a warship, ca. A.D. 100, possibly part of a fountain); to Armin von Gerkan, *Der Nordmarkt und der Hafen an der Löwenbucht* (*Milet*, I, 6), Berlin and Leipzig, 1922, pp. 55ff. (an Augustan ship-monument); and a sketch made by him in 1957 in the Archaeological Museum at Cordova, showing a limestone prow provided with a boar's head and ram. Preserved length ca. 0.585 m.; height 0.70 m. P.W.L.]

[38] Harold Mattingly, *Coins of the Roman Empire in the British Museum*, I, London, 1923, pp. CXXIII, 45, 49, 60, 64, pl. 15, 6–7. [Bellinger-Berlincourt, *op. cit.*, pp. 51f., pl. X, 4. P.W.L.]

As early as the Republic, in a generalization of the idea of naval power as a guarantee of the well-being of the Roman state, the Greek symbol of the ship's prow had gained a paramount place on Roman coinage—a near monopoly quite out of proportion to the reality of naval strength and without specific allusion to individual naval exploits (fig. 25).[39] By the time of Augustus, when the empire was established, the Ship of State tossed around on the stormy sea of temporary events and steered firmly through danger by the prince had become a symbol in poetry. A famous ode of Horace is a document of this symbolism.[40]

On gems of the late Republic and the early Empire this Ship of State appears: a galley carrying symbols of Rome—the She-Wolf, the fig tree of the Roman Forum, the head of Roma, a fortress. Later, on such gems, the eagle and the vexilla of the imperial army are shown on ships, as well as trophies or cornucopias.[41] In the reign of Hadrian, one begins to find on coins the imperial galley labeled as the Ship of Felicity of the Emperor, equivalent to the Ship of State (fig. 26).[42] Under Commodus, it becomes the Ship of Providence (*Providentia Augusta*).[43] In the third century, the idea is expanded to the Ship of Felicity of the Age (*Felicitas Temporum*),[44] of Abundance (*Abundantia Augusta*),[45] or of the Delight of Imperial Government (*Laetitia Augusti*);[46] in the fourth century, the emperor is shown standing on the Ship of State as the renovator of felicity (*Felicium Temporum Reparatio*), holding

[39] This, of course, follows—as it enhances—a Greek tradition: see above, pp. 190f. and nn. 12f. Victory eventually appears on such prows: H. A. Grueber, *Coins of the Roman Republic in the British Museum*, III, London, 1910, pl. LXXVIII, 12, 13.

[40] *Odes* 1.14. The earliest Roman coins with ship's prow and head of Janus were then interpreted as referring to the arrival of Saturn in Italy and the Golden Age: Ovid, *Fasti* 1.227ff. Other sources in *Publii Ovidii Nasonis, Fastorum Libri Sex, The Fasti* of Ovid, ed. by Sir James George Frazer, II, London, 1929, p. 121.

[41] Adolf Furtwängler, *Die antiken Gemmen*, Berlin, 1900, I, pl. 28, fig. 57; pl. 46, figs. 48, 49, 50, 51; Salomon Reinach, *Les pierres gravées des Collections Marlborough et d'Orléans*, Paris, 1895, pl. 59, no. 49, 2–4; pl. 60, no. 50, 4.

[42] Basic discussion: Andreas Alföldi, *A Festival of Isis in Rome under the Christian Emperors of the IVth Century* (Dissertationes Pannonicae, ser. 2, fasc. 7, Budapest, 1937), pp. 55ff. I owe much to this penetrating study for the following discussion. The ship of *Felicitas: ibid.*, pl. XI, 4–9 (sometimes with Victory): Harold Mattingly and Edward A. Sydenham, *The Roman Imperial Coinage*, II, London, 1926, pl. XV, 315.

[43] Francesco Gnecchi, *I Medaglioni romani*, II, Milan, 1912, pl. 86, fig. 4.

[44] Alföldi, *op. cit.*, p. 56; Mattingly, Sydenham, and C. H. V. Sutherland, *op. cit.*, IV, 2, London, 1938, pl. III, 6; Mattingly, Sydenham, and Percy H. Webb, *ibid.*, V, 2, London, 1933, pl. XVI, 4, 8.

[45] *Ibid.*, pl. V, 18.

[46] *Ibid.*, pl. XIX, 16.

the symbol of renascence, the phoenix, and the new banner of faith with the monogram of Christ (fig. 27).[47] It is in such a context, too, that the figure of Victory on the ship remains alive on Imperial coinage; and, on the coins of the new capital, Constantinople, in a return to the ideals of the Greek city-state, this ship, now under the protection of imperial power, becomes the Ship of Liberty (*Libertas Publica*).[48]

From early times onward,[49] the imperial galley as a symbol of the felicitous Ship of State commonly appears on coins with its prow decorated with a boar's head. This is the type of ship represented in the ship-fountain from Nero's gardens,[50] and it seems probable that in this fountain, as well as in some others, allusion was made to the felicity and abundance of the imperial state.

If the emperor was a god, as he increasingly was, his Ship of Felicity, Providence, Abundance, Delight, and Liberty, the Ship of the Roman State, was also a religious symbol—quite unlike the successful warships of the Hellenistic age, even if they had been led by and to Victory under the protection of such divinities as the Gods of Samothrace, Asklepios of Epidauros, or Athena of Lindos. And here the symbolism of the Ship of State was increasingly fused with another old symbolic realm, one also originating with the Greeks—the ship of the gods.

There had been such old cosmological imagery as the Egyptian boat of the

[47] Alföldi, *op. cit.*, pl. XI, 16. [Bellinger-Berlincourt, *op. cit.*, pp. 61f., pl. XIII, 1. P.W.L.]

[48] J. Maurice, *Numismatique Constantinienne*, II, Paris, 1911, p. 505, pl. 15, fig. 6; see also *Felicitas Rei Publicae* (Aquileia), Mattingly, Sydenham, and J. W. E. Pearce, *op. cit.*, IX, London, 1951, pl. VII, 18. Other legends emphasizing the benefits of Imperial government and pointing to military power which occur in connection with the ship's types as well as with others are *Victoria Augusta* (Gnecchi, *op. cit.*, pls. 131, fig. 9; 133, fig. 12); *Virtus Augusta* (Mattingly-Sydenham-Pearce, *op. cit.*, p. 186, pl. X, 14); *Gloria Romanorum* (*ibid.*, p. 183, pl. X, 7; pp. 194, 283, pl. XIV, 14).

[49] Though the legends become ideologically explicit only with Hadrian's *Felicitas*, one will assume that the coins of Vespasian with Victory on the prow (for example, Mattingly-Sydenham, *op. cit.*, pls. V, 2; XXIII, 7, 15, sometimes with the legend *Victoria Augusta*) or with a lucky star (*ibid.*, pl. I, 11), and of Titus (*ibid.*, pl. LVII, 2, and Domitian, *ibid.*, pl. LX), have the same implication. The high value which the emperors themselves from Nero on attached to the symbol of the ship is documented by the fact that Galba's seal was a ship's prow with a "dog's" (wolf's?) head: Dio Cassius, *Roman History* 51.3.7, ed. by Earnest Cary, Loeb edn., VI, London, 1917, p. 10.

[50] See above, n. 32.

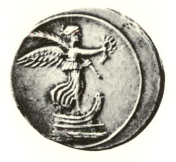

24. Obverse of Augustan
denarius:
Victory on ship's prow.
New York, American
Numismatic Society

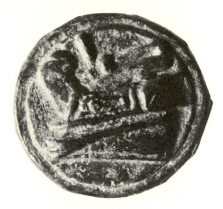

25. Reverse of *aes grave* of the
Roman Republic: ship's prow.
London, British Museum

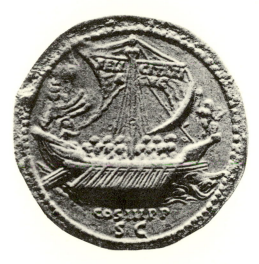

26. Reverse of bronze coin of Hadrian:
the imperial galley

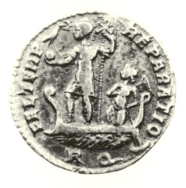

27. Reverse of bronze coin of
Constantius: emperor
in the Ship of Felicity.
New York, American
Numismatic Society

Sun God,[51] and in other regions of the Mediterranean similar ideas seem to have existed. But with a nation of sailors like the Greeks, the ship had become common as a more tangible, actual means of divine sailing over the seas.[52] Apollo had miraculously arrived in Delphi by sea,[53] and Dionysos, quietly reclining in a miraculous ship out of which grew his vine, had already become a compelling image in archaic Greek art (fig. 28).[54] The use of this imagery for the most popular mystery god of the Roman empire continued in later antiquity. Around A.D. 200, Philostratus described a painting in which the god was shown in the miracle of transforming the Tyrrhenian pirates into dolphins. He appeared in a ship whose mast was his symbol the thyrsus, a ship with vine and ivy growing in it to form an awning, and a fountain of wine beneath it, the god himself being on the prow.[55] There was a representation of the same sacred ship of Dionysos in a fourth-century-A.D. floor mosaic in Rome in what later became the Church of Sta. Costanza.[56]

In the process whereby divinities were transferred from the Greek world to Rome, such miraculous voyages of gods on ships as that of the sacred stone of the Great Mother (immortally commemorated by Virgil and shown on Roman works of art)[57] or of the snake, Asklepios, arriving on the island in the Tiber (represented on medallions of Antoninus Pius, fig. 29)[58] had

[51] H. Haas, *Bilderatlas zur Religionsge-schichte*, II–IV, Leipzig, 1924, passim.

[52] See E. Schmidt, *Kultübertragungen* (*Religionsgeschichtliche Versuche und Vorarbeiten*, VIII), Giessen, 1909, pp. 89ff.; A. Blanchet, "Statuettes de bronzes trouvées pres des sources de la Seine," Fondation Piot, *Monuments et Mémoires*, 34 (1934), pp. 59ff., pl. 5; M. A. Canney, "More Notes on Boats and Ships in Temples and Tombs," *Journal of the Manchester University Egyptian and Oriental Society*, 21 (1937), pp. 45ff.

[53] Homeric Hymns 3.298ff. (Hymn to Pythian Apollo).

[54] See the famous kylix of Exekias: Paolo Enrico Arias and Max Hirmer, *A Thousand Years of Greek Vase Painting*, New York, 1962, pl. XVI, as well as Pietro Romanelli, *Tarquinia, The Nekropolis and Museum*, Rome, n.d., p. 125, fig. 73; and J. D. Beazley, *Attic Black-Figure Vase*

Painting, Oxford, 1956, p. 639, no. 100. The coin type of Mytilene showing a herm of Dionysos on a ship's prow (L. Lacroix, *Les reproductions de statues sur les monnaies grecques*, Liège, 1949, pp. 48ff., pl. I, 5) surely also alludes to the arrival of the god, or rather, his image, by sea and does not represent an actual monument.

[55] Philostratus, *Imagines* 1.19.

[56] Karl Lehmann, "Sta. Costanza," *AB*, 37 (1955), pp. 194ff.

[57] See Schmidt, *loc. cit.* (above, n. 52); H. Stuart Jones, *The Sculptures of the Museo Capitolino*, Oxford, 1912, pp. 181f., no. 109B, pl. 43; *NS*, 1907, p. 682 [and Helbig-Amelung-Speier, *op. cit.* (above, n. 31), pp. 24f., no. 1175].

[58] Gnecchi, *op. cit.*, pl. 43, figs. 1, 2; Jocelyn M. C. Toynbee, *The Hadrianic School*, Cambridge, 1934, pp. 113f., pl. 16, 5.

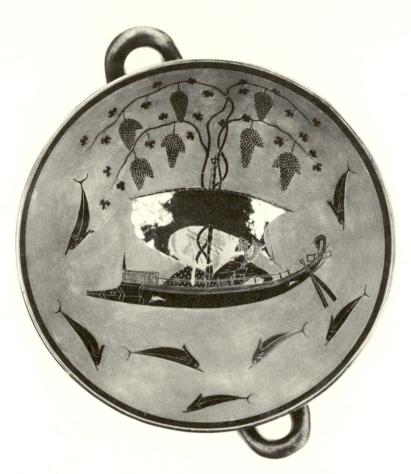

28. Interior of kylix by Exekias:
Dionysos sailing. Munich,
Staatliche Antikensammlungen

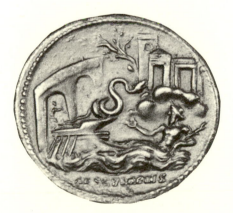

29. Reverse of bronze medallion of
Antoninus Pius: snake of Asklepios
arriving at the Tiber Island.
Paris, Bibliothèque Nationale,
Cabinet des Médailles

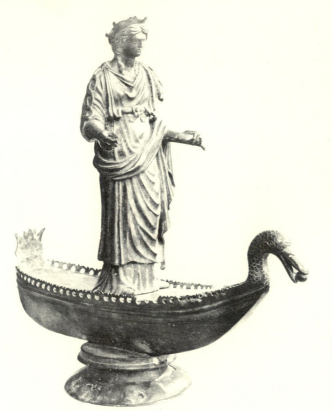

30. Bronze statuette: goddess in ship. Dijon, Archaeological Museum

played their part in legend, poetry, and art. Thence the legendary, divinely directed ship of saints and relics passed into the Christian world[59] and gave rise to votive ships and other representations in the art of the Middle Ages.

In antique processions, ship symbols and gods on ships played their part, the ships of Athena and of Dionysos in Athens, for instance. And representations of gods on their ships are not uncommon in the art of the Roman Empire: for example, Venus Pompeiana at Pompeii, or an unknown goddess on a bronze ship found in France (fig. 30).[60] It seems likely that the two

[59] See Schmidt, *loc. cit.*

[60] For the often represented fresco-icon of Venus Pompeiana, see now V. Spinazzola, *Pompeii*, I, Rome, 1953, pp. 189ff., fig. 222. For the bronze ship: Blanchet, *op. cit.*, pl. 5; *Archaeologiai Ertesito*, 48 (1935), p. 210, pl. 6. Emile Espérandieu, *Recueil général des bas-reliefs, statues et bustes de la Gaule romaine*, XI, Paris, 1938, no. 7676, pp. 22ff.; [Anita Büttner, "Eine prora aus der Mosel bei Trier," *Germania*, 42 (1964), p. 68, n. 12. The recently discovered fragment of a bronze-sheathed votive ship dedicated to an Antonine emperor and the *Genius proretarum* of the Mosel published and illustrated here, pls. 6–9, is of interest in the present context. P.W.L.]. For others, see the ship of Fortuna in George K. Boyce, "Corpus of the Lararia Painting of Pompeii" (*Memoirs of the American Academy in Rome*, 14 [1937], pl. 20).

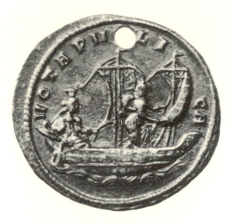

31. Reverse of bronze coin of Diocletian:
Ship of Isis. Copenhagen, National Museum

marble ships in the Roman National Museum and the Villa Albani—presumably from a fountain—which carried columns that probably supported statues are such ships of gods.[61]

During the Roman Empire, the miraculous ship of Isis and Serapis, the outstanding symbol of a great spring festival, became the most popular divine ship. It survived down into the Christian Middle Ages in popular processions in Italy as a float in the Carnival procession, thus probably giving rise to the name "carnival" (*carrus navalis*), according to an old theory, once abandoned, but recently revived with cogent arguments.[62]

Andreas Alföldi has dedicated a most illuminating study to the Isis Festival in Imperial Rome.[63] He has shown, via the interpretation of representations on coins and literary sources, that the spring festival of Isis in Rome was very popular in the middle and late Empire. From the late second century A.D. on, the ship of Isis appears as a symbol of imperial well-being in connection with vows at the beginning of the year.[64] As such, it was blended with the imperial galley, the Ship of Felicity, Abundance, and Providence. It thus became a divine ship of salvation of the civilized world organized within the Roman empire. The ship of the gods, led by them, and the Ship of State have become one.

But in the fourth century, as Alföldi has shown, the ship of Isis, with the goddess holding the sail and Serapis often as helmsman (fig. 31), became a symbol of the pagan state, too, in the educated pagan circle of the resistance to Christianity and was cherished by it as a badge of opposition to the Church.

[61] Above, n. 36.

[62] For the *navigium Isidis* and its survival, see Alföldi, *op. cit.*, pp. 48ff., 57f. See also Doro Levi, "Mors Voluntaria, Mystery Cults in Mosaics from Antioch," *Berytus*, 7 (1942), pp. 32ff.

[63] *Loc. cit.*

[64] *Ibid.*, pp. 55ff.

Out of the pagan symbolism of the Ship of State and the ship of the gods which had been thus blended, the Christians, in turn, had attached their own meaning to the ship as a symbol. The simile of the Ship of the Church[65] was already fully developed before the official recognition of Christianity in the time of Constantine. In the third century, St. Hippolytus used this simile. The Ship of the Church, the refuge of Christians, is tossed around on the stormy sea, but it cannot perish.[66] The Fathers expanded the simile in the following century amid the strife against heresy and paganism. The Ship of the Church may be threatened by the stormy seas of the world, weighed down by "bad Christians," but it will not sink.[67] No doubt the Ship of the Church had its primary background in the secular and pagan symbolism discussed previously.[68] But unlike the Roman imperial ship of temporal felicity, it was a ship of eternal salvation.[69] It is a debated question whether representations

[65] The literature on this symbolism is extensive and controversial, and though I have consulted whatever has been accessible to me, it is not necessary to refer to it fully for our argument. The most important recent studies are those by Hugo Rahner, *Zeitschrift für katholische Theologie*, 65 (1941), pp. 123, 152ff.; 66 (1942), pp. 91ff., 206ff.; 67 (1943), pp. 21ff.; "Navicula Petri: Zur Symbolgeschichte des römischen Primats," *ibid.*, 69 (1947), pp. 1ff.; *idem, Griechische Mythen in christlicher Deutung*, Zurich, 1945, pp. 414ff. Other recent discussions containing valuable observations and references to monumental evidence: G. Stuhlfauth, "Das Schiff als Symbol der altchristlichen Kunst," *Rivista di archeologia cristiana*, 19 (1942), pp. 111ff.; Kurt Goldammer, "Navis Ecclesiae," *Zeitschrift für die neutestamentliche Wissenschaft*, 40 (1942), pp. 76ff.; F. J. Dölger, *Ichthys*, 5 (1943), pp. 285ff. The same author's "Das Schiff der Kirche auf der Fahrt zum Sonnenaufgang," *Sol Salutis*, 2 (1925), pp. 242ff., has not been available to me.

[66] *De Christo et Antichristo*, chap. 59. (*Die griechischen christlichen Schriftstel-*ler der ersten drei Jahrhunderte, Hippolytus, Leipzig, 1897, I, 2, p. 39, lines 13ff.)

[67] St. Augustine, *Sermon* 13, chap. 2: *premi potest, mergi non potest.* (G. Morin, *Sancti Augustini Sermones post Maurinos reperti* [*Miscellanea Agostini*, I], Rome, 1930, p. 713, line 6.) For other similar phrases and their continued use into the Middle Ages, see Rahner, "Navicula Petri," pp. 1, 18ff., 21ff., 26.

[68] The transition is particularly evident in a Christian tomb-monument showing the ship inscribed on the side *Eusebia*, an inscription which explains it to be the Ship of Piety, as the Ship of the Roman State had been labeled the Ship of Felicity: Stuhlfauth, *op. cit.*, p. 119, no. 25. Stuhlfauth, pp. 113ff., tried to discard this evidence for the sake of his theory that all the early monuments allude only to the ship as a vehicle to the other world, not as a symbol of the Church, and he interpreted the word *eusebia* as the name of a deceased. But the names of the deceased are quite separately and explicitly stated to be Silvanius and Zenobia.

[69] *navis ecclesiasticae salutis*, Cyprian, *Epistles* 30.2.

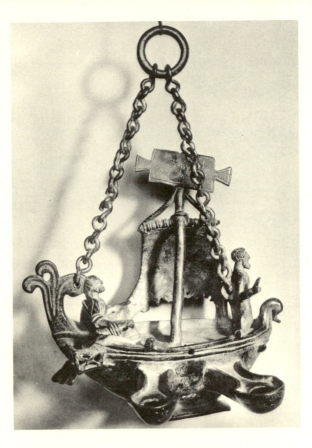

32. Bronze lamp found on the
Caelian Hill. Florence,
Museo Archeologico

of ships in the art of the Christian catacombs refer to the Ship of the Church.
But they surely show the transfer of another widespread pagan symbol: the
ships in which the deceased are transported over the waters to the Islands of
the Blessed.[70] And an element from this realm of pagan and Early Christian
eschatological hope entered the ship symbolism of the Church to make it a
symbol of eternal promise to the individual.

By the late fourth century A.D., the symbol of the Ship of the Church as
such was fully developed. We have a curious graphic illustration of it in a
monument found, again, on the Caelian Hill, not far from the Church of Sta.
Maria in Domnica and now in the Archaeological Museum in Florence. It is a
bronze lamp in the form of a ship with two figures on it, probably Peter pray-
ing on the prow and Paul as helmsman (fig. 32).[71] The inscribed tablet seems

[70] Stuhlfauth, *loc. cit.*; Goldammer, *loc.
cit.*

[71] G. Bonini, "Monumenti figurati paleo-
cristiani conservati a Firenze," *Monumenti
di antichità cristiana*, 2d ser., 6 (Vatican
City, 1950), pp. 8ff., no. 1, with earlier
bibliography. Colini, *op. cit.* (above, n.
31), p. 254, fig. 13.

to indicate that this Ship of the Church, the Ship of Salvation and, in this case as in that of other Christian lamps in ship form,[72] the source of divine light, was a baptismal present.[73]

We possess an amazing document from the same period, the *Apostolical Constitutions,* in which the church building itself is likened to a ship: the bishop as helmsman sits on his throne in the apse; the deacons are the crew providing for order; and the members of the community are the passengers.[74] From that background, it seems probable, the term *nef,* nave, was ultimately applied to the main part of the church building.

But the bishop as helmsman in the Ship of the Church had another connection, one specifically Christian, in the past. The Christians had their own legendary ships. One of them was the Ark of Noah, early likened to the Church;[75] the other was the boat of Peter, the fisherman. Hugo Rahner[76] has shown how the *navicula* or *navicella* of St. Peter was gradually fused with the general symbol of the Ship of the Church. This particular boat of Christian legend became the more specific symbol of the Church of Rome, the church directed by St. Peter and his successors, the bishops of Rome. In a sense, by the high Middle Ages the boat steered by Peter, the *navicula Sancti Petri,* had absorbed the more general symbol, the ship of Christian salvation. It symbolized, by that time, the claim of primacy of the Church of Rome, the supremacy of the successor of St. Peter, the doctrine that there is no truth and no salvation outside the Catholic Church. At the climax of medieval thought and art in Italy, Boniface VIII commissioned Giotto to represent the

[72] Stuhlfauth, *op. cit.*, pp. 127f.; Henri Seyrig, "Antiquités syriennes. 47. Antiquités de Beth-Mare," *Syria*, 28 (1951), pp. 101ff. For ships used as incense burners in the church, see Canney, *op. cit.* (above, n. 52), pp. 47f. [and for a bronze lamp in the form of a ship found in the Erechtheion and dedicated to Athena: V. Staïs, *Marbres et bronzes du Musée National*, Athens, 1910, no. 7038, pp. 276f., and James Morton Paton, et al., *The Erechtheum*, Cambridge, 1927, p. 572, fig. 229. P.W.L.]

[73] Regarding the early association of the Ship of Salvation with baptism, see Tertullian, *De baptismo* 12; Rahner, "Navicula Petri," pp. 4f.; Goldammer, *op. cit.*, pp. 79, 84.

[74] *Constitutiones Apostolicae*, II, chap. 57. [F. X. Funk, *Didascalia et Constitutiones Apostolorum*, Paderborn, 1905, pp. 158ff. I am indebted to Richard Krautheimer for this reference. P.W.L.]

[75] Stuhlfauth, *op. cit.*, pp. 133f.; Rahner, "Navicula Petri," pp. 17f.; Goldammer, *op. cit.*, p. 80.

[76] "Navicula Petri."

Calling of Peter in his famous *Navicella* mosaic at the entrance of St. Peter's
to express this very idea (fig. 33).[77]

THE SYMBOL of the Ship of the Church, more specifically the Ship of the
Church of Rome, the *navicula Sancti Petri*, is a precise expression of medieval
thought. But as it derived from the pagan, divinely directed Ship of State,
so it, in turn, led to the renascence of the ship-fountain of pagan antiquity
in the Renaissance. In this instance, and in an exceptionally concrete and

[77] *Ibid.*, pp. 34f. [Wilhelm Paeseler, "Gi-
ottos Navicella und ihr spätantikes Vor-
bild," *Römisches Jahrbuch für Kunstge-
schichte*, 5 (1941), pp. 49ff., especially
pp. 150ff., "Der altchristliche Sinngehalt
des Navicella-Motivs." I am, again, in-
debted to Richard Krautheimer for this
reference. P.W.L.]

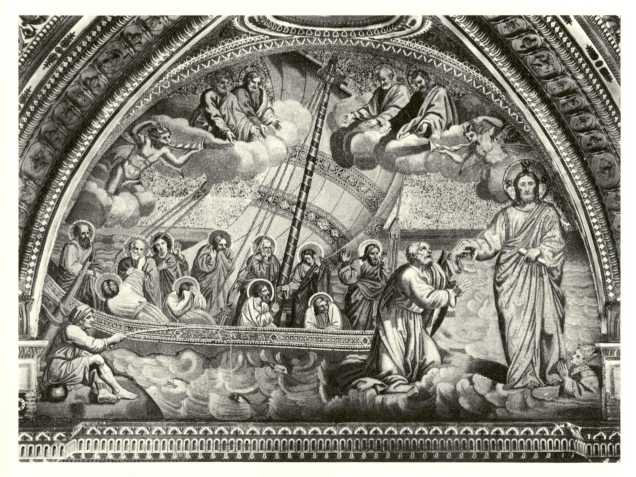

33. Giotto, *The Navicella* (mosaic). Rome, St. Peter's

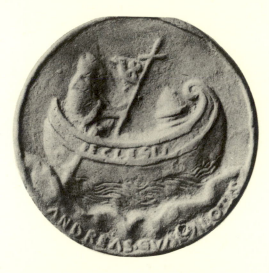

34. Reverse of medal by Andrea Guacialoti: *"Eclesia"* steered by Nicholas V

documented case, we can observe the revival of an antique artistic form as a result of the meeting between a Christian idea that had its own antique background and a renewed interest in the surviving relics which gave plastical expression to the related ideas of pagan antiquity.

As the Renaissance in Italy progressed and the Reformation drew nearer, the artistic symbol of the *navicula Sancti Petri* not only remained alive in imagery but also became particularly popular and meaningful. From the middle of the fifteenth century on, this symbol was increasingly selected for the reverses of pontifical coins and medals. The ship *"Eclesia,"* steered by the pope, first appears on medals struck under Nicholas V in 1455 (fig. 34).[78] Possibly issued at the moment of his death, this medal may be connected with the address which the Pope is reported to have made to the assembled cardinals on his deathbed: "This [*scil.* the Church] is that bark of S. Peter the Apostle the chief of them all, tossed about by varied accidents of the winds and not in the least discomfited: disturbed by vicissitudes of all kinds and neither submerged nor sunk;[79] for Almighty God has held her up. Support and rule her with all the strength of your souls, and let this task be helped on

[78] G. F. Hill, *A Corpus of Italian Medals of the Renaissance before Cellini*, London, 1930, nos. 740, 741, pl. 125. The latter is certainly a posthumous reissue. See also Rahner, "Navicula Petri," p. 35, n. 51.

[79] See above, n. 67; below, p. 234 and n. 111.

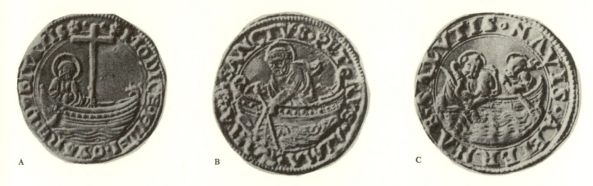

35. Reverses of pontifical bronze coins. A. The Ship of the Church with Peter as helmsman (Callixtus III). B. With Peter as fisherman (Sixtus IV). C. With Peter and Paul (Julius II)

by your good works. . . ."[80] From that time on, the *navicula* becomes a current type on pontifical coins, with either the pope or St. Peter as helmsman, or, more commonly, with Peter the fisherman, who hauls the faithful fishes into his boat. From Paul II (1464–1471) through Julius II (1503–1513), this type is persistently used (fig. 35 A-C).[81] It continues in use through the age of reformation and the pontificate of Paul III (1534–1549)[82] and then disappears from the coinage as suddenly as it had emerged to prominence. It is the specific and leading type in both the developed age of the Renaissance and in the period of the impending and actual Reformation.

[80] Vespasiano da Bisticci's Life of Nicholas V, *The Vespasiano Memoirs*, tr. by William George and Emily Walters, London, 1926, p. 58. [See, too, Pius II's reference to the Church of Rome as "St. Peter's skiff" in Book VII of his *Commentaries: Memoirs of a Renaissance Pope, The Commentaries of Pius II*, tr. and ed. by Florence A. Gragg and Leona C. Gabel, New York, 1959, p. 230. P.W.L.]

[81] Callixtus III, 1455–1458: C. Serafini, *Le monete e le bolle plumbee pontificie del Medagliere Vaticano*, I, Milan, 1910, pp. 115ff., pl. 18, figs. 16ff. ~ Pius II, 1458–1464 (the pope, instead of Peter, in front of an altar in the ship), *ibid.*, pl. 19, figs. 3 and 7. ~ Paul II, 1464–1471, *ibid.*, pls. 20, fig. 17; 21, figs. 10, 14, 15. ~ Sixtus IV, 1471–1484, *ibid.*, pls. 22, fig. 14; 23, figs. 11 and 14; *ibid.*, IV, pl. 173, fig. 1. ~ Innocent VIII, 1484–1492, *ibid.*, I, pls. 23, fig. 20; 24, fig. 3; 27, fig. 8. ~ Alexander VI, 1492–1503, pl. 24, figs. 13, 15, 19; IV, pl. 173, fig. 14. ~ Pius III, 1503, *ibid.*, I, pl. 25, fig. 8. ~ Julius II, 1503–1513, *ibid.*, pl. 25, figs. 10, 11; IV, pl. 174, fig. 1.

[82] Leo X, 1513–1521, *ibid.*, I, pl. 28, fig. 6; IV, pl. 174, figs. 16, 17; I, pls. 28, fig. 5; 30, fig. 23; 31, fig. 9. ~ Hadrian VI, 1522–1523, *ibid.*, pl. 31, figs. 11–13. ~ Clement VII, 1523–1534, *ibid.*, pl. 32, figs. 16–20. ~ Paul III, 1534–1549, *ibid.*, pl. 35, figs. 13–16. For modifications, see below, n. 84.

For a singular revival early in the eighteenth century under Clement XI, see *ibid.*, III, pl. 107, fig. 4.

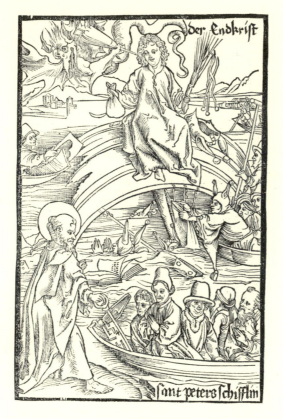

36. Woodcut from Sebastian Brant, *Narrenschiff*, 1494.
New York, Pierpont Morgan Library

What the symbol meant as an expression of the acute reality of the crisis in faith is perhaps best illustrated by a woodcut in Sebastian Brant's *Narrenschiff*, first published in 1494 (fig. 36). It shows, above, the Antichrist riding in glory on a wreck of the ship; below, the *navicella* of St. Peter; and it illustrates the text from which two passages may be quoted:

> The paper ship is then immersed,
> Each tears away a bit of border,
> 'Twill sink the ship in shorter order.

and:

> I fear the ship will never land.
> St. Peter's ship is swaying madly,
> It may be wrecked or damaged badly . . .[83]

[83] *The Ship of Fools* by Sebastian Brant, tr. by E. H. Zeydel (Records of Civilization, 36), New York, 1944, pp. 331ff., no. 103. Compare, also, a probably Venetian woodcut of ca. 1500 showing the Ship of the Church in a stormy sea with the inscription: *Ecclesia navis de longe portans eterna vitae divitias | et si heresum tempestate turbatus, | qui non ingreditur, non salvatur | virtute tamen Spiritus Sancti.*

In the time of Julius II, a new and more emphatic variety appears on coins in which Paul, the Apostle of the Gentiles, is added to Peter in the ship—as if it were a revival of the type known from early Christianity—with the explanatory legend "the ship of eternal salvation" (*navis aeternae salutis*).[84]

In 1515, two years after his ascension, the Medici pope of the Reformation, Leo X, commissioned Raphael to make cartoons for tapestries to decorate the Sistine Chapel. The program assigned a prominent place (to the right of the pontifical altar) to the *Miraculous Draught of Fishes* with the *navicula Sancti Petri* in what has become probably the most famous of these tapestries (fig. 37)—although the subject had already been shown in one of the Quattrocento frescoes in the Chapel.[85]

More than two centuries earlier, Boniface VIII had used this iconographic elaboration of the *navicula Sancti Petri* to advance the double claim of the Ship of the Church as the only means of salvation and the primacy of the Roman pope as successor of St. Peter in commissioning Giotto to execute the *Navicella* mosaic (fig. 33).[86] Sixtus IV, while issuing coins with the *navicula* of St. Peter, in 1475, also had a medal struck which showed the Ship with the disciples and Christ walking on the waves to rescue St. Peter as an explicit symbol of strengthening the Catholic faith.[87] The correlated meaning of the Ship of the Church and the scene of the Calling of St. Peter is, at the same time, equally stated in the juxtaposition of an allegorical Ship of the Church—a galley filled with saints, clergymen, and scholars steered by God the Father Himself, with Christ crucified on the mast, the dove of the Holy Spirit on the prow, and, in the cockpit, the pelican, symbol of piety—with the scene of the Calling of St. Peter on the opposite page in a splendid Italian

W. L. Schreiber, *Handbuch der Holz- und Metallschnitte des 15. Jahrhunderts*, 4, Leipzig, 1927, p. 52, no. 1871.

[84] Julius II: Serafini, *op. cit.*, pl. 25, figs. 9, 12; Leo X, *ibid.*, pl. 28, fig. 2. Here should be mentioned, too, a curious medal issued by Julius II in 1488, when he was still a cardinal, with a related and somewhat enigmatic allegory (Hill, *op. cit.*, pl. 73).

[85] John White and John Shearman, "Raphael's Tapestries and Their Cartoons," *AB*, 40 (1958), pp. 193ff., especially fig. 1, p. 195, and pp. 202, 204.

[86] See above, n. 77.

[87] Hill, *op. cit*, no. 816 bis, pl. 133. Legend: *Domine adiuva nos modice fidei quasi dubitasti.*

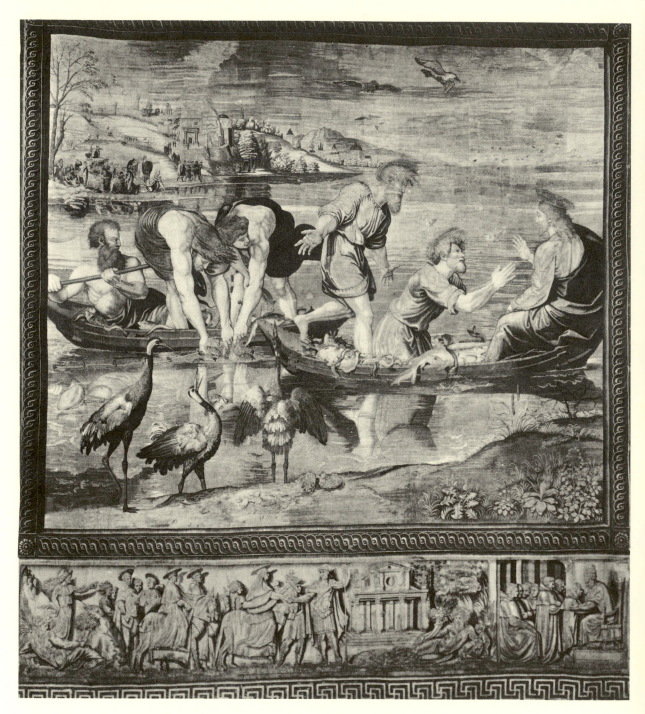

37. Raphael, *The Calling of St. Peter* (tapestry). Rome, Pinacoteca Vaticana

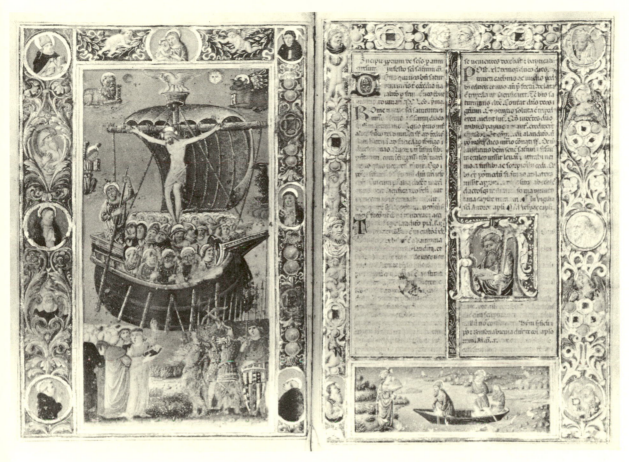

38. Ms. 799, fols. 234v, 235r: the *Ship of the Church* and the *Calling of St. Peter.*
New York, Pierpont Morgan Library

breviary in the Morgan Library (fig. 38).[88] The *Calling of St. Peter* in Raphael's famous tapestry carries this symbolism into the High Renaissance, as do the contemporary pontifical coins. In the lower frieze of this very tapestry, Raphael represented the voyage of the Cardinal Medici from Florence to Rome and, at the right, his receiving the homage of the cardinals as Pope Leo after his election. The scenes are separated by an interval of landscape in which the Tiber appears in classical personification, as a reclining river god, and, in the background, the church of which Leo had been titular cardinal

[88] Ms. 799, fols 234v, 235r, illustrated here with the kind permission of the Librarian of the Pierpont Morgan Library. See *Italian Manuscripts in the Pierpont Morgan Library*, New York, 1953, p. 32, no. 58. It will be noted that the pelican also occurs on the ship of *Vita Supera* represented on a medal of Julius II referred to above, n. 81. It is not necessary for our purpose to discuss here the historical allusions in the scene of the allegorical ship. I recognize, at the lower left, Faith leading clergymen and monks to the scene and pointing to the divine Ship of the Church.

since, in his childhood, he had been made a cardinal—Sta. Maria in Domnica on the Caelian (fig. 37).[89]

Representation of this church[90] in the scene showing this climactic episode in the life of Leo seems natural, since it stands at the border between his career as cardinal and his reign as pope. Yet the occurrence of this church beneath the great scene in which the *navicula* of St. Peter symbolizes the responsibility of his successor to steer the Ship of the Church of Rome through the perils of the age has a more specific connection: it was in front of this church that, during those years, Leo X erected a marble ship of antique type,[91] a *navicella* of St. Peter which, at the intersection of Christian medieval ideology and classical form, revived the ship-fountain of antiquity.

When still cardinal, Leo had started remodeling his titular church, and, after his ascendancy to the pontificate in 1513, he continued this work, adding the present High Renaissance porch.[92] As we know from documents,[93] work was begun immediately, too, in 1513, on the *Navicella Fountain*, which, after several modern restorations, again stands in front of the church (figs. 39, 40).

[89] As E. Steinmann, "Die Anordnung der Teppiche Raffaels in der Sixtinischen Kappelle," *JPKS*, 23 (1902), p. 190, has already seen.

[90] Karl Frey, "Zur Baugeschichte des St. Peter," *ibid.*, Beiheft, 31 (1911), pp. 38ff.; on the Church, see mainly: Christian Hülsen, *Le Chiese di Roma*, Florence, 1927, pp. 331ff.; A. Pernier, "I dintorni della Navicella dal medio evo ai nostri giorni," *Capitolium*, 7 (1931), pp. 166ff.; F. X. Zimmermann, *Die Kirchen Roms*, Munich, 1935, pp. 287ff.; M. Armellini, *Le Chiese di Roma del secolo IV al XIX*, rev. edn., Rome, 1942, I, pp. 611ff.; G. Giovannoni, "La Chiesa della Navicella a Roma nel Cinquecento," *Palladio*, 7 (1943), pp. 152ff.; Richard Krautheimer, Wolfgang Frankl, and Spencer Corbett, *Corpus Basilicarum Christianarum Romae*, II, Rome and New York, 1959, pp. 308ff. For the appearance of the façade and portico as actually constructed, see fig. 337.

[91] On the *Navicella* see, mainly, in addition to the sources cited in the preceding note: G. B. de Rossi, "Note di topografia romana raccolte dalla bocca di Pomponio Leto e testo Pomponiano della Notitia regionum urbis Romae," *Studi e documenti di storia e diritto*, 3 (1882), pp. 49ff., 62; R. Lanciani, *Storia degli scavi di Roma*, I, Rome, 1902, pp. 16, 83, 170, 211; A. M. Colini, "I dintorni della Navicella nell' epoca antica," *Capitolium*, 7 (1931), pp. 157ff.; M. Tonello, "Alcune note sulla nuova sistemazione di Via della Navicella," *ibid.*, pp. 344ff.; Colini, "Storia . . . del Celio" (above, n. 31), pp. 231f., with bibliography; L. Callari, *Le fontane di Roma*, Rome, 1945, p. 154.

[92] Giovannoni, *op. cit.*, pp. 152ff. His use of the document is questionable and does not consider the fact that, as Frey has pointed out, *op. cit.*, pp. 6ff., 39, earlier accounts are often recorded much later.

[93] Frey, *ibid.*, p. 42; Giovannoni, *op. cit.*, pp. 157ff.

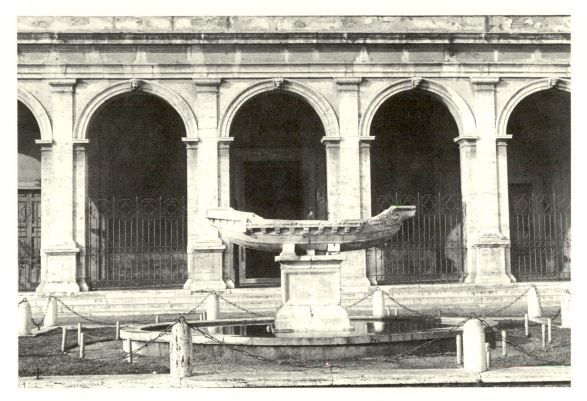

39. The *Navicella Fountain* before Sta. Maria in Domnica, Rome

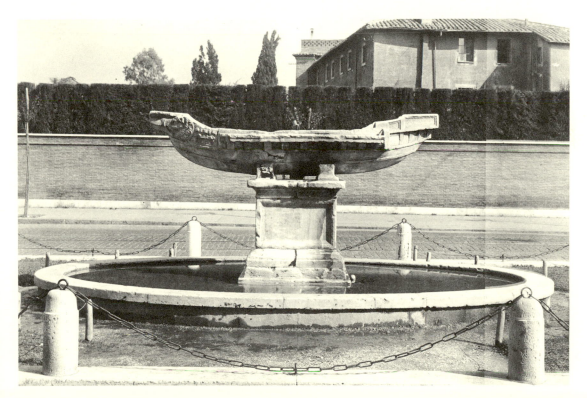

40. The *Navicella Fountain*

That the marble ship erected here by Leo is antique in type has long been recognized. Several documents show that as early as the second half of the fifteenth century there was a marble ship, undoubtedly of antique origin, near the church. One such document, of the year 1478, already gives to the church the name Sta. Maria in Navicella;[94] another, of about 1480, mentions the Capitulum Stae. Mariae in Navicella.[95] A third document of the time mentions the church of "Sta. Maria in Domnica, or in navicula, where the marble ship is."[96] And at the time of Leo's cardinalship, the church was called "commonly" (*vulgo*) *in navicula*.[97] But even earlier than all these Italian documents is the reference to a marble ship ("ein steine schiff") near the church by a traveler from Nürnberg in 1452.[98] That it was already there in the high Middle Ages and connected with a fountain, we shall see shortly.[99]

Modern scholars have often assumed that the ship erected by Leo X, although based on an antique prototype located in this region, is entirely a Renaissance work, its antique model having become badly damaged.[100] But investigation shows that that assumption is not correct.[101] The rear half of the

[94] *in loco qui dicitur Sancta Maria in Navicella* (A. S. 67 C, quoted by Pernier, *op. cit.*, p. 169).

[95] Hülsen, *op. cit.*, p. 547.

[96] De Rossi, *op. cit.*, pp. 41ff.: *post templum S. Mariae in Dominica, sive in navicula, ubi est navicula marmorea.*

[97] Fr. Albertini, *Opusculum de mirabilibus novae et veteris urbis Romae*, Rome, 1510, ed. by A. Schmarsow, Heilbronn, 1886, pp. 7ff.

[98] Nikolaus Muffel, *Beschreibung der Stadt Rom*, ed. by W. Vogt (Bibliothek des litterarischen Vereins in Stuttgart, 118), Tübingen, 1876, p. 42: "Item am suntag Reminiscere zu unser lieben frawen zum schifflein, und ist ein steine schiff, do die heyligen junckfrawen uber mer flussen, das nit untergeng, dan ir vater woltz also ertrenckt und in das mer gesenckt haben, darumb das cristen wurden wan ⟨weil⟩ die hat Christus selber gekront umb yr marter und ligen in der capellen do Constantinus schlaffgaden ⟨Schlafgemach⟩ gewest ist zu

sand Johanus latron als am ersten stet." The pilgrim guides thus coupled with this ship a miraculous legend of Christian martyrs, in which, in our context, it is notable that the ship did not sink (*non mergitur*; see above, n. 67; below, p. 234 and n. 111) and was saved by Christ.

[99] See below, n. 106.

[100] Pernier, *op. cit.*, p. 169 (he announced imminent publication of a paper proposing to prove this, which was not published before his death); Tonello, *op. cit.*, p. 344; Callari, *loc. cit.*; Giovannoni, *op. cit.*, p. 154; Colini, *Capitolium*, 7 (1931), p. 162. [Büttner, *op. cit.*, p. 67.]

[101] Lanciani, *op. cit.*, p. 16, Hülsen, *op. cit.*, p. 331, and Zimmermann, *loc. cit.*, indicated their belief that Leo restored the antique marble ship. The following statements are based on a detailed investigation of the monument undertaken by me with the assistance of Phyllis Lehmann in 1953. I am greatly indebted to A. M. Colini for permits and help. [Cesare d'Onofrio, *Le*

ship, which ends in an irregular break at its center, is of different and much finer workmanship than the front half, which was made under Leo X (figs. 41, 42). Furthermore, on the left side of the stern, a horizontal outer tie bears two carefully incised Greek letters (lambda and chi), of undoubtedly

fontane di Roma, Rome, 1957, p. 176, figs. 146, 160, described the *Navicella* as "d'età romana" and adapted to a fountain by Leo X.

Richard Krautheimer draws attention to the following relevant passage in P. Ugonio, *Le stationi di Roma*, Rome, 1588, c. 120: (Leo X) "Et vi fece una Navicella di marmo nova, drizzandola sopra una bella base dinanzi alle sua porte. *La vecchia si vide quivi appresso mezza rotta, à lato al portico*." As he points out, it is probably a reference to the original prow copied in the new prow added by Leo to the ancient stern. P.W.L.]

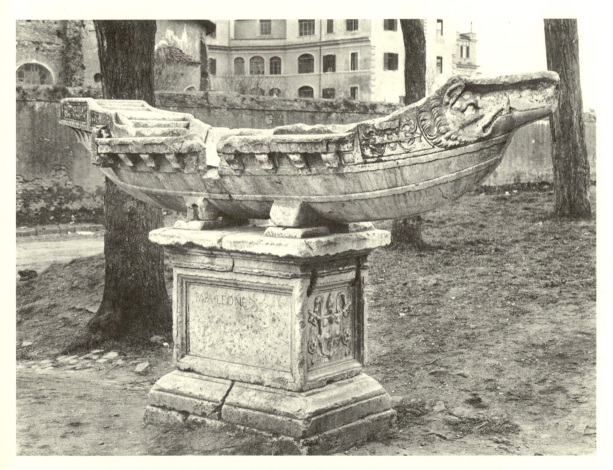

41. The *Navicella Fountain*, ca. 1906, with S. Stefano Rotondo and the Hospital of the English Sisters in the background

antique origin, if of uncertain meaning (fig. 43).[102] Finally, old photographs showing the state of the ship before the latest restorations[103] demonstrate clearly that the props beneath the rear part of the boat, which are made in one piece with it, are different from and less clumsy than those beneath the Renaissance front half (cf. fig. 41). Thus, it is clear that Leo X found the antique marble ship that had long been near the church and had given it its popular name *in navicula* or *in navicella* in a somewhat dilapidated state, and had it restored.

[102] Compare the enigmatic legend △ ∧ ∨ accompanying a ship: Furtwängler, *op. cit.* (above, n. 41), pl. 46, fig. 47. [Other graffiti, of varying date, may be seen in fig. 43 and appear elsewhere, too, on the exterior of the ship. P.W.L.]

[103] Best seen in Anderson photograph 20894 (also Alinari 20161) and A. D. Tani, *Le acque e le fontane di Roma*, Turin, 1926, pl. 4. The post-Renaissance story of the *Navicella* can only be pieced together from illustrations, inasmuch as I have found neither descriptions nor reports giving reliable evidence. Until the nineteenth century the *Navicella* stood, in rather decayed state, on the base on which it was placed by Leo X: *Capitolium*, 7 (1931), illustrations on pp. 157, 166. The ship stood directed as it is now, with the prow toward the right of a spectator facing the church, but the base was later revised to its present position (see below). A drawing of the Cultori di Architettura di Roma made between 1803 and 1905 shows this earlier state. The photographs mentioned above record that sometime after 1905, in which year the Hospital of English Sisters was built across the street (*Capitolium*, p. 161), the *Navicella* was temporarily transferred to a position beneath some great trees to the left of the church. The new hospital appears in the background of these photographs, which were probably taken around 1906. Sometime afterward, the boat must have been taken off its base, because it was replaced in front of the church with the base reversed so that the side preserving part of the inscription of Leo X now faces the church (illustrated in *Capitolium*, p. 346). At the same time, the originally quite differently shaped supports between the boat and the base, each made in one piece with their respective antique (rear) and Renaissance (prow) parts, were equalized in shape (see the illustrations preceding the last restoration of 1931, *Capitolium*, pp. 346 and 347), probably in cement, and the thus partly restored *Navicella* was enclosed within an iron fence (*ibid.*, illustration on p. 346). Many of us remember the *Navicella* in this state. A final remodeling took place in 1931. The fence was removed and a pipeline led in through extant channels (horizontal on the bottom of the base, and vertical through its center) for a spout emerging through a hole in the center of the boat (*Capitolium*, illustration on p. 347). The section of pipe between the center of the base and the boat was then included in a cement block, as it is now. At the same time, the ancient and Renaissance props under the boat were given a new equal, more elaborate bracket-shaped outline in stucco or cement (*ibid.*, illustration on p. 348), which for some reason had disintegrated again by 1952. The illustrations in figs. 39, 40 from new photographs taken in 1952 show the state of the monument after this restoration.

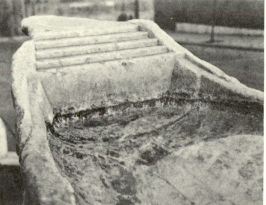

42A

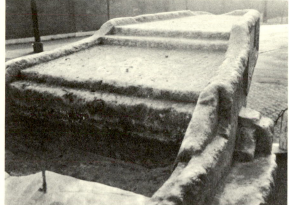

42B

42. Details of the interior of
the *Navicella Fountain*.
A. The Renaissance prow.
B. The antique stern

43. Detail of the exterior of
the *Navicella Fountain*:
ancient graffito

43

In restoring it, he had it placed in front of the church on a postament provided on the bottom with a horizontal channel and, in the center, with a vertical channel for a pipe.[104] In Leo's time, the water was thus intended to be led up to emerge beneath the center of the boat and to spout out sideways into a basin surrounding the base. This arrangement[105] is responsible for the corroded state of the base and has caused the almost complete obliteration of the dedicatory inscription of Leo, of which only the beginning, "Papa Leone X," is preserved on one side of the base (fig. 41). Leo's fountain must thus have functioned for quite a long time. But by the mid-seventeenth century, when our information about Roman fountains becomes plentiful, it seems no longer to have been working.

In re-using an ancient marble ship and placing it in a fountain, Leo revived what we have seen was a not uncommon Imperial Roman type. And one might suggest, without much hesitation, that the antique monument thus revived had always been part of a fountain. Fortunately, we can still prove that this was actually the case. Old photographs show that the antique props preserved under the ancient, rear part of the marble ship have cuttings—now filled up with cement—for pipes which originally led the water to spout out around the lower part of the boat. We are fortunate to possess one more piece of evidence which shows this use of the ship as part of a fountain and, at the same time, proves that it continued to be used as such into the Christian Middle Ages.

Richard Krautheimer points out that the medieval guide known as the *Mirabilia* mentions S. Stefano Rotondo (*Templum Fauni*) on the Caelian as

[104] The channels precede the restoration of 1931 during which the boat was not taken off the base. Theoretically, they could have been made during the operations after 1905, but inasmuch as these did not envisage re-use of the monument as a fountain, it seems evident that they are of Renaissance origin. It is noteworthy that Tonello, at the time of the last restoration and involved in it, assumed without question "uso di fontana" in the restoration of Leo X (*Capitolium*, p. 344), as Fea had done, a hundred years earlier (Pernier,

ibid., p. 170). Pernier, *loc. cit.*, assumed use as a fountain since the later Cinquecento only because of the deplorable state of the water supply in the time of Leo X. What matters is his intention rather than its realization. See also Callari, *loc. cit.*

[105] Mentioned by Pernier, *op. cit.*, p. 168. The destruction of part of the center of the boat visible in the old photographs but now patched up (fig. 42) may have been caused by people who ripped out the pipes.

situated near St. Mary at the Fountain (*ad sanctam Mariam in fontana*).[106] The only church of St. Mary on the Caelian is Sta. Maria in Domnica, and it is astonishing to see that writers on the Christian churches of Rome have failed to make this obvious identification. "St. Mary at the Fountain" and "St. Mary at the Ship" are one and the same, and the ship is the fountain (fig. 44).

The antique *Navicella* on the Caelian was thus part of a Roman fountain

[106] *Codex Urbis Romae Topographicus*, ed. C. L. Urlichs, Würzburg, 1871, p. 111. It is astonishing that this document seems never to have been related to Sta. Maria in Domnica. Hülsen, *op. cit.*, p. 517, thought it to be a mistake and to refer to S. Lorenzo in Fontana.

44. The *Navicella Fountain*, ca. 1900, with S. Stefano Rotondo in the background

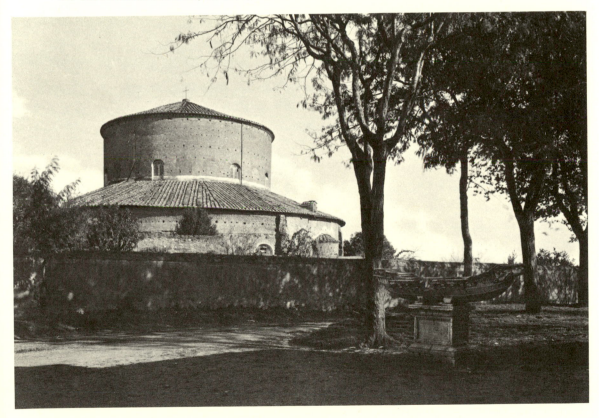

and is to be added to the number of Roman ship-fountains previously discussed. It will be noted that Leo X had it restored with a boar's head emerging from the prow, a motif strikingly similar to that preserved on an authentic Roman fountain-ship not known at the time. It is obvious, therefore, that this detail of the Renaissance restoration is based on a feature preserved on this part of the antique ship, and that the latter had a boar's head at its prow. This motif, as we have seen, implies an allusion to the imperial galley, the Ship of the Roman State, of Temporal Felicity, and of Abundance. If, as has been suggested, the antique ship—or rather, we should now say, the antique ship-fountain—was originally dedicated in connection with vows for the felicitous return of a Roman emperor, this interpretation would become even more specific.[107]

The antique fountain remained in use, as we have seen, into the high Middle Ages,[108] and by the end of the Middle Ages, at least, the ship was called simply *navicella* or *navicula*. Men of that period would naturally have connected it and its name with the *navicula Sancti Petri*, the Ship of the Church of Rome. Thus, as an individual monument, the *Navicella* of Sta. Maria in Domnica experienced the changes in a coherent tradition that we have traced: a Roman descendant of the Greek ship-fountain symbolizing the Ship of State of imperial government, it survived into the Middle Ages to become the Ship of the Church of Rome, and, in the Renaissance, was restored in "authentic" antique form to its original function.

There is no doubt that implicit in Leo's use of the pagan monument is the symbolic meaning of the Ship of the Church. In fact, the Church of Sta. Maria in Domnica itself preserves documents from the following generation for

[107] Almost all modern writers state more or less assuredly that the antique marble ship was a votive gift to Jupiter Redux: Hülsen, *op. cit.*, p. 331; Zimmermann, *loc. cit.*; Colini, *Capitolium*, 7 (1931), p. 162; Pernier, *ibid.*, p. 169; Tonello, *loc. cit.*, p. 344, and others. This is mere conjecture, and we do not know with which of the Roman buildings of this region the ancient monument was connected. If it was related to the Castra Peregrina, it is tempting to think that this fountain-ship was the ship of Isis and referred to the *navigium Isidis* as well as to the imperial galley (see above, pp. 212f.). In 1848 an inscription was found: a dedication to Isis on the occasion of the enlargement of a bath in the Castra Peregrina (*CIL*, VI, 354). It is of the time of Septimius Severus, the period in which the symbolism of the Ship of State and the ship of Isis were fused (above, p. 213 and nn. 62ff.).

[108] Above, pp. 230f.

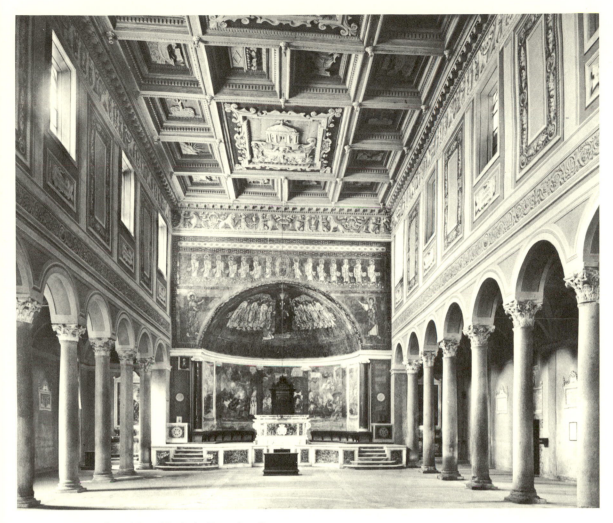

45. Interior of Sta. Maria in Domnica, Rome

an authentic interpretation of this meaning. In 1566, the young Cardinal
Ferdinand Medici—a successor of Leo as titular head of the Church of Sta.
Maria in Domnica who, like Leo, had been made cardinal when still a child
—the later Duke Ferdinand I of Tuscany, adorned the church by commis-
sioning for it a new, richly carved ceiling (fig. 45).[109] Its central field con-
tains an inscription beneath the Medici arms dedicating it "to the memory

[109] It is curious to see this ceiling re-
ferred to as a work of the end of the six-
teenth century: Giovannoni, *op. cit.*, p.
152; Zimmermann, *op. cit.*, pp. 287f. The
inscription in the center reads: *Ferdin(an-
dus) Medicis Card(inalis) templi ornamen-
t(o) | memoriaeque Leonis X renovandae
f(ecit) | Pii V. anno I* (1566).

of Leo X" (fig. 46). The two other major fields show ships: the eastern one, the Ark of Noah, since Early Christian times a variant of the symbolical Ship of the Church, with the inscription: "Be greeted our hope" (*Spes nostra salve*); the western one, a ship this time supporting a domed, round temple, containing the Host, undoubtedly, the tomb of Christ, inscribed on the entablature beneath the dome: "The Lord is the Firmament" (*Dominus firmamentum*) (figs. 47, 48).[110] The two ships of the Old and New Testaments thus paraphrase the symbol of the ship of hope and salvation as the main theme of the ceiling decoration. Nor is that all: among the many and interesting symbols carved in the small coffers surrounding the three major fields, the ship motif is taken up once again. Four pairs of ships are represented—two in the outer corners, the other two in the outer fields of the rows of coffers separating the three main panels. Each pair is connected by the continuous text of an inscription which begins in one field and ends in the other, saying: "The depressed (ship) is raised high by the two (ships)" (*depressa extollitur | duabus*). The depressed Ship of the Church is raised by the two ships of promise and fulfillment, of the faith embodied in the Old and New Testaments. The inscriptions recall an Early Christian statement of St. Augustine, who said of the Ship of the Church that it could be "pressed down but not sunk" (*premi potest, mergi non potest*).[111] Thus, the ceiling which Ferdinand Medici dedicated to the memory of his illustrious relative, Leo X, elaborates on the symbolism of the Ship of the Church—in the very church commonly called Sta. Maria in Navicella after the ancient marble ship-fountain that Leo placed conspicuously in front of its entrance and restored to its original use as a fountain.

[110] It should be noted that, apart from the tradition of the Ark, this type of celestial ship containing a building may have a background in astrological illustrations. The heavenly ship (see above, n. 36) derived from the Egyptian star-ship occurs in the Middle Ages with a temple-like structure supplanting the common antique light superstructure of barks on the Nile: Boll, *Sphaera* (above, n. 36), pl. 1.

[111] See above, p. 214 and n. 67. See also St. Hippolytus, *loc. cit.* (above, n. 66).

46. Detail of ceiling over nave, Sta. Maria in Domnica, Rome

47. Detail of ceiling over nave, Sta. Maria in Domnica, Rome

48. Detail of ceiling over nave, Sta. Maria in Domnica, Rome

THE ANTIQUE ship-fountain was revived as a meaningful symbol of the Roman church in the heyday of the Renaissance. But once the long obsolete, antique artistic formula had come to life again, it lived on and was adapted to the different ideas of succeeding generations, both secular and ecclesiastic. In the third quarter of the sixteenth century, the motif crossed with the extensive new play with fountains and cascades in the gardens of the late Renaissance. In the famous alley of the Villa d'Este at Tivoli called the Viale delle Fontanelle,[112] sculptured ships were placed among other objects in a loose association of symbols, devices, and antiquarian details (fig. 49). At the end

[112] A. Colasanti, *Le fontane d'Italia*, Milan, 1926, p. 153. [See now David R. Coffin, *The Villa d'Este at Tivoli*, Prince- ton, 1960, pp. 15ff., 28f., figs. 27, 28; Carl Lamb, *Die Villa d'Este in Tivoli*, Munich, 1966, pp. 70ff. P.W.L.]

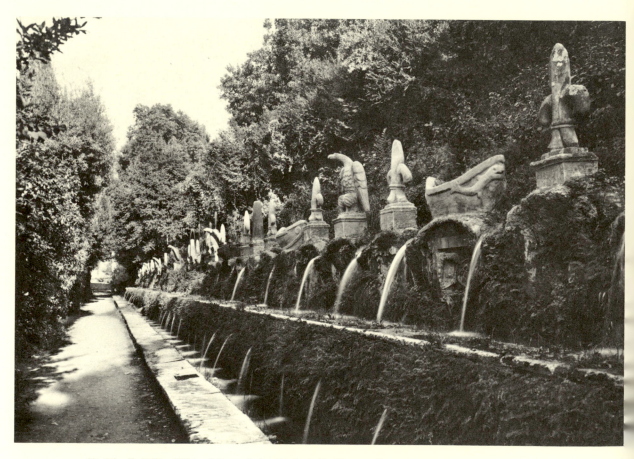

49. Tivoli, Villa d'Este. View of the Viale delle Fontanelle

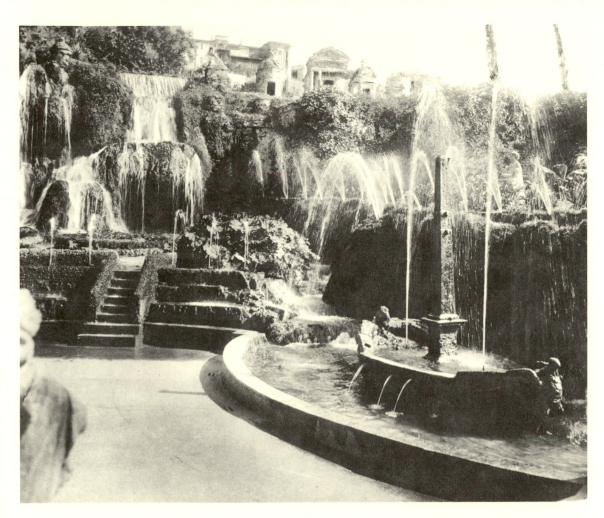

50. Tivoli, Villa d'Este. *Fontana della Rometta*

of this alley, Pirro Ligorio, the learned antiquarian-architect, introduced the ship in a more specific sense, now as an expression of antiquarian learning, in a famous ship-fountain known as the *Fontana della Rometta* and now incorrectly restored (fig. 50).[113] Built before 1573, when it appeared as finished in a print by Du Perac[114] it is connected in a curious, indirect fashion with the *Nike of Samothrace*.

[113] Colasanti, *op. cit.*, pl. 182. G. B. Falda, *Le fontane di Roma*, Rome, 1691, IV, pl. 5 (G. F. Venturini). Photograph: Alinari 7095A (1935). [Coffin, *op. cit.*, pp. 23ff., figs. 20–24; 127 a, b; Lamb, *op. cit.*, pp. 72ff., pls. 45, 46, 76, 83, 84, 102. P.W.L.]

[114] Thomas Ashby, "The Villa d'Este at Tivoli and the Collection of Classical Sculpture Which It Contained," *Archaeologia*, 61 (1906), I, pp. 219ff., pl. 25. [For Du Perac's engraving, see now Coffin, *op. cit.*, pp. 15f., n. 3. P.W.L.]

The reader will recall the ship-monument commemorating a naval victory of the late Roman Republic and seemingly directly inspired by the *Nike of Samothrace* which was placed at one tip of the Tiber Island in the river's water (fig. 16).[115] Renaissance scholars, seeing only as much of the monument as we can see today, assumed that what is preserved was only one end of a gigantic ship into which the entire island had been transformed in antiquity to commemorate the arrival of the snake, incarnation of the god Aesculapius, at this spot.[116] In Renaissance drawings and reconstructions of ancient Rome, the island thus appears as a huge ship supporting a number of temples and an obelisk which was found on it. The drawing reproduced here (fig. 51)[117] comes from the circle, though not from the hand, of Pirro Ligorio,

[115] See above, p. 200 and nn. 29f.
[116] M. Besnier, *op. cit.*, pp. 32ff.
[117] Cod. Vat. lat. 3439, fol. 42r, upper figure. The drawing was attributed to Ligorio by Besnier, *op. cit.*, p. 38. But

it is decidedly by a hand other than the drawings on folios 24–39, which seem to be Ligorio's own. This draftsman lacks skill in making architectural drawings. See also Kerényi, *Asklepios*, pp. 3ff.

51. Ms. Lat. 3439, fol. 42r: reconstruction of the Tiber Island.
Rome, Biblioteca Apostolica Vaticana

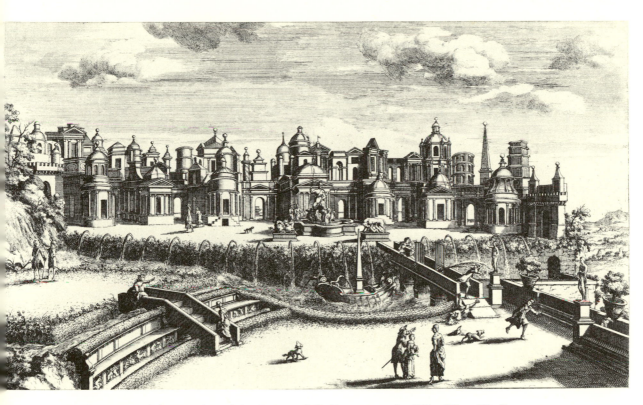

52. G. F. Venturini, engraving of the *Fontana della Rometta* at the Villa d'Este, Tivoli

the architect of the Villa d'Este. It also shows a similarity to the ship of the New Testament on the contemporary ceiling of Sta. Maria in Domnica, which may well have been inspired by this type of antiquarian study.

In its original form, the fountain of the *Rometta* at Tivoli was part of a playful restoration of ancient Rome, the buildings of which—now mostly destroyed—appeared as a backdrop in stucco architecture (fig. 52).[118] The ship itself, placed as it were in the Tiber and near a large bridge (a real ship, that is, and not the Tiber Island), carries an obelisk in learned allusion to the island and also, probably, to the stories in ancient writers about special ships

[118] [Coffin, *op. cit.*, pp. 23f., assumes that the source of the fountain's water, a cascade at its upper left, and the river god at its top, allude to Tivoli, its cascade and Round Temple. For building accounts from 1570 recording work on this backdrop, see p. 24f., n. 30. See fig. 21 and, for the present state of the stucco backdrop representing the city of Rome, especially figs. 20, 24. P.W.L.]

built for the transport of obelisks from Egypt to Rome. But it is, primarily, the ship of Aesculapius: he appeared on the stern of the ship in the form of a snake (the form in which he traveled to Rome), probably in bronze, and undoubtedly inspired by the medals of Antoninus Pius which show the arrival of the god on a ship near a bridge at the Tiber Island (fig. 29).[119] The snake was used ingeniously as a pipe and spouted salubrious water into the ship itself—as the god of health would do. Thus, a new motif was introduced: the ship is not only in water, it is also filled with it, the water flowing out through lateral gun holes and blown out by birds' heads at the prow and stern. It is a curious, learned, and, at the same time, playful elaboration of the ancient theme.

Once the motif of the ship-fountain had been introduced into the light realm of garden fountains, it gained in them a certain popularity in Rome and its vicinity[120] in the late sixteenth and early seventeenth centuries. Probably between 1570 and 1580, the park of the Villa Lante at Bagnaia, near Viterbo, was embellished by a large square pond with an island in the center to which four bridges lead. In each of the thus divided four sections of this monumental fountain, a marble ship with *putti* seems to float (fig. 53).[121] On the Caelian Hill in Rome—the hill on which we have found curiously concentrated so much of the historical evidence for our theme—and near the *Navicella* of Sta. Maria in Domnica, the garden of the Villa Mattei (begun in 1582) received a small fountain niche in which water emerged beneath a ship.[122]

In the first decade of the seventeenth century, the ship-fountain was used several times in the famous gardens of the Villa Aldobrandini at Frascati, most notably in a now sadly dilapidated monument beautifully placed at the

[119] Above, p. 210 and n. 58.

[120] As far as I can see, the Baroque fountain in the form of a ship is limited to Rome and its region. In the rich literature on fountains in other parts of Italy and in other countries, I have not found any examples preceding the nineteenth century. The ship is also absent from the fanciful fountain designs of Hans Fridmann (Ioann. Friedmannus), *Artis perspectivae plurium generum elegantissimae formulae*, I, Antwerp, 1563; Jean de Vries, *Puits et fontaines*, Antwerp, 1573; and G. A. Boeckler, *Architectura curiosa nova*, Nürnberg, 1669.

[121] B. H. Wiles, *The Fountains of Florentine Sculptors and Their Followers from Donatello to Bernini*, Cambridge, Mass., 1933, p. 72, fig. 141; A. Venturi, *Storia dell' arte italiana*, XI, 2, Milan, 1939, pp. 744f., figs. 688, 689.

[122] Illustrated by A. Pernier, *op. cit.* (above, n. 90), p. 173.

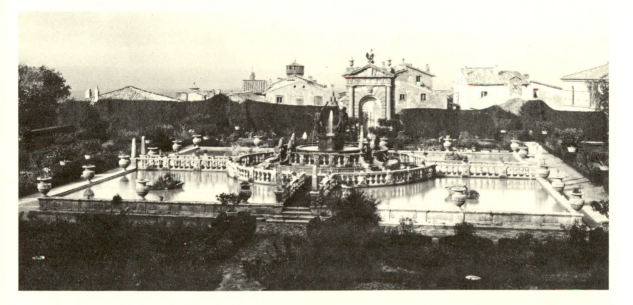

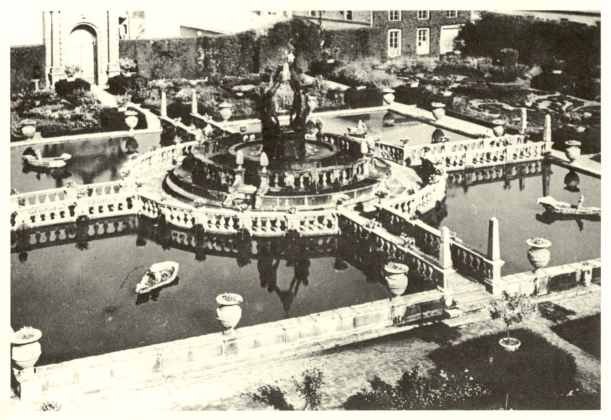

53. Bagnaia, Villa Lante. Views of the *Fontana del Moro*

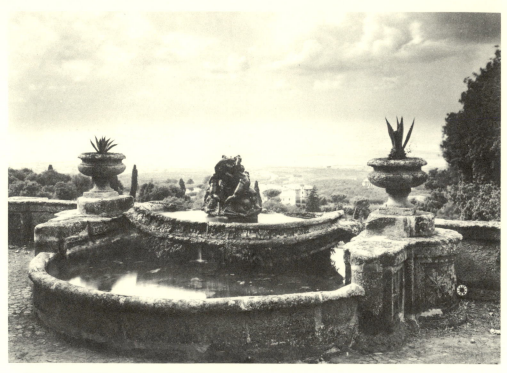

54. Frascati, Villa Aldobrandini. Ship-fountain

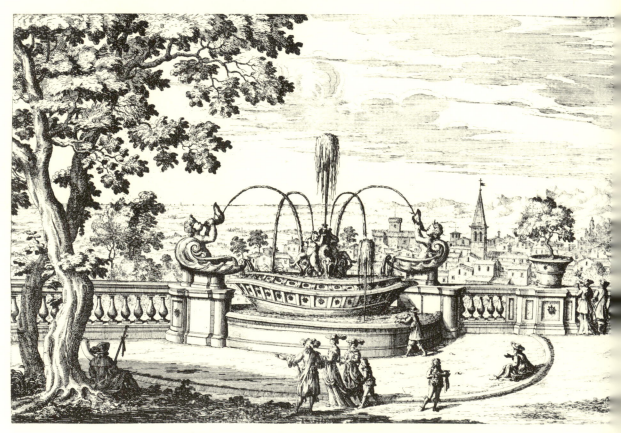

55. G. B. Falda, engraving of the ship-fountain in the Villa Aldobrandini at Frascati.
New York Public Library

edge of a terrace overlooking the wide Campagna (figs. 54, 55).[123] We do not know whether any of the famous architects who succeeded each other in supervising work on the villa[124]—Giacomo della Porta[125] (until his death in 1602), Carlo Maderno,[126] Giovanni Fontana[127]—designed this fountain. But it was early said that one Orazio Olivieri from Tivoli was employed in the execution of the waterworks,[128] and the fountain was surely inspired by the *Fontana della Rometta* of the Villa d'Este. From the latter was adapted the idea of filling the ship with water by mythical antique power. Where two ugly flower pots now flank the ends of the ship, there were once two little lateral fountains: horned satyr-boys sitting in shells and spouting water into the ship from conch shells (fig. 55).[129] But instead of discharging the liquid brought in by these little demons through natural outflows in the sides, prow, and stern, as was done at the Villa d'Este, here another fountain jets the water upward from a rocky island that seems to have grown up miraculously and mysteriously in the very center of the ship. Little badly-mutilated *putti* adhere to this fountain within the ship, undoubtedly brothers of the lateral *satyriskoi* who support two more jets.

[123] Falda, *op. cit.*, II (Falda); Colasanti, *op. cit.*, pl. 184; S. Kambo, *Il Tusculo e Frascati*, Bergamo, n.d., pp. 63ff.; Venturi, *op. cit.*, p. 811. The drawing recently published by Roberto Pane, *Bernini Architetto*, Venice, 1953, fig. 81, may be a preliminary study for this fountain or a study for an unexecuted or unpreserved monument. In this design, two naked nymphs instead of the satyrs press water from their breasts and jet it from their mouths into the ship in the center of which a high unsculptured jet emerges (like that of Leo X's *Navicella*). [See now, too, Cesare d'Onofrio, *La Villa Aldobrandini di Frascati*, Rome, 1963, pp. 66ff., figs. 68, 69, 70, 77, 114, 115. P.W.L.]

[124] G. and F. Tomassetti, *La Campagna Romana antica, medievale e moderna*, IV, Rome, 1926, pp. 456ff.; *Enciclopedia Italiana*, XVI, Treves, 1932, pp. 29ff., s.v. *Frascati*.

[125] So Venturi, *op. cit.*, p. 815.

[126] Colasanti, *loc. cit.* (with question mark). [Klaus Schwager, "Cardinal Pietro Aldobrandinis Villa di Belvedere in Frascati," *Römisches Jahrbuch für Kunstgeschichte*, 9–10 (1961–1962), pp. 333, n. 163; 349, n. 246. I am indebted to Richard Krautheimer for this reference. P.W.L.]

[127] Tomassetti, *op. cit.*, p. 458, states that the waterworks were under the direction of Maderno and Fontana.

[128] Tomassetti, *loc. cit.* He was evidently early confused with P. P. Olivieri Romano, who had died in 1599, several years before the Villa was begun. Falda, *loc. cit.*, attributes the fountain to Olivieri Romano. [See now d'Onofrio, *op. cit.*, pp. 120, 136, 140, 142. P.W.L.]

[129] Falda, *loc. cit.* [This motif recalls the Tritons who blow wine from shells in Philostratus' description of the Andrians: *Imagines* 1.25.3, as I find among the author's notes to be added to this discussion, and constitutes another tangible connection with that influential writer. See also below, nn. 130ff. P.W.L.]

Once again an antique idea is alluded to and is responsible for what seems, at first, to be a merely paradoxical, if playful, elaboration of the ship-fountain for this fountain jetting up within the ship. The reader will recall the divine ship of Dionysos in a painting described by Philostratus,[130] an author who inspired many works of Renaissance and Baroque art. The ship of Dionysos has an awning of vine and ivy, "a miracle, indeed, but even more miraculous is the fountain of wine which emerges and wells up from the hollow of the ship." This ship, known to the Renaissance visually in a mosaic still preserved at the time in Sta. Costanza,[131] is described and illustrated, with a fountain in the form of a conventional vase jetting up liquid, in Cartari's book, *Le imagini de i dei de gli antichi,* in the edition published in 1571 and often reprinted afterward (fig. 56).[132] The allusion to this ship of Dionysos and its miraculous fountain is clear in the fountain at the Villa Aldobrandini: the horned satyr-*putti* who blow water into the ship are companions of the god.

The most famous of the Roman ship-fountains[133] (and one of the most popular monuments of Baroque Rome), the *Barcaccia* in Piazza di Spagna (figs. 57, 58), is, in turn, a descendant of the fountain in the Villa Aldobrandini. Here water is again blown into the ship by two demons—masks of weather gods with flaring hair, who spout water into the ship from each end. The ship itself supports, at its center, a fountain with a jet which vaguely repeats its

[130] Above, p. 210 and n. 55. [It is interesting to note that it has recently been assumed that another passage in Philostratus is the source of certain figures in the Teatro dell' Acqua: R. M. Steinberg, "The Iconography of the Teatro dell' Acqua at the Villa Aldobrandini," *AB*, 47 (1965), p. 458. p.w.l.]

[131] See above, p. 210, n. 56.

[132] Erwin Panofsky has called my attention to the fact that the ship in Cartari's illustrations appears to have been based on one of the ships in an engraving by Fantuzzi of one of Rosso's frescoes at Fontainebleau—*The Shipwreck of Odysseus and Ajax* (see Paolo Barocchi, *Il Rosso Fiorentino*, Rome, 1950, figs. 118, 119).

[As Panofsky continued, in the letter of November 14, 1955, conveying this suggestion, Fantuzzi was active at Fontainebleau from 1537 to 1550, and Cartari's illustrations are known to have been drawn from a variety of sources. p.w.l.]

[133] It soon eclipsed the earlier examples of the type. Among forty-five fountains shown by G. J. Rossi (Maggi), *Nuova raccolta di fontane*, the *Barcaccia* appears on fol. 14. In the incomplete copy in the Print Department of the Metropolitan Museum, where eleven folios are missing, other fountains of both the Villa d'Este and the Villa Aldobrandini appear, but not the ship-fountains.

silhouette, the overflow pouring out through the holes for anchor chains at the
prow and stern. At times, as Falda's old illustration shows (fig. 59),[134] it flows
over the sides and gives to the ship the appearance of a sunken vessel.

There is reliable documentation, it seems, for the fact that this fountain
was executed about twenty years after the fountain in the Villa Aldobrandini
by Pietro Bernini, the father, who may have been assisted by his son, Lorenzo,

[134] *Op. cit.*, I.

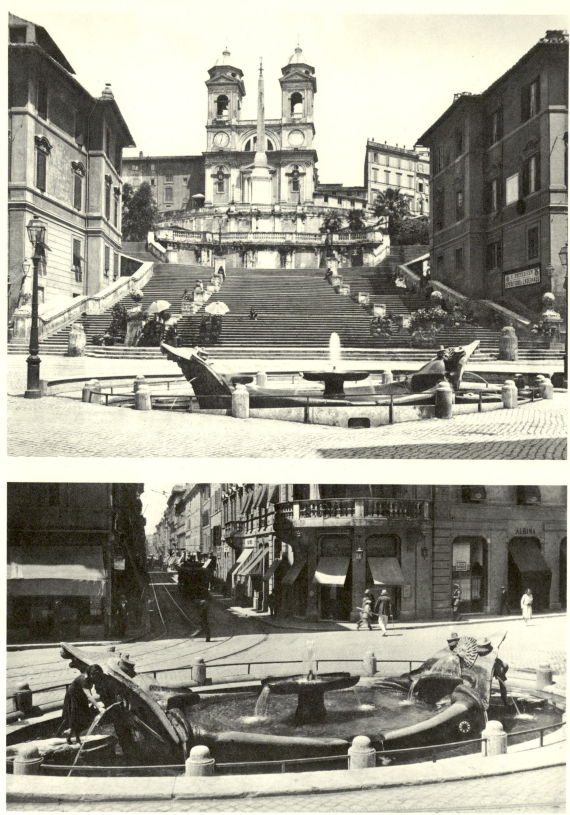

57

58

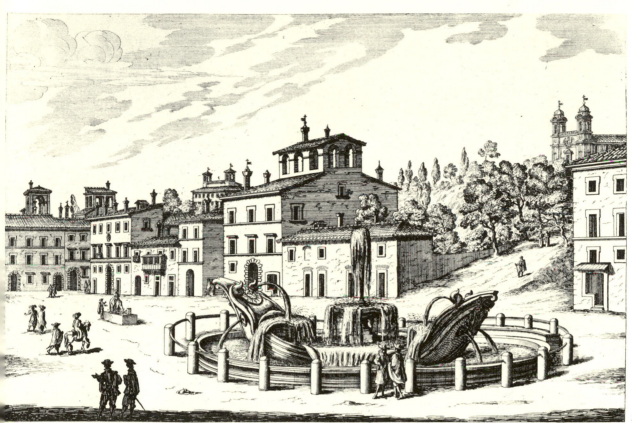

59

57. Rome, Piazza di Spagna. *Fontana della Barcaccia*

58. Rome, Piazza di Spagna. *Fontana della Barcaccia*

59. G. B. Falda, engraving of the *Fontana della Barcaccia*.
New York Public Library

between 1627 and 1629, during the pontificate of Urban VIII.[135] But, later in the century, the fountain was attributed to his great son. Furthermore, two contradictory interpretations are offered for this fountain. One is the popular tradition according to which a rescue boat had moved to this region during a flood and had been left behind stranded, thus inspiring the use of a boat filled with water.[136] The other recognizes in the boat, spouting the water of peace instead of the flames of war, a symbol of the Church. The latter explanation, as we shall see, is based on the mistake of a seventeenth-century writer.[137] It would be a curious idea, indeed, to make the ship appear almost sunk, as it does, if it alluded to pontifical power! The popular legend is more to the point. But given the, by that time, well-established tradition of ship-fountains, a play on the motif as such, based on the last stage of development as we have met it at the Villa Aldobrandini, is also possible. It is an enchanting, and in comparison with the earlier ship-fountains, irrational play with the idea. Ship and fountain are entangled and integrated into an insoluble complexity, a dynamic unit of concrete and abstract elements, of swaying curves of stone and fluidity of water. In this very character, the *Barcaccia* of Piazza di Spagna contrasts with the objective illusion of antique monuments,

[135] The attribution of the design to Pietro—who admittedly was officially commissioned—or to his great son is still debated. Since Baldinucci's biography of Giovanni Lorenzo Bernini (Filippo Baldinucci, *Vita des Gio. Lorenzo Bernini*, ed. by Alois Riegl, Vienna, 1912, pp. 30ff.), most critics have preferred the attribution to Lorenzo: recently, Pane, *op. cit.*, pp. 46ff.; Rudolf Wittkower, *Gian Lorenzo Bernini* [2d edn., London, 1966, pp. 29, 265, no. 80, especially citing Howard Hibbard and Irma Jaffe, "Bernini's Barcaccia," *The Burlington Magazine*, 106 (1964), pp. 159–170, against d'Onofrio, *Le fontane di Roma*, pp. 177ff. See also Valentino Martinelli, "Contributi alla scultura del seicento. IV. Pietro Bernini e figli," *Commentari*, 4 (1953), pp. 150f. P.W.L.] The documents for the commission to Pietro: Riegl, *op. cit.*, p. 30; O. Pollak, *Die Kunsttätigkeit unter Urban VIII*, 1, Vienna, 1927, pp. 12ff.

[136] Riegl, *op. cit.*, p. 37; Callari, *op. cit.*, p. 154.

[137] Baldinucci-Riegl, *op. cit.*, p. 32. [This interpretation is accepted by Hibbard-Jaffe, *op. cit.*, p. 160, and, seemingly, by Wittkower, *op. cit.*, p. 29. Both Hibbard-Jaffe, *loc. cit.*, and d'Onofrio, *op. cit.*, p. 176 and figs. 148, 149, interpret the masks spouting water on the interior of the ship as symbols of the sun (as opposed to weather gods). The former authors suggest that the sun of Divine Truth and Wisdom and the bees of Providence, both emblems of the Barberini, guide the *Barcaccia*—in accord with their assumption that it is the papal ship referred to in the poem written by Urban VIII when he was still Cardinal Barberini, for which see below, p. 254 and nn. 143f. P.W.L.]

the allegorical metaphor of the High Renaissance, the light and playful, if learned, combination of elements around and in the ship at the Villa d'Este and the Villa Aldobrandini. In this fountain, the ship has become, as it were, a floating allusion, a musical motif submerged in and emerging from the natural element of water.

In the same period, however, the religious symbolism of the *navicula Sancti Petri,* the Ship of the Church, was still alive, as, a century before, it had led to the revival of the antique ship-fountain under Leo X. Rudolf Wittkower[138] has called attention to a fantastic project of Papirio Bartoli, who planned to erect a symbol of the Ship of the Church over the tomb of the Apostles in St. Peter's. Directly related to the ship-fountain, on the other hand, was the restoration by Paul V, in 1617, of the *Navicella* of Giotto. For seven years this famous mosaic, which over three hundred years earlier had proclaimed the symbolism of the *navicula Sancti Petri,* had been lying dismantled and neglected. Paul V placed it to the north of the Scalinata di S. Pietro on the wall of the newly built entrance to the Vatican Palace and made here "a fountain which served as decorative framework of the mosaic Navicella."[139]

This example of the *navicula*-fountain illustrates the background of the famous *Galera* in the Vatican Gardens (figs. 60, 61). It was commissioned of Maderno slightly earlier than the *Barcaccia* of Piazza di Spagna by the same Pope Paul V, the predecessor of Urban VIII.[140] Since the sixteenth century, a fountain had existed on a terrace outside the Belvedere complex of

[138] "A Counter-Project to Bernini's 'Piazza di S. Pietro,'" *JWarb*, 3 (1939–1940), pp. 104f.

[139] G. Baglione, *Le vite de' pittori, scultori et architetti*, Rome, 1642, p. 180: "una fontana che stava per ornamento della Navicella di musaico": A. Munoz, "Vicende del mosaico della Navicella di S. Pietro," *Bollettino d'arte*, ser. I, 5 (1911), pp. 179ff.; Paeseler, *op. cit.*, pp. 81f. Giovanni Lorenzo Bernini and Carlo Maderno were members of a commission, in 1628, that examined the condition of the mosaic, which had suffered from humidity in the intervening ten years. But these fountain enthusiasts pleaded for its being left where it was. Ultimately, however, Bernini himself had to re-place it in the Portico of St. Peter's.

[140] See Riegl, *op. cit.*, p. 37. Maderno died in 1629. That the *Galera* is earlier than the pontificate of Urban VIII is clear from the epigram cited below, n. 144. Maderno is given as author in the engraving by Venturini. [D'Onofrio, *Le fontane di Roma*, p. 183, n. 14, disputes this traditional attribution and ascribes the *Galera* to Vasanzio. P.W.L.]

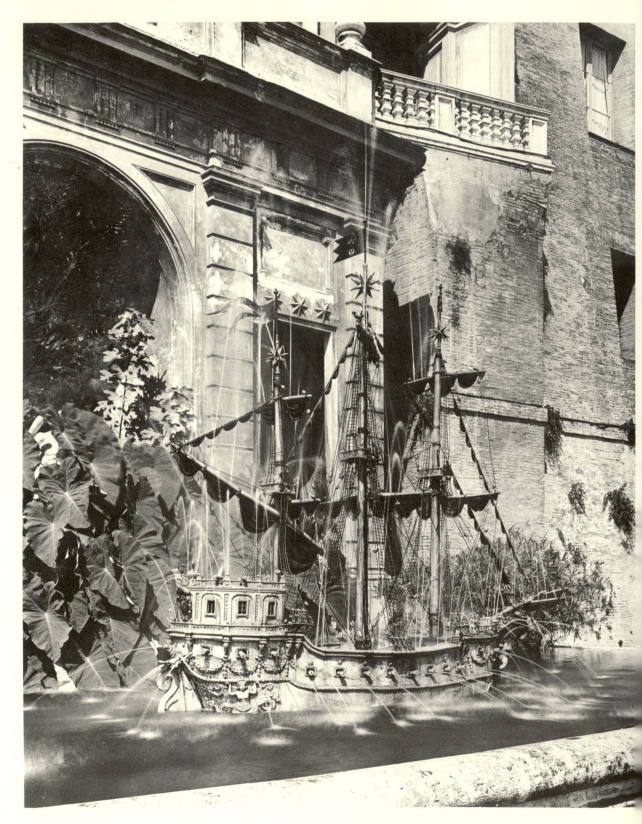

60. Carlo Maderno, *Fontana della Galera*. Rome, Giardini Vaticani

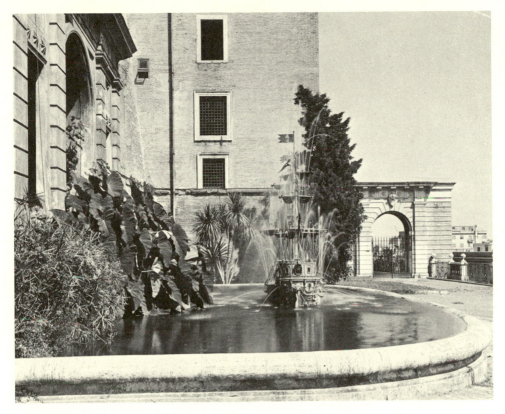

61. Carlo Maderno, *Fontana della Galera*. Rome, Giardini Vaticani

the Vatican from which there was a wide view over Rome.[141] It was elaborated under Paul V, early in the seventeenth century, by a large pond in front of a grotto overgrown by vegetation, and in it there was placed, as it were, floating, a faithful bronze imitation of a pontifical galley with three masts and all the necessary trimmings made by Carlo Maderno, who, it will be remembered, may also have had a hand in the ship-fountain of the Villa Aldobrandini. In

[141] Professor James S. Ackerman has kindly provided the following information: fountain by Bramante (?); Serlio, *Terzo Libro* (edition of 1566), fol. 120v.; remodeling by Julius III ca. 1551; engraving by Cartaro, "Pescheria di Papa Giulio 3º," 1574, reproduced in W. Friedlaender, *Das Kasino Pius des Vierten*, Leipzig, 1912, p. 2, fig. 1; T. Hofmann, *Raffael in seiner Bedeutung als Architekt*, IV, Leipzig, 1911, pl. 11, 1, and elsewhere. Remodeling by Paul V: Maggi-Mascardi, *View of Vatican* No. 16 *Fons rusticus ad Bramantis scalam a Paulo V instauratus atque ornatus*. The origin of the *Galera* in the time of Paul V (not of Urban VIII) is further documented by the inscription recording the remodeling under Pius VI: *Pius Sextus Pont. Max.* | *fontem rustico antea opere* | *a Paulo V extructum . . . restituit* (1779): V. Forcella, *Iscrizioni delle chiese e d'altri edificii di Roma*, VI, Rome, 1875, p. 189, n. 701.

an engraving by Venturini (fig. 62),[142] it appears in its original state (which has been much altered by subsequent modifications and additions) spouting water from a broadside of two rows of guns—so powerfully, indeed, that the water shot from these guns might hit those who approached the fountain.

This seems like nothing but an ingenious joke based on the idea of the ship filled with water in the fountains of the Villa d'Este and the Villa Aldobrandini. Actually, however, the monument once again emphasized the symbolism of the Ship of the Church, which had led Leo X to revive the antique ship-fountain in the *Navicella* on the Caelian and Paul V, himself, to place Giotto's *Navicella* in a fountain. We possess, in fact, an explicit contemporary explanation of the monument in a Latin poem written by the later Pope Urban VIII when he was still Cardinal Barberini in the time of Paul V.[143] It is this poem which erroneously has been said to refer to the *Barcaccia* in Piazza di Spagna. It is entitled: "On the Pontifical Fountain Having the Effigy of a Ship" and says:

> The Pontiff's man of war shoots not the flaming fire
> It shoots the water sweet to end the fire of war.[144]

[142] Falda, *op. cit.*, III. Venturini's engraving must antedate 1669, when, under Clement IX, the fountain was elaborated with many additional waterspouts, as described by G. P. Chattard, *Nuova descrizione del Vaticano*, III, Rome, 1768, pp. 204f. In this restoration the ship was turned around. A last elaboration to its present form (our figs. 60, 61; Colasanti, *op. cit.*, pl. 183) took place under Pius VI (see above, n. 141).

[143] This fact seems to have been curiously overlooked by all modern critics: the epigram is published in the collection entitled *Maphaei S. R. E. Card. Barberini nunc Urbani P.P. VIII Poemata*, Rome, 1631, p. 155. The title without doubt indicates that it was composed before Cardinal Maffeo Barberini ascended to the pontificate as Urban VIII. The caption of the epigram, "*De Fonte | Pontificio | navis effigiem habente*" also clearly refers to the Pope as a person other than the author, i.e.,

Paul V, whose commissioning of the *Galera* is otherwise documented (above, n. 141). This excludes any connection between the epigram and the *Barcaccia* of Piazza di Spagna (see above, p. 250 and n. 137) which dates from Urban's own pontificate, since the *Barcaccia* does not "shoot" water as the *Galera* does, and cannot even be called a warship. Yet there is nothing more tenacious in scholarship than a confusion once put down black on white: see Filippo Baldinucci, *Vita di Bernini*, ed. by S. S. Ludovici, Milan, n.d., pp. 83, 210, nn. 50, 51. [D'Onofrio, *Le fontane di Roma*, p. 183, has made some of the same points in also referring this poem to the *Galera*. Nevertheless, I have left this note as it was originally written. For further comment on this controversy, see Hibbard-Jaffe, *op. cit.*, p. 163, n. 13. P.W.L.]

[144] *Bellica Pontificum non fundit machina flammas | sed dulcem, belli qua perit*

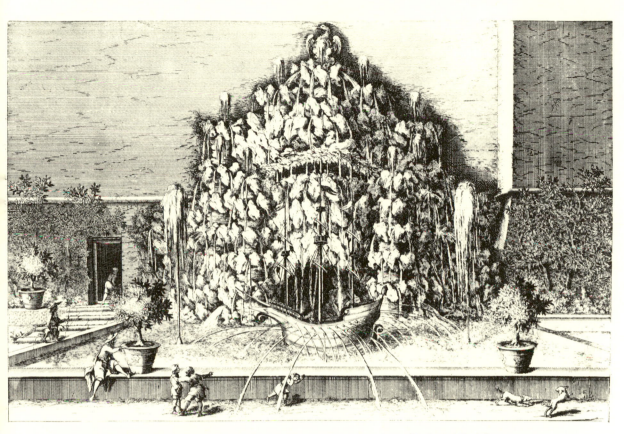

62. G. F. Venturini, engraving of the *Fontana della Galera*. New York Public Library

It is the ship of the *ecclesia militans* of Rome, which spreads peace in a troubled world, made about the time when the Thirty Years' War initiated the final struggle in the conflict that had started, under Leo X, with the Reformation.

Although published later, Venturini's engraving must have been made by the young artist before 1669. In that year, at the latest, Pope Clement IX had the ship remodeled, possibly turning it around as it now stands, adding to its superstructure, making many jets spout water upward from the interior of the galley and the masts, and richly decorating the stern with sculpture and

ignis, aquam. The whole point of the epigram and, for that matter, of the *Galera* is that the guns (lacking in the *Barcaccia*) shoot water instead of fire.

an elegant cabin.[145] The present architectural backdrop and, surely, too, the stars on the masts were added in 1779 by Pope Pius VI.[146]

Like the *Nike of Samothrace*, the *Galera* is once again an image of a real warship in real water. As the galley of a ruler, it is a descendant of the imperial galleys of Roman ship-fountains. As a symbol of the spiritual power of the Church of Rome, it is derived from Leo X's *Navicella*. The miraculous ship, which itself becomes the source of the beneficial liquid it emanates, is a successor of the ship of Dionysos in Philostratus, the ship of Asklepios at the Villa d'Este, and the ship-fountain of the Villa Aldobrandini. As a showpiece of modern engineering, it is a product of the incipient age of science.

THE REVIVAL of the ship-fountain of antiquity, if fascinating in its ramifications of meaning and varieties of form, was restricted to the High Renaissance and early Baroque periods of Rome and her immediate vicinity. Among the abundant fountains all over Europe outside that region from the sixteenth to the eighteenth century, it does not occur.[147] Only a few sporadic experiments in the nineteenth century—of no artistic merit[148]—are, in turn, derived from the tradition of Renaissance and Baroque Rome. Within that tradition, the revival had been caused and its manifestations motivated by the theological and antiquarian interests of the Pontifical Court.

Victory, having alighted on a ship, had no place in this circle of popes, cardinals, and noblemen of the Curia. Yet the scheme of this artistic symbol, which had given rise to the idea of the ship-fountain in Greece, was known to Renaissance and Baroque antiquarians from Roman coins on which it had been revived with various meanings in the late Empire. From this source, the idea which had found grandiose expression in the *Nike of Samothrace* on her ship emerged once more, too, and in a curious context as characteristic of the age as the symbolical ship-fountains which have been discussed: as an allegorical paraphrase of the age of exploration, of that same age as the Reformation and the Counter Reformation, the age of Renaissance and early Baroque antiquarian learning.

[145] See above, p. 254 and n. 142.
[146] See above, p. 253 and n. 141.
[147] See above, n. 120.
[148] The most noteworthy—returning to the original idea—is the fountain by R. Weyr symbolizing Might at Sea in front of the Hofburg in Vienna.

63. Reverse of bronze medallion of Constantine the Great: Victory on the prow of a ship

In the decade following the revival of the ship-fountain in the *Navicella* on the Caelian Hill, Ferdinand Magellan set out on his great voyage to circumnavigate the world. And in the early years of the seventeenth century, in 1603, at the time when the fountain in the Villa Aldobrandini was designed, the first illustrated account of that voyage was published by Levinus Hulsius in Nürnberg.[149] In assembling his fleet, Magellan had—in humanist fashion—baptized one of his ships "Victoria," and it is this ship which appears throughout Hulsius' illustrations as the only one decorated with a figure on the prow: a Victory running forward on it with a palm branch in her right and a crown in her extended left hand. Whether Magellan's "Victoria" actually had such a sculptured figure (if so, carved of wood) or it is simply an illustrator's elaboration of the name of the ship, it clearly was inspired by late Roman numismatic representations such as the Victoria Augusti of Constantine (fig. 63),[150] which, in turn, had revived the Greek tradition so magnificently crystallized in the *Nike of Samothrace*.

[149] Levinus Hulsius, *Kurtze Warhafftige Relation und beschreibung der Wunderbarsten vier Schiffarten so jemals verricht worden*, Nürnberg, 1603. Later illustrations of Magellan's ship, partly based on this: *Magellan's Voyage Round the World*, by Antonio Pigafetta, ed. by J. A. Robertson, Cleveland, 1902; O. Koelliker, *Die erste Umseglung der Erde durch Fernando de Magallanes und Juan Sebastian del Cano, 1519–1522*, Munich, 1908, p. 240, pl. 25; J. von Pflugk-Harttung, *Weltgeschichte, Geschichte der Neuzeit, Das religiöse Zeitalter 1500–1650*, Berlin, 1905, fig. on p. 44; *Annual of the Royal United Service Institutions*, 60 (1915), pp. 315ff.

[150] Gnecchi, *op. cit.* (above, n. 43), pls. 131, fig. 9; 133, fig. 12. [For this type, see A. Alföldi, "On the Foundation of Constantinople: A Few Notes," *JRS*, 37 (1947), pp. 10ff., pl. 2, nos. 5, 7, where it is pointed out that the reverse type commemorates the Emperor's naval victory

On the title page of the book (fig. 64), this ship appears between the portraits of four eminent sixteenth-century explorers—first and foremost among them, Magellan—who are shown on coins or medals of antique-Renaissance type. And above them is inscribed a poem in humanist Latin:

I am the first to have sailed around the orb of the earth
Led by leader Magellan over the widespread seas.
I sailed around the earth. Victory am I named.
Sails are my wings, my price fame, the battle the sea.[151]

The antique symbol has here been reinterpreted once again. The ancient goddess guiding the ship of mortals to success in war has become an allegory: she is herself but the mythological simile of the successful ship, and both are symbols of the irresistible progress of mankind into the modern age.

over Licinius at Chrysopolis. Alföldi, now followed by Patrick M. Bruun, *The Roman Imperial Coinage*, VII, London, 1966, p. 332, no. 301, has attributed this type to the mint of Rome rather than, as previously assumed, to that of Constantinople. P.W.L.] The Isis ship of ancient coinage was also revived in the Renaissance: see, for example, a Venetian medal (between 1526 and 1530): Hill, *op. cit.* (above, n. 78), no. 519, pl. 95 (the ship of *Spes*?). The ship of Isis, based on coins, is used in Cartari, *op. cit.* (above, p. 246), edn. of 1674, p. 62, for a spurious gem which reflects misunderstanding of a coin

such as the one shown by Alföldi, "A Festival of Isis," pl. x, 23.

[151] *Prima ego velivolis ambivi Cursibus Orbem | Magellane novo te duce ducta freto | Ambivi meritoque vocor VICTORIA: sunt mi | Vela alae, precium ⟨sic⟩ gloria, pugna mare.*

Beneath: *Conveniunt rebus nomina sepe ⟨sic⟩ suis.* The title page occurs repeatedly in later editions of 1616, 1618, and 1626: G. W. Cole, *A Catalogue of Books Relating to the Discovery and Early History of North and South America Forming a Part of the Library of E. D. Church*, New York, 1907, II, p. 1626 (edition of 1626).

Sechste Theil/
Kurtze/ Warhafftige
Relation vnd beschreibung der Wunderbarsten vier Schiffarten/ so jemals verricht worden Als nemlich:

Ferdinandi Magellani Portugalesers/mit Sebastiano de Cano.
Francisci Draconis Engeländers.
Thomæ Candisch Engeländers.
Oliuarij von Noort, Niderländers.

So alle vier vmb den gantzen Erdtkreiß gesegelt/ auß vnterschiedenen authoribus vnd sprachen zusamen getragen/ vnd mit nötigen Landt Charten/ feinen Figurn vnd nützlichen erklerungen geziert/ vnd verfertiget. Durch/

LEVINUM HULSIUM

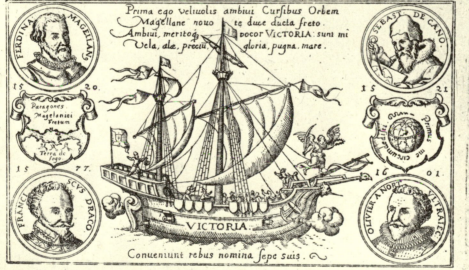

Prima ego veliuolis ambiui Cursibus Orbem
Magellane nouo te duce ducta freto.
Ambiui, meritoq; vocor VICTORIA: sunt mi
Vela, alæ, preciu, gloria, pugna, mare.

FERDINAN MAGELLAN
1520
Paragones Magelanici Fretum
Terra de fogo
1577
FRANCISCVS DRACO

SEBAST. DE CANO
1521
Primus me circumdedisti

VICTORIA

Conueniunt rebus nomina sepe suis.

1601
OLIVIER A NORT VLTRAIECT

NORIBERGÆ,
IMPENSIS COLLECTORIS. M. DCIII.

64. Levinus Hulsius, *Kurtze Warhafftige Relation . . .* (title page).
New York Public Library

1. INDEX OF MONUMENTS

2. GENERAL INDEX

Vasanzio, Giovanni, 251 n. 140

Vasari, Giorgio, *Lives of the Painters*, 161 n. 213, 176 n. 258

Veneziano, Agostino, 75 n. 33

Venus, 59f. and nn. 4, 13, 14, 62ff., 70ff., 82 and n. 47, 98 n. 70, 116, 142 nn. 169f., 146ff. and n. 180, 156f., 160f. and nn. 208, 210, 213, 164ff. and n. 228, 167ff., 172, 175; role of, in the *Parnassus*, 157ff.; *see also* astrology; astronomy; color, symbolism of; couches; *emblemata*; Este, Isabella d'; hares; laurel; myrtle; oranges; planets; quince; *and Index 1, s.v.* Mantegna, *The Parnassus*: antique sources

Venus Pompeiana, 212 and n. 60

Victory, 191f. and nn. 13f., 193 n. 16, 196 nn. 23f., 198, 200, 206f. and nn. 39, 42, 208 and n. 49, 256ff.; *see also Index 1, s.v.* Samothrace, sculptures from: *Victory of Samothrace*

Villa d'Este, architects of, 245; *see also Index 1, s.v.* Ligorio, Pirro, *and* Tivoli

Virgil, 4 n. 3, 143 and n. 172, 210

Aeneid
 4.242–244: 131 n. 143
 7.208: 3, 5 and n. 5
Eclogues
 7.62: 168 n. 236
 7.64: 169 n. 242
Georgics 2.18: 169 and n. 243
see also Servius

Vitruvius, 148 n. 180

Voragine, Jacobus de, *Golden Legend*, 149

Vulcan, 59, 60, 61 n. 14, 64 n. 17, 66 and n. 18, 69, 142ff. and nn. 169ff., 148f. and n. 180, 157, 161 and n. 213, 172 n. 250; cave of, 66, 69, 143f., 154, 170 n. 246; *see also* Amor; blowpipe; Marsyas; music; musical instruments; Tubal-Cain; *Tubilustria; and Index 1, s.v.* Mantegna, *The Parnassus*: antique sources, scale; *and* manuscripts, *s.v.* Rome: Vat. Reg. lat. 1290

Zeus, *see* Jupiter

zodiac, signs of, 156 n. 200, 161, 174 and nn. 254f.